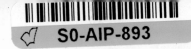

ETHNIC AND TOURIST ARTS

The Fourth World comprises those
native peoples whose lands and cultures
have been engulfed by the nations of the
First, Second and Third Worlds.
Nelson H. H. Graburn

The editor wishes to acknowledge financial
support from the Comparative/International
Fund of the Institute of International Studies,
University of California, Berkeley, for much of
the research that made this volume possible.

ETHNIC AND TOURIST ARTS

Cultural Expressions from the

Fourth World

Nelson H. H. Graburn, editor

University of California Press • Berkeley • Los Angeles • London

University of California Press
Berkeley and Los Angeles, California

University of California Press, Ltd.
London, England

First Paperback Printing 1979
ISBN 0–520–03842–8
Library of Congress Catalog Card Number: 74–30521
Printed in the United States of America

1 2 3 4 5 6 7 8 9

Contents

List of Maps

List of Illustrations

Note: Captions are placed next to illustrations in the text. Courtesy notices citing the sources of the objects illustrated and credit notices citing the photographers are in two separate lists at the back of the book.

TEXT FIGURES

COLOR PLATES

Preface and Acknowledgments

The gestation of this book has been a long and at times exciting and painful process. My interest in the subject was first aroused in 1959 when I discovered that the Eskimos of Sugluk, P.Q., in the Eastern Canadian Arctic, expressed feelings about their contemporary arts in ways that contradicted much of what was published about Eskimo art in Southern Canada (Graburn 1960). After additional fieldwork I decided to make an anthropological study of the commercial and domestic arts of the Canadian Inuit and "to tell their side" of the story.

A stimulating paper by Sonya Salamon, "Art Complexes and Culture Change" (Salamon, 1964) compared the commercial and innovative aspects of a number of instances of contemporary arts, including my own unpublished Eskimo material, and brought to my attention several comparable cases in the literature—especially Akamba wood carving and Navajo jewelry. Professor Stewart Morrison of Auckland University, New Zealand, later discussed with me similar processes of development observable in the arts of the Maori. He had devised a classification system for these processes that helped form a rough basis for my own thinking, and this same system is applied to some degree in this book. When UNESCO invited me to contribute an article on the sociology of art to the *International Social Science Journal* in 1967–68, I combined my own observations of the Inuit with Salamon's and Morrison's ideas, which resulted in "Art and Acculturative Processes" (Graburn, 1969b).

By this time I was deeply interested in the entire subject of arts of acculturation, and I was fortunate enough to be awarded a grant by the Institute of International Studies, Berkeley, to aid my search for comparable data to test hypotheses. Through correspondence I learned of numerous scholars with parallel interests, so I convened a Symposium on the Arts of Acculturation at the annual meeting of the American Anthropological Association in San Diego in November, 1970. The papers presented there by Kaufmann, Ryerson, Charlton, Lathrap, Williams, Ben-Amos, Biebuyck, and Sandelowsky formed the nucleus

for this book. Other scholars were invited to contribute later.

By the autumn of 1972 we had prepared a rough draft of the book, which contained reproductions of most of the photographs that had been submitted, thanks to the unstinting help of Mari Lyn Salvador. This draft version was used in both a large undergraduate class and a small seminar at Berkeley and was sent out to colleagues. The draft generated many helpful suggestions that have since been incorporated into this book. It was Judy Kleinberg who made the draft version possible by handling the correspondence, typing the manuscript, and editing much of the textual materials in their early form.

We then prepared a revised manuscript, which was edited by Anne Brower of the Department of Anthropology, before it was submitted to the University of California Press. During this preparation, financial and secretarial aid was continued by the Institute of International Studies and supplemented by the Committee on Research of the University of California, Berkeley. Lucy Turner, then a graduate student of folklore and anthropology at Berkeley, provided much advice and encouragement, as did many of the faculty of the Department of Anthropology, who read and criticized a number of the papers. The department was continually supportive in allowing me to teach subjects that advanced my scholarship in this field, in approving my applications for grants, for research leaves, and sabbaticals.

I am grateful for both the patience and encouragement of the majority of the co-contributors who made suggestions and took an interest in the intellectual and mechanical tasks that had to be undertaken. Other scholars who were not contributors were also helpful, particularly Dolores Richter of the University of Southern Illinois, Carbondale, Dennis Belindo of the Native American Studies Program, Berkeley, and Professor Edmund Carpenter of Adelphi University, New York.

Many people assisted in making final revisions, especially Linda Draper, Terry Paris, and Niloufer Hirschmann of the Department of Anthropology at Berkeley; Mary Ellen Alonso and Ronald Davidson of Berkeley; Charles Briggs of the University of Chicago; and particularly Professor Jehanne Teilhet of the University of California, San Diego. During this same period, the staff of the Lowie Museum at the University of California, Berkeley, mounted a major exhibit, "Traditions in Transition" based partly upon some of the ideas and cases in this volume. I had the pleasure of working with Lawrence Dawson and Vera-Mae Fredrickson on a small book that accompanied the exhibit, which made the case material and thematic ideas available to a wider audience (Dawson, Fredrickson, and Graburn 1974).

Director Willam Bascom and Assistant Director Frank Norick of the Lowie Museum have been most supportive of my efforts to publish, as have other staff members who have aided me with their expertise and thoughtfulness. Not only did they provide me with the opportunity to examine the museum's vast collections, including items already on exhibit, but they also offered me access to specimens in their own and other collections. For photographing many new specimens and for expert

reprinting of illustrations submitted by others, we are grateful for the skills and care of Phil Chan, and for the advice and experience of Gene Prince of the Photographic Division of the Lowie Museum, as well as for the continuing advice and enthusiasm of Mari Lyn Salvador. Adrienne Morgan, of the Department of Geography at Berkeley, prepared the maps, and Grace Buzaljko, of the Department of Anthropology, prepared the final index; I am grateful to both for their suggestions and expertise.

It is impossible to thank individually all those who did typing, research, and bibliographic work, many librarians, the staffs of numerous bookstores, galleries, museums, and exhibitions around the world, and hundreds of artists and craftsmen all of whom provided the answers to questions that I and my colleagues have posed. To Grant Barnes, editor, and to the staff of the University of California Press, we express our thanks for their enthusiasm, encouragement, and support.

Introduction: Arts of the Fourth World

Nelson H. H. Graburn

When my family and I were talking about this book, we tried to think of a better title than the provisional "Contemporary Development in Non-Western Arts"—a title that, while it avoided the problematic word "primitive," left us with ambiguous connotations that "Non-western" must be Eastern, i.e., Oriental, or perhaps even Ivy League! They asked me what kinds of arts the chapters covered and I explained: "Oh, things like Benin woodcarving, Panamanian Cuna molas, Eskimos soapstone carvings, New Guinea shields. . . ." "Ah," said my brother-in-law, "you mean Third World Arts?" To which I replied, "No, Fourth World Arts!"

The concept of the Fourth World, which has already been the title of two books (Whitaker 1972; Manuel and Poslums 1974),[1] is a particularly appropriate one for the study of anthropology and for the majority of the peoples whose arts are discussed in this book. The Fourth World is the collective name for all aboriginal or native peoples whose lands fall within the national boundaries and techno-bureaucratic administrations of the countries of the First, Second, and Third Worlds. As such, they are peoples without countries of their own, peoples who are usually in the minority and without the power to direct the course of their collective lives.

Not only are they no longer isolated or autonomous peoples as they perhaps once were, but their arts are rarely produced for their own consumption or according to their own unmodified tastes. In many ways these peoples

[1]Vine Deloria, in his foreword to the second of these two references, traces the evolution of consciousness of the differences between the Third and the Fourth World. The term was also used in a more limited, but slightly incorrect, fashion by Berreman (1972:396), who wrote " 'fourth-world' colonialism, i.e., exploitation inflicted by 'third-world' (non-Western) people on their internal minorities, analogous to that they have often experienced themselves at the hands of 'first-' and 'second-world' colonialists (Western noncommunist and communist nations respectively)."

In recent popular journal articles economists have been quoted as dividing the underdeveloped nations into Third and Fourth worlds, solely on the basis of average per capita income. Not only is this at odds with the original (1955 Bandung conference) political and structural intent of the division into First, Second, and Third worlds, but it produces perhaps temporary and anomalous divisions of contiguous poor nations on the basis of ill-reported and hard to calculate income statistics. I here assert that "non-nations"—native peoples subject to internal colonialism—logically form a politico-structural Fourth World category, though they may soon emerge as independent nations in their own right.

have become dependent part-societies (Graburn 1967a) whose very thought and culture reflect the differences from, and accommodation to, the realities of the majority peoples surrounding them. Thus, the study of the arts of the Fourth World is different from the study of "primitive" art, characteristic of most earlier anthropological writings, for it must take into account more than one symbolic and aesthetic system, and the fact that the arts may be produced by one group for consumption by another. The study of Fourth World arts is, par excellence, the study of *changing* arts—of emerging ethnicities, modifying identities, and commercial and colonial stimuli and repressive actions.

ATTITUDES TOWARD FOURTH WORLD ARTS

This volume, then, concerns one of the most neglected fields within the disciplines of anthropology and art history. It involves the study of what used to be called "primitive" art in the changing sociocultural context of the modern world, a world in which small-scale nonindustrial societies are no longer isolated and in which holistic cultures with their inner-directed traditional arts have almost ceased to exist.

These arts were only "discovered" to have aesthetic value during the last century (Goldwater, in Biebuyck 1969). Before this, although they were collected, it was only for their curiosity value. They were first seriously and widely appreciated by disaffected Western artists, who took them as a form of innovative inspiration without realizing their inherent conservatism. This is the first point where one might say that (segments of) Western society "needed" primitive arts. Perhaps this need coincided with the bankruptcy of the academic art world, and more importantly, with the increasing secularization, standardization, and industrialization of Euro-America. This early interest in and collection of works of primitive art, however, (see Gerbrands 1957:25–64; Claerhout 1965), was without appreciation of their cultural context. In many cases the agents of colonialist powers, after they had overcome some of their revulsion toward the subject peoples, collected arts and crafts as souvenirs of their sojourns in the service of the empire (see especially Bascom in chapter 17 below). These souvenirs might have been actual examples of the traditional arts of the local peoples and occasionally were commissioned models of such items. Even in the former instance, however, the colonial agents were usually unable to tell whether the items they had bought were truly traditional or whether they were specially made and modified for the souvenir market.

As "civilized societies" come to depend more and more upon standardized mass-produced artifacts, the distinctiveness of classes, families, and individuals disappears, and the importation of foreign exotic arts increases to meet the demand for distinctiveness, especially for the snob or status market. One gains prestige by association with these objects, whether they are souvenirs or expensive imports; there is a cachet connected with international travel, exploration, multiculturalism,

etc. that these arts symbolize; at the same time, there is the nostalgic input of the *handmade* in a "plastic world," a syndrome best described in Edmund Carpenter's "Do You Have the Same Thing in Green? or Eskimos in New Guinea" (1971). But for many items of commercial art, this very demand often leads to a proliferation and a mass production that vitiates the prestige and usefulness in the very snob market for which the new arts were invented—thus, "success breeds failure" is a new version of the adage "familiarity breeds contempt."

THE ANTHROPOLOGY OF ART

Falling well within the major boundaries and goals of traditional anthropological theory, this study is an enquiry into the nature of social integration, in the Durkheimian sense (1893), and of course, the converse, differentiation. Our attempts to understand both integration and differentiation have often been expressed as the study of structure, social or cultural, depending on the levels. Integration and differentiation are but two sides of the same coin, essential to the processes of solidarity within groups and between parts of groups, or between groups that go together to form a part of larger entities. These groups, or segments of society, are called by many names: classes, castes, tribes, ethnic groups, identity groups, etc., all of which are tending to merge in the contemporary world. The arts of these peoples have been called "primitive" art and "folk" art, depending on whether the creators are, respectively, members of a re-

cently conquered group or of the long-familiar "lower classes" of complex societies.

Though the terms "primitive" and "folk" art may have been satisfactory for the purposes of nineteenth-century Europeans, it now seems clear that such categories are hopelessly inadequate for any contemporary description (see Gerbrands 1957:9–24). Indeed, they are often taken to be either prejudicial or patronizing slurs upon the arts and artists in question. Even the label "art" itself reflects the elitist traditions of "high civilizations" concerning the value of arts vs. crafts, the importance of creativity and originality, and specializations and distinctions that emerged in Europe and China. As J. Maquet (1971) has clearly shown, aesthetic productions may be (1) *art by destination*, that is to say, they may have been intended by their producers to be art per se or to have a primarily aesthetic locus, or (2) they may be *art by metamorphosis*, in which case they are deemed art sometime *after* they were originally made (often as a result of the changing standards and preferences of the consumer). A special case of "art by metamorphosis" occurs when objects produced in one society are transported to another and labeled as "art." That the object may have been intended for such external consumption is itself an indication of the special relationship that exists between the art-producing peoples of the Fourth World and the tourists and art-consumers of the West; it is this relationship that provides much of the subject matter for this volume. (See, for instance, my article "I like things to look more different than that stuff did," 1976a).

As Maquet so aptly remarks (1971:16)

"Outside our showcases, there is no primitive art, particularly not in the nonliterate societies where museum and gallery objects have been created." The concept of "primitive" art is a particularly Western concept, referring to creations that we wish to call art made by peoples who, in the nineteenth century were usually called "primitive," but in fact were simply previously autonomous peoples who had been overrun by the colonial powers. The descendants of these peoples are no longer autonomous, nor are they necessarily preliterate, and their arts—the arts of the Fourth World—are rarely free of the influences of the artistic traditions of the dominant societies that engulfed them.

Similarly, "folk" art was a concept invented in the nineteenth century by which the literate upper classes of such stratified societies as those in Europe and India could label the arts and crafts of the lower classes, the often nonliterate rural peoples who followed local as well as national traditions. Nations are no longer organized along such feudal lines, and most classes of people are no longer illiterate; moreover, even if they were, most of them are now exposed to national and international traditions and tastes, through radio, travel, marketing networks, and increasing worldwide standardization. Today, the term "folk" art is used for those remnants of local traditions that have broad appeal, that represent the continuing traditions of handmade things, and that are not officially part of the art establishment or the avant-garde. Hence, our book deals with the descendants of the primitive arts and the transformations of some folk arts. Many, if not most, of these arts are made

for appreciation and consumption outside of the society of creation, contrasting with the internal orientations of primitive and folk arts in the past. That these processes are not confined to minority cultures in a capitalist environment is well illustrated in Kaplan and Baradulin (1975).

Although the general purpose of this book is to explore the forms, functions, and meanings of Fourth World arts in their changing sociocultural contexts, the increasing importance of this "special relationship" between producer and consumer should be kept in mind as the reader proceeds through the various chapters. For this is not only an *art* book, it is an *anthropological* book as well. The reader, then, is urged not only to evaluate the various objects herein discussed in terms of their "artistic significance," but also to consider his own "emotional investment" in the objects, perhaps his own unintentional or unconscious distortions of the work of art and the artist. This suggestion can be taken as a methodological *caveat*, a reminder that *all* people (even the "primitives") tend to want to make the unfamiliar less frightening and more "understandable" by bending it to their own preconceptions. The danger is that what often results is not the world as we know it, but the world as we would have it.

The Changing Arts of the Fourth World

In stratified societies that consist of dominant and conquered strata, the arts of the latter peoples may be of two major types: (1) Those arts—the inwardly directed arts—that are made for, appreciated, and used by peoples within

their own part-society; these arts have important functions in maintaining ethnic identity and social structure, and in didactically instilling the important values in group members. (2) Those arts made for an external, dominant world; these have often been despised by connoisseurs as unimportant, and are sometimes called "tourist" or "airport" arts. They are, however, important in presenting to the outside world an ethnic image that must be maintained and projected as a part of the all-important boundary-defining system. All human social groups, from the family to the United Nations, need symbols of their internal and external boundaries; the practical and decorative arts often provide these essential markers.

Most of the societies that are described in this book have undergone some form of change or acculturation that has been defined as "those phenomena which result from groups of individuals having differing cultures coming into first-hand contact, with subsequent changes in the original culture of either or both groups" (Redfield, Linton, and Herskovits 1936:149). Thus, they could be called the "arts of acculturation," which I have defined elsewhere as "art production, which differs significantly from traditional expressions in form, content, function, and medium, and which also differs from the various forms of art production indigenous to ever-growing 'civilization'" (1969b:457). This broad category embraces those forms that have elsewhere been labelled transitional, commercial, souvenir, or airport arts, but it also includes certain novel noncommercial art forms.

Building on a previous classification (Graburn 1969b), we may attempt to outline some of the differing directions taken by the processes of artistic change, as illustrated in this book:

1. EXTINCTION: The decline or disappearance of the indigenous art form has, surprisingly, rarely been described. One case is illustrated in chapter 19 by Biebuyck's description of the demise of Lega *bwami* sculpture.

2. TRADITIONAL OR FUNCTIONAL FINE ARTS: The persistence of a traditional art form can be accompanied by some changes in technique and form, or even show incorporation of a few European-derived symbols and images. As long as these changes do not seriously disturb the transmission of symbolic meaning, and hence the culturally appropriate satisfactions, these may still be called functional or contact-influenced traditional arts (May 1974:1–6). They are exemplified by some of the pottery made for home consumption at Laguna (see Gill, chapter 5.) and other Pueblos, by the temple and wall paintings of Rajasthan (see Maduro, chapter 13), or by the larger bark paintings of traditional beliefs made by the aborigines at Yirrkala, Arnhem Land (see Williams, chapter 15). In chapter 16, Mead describes the still-traditional carvings and buildings of the New Zealand Maori, which serve the minority community, but are made with metal tools and modern paints, by artists with government-sponsored university instruction in the arts.

3. COMMERCIAL FINE ARTS: Many art forms similar to the above may be called

commercial fine arts or pseudo-traditional arts (May, ibid.) because, although they are made with eventual sale in mind, they adhere to culturally embedded aesthetic and formal standards. The better of the Peruvian gourds described by Boyer (chapter 10), some of the Shipibo pottery described by Lathrap (chapter 11), and Australian aborigine and Maori productions fall into this category. Commer-

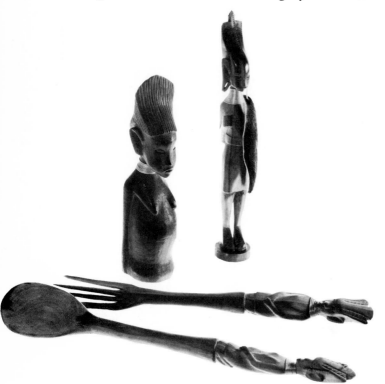

1. East African Akamba souvenirs: carved wooden fork and spoon, with anthropomorphic handles (37 and 38 cm. long); female bust (24 cm. high) and warrior figure (25 cm. high); all mid-twentieth century.

cial arts range almost imperceptibly from the truly functional, such as Asmat *biche* poles and Melanesian *malanggan*, which may be sold to anthropologists or collectors after ritual usage, through considerably modified forms, such as Huichol yarn paintings (see plate 1), to objects with less meaning and lowered standards, such as those described in our next category.

4. SOUVENIRS: When the profit motive or the economic competition of poverty override aesthetic standards, satisfying the consumer becomes more important than pleasing the artist. These are often called "tourist" arts or "airport" arts and may bear little relation to the traditional arts of the creator culture or to those of any other groups. Akamba wood carvings (see figure 1), Seri ironwood carvings (see Ryerson, chapter 6), the bark paintings of Xalitla (see Stromberg, chapter 8), or even the ebony carving of the Makonde of Tanzania (see figure 6) are innovations or novelties, with specific dates and recorded origins that indicate they have been made within the past 20 years! The rationalization of production and the standardization or simplification of design of many souvenir arts have tended to give all commercial, contemporary arts a bad name. The symbolic content is so reduced, and conforms so entirely to the consumers' popular notions of the salient characteristics of the minority group, that we may call these items ethno-kitsch, paralleling Dorfles' concept of porno-kitsch (1969:219–223).

5. REINTEGRATED ARTS: Not all contemporary arts fall on a simple continuum be-

tween traditional arts and European arts. Cultural contact between dominant and minority peoples has often led to fertile new forms, developed by taking some ideas, materials, or techniques from the industrial society and applying them in new ways to the needs of the small-scale peoples. These arts are new syntheses, such as the colorful *mola* blouses (see Salvador, chapter 9) that the Cuna Indians of Panama made after they were introduced to imported textiles, needles, and scissors. In the American Southwest, the traditionally mobile Navajo hunters learned weaving from the sedentary Pueblo Indians, adapted sheepherding from the colonial Spanish, and themselves developed a unique weaving tradition (see Kent, chapter 4) to fill their needs for clothing and saddle blankets. Later, these textiles in turn came to be sold to white Americans. We might say that this art form went from a new integrated synthesis to a Navajo tradition to a form of highly valued commercial art.

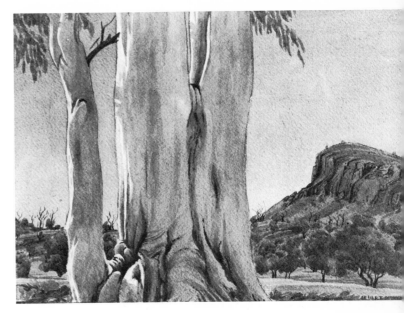

2. Water color painting by the Australian Aborigine artist Albert Namatjira, "The Ancient Ghost Gum of Temple bar" (1943). Namatjira painted landscapes in his aboriginal homeland, in the style of the white artist Rex Battarbee.

6. ASSIMILATED FINE ARTS: There are an increasing number of instances where the conquered minority artists have taken up the established art forms of the conquerors, following and competing with the artists of the dominant society. These are characteristic of extreme cultural domination and hence a desire to assimilate. Excellent examples are most of the Plains and Southwest Indian painting (Brody, chapter 3, and 1971) and the watercolor productions of the Australian Aborigine painter, Namatjira (see figure 2), and the Hermansburg school (Batty 1963).

7. POPULAR ARTS: The assimilation of previously colonialized peoples to the arts and traditions of the dominant European powers can also take another turn. An artistic elite has arisen whose arts often take the forms of European traditions, but in content express feelings totally different, feelings appropriate to the new cultures that are emerging among the leaders of the Third World. Thus, there are painters and poets in Mozambique, such as Malangatana (Schneider 1972), who express in European terms African feelings about art and

Aesthetic-Formal Sources and Traditions

	Minority Society	Novel/Synthetic	Dominant Society
Minority Fourth World	*Functional Traditional* e.g., Lega, Maori *marae*, some pueblo pottery	*Reintegrated* e.g., Cuna *molas*, Pueblo *kachinas*	*Popular* e.g., Zaire, Mozambique, Navajo jewelery
External Civilizations	*Commercial Fine* e.g., Maori woodcarving, New Guinea shields	*Souvenir Novelty* e.g., Seri, Makonde carving; Xalitla *amate*	*Assimilated Fine* e.g., Santa Fe Indian painting, Namatjira watercolors, Eskimo prints

Intended Audience

life, and in the former Belgian Congo, now Zaire, there is a genre called *arts populaire* (Szombati-Fabian and Fabian 1976) that records for the modern Africans their feelings about their ancestral tribal past, their domination by harsh Belgian colonists, and their present developing and urbanizing country. Such phenomena are not properly the subject of this book, for these people are moving from being powerless Fourth World minorities to being powerful leaders—if not majorities—of their own Third World countries.

We may now summarize these processes in the above two-dimensional diagram of the various art forms of the Fourth World. Moving from top to bottom, we pass from arts made for the peoples of the minority cultures themselves, to those made for export to outgroups and foreign markets; moving from left to right we pass from arts made purely according to traditional aesthetic and formal criteria (even

if made with new techniques and materials in some cases) to, at the far end, arts that fall squarely within the traditions of the dominant powers. In the center column are those arts specially developed from a synthesis of native and European forms, or even complete innovations created out of the unique contact situation.

Not all contemporary arts of Fourth World peoples fit the above scheme neatly. Many art forms fit more than one category at the same time, as they are quite purposefully multifunctional. For instance, to teach their young men their beliefs about Dreamtime, aborigine men in Australia (see Williams, chapter 15) make bark paintings of "important scenes," which they sell, along with other paintings to museums and rich collectors. They also, however, produce small portable and relatively meaningless barks for the tourist trade. One might diagram the processes as follows:

Traditional barks		
Hunting scenes	Suitcase souvenirs	Namatjira watercolors

In this fashion we might, in fact, diagram many of our other cases, noting the movement of the art form over time, e.g., as the functions and techniques change:

worn	*Cuna molas*	Western dress
for sale	tourista molas	

Pueblo pottery	revivals	manufactured utensils
sale	souvenirs	

This kind of diagram represents only the arts of the contact situation produced by the no-longer isolated groups. If we could imagine a third dimension, below the diagram would be the uninfluenced traditional arts of tribal and small-scale societies. Moving with the flow of time, we would find contact first in the upper left-hand square—contact-influenced traditional arts. As cultural contact and accommodation increased, any of the other art forms could arise; the one on the top right, which is usually the last, is where the minority peoples have reassumed some power of au-

tonomy and have undergone considerable assimilation. At that point, they have become consumers of arts from traditions outside their own, often borrowed from the dominant powers themselves, but still produced by their own elites. Then the formerly powerless Fourth World peoples may pass up and out of the diagram, to become a self-governing national elite in the First, Second, or Third World.

We should also note that the arts of the dominant cultural traditions—at a third level above the surface of the diagram—often dip down, as it were, and use, steal, or copy ideas from Fourth World arts. This ranges all the way from Picasso's reproduction of the sculpture of West African peoples under colonial domination, to Dutch textiles based on Indonesian *batiks*, to the process of commissioning poor village people to mass produce "art" according to Western notions of what the consumer thinks "folk" art is like (Hirschmann 1976). These processes, of course, have serious repercussions on the arts of the Fourth World peoples and even on their cultural self-image (see later section, *Borrowed Identity*).

PROCESS AND CHANGE

Now let us consider in more detail the process of change involved in the emergence of new art forms, noting how particular kinds of arts have been subject to certain forces and trying to explore why some contemporary arts

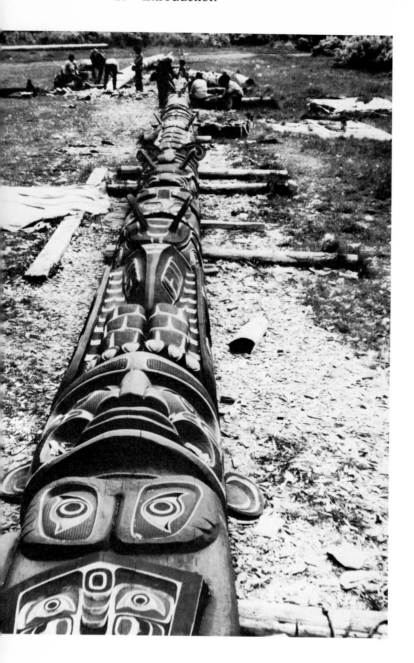

3. At the Kwakiutl village of Alert Bay, Vancouver Island, the James family carves an enormous totem pole for the tribe. The motifs, though traditional in style, are a selection from sub-tribal forms. The pole, donated by a lumber company, is made in two parts bolted together, which at 170 feet, is the tallest in the world. 1971.

look much the same the whole world over.[2] Although many of the same cultural and technical forces are operating on both the functional, internally directed arts and on the commercial, made-for-export arts, we shall consider them separately, starting with the former.

Functional, Noncommercial Arts

These arts, which are those most meaningful to the creator peoples, include the only slightly modified contact-traditional arts, completely borrowed foreign popular arts, and the innovative and syncretistic reintegrated arts. Just because arts are made for local consumption and are never intended for outside peoples or for external display or trade, does not mean that they do not change. Two major sets of forces are at work: material and technical opportunities, and cultural and formal influences.

Material and technical changes: All societies that are in contact with each other eventually exchange materials, items, and ideas. If two societies are in long-term contact, and are at greatly different economic and technological

[2]Some of the ideas and examples in the following sections were generated during the research and writing for *Traditions in Transition* (Dawson, Fredrickson, and Graburn 1974).

levels, great modifications are introduced into the material culture of the less-developed societies. All peoples, save the most spartan, may seek easier ways to carry out their essential activities, from growing crops to making idols. The great woodcarving peoples discussed in this book—the Maori and the Northwest Coast Indians—adapted their stone-blade tools so they could use metal blades and started using manufactured pigments for their important ceremonial houses and monuments during the eighteenth and nineteenth centuries. As a result, they could more easily fell and sculpt great trees, which led to a consequent florescence in architecture and the woodcarver's arts. Today these peoples make use of the latest in blades, power tools, and long-lasting paints in refurbishing and renewing these ceremonial houses and monuments (see figures 3 and 88).

Similarly, the traditional painters, such as **the Brahmins of Nathdwara and the aborigines** of Yirrkala, sometimes take to commercial brushes and pigments, or at least use better methods of making the paints stick (see figures 77 and 86). Foreign materials are substituted for hard-to-obtain native objects, such as imported beads for porcupine quills, freeing artists from the problems of gathering and preparation and allowing them to concentrate on design and execution—and greater production. Metals and manufactured items often come "prepackaged" and last much longer than native items. Although this may benefit the arts and crafts in some ways, it might also destroy such social relationships as a traditional one between materials suppliers and artists.

Often traditional arts and crafts are in direct competition with imported manufactured items. Cheaply reproduced pictures, for example, reduce the sales of such artists as the painters of Rajasthan, who—following the edict "If you can't lick 'em, join them"—now sell their paintings to calendar companies in Bombay, who in turn reproduce and sell them by the thousand (figure 75). Practical arts, such as carriers and containers, are often the first to go: if their prime functions are utilitarian rather than aesthetic and ritual, they are replaced by lighter and stronger, but even less aesthetic, imports (see figure 66); but this is not always the case, as Gill informs us (chapter 5)—Laguna Pueblo wares are not really replaceable (figure 31).

The assimilation to popular arts—the copying of foreign art traditions from schooled and stratified "civilization"—sometimes occurs in that painful period of rank imitation that follows a people's loss of independence. The caps, badges, clothes, and songs of the conquerors are imitated by the conquered as though power and prestige will follow. And novelty and a taste for the exotic do not seem to be an exclusive characteristic of the conquerors: Canadian Eskimos decorate their drab wooden houses with *Life* magazine pictures and plastic flowers from Hong Kong. The Indian villagers of the Andes wear local "ethnic" clothes that are imitations of sixteenth-century Spanish dress. The Navajo "borrowed" silver jewelry from the Spanish, and Hopi Kachina dolls are probably imitations of the apparently magic *santos* that the Spanish Catholics brought to the Southwest.

Totally new forms arise with the access to

new materials. Eskimos now wear parkas that deviate from their traditional skin garments (see figure 12) because of the advantages and disadvantages of the wool duffle and Grenfell cloth that they import; Cuna molas were developed from body-painting and basketry designs, via painted skirts, with the advent of cotton cloth, scissors, needle, and thread. The Cuna have also adopted certain very bright color schemes, just as some American Indians have dyed the feathers in their headdresses, Pueblo and Peruvian potters have come to use brightly painted designs, and the Iwam of New Guinea have developed even more complex painting styles with greater contrast on their shields (figures 83 and 84).

Other modified functional or reintegrated arts include African masks, which have in many areas long incorporated trade items, such as beads, nails, cloth, and even European symbols (Bravmann 1974; Bascom 1973). Modern American Indian costumes have "traditionally" contained imported items. Eskimo skin parkas have been decorated with beads, coins, spoons, and trinkets; the Cuna have used English cotton prints (figure 53), and so on. As these Fourth World peoples decorate their lives with manufactured items, perhaps they might say that we are the makers of their "folk" or "primitive" arts!

New materials and tools become available as they are invented and improved, but mainly as transportation and trade become more widespread. As I have emphasized elsewhere in this book, the same routes that carry in these industrial products carry out those very arts that are our subject matter.

Cultural Changes: More important than the availability of new materials and techniques is the advent of new ideas and tastes. Contacts with foreign peoples, education, literacy, travel, and modern media so broaden the ideas and experiences of Fourth World peoples that they may *want* to change, break away from, or enlarge upon their previously limited traditions.

It is these ideas that not only build up new arts, but that are eventually destructive of old traditions. Missionaries and governments have destroyed many art traditions around the world, but neglect and competing ideas have destroyed just as many. The potlatch was banned for the Northwest Coast Indians so totem poles were no longer raised; but new forms of prestige, derived from occupations and commerce, also destroyed the prestige system that was the underpinning of the ceremonial and art traditions of these same Indians. Totem poles are still made and raised (figure 3), but not with the same frequency, pomp, and complex nuances of meaning that formerly obtained. African masks and New Guinea *biche* poles and long houses have been burned by outsiders, but some have also been burned by African and Melanesian converts to the new iconoclastic religions of Islam and Christianity. Indeed, it has often been said that traditional religions are the raison d'être for local art traditions, and, though this is not universally true (for secular beliefs such as rank and power are also expressed), the death of the local religion often coincides with the demise of the functional arts. World religions may substitute no comparable expressions or they

may be a cover for growing secularism, the turning away from the magic and the spiritual to a more drab life based on material and individual satisfactions. If no one wants to dance in rituals, the masks are not made; if all are equal—or equally downtrodden—then distinctions of rank and ancestry will not be expressed in elaborate costume and paraphernalia. Education, political bureaucracy, and a materialist orientation tend to turn Fourth World peoples into pale imitations of the masses of the larger societies that have engulfed them. The persistence of traditional arts and crafts depends on: (1) continued demand for the items, (2) availability of the traditional raw materials, (3) time to work and lack of competing attractions, (4) knowledge of the skills and the aesthetics of the arts, (5) rewards and prestige from peer-group members, (6) the role of the items in supporting the belief systems and ritual or gift-exchange systems. Much as we are nostalgic about these loved arts, people do not go on making them for our pleasure if our society and technology have destroyed the incentive to do so. They go off and become bus drivers or betel-nut sellers (Maduro, p. 243 below).

But not all change is destruction. We have talked about the impact of materials and techniques, and ideas flow along the same channels. Many up-to-date functional arts are constantly changing, incorporating and making explicable new ideas and events. The Maori took up a version of European dress as a mark of status in the nineteenth century (figure 95), adopting imported ideas to make bandoliers and bodices, which they wear along with their more traditional clothing (Mead, chapter 15). The Cuna portray the Kennedys (Dawson, Fredrickson and Graburn, 1974: figure 19), political parties, and space ships in their molas; the Indonesians incorporate rockets and supermen into their batiks, and portray Nixon and the Communists in their *ludruk* dramas (Peacock, 1968); the Hopi make Mickey Mouse Kachina dolls (Carpenter 1972, coverpiece) and Africans include modern themes in the mud architecture of their gas stations (Beier 1960). As outsiders we might not like such phenomena, or bemoan the "lack of tradition." But this *is* tradition; it is as real to the peoples now as the spirits of skulls and amulets were to their ancestors one hundred years ago. If Eskimos are Christian, they want to make crosses and altar-pieces for themselves, as they used to make ivory-tooth charms. When the Navajo made textiles for themselves and for local consumption (and not for the national collectors' market), they made them to their own liking, with imported bright cochineal and indigo dyes and unravelled bayeta (Kent, p. 88, below); it is only recently that outsiders taught them to find and use muted, local natural dyes.

European and Western society in general, while promoting and rewarding change in its own arts and sciences, bemoans the same in others. They project onto "folk" and "primitive" peoples a scheme of eternal stability, as though they were a kind of natural phenomenon out of which myths are constructed. Much as Lévi-Strauss (1963) has shown that these peoples use "nature" as a grid against which to demarcate their experience, so the

rulers of the world have used the powerless and the exotic as "nature" by which to demarcate their "culture."

Commercial and Tourist Arts

Though there are many instances where traditional arts and exact model crafts have been sold for souvenirs and curios, most commercial arts are modified somewhat, or even invented, for the purposes of sale. In the first diagram above, we have separated the types: commercial fine arts, souvenir arts, and assimilated arts. Sources of change incorporated into commercial arts come from both without and within, according to the tastes of the buyers and the efforts of the producers.

Perhaps the commercial fine arts—the pseudo-traditional arts—follow most closely the changes previously outlined for the functional arts, involving the use of materials and techniques for elaboration of form and color. The commercial fine arts are generally those demanded—more as status objects than as memorabilia—by people who wish to get "close to the native" spirit (not body of course) by having "genuine," "authentic" artifacts to show. The buyer, at this point, does not have to understand the symbolism or the iconography of the item, he only has to find it aesthetically acceptable and visually authentic. Closeness to what is believed to be traditional by the collector's reference group is the goal. (See below the section on faking and reproduction.) Thus the forces on the artist who makes traditional objects for sale usually point in the direction of some historical recorded model of what is "the real thing." Even here the accepted model of "traditional"

changes over generations in the culture of the collectors; objects that would be deemed too innovative at one time are later found acceptable; collectors or museum curators who reject items as too new or mere junk, often pay high prices for the same objects later on. "Classic period" Navajo blankets (plate 2), or even Haida argillite miniatures (chapter 2), were deemed "trade stuff" for decades, but are now worth hundreds of dollars apiece. One wonders if it is aesthetic tastes or market values that have changed?

Fourth World artists who depend on sales for a living—the Canadian Eskimos, some Pueblo Indians, Xalitleños, the people of Yirrkala, the Makonde, and many others discussed in this book—find the constraints of their belief system sometimes lead them away from mere reproductions of their believed-in functional arts. Since these latter arts may be sacred, artists would not, as Kaufmann shows for the Haida (chapter 2), make models of important functional items until their culture had been so destroyed and secularized that such things had lost their original value. In Central Australia, for example, the Aranda did not sell, or even show, their *churingas* to whites until the missionized and educated young saw the opportunity to make a shilling or two. Thus: (1) Tourist arts may be strictly separated from other arts on the grounds that to do otherwise would be a sacrilege, thereby forcing those involved in commerce to choose less sensitive items to make for sale: the people of Laguna Pueblo make pottery for sale but never include ritual and gift pieces among their ware. (2) The arts may have a dual purpose: the Australian aborigines use their bark

paintings of important scenes (chapter 15) to teach their beliefs to their children, and then sell the paintings to the missions and dealers; similarly, the Cuna wear their valued (though secular) molas until they are worn out or their themes are "dated," and then sell them to visitors or in Panama. (3) Though apparently identical objects are made both for ritual purposes and for sale, the artists may keep them separate in their heads: the santeros of Cordova, New Mexico, make wooden *santos* for religious worship, and make the same or similar items for sale, but call the latter *monos*, "mere dolls, models" (Briggs 1974). (4) The commercial success may lead to secularization: the Huichol Indians of Nayarit, Mexico, used to make small wool-pressed-into-beeswax paintings on bits of board as offerings in their peyote cult rituals (Furst 1968–69). As these grew in size and popularity, some of the Huichol grew wealthy and famous and left their rural homeland. Now, many apostate Huichol make yarn paintings that have no intrinsic spiritual value but simply illustrate interesting aspects of their beliefs (see plate 1).

The market itself is the most powerful source of formal and aesthetic innovation, often leading to changes in size, simplification, standardization, naturalism, grotesquery, novelty, and archaism. Souvenirs or trade objects for the mass market must be (a) cheap, (b) portable, (c) understandable, and (d), as D. Ray (1961) has shown us for Alaskan Eskimo ivory carvings, dustable! Sometimes it helps if they are useful, for at least then the owners will know what to do with them and they will have some inherent meaning in the home environment of the traveller (figure 1).

Makers must compete with each other and with imported souvenirs (plastic totem poles, post cards, manufactured items), always keeping an eye on low unit cost. This in turn may lead to small sizes, such as Yirrkala souvenir barks, small Cuna mola panels, or Ainu "couple" dolls, which are easily stored, sold, transported, or bought in number by visitors for gifts. Similar forces are also behind the manufacture of not just small souvenirs, but miniatures of beautifully made traditional items, such as California Indian basketry (Dawson, Fredrickson and Graburn, 1974; figure 6), Laguna pottery (figure 33), and some Indian paintings (figure 74).

Miniaturization also has several advantages: applicability for decorative use; economy of materials; a doll-like, folkloristic quality not associated with the real article. Though miniaturization makes some arts more salable, the opposite, increase in size, may be considered more economical by the artists: for instance, Eskimo soapstone sculptors and Cordova *santeros* (Briggs 1974) calculate that far less time and effort is spent making large, expensive carvings than the more typical small ones—they just can't sell so many of them!

Economic forces lead not only to changes in size, but also to simplification of form and decoration. The fewer steps that are involved, the more the artisan will be able to produce, and the lower the unit price. If artisans specialize in different stages of the production, they may become more skilled at each and a sort of "production line" is set up, as with the family division of labor of the Kamba woodcarvers or the bark-painters of Xalitla (figure

48). Simplification is aided by the fact that the buyer does not know the meaning of the omitted detail (such as the painted colors on Asmat items) or may not even be aware that there was more to the traditional objects than the ones in the shop (see figure 62–65).

Large-scale souvenir production methods, such as those of the "factory" that makes Makonde pieces at Mtwara, Tanzania (Stout

4. Robbie Dick hand painting "Cree Craft" rattles and drums, in the Great Whale River Indian-Eskimo Cooperative, 1970. Note the "authenticating" models on the wall, and the degree of perfection.

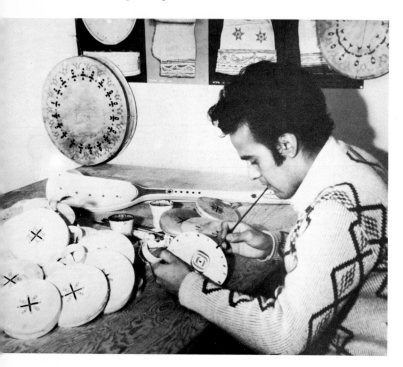

1966), those used in the craft shops of the Ainu (chapter 12; figure 69) or even those used by Canadian Eskimos, sometimes employ power machinery to ease and speed up operations. This may not lead to a lowering of standards, but it might well lead to a uniformity or standardization of product that will make it less salable and less admired as a handicraft. The Naskapi-Cree of Ungava (see also below; figure 4), however, made things so well by hand that a middle-class audience thought they were machine made and wouldn't buy them.

Beyond the raw forces of "unit cost" are more subtle matters of content and taste, which force peoples to produce for sale things that are acceptable to a public that already has its preconceptions of what is typical and appropriate. For instance, the travelling public of the Western world seems to believe that souvenirs should match the skin color of their producers, particularly that black people should produce black art objects. Although the early Kamba items (figure 1) were in light-colored wood, the nearby Makonde make things in ebony (figure 6), as do the Bini in Nigeria (figure 103); and the Papuans of the Sepik (figure 5), who don't have any dark woods at all, dye or shoe polish their souvenir arts. The buying public also emphasizes "valuable" materials such as ebony and mahogany in the tropics, shiny brown ironwood from the Mexican Indians (chapter 6), and argillite and ivory from the Alaskan Indians and Eskimos respectively. Eskimo sculptures made of dark green serpentine are inherently more attractive than those made of a gray

soapstone, and are often bought for their material rather than their workmanship (figures 11 and 13).

The subject matter and form of commercial arts must symbolize to outsiders a few central characteristics or beliefs about their makers. Two opposite trends have been pointed out, particularly for African arts, by Bascom (chapter 17) and Ben-Amos (chapter 18). The major tendency is toward naturalism, the simple portrayal of some being, person, or object in such a way as to be understood and recognized by someone who is not too familiar with the culture. Crafts and models, such as the Seri animals and birds (figures 38 and 39) and Eskimo sculptures (figures 11 and 12), are also prime examples of this trend. As Ben-Amos has explained it: "Tourist art . . . operates as a minimal system which must make meanings as accessible as possible across visual boundary lines . . . [a] reduction in semantic level of traditional forms, expansion of neo-traditional secular motifs, and utilization of adjunct communicative systems" (1977: 129). Thus, Ben-Amos demonstrated that tourist arts are like an obvious visual cross-cultural code, rather like pidgin languages are when used in trade. At this level, we might say that their content consists of signs rather than symbols.

Similarly, reproductions of everyday objects and portraits of village life are an important part of other commercial art forms (e.g., figures 28, 49, 58, 86, 111). This need for understanding and realism, combined with the romantic impulse, is behind the popularity of certain completely non-native assimilated arts.

5. Miniature middle Sepik ancestor figure, black stained light colored wood, 1969. (24 cm. high)

6. Modern Makonde commercial sculptures of ebony wood. Left: naturalistic *bindamu* sculpture of man and boy (30 cm. high); right: abstract *shetani* (spirit) sculpture, expressing the "exotic" often demanded of "primitive" arts (63 cm. high), Tanzania, 1971.

Namatjira, an Aranda, took up watercolor painting (figure 2); the Santa Fe Art Studio for Indians produced a much appreciated style by presenting selected aspects of Indian life in a familiar genre (figures 23 and 24).

The opposite trend is toward grotesqueness or exoticism, arousing in the minds of the millions living dreary, affluent, "civilized" lives the fears and excitement of exploration, the unknown, and the untamed. Sometimes this leads merely to giganticism, the exaggeration of features or the creation of something "larger than life" (figure 97). More often it encourages the definite effort to promote repulsion, awe, terror, or the inexplicable, cashing in on the Westerner's ambivalent attitudes toward exotic peoples. The Makonde of Tanzania, who only recently took up ebony carving because of poverty and displacement from Mozambique, have made the best use of this trend: they have developed two entirely new tourist art forms (figure 6), the *bindamu*, purely realistic forms that are recognizably African, and the *shetani* or spirit forms, which are semi-abstract. Similarly, the peasants of Ochumicho have found that there is a greater tourist demand for their "devil" figures (plate 3) than for their traditional whistles. Even the Canadian Eskimos feel that they are encouraged to make imaginative or mythological figures by the white buyers. Grotesqueness is an exaggeration of unfamiliar or distorted features; although it is not naturalistic, it is not abstract either. The latter quality is rare in commercial arts, in spite of the tendency toward simplification; realism is generally dominant, although the Seri, perhaps (chapter 6, note 6), prefer abstract human figures. Here too, some

of the Canadian Eskimos feel that buyers force them to make more abstract sculptures than they presently like.

What the outside world recognizes as ethnicity is a small bundle of overt features. A few things are selected for souvenir purposes—black skin, hunting prowess, traditional occupations, or past glories. These are the things that get exaggerated by the market, and sometimes feed back to the creator people. Though they may know that they are not as portrayed in the stereotypic arts, over the years the demand is bound to have an influence on a people's own self-image. Eskimos and Australian aborigines are "taught" by the powers that be that they are "naturally" good artists; Africans are "supposed" to be woodcarvers, and, even where they are not, as in East Africa, they take up the métier and become good at it! When stereotypes are constantly played out in commercial arts, a people may come to believe the same things about themselves or their past as the outside world does. Numerous examples in this book, however, testify to resistance to this process.

With the Western world's search for the primitive, the handmade, the rare, and the authentic, the search inevitably turns to the past. There is a well-developed cult of the authentic that translates as the cult of the antique for both Western and non-Western arts: things "stand the test of time," "come from a long ancestry," "mature," and grow rare and more valuable. So artists, promotors, and dealers are often faced with the question of preserving, reviving, or reproducing ancient or dying arts. In some circumstances this is a happy feature, for as D. Crowley (1970) has

shown, Africans believe old masks lose their vigorous powers just at the time that Europeans deem them valuable. This may lead to the sale of old masks, or to the wholesale faking and antiquing of objects (see Bascom, chapter 17; Carpenter 1972; Crowley 1970).

Revivals and modifications of traditional crafts for sale is almost as common as straight faking or invention of new genres. The Asmat (see map 8), once so famous for their ancestor poles and canoe prows, were forbidden to make them by their Indonesian colonizers. At the behest of the United Nations, they are now making simpler (but better-finished) models of their former arts (Schneebaum 1975). Even more tragic is the case of the Naskapi-Cree peoples of Great Whale River and the eastern James Bay (see map 1). These northernmost Algonkian Indians had suffered by comparison with their neighbors, the Eskimos, whose soapstone carving had been well received and promoted and had brought both fame and a good income. The efforts of the Indians to sell soapstone carvings, wood carvings, dolomite carvings, and souvenirs had been relative failures. The white and Indian staff of the Fédération des Coopératives du Nouveau Québec devised a new genre, marketed as "Cree Craft," that was scaled to a lower price bracket than the Eskimo sculptures and reflected the ethnicity and environment of the Indian creators. These artifacts included decorated copies of full-size aboriginal utensils and models of larger items, all of which had been in use until recently. All were made of local woods—black pine, spruce, tamarack, or birch—which were logged and worked by handknife by the men of this area.

7. "Cree Craft" wooden ladle, Naskapi-Cree, 1970 (37 cm. long) and Canada goose wall plaque by Johnny Blueboy, James Bay Cree, 1972 (21 cm. wide).

They were made for sale and decorated by two or three young men, using aboriginal motifs, symbols, and color combinations applied with imported brushes and acrylic paints. Though well made and promoted and sold for a very low price, the market for them soon fell off and the Naskapi-Cree were told to stop producing for the already swollen warehouse inventory.

In contrast, the closely related Cree peoples at the southern end of James Bay continue to make souvenir carvings for sale. These are not promoted through the cooperative or other middlemen, and only a few Cree who want to pursue this occupation spend much time on it. Older men, such as Johnny Blueboy, whittle wall plaques, cozy "northern scenes," and model birds and animals, producing a genre of crafts that is closer to plastic models from Japan or Middle America than it is to anything aboriginally Indian (figure 7). Yet the demand from local whites and visitors continues and generally outstrips supply. The agents of change are the makers and buyers themselves; there are no promoters and no one has to guess or research the market.

Perhaps we should unravel some of these value-laden terms. *Revival* refers to the attempted re-creation of an art form that has fallen into disuse (such as Cree Craft); it may involve slight modification of the form and probably does not re-create the context of the original manufacture. *Faking* refers to the manufacture of something valuable (and often past) by whatever means—including antiquing in a termite mound or by drilling holes or using rotten materials—and passing it off as authentic (see Crowley ibid.). *Reproduction* refers to approximately the same phenomenon, the re-creation of something old or valuable by whatever means, so that the final object resembles the original, even if it is made of entirely different materials, but not claim-

ing that it is original. *Archaism* is a tendency to make things that look old, or resemble to some degree an ancient tradition, without actually reproducing some particular object: archaism is attractive both commercially, to tourists who buy Mexican pots (figure 41) or paintings (figure 50) that have Aztec themes, and non-commercially, to governments who are trying to create a national "ethnicity" out of some glorious past (see later section on *Borrowed Identity*).

Thus commercial arts at all levels are subject to more contingencies than internally important arts. They have to satisfy the aesthetics of the foreign consumer as well as the producer, if possible; they have to project a clear image, either ethnically relevant or suitable exotic; they have to be transportable and not too fragile and resemble some genre that is deemed worth collecting by outsiders. These forces are very similar to those experienced by pockets of "folk" artists within the First World itself—such as the artisans of Appalachia or counterculture artists of Telegraph Avenue, Berkeley (Levin 1976)—for they too have to make a living and have their own "ethnicity" to project and protect. The many solutions to these problems lead to sometimes disheartening, often ingenious, and occasionally exciting new art forms.

INDIVIDUALISM AND THE ARTIST

In the nineteenth century, it was commonly believed that what were then called "folk" and "primitive" arts were anonymous, that the artists and artisans were unknown, and that the person who made these objects did not matter to the people of the culture where they were created. Unfortunately, many people today still believe this myth, which is maintained by a number of misconceptions. First of all, just because collectors or museum audiences do not know who made something does not mean that the artist's village mates did not. And secondly, just because an object is not signed by name does not mean that other members of the artist's living group do not know who created it: quite possibly, though not necessarily, they may have been illiterate, and therefore able to read other nonverbal personal characteristics in the work (see, for instance, chapter 1 on Eskimo *nalunaikutanga*). In small-scale societies where everything is everybody's business, there is little anonymity, and most people would know the details of style, the aesthetic choices, and even the tool marks of their contemporaries. This, of course, applies to arts and crafts produced and consumed within the same small area, not to trade objects. And it would also apply as much to the peasant villages of Europe (for which the term "folk" art was invented) as to the plains cultures of Africa and North America (to which the term "primitive" art was applied). Only in large-scale societies is anonymity truly possible, for there creator and user are separated by class, trade, and vast numbers; it was in this milieu, in fact, that writing itself and the signing of art works were developed to offset the growing lack of individuality. Furthermore, the world has now become so homogenized and self-conscious that the most folksy arts and crafts are soon identified,

glorified, preserved, and stultified. In Japan, since the 1930s, the most competent artists and craftsmen have been designated as "living national treasures" (Beardsley 1973: 70) with the result that their works are now worth ten times as much as those signed by their less well-known neighbors.

Consequently, when Fourth World arts and crafts are modified and introduced to national and international markets, the agents of change and trade have often attempted to get the creator artists to write or mark their names on the objects. Eskimo soapstone sculpture (chapter 1), Seri woodcarving (chapter 6), and Pueblo pottery (chapter 3) are well-known examples discussed in this book. In all three cases, middlemen and dealers have tried to promote the names of individual artists to the buying public. For the art-collecting public, the underlying analogy is that since creative works of value are made by named individuals in our culture, the best of someone else's culture must also be made by unique, named individuals as reflected in such volumes as Monthan and Monthan (1975). This way of thinking has in turn been introduced into the cultures of the small-scale dominated peoples, with a resultant enhancement of individualism, competitiveness, and the emulation of the successful *for his success* rather than for the beauty or utility of his product. Thus, the better pottery figure-makers of Ocumicho (Kassovic 1975), who have been told to sign or put personal seals on their works, occasionally sell or lend their names to the works of others, just as have some of the famous Pueblo potters. Charlton (chapter 7, figure 40) demonstrates that some of the ceramic vendors of central Mexico even put fake names on their pottery in the belief that any name is better than none at all. Not far away, the amate painters of Xalitla have evolved a rectangular bordered format with signatures near the bottom in an effort to raise their productions from souvenirs to arts (Stromberg, chapter 8).

The encouragement of individualism and the "name artist" as a response to commercialization and acculturation is apparent in Australian bark painting (chapter 15), some contemporary Maori arts (chapter 16), and even in some wood-carving traditions of West Africa (see chapters 17 and 18). Some well-known Fourth World art traditions have not been so subject to this trend, perhaps because they resemble to a lesser degree the "high arts" of the Western world, with their accent on names and originality. For instance, only a few of the souvenir ivory-carvers of Alaska ever became known by name (Ray 1961; Frost 1970), and relatively few carvers of totem poles became well known. In the California-Nevada area, two or three Indian basket-makers, such as Dat So La Lee, were promoted by name with great success (Gilgli 1974), but the phenomenon disappeared with their demise decades ago. Few collectors of Peruvian gourds (chapter 10) or Cuna molas (chapter 9) or Navajo rugs (chapter 4) attempt to discern the names of their creators, although these are sometimes known. In the case of Navajo textiles, the names of some of the weavers-artists are now being promoted and recognized (Kent, p. 97, below) at the very moment when these items are being "hung" as works of art, rather than being put on the floor as rugs, i.e., crafts. There are even traditions where individual recognition is neither apparent nor encouraged, such as in Af-

rican masks, Southwestern and Auracanian Indian jewelry, or Malaysian silverwork. Furthermore, the promoters of Cree Craft (figure 7) specifically stated in their brochures that the craft will remain anonymous, though they by no means encouraged mass production or lowered standards of workmanship (Graburn 1976a).

An emphasis on individualism in the arts of the Fourth World may be accounted for by several factors: (1) the presence of a Western or international market with middlemen and retailers; (2) the presence of such readily identifiable characteristics of workmanship that individual styles are recognizable; (3) relatively low-volume or high-price objects, or at least such a lack of standardization that it is worth making discriminations; and (4) the similarity to an established Western genre already characterized as "art" and populated by named "artists." As a result, Eskimo lithographic prints, large Maori sculptures, and Benin bronzes became art, whereas argillite totem poles, Eskimo scrimshaw, Cree Craft, Peruvian gourds, and all dolls and clothing remain anonymous to their buyers and are usually spoken of disparagingly as crafts, though occasionally this shallow reasoning is disputed (Rossbach 1973).

But why should one worry at all about the name of the creator or the uniqueness of a work of art? The cult of individualism and originality is not a human universal. In our field, it emerged in those societies that had grown large and stratified, societies in which the concept of the artist as someone with special powers of creativity had become distinguished from that of the craftsman as someone who is expertly skilled in a particular technique. In the highly differentiated societies of China, Japan, and Renaissance Europe, the idea of being different apparently appealed to the elite. Then, with the emergence of industrialization with its accent on standardization, competitiveness, and progress, the artist became further glorified. This cult of individualism, as opposed to cooperative equalitarian effort, fits a belief system that differentiates art from life and leaders from ordinary people. It is most heavily ensconced in the scientific establishment and in the artistic avant-garde of the West, where originality, progress, creativity, uniqueness, and innovation form an attractive syndrome. These values are easily applied to all human endeavors where differences can be observed and rewarded. It is this same set of beliefs that makes *art* so important in the interface of civilizations and Fourth World peoples, because members of the dominant society inherently respect artists, even while often despising other members of an ethnic group. These artists, designated, of course, by the dominant society, are almost like religious leaders, being at the forefront of contact in movements of assimilation or resistance. In such cases, the arts have the power of carrying cross-culturally those messages that might be rejected in any other form.

ART, COMMUNICATION, AND ETHNICITY

All peoples surround themselves with material objects that express their individual identity and their identity within a social

category. These social categories or statuses may be as simple as age or sex groups, or they may be as esoteric as totemic phratries, Hindu sects, or World War I military regiments. The means by which material items express identity is through *symbols*. Symbols—visual, verbal or aural—are arbitrary expressions that *stand for* something; they are arbitrary because usually there is no necessary connection between the content of the sign or word and the object or category for which it stands. Thus, symbols are conventional devices by which we recognize something. Their only limitation is that the bearers and the viewers (or transmitters and receivers) must "speak the same language," that is, agree on the meaning conveyed.

Social identity such as ethnicity needs to be conveyed for two different purposes: for the members of the in-group—that is, for the other people of the same group who wish to get together; and for members of the out-group—that is, for people whose relationships depend upon their being different. Recognition of shared social identity is the basis of what Durkheim (1893) called mechanical solidarity, as would be exemplified by nuns worshipping together; different but complementary identity is the basis of organic solidarity, recognized in our phrases "vive la différence," "it takes two to tango," or "opposites attract." In many parts of the world, people of different ethnic groups perform different but essential services in the running of the whole society and must therefore wear clothes or symbols indicating their identities and their functions, as do Mexican peasants from different areas who bring different kinds

of ceramics to a marketplace (see Charlton, chapter 7). In brief, all societies contain social categories within which members are similar, but between which they are different but complementary; these categories are marked, often by material symbols, to enable society to function and for people to know how to behave properly toward each other. If a society is stratified, as most are to some degree, then possessing or wearing certain symbols are marks of prestige leading to deferent behavior by other members. Ethnicity is an increasingly important form of identity in a pluralistic world where communication, education, and travel allow every group knowledge of and access to almost every other.

Internal Identity

People of small societies have usually maintained their social subdivisions with material symbols and paraphernalia, often in the form of clothing and ritual objects. These are guides to appropriate behavior for other members of the group and mark differences as gross as those between the sexes, or as fine as those between ranks of Samoan aristocracy. Yet within one symbol system the mutual recognition of differences reinforces the shared set of beliefs and group membership. Under the threat of external political and economic forces, Fourth World societies often feel the need to retrench, or at least to emphasize their native customs and values, especially when up against pressure from missionaries or attractive but disruptive material offerings. Salvador (chapter 9) describes how the Cuna, as part of their rebellion against Panama, reinstituted

the markedly ethnic "uniform" for their women, including the distinctive mola blouse. American Indian groups have emphasized their costumes as part of their threatened ethnicity, and Maori have taken full advantage of the social and technological aspects of white New Zealanders to preserve and revive their arts and ethnicity (chapter 16). Williams (chapter 15) describes in some detail how the aborigines of Yirrkala make a conscious effort to use bark painting to keep their traditions alive.

Other groups have been less successful in the struggle. Lega culture, which focused on the *bwami* association (chapter 19), used deception and substitution to avoid punishment by the colonial Belgians and the nationalist Zaire government and has thereby lost forever its ivory-carving traditions. The painter castes of the Hindu sect at Nathdwara, India, are struggling against secularism and photoreproduction of ritual paintings. They appear to be losing their patronage, and hence their sacred occupation and the opportunity to carry on their ancient traditions. In New Guinea, the laws against head hunting and tribal warfare have led to the virtual disappearance of locally distinctive painted-shield styles among the Sepik (chapter 14). Sepik ancestor figures have lost their meaning as sources of power and revenge, and extensive tourism and scorched-earth collecting have led to the mass production of pseudo-traditional arts that are no longer necessarily tied to ethnically distinctive traditions (see Carpenter 1972; May 1974; and figure 5). In another part of New Guinea, the Asmat, who were famous for their men's houses and their woodcarving

(Rockefeller 1967), experienced the repression of both the house-building and the carving tradition by the Indonesians when the latter created West Irian out of the former Dutch colony; not only were these art forms seen as graven images—banned under Islam—but as symbols of Asmat ethnic resistance to the new colonizers. It is only recently that they have revived carving as a copied and paler imitation of their former meaningful traditions, using the plates in Michael Rockefeller's book (1968) for their models (Schneebaum 1975).

Threatened identities often lead to a revival of archaic traditions. This bolsters a sense of unique identity and links the people to a past perhaps more glorious than the present. The Ghost Dance of the Plains Indians and the Longhouse Religion of the Iroquois are both examples from nineteenth-century North America. Hopi kachina dolls (Dockstader 1954) were given added emphasis in the face of missionary work by the Catholic Church, and the new noncommercial yet nontraditional totem poles being erected along the Northwest Coast militate against the final disappearance of indigenous Indian culture and arts in that area. Archaism is a variant of ethnic retrenchment, for there is a deliberate attempt to imitate or even revive the styles of an earlier period: this period could be the recent past, as in the case of *hohoa* of New Guinea (Beier and Kiki 1971); the remote past of a peoples' own culture, as with the Pueblo revival of archeological pottery traditions such as Mimbres and Sikyatki (see Brody in chapter 3); or even the resurrection of the features of some other prestigious society (see later section on *Borrowed Identity*).

External Identity

What were once relatively independent societies have become Fourth World minorities, overrun by and up against the more powerful peoples who have taken charge of the world. The need for external distinctions, as well as the maintainance of internal order, has become more complicated. With the recent increase in world travel and communications, not only are people seen directly by visiting strangers, but also their artifacts have penetrated to the ends of the earth. As transistor radios and plastic flowers have found their way into the homes of the most far-off Third and Fourth World peoples, by the same routes *their* productions are known in the shop windows and living rooms of much of the middle-class industrial world.

These colonized peoples, though forced to relinquish much of their tradition, nonetheless usually wore dress forms and other symbols that separated them from their conquerors; often these were actually imitations of out-of-date items of the dominant peoples themselves, such as Navajo women's dress and Andean villagers' millinery. The nineteenth-century Navajo developed new forms of costume out of imported materials; in addition, both their woven blankets and their silver jewelry (Adair 1944)—in imitation of Kiowa and Spanish-Mexican silver—became items of trade as well as new markers of Navajo ethnicity. Now that tourism and travel have replaced colonialism as a prime source of intercultural contact, ethnic markers such as Panamanian Cuna costumes and Ecuadorian Otavalan Indian dress have become even

more necessary for carrying out lucrative trade with foreigners. Commercial works of art have often become the mere souvenirs of fleeting visits to far-off places, for though their distinctive features are much simplified, these items are all the tangible evidence the traveller needs to recall the reality of the trip (see also **Graburn "The Sacred Journey," 1977**).

But it is not only the buyers who ordain what they wish to believe in; the makers of these movable symbols also wish to express values important to themselves. Thus a Fourth World people's "image" in the eyes of the rest of the world is often as strongly influenced by their portable arts and crafts as by what they actually do in some remote and forgotten homeland or reservation. Who would have heard of the Seri of Sonora (chapter 6) or the peasants of Cochas Chico, Peru (chapter 10), if it were not for the woodcarving of the former and the pyro-engraved gourds of the latter? Better-known peoples, such as the Canadian Eskimos (chapter 1) and the Ainu of Hokkaido (chapter 12), embellish and perpetuate their favorable image through having their soapstone and wood carvings distributed around the world. The commercial arts of these small populations may be made for outsiders only (as in three of these four cases), but they carry the message: "We exist; we are different; we can do something we are proud of; we have something that is uniquely ours." The accommodation between the demand and the traditional features of the culture often produces a narrowing or stereotyped notion of what constitutes the important parts of their ethnicity—i.e., what they have as against what other ethnic groups possess. In some cases, of

course, such as the "cutie" Ainu couple dolls (figure 72) or the Akamba and Makonde woodcarvings (figures 1 and 6), they are travesties of human form. In others, such as the revivals of exotic "Aztec" themes in Ocumicho pottery (plate 3) and in the latest Xalitla bark paintings (figure 50), it is hard to say whether the ethnic marker is totally imposed by promoters or whether it shows the influence of long-held beliefs in new syncretistic forms.

Often the subject matter of models and souvenirs presents assets, achievements, and artifacts that are the pride of the group, embodying the style or glamor of the culture. Tourists and other buyers are often interested in the same positive features. The Cuna literally "sell the shirts off their backs" when they trade their used molas blouses, of which they are very proud. The Canadian Eskimos try to convey what they think is the best of their rapidly disappearing way of life (see figures 11 and 12); Peruvian gourds embody scenes of village life (figure 58); and Australian bark paintings tell "important stories" (plate 8).

When the desperation of poverty and the forces of the market cause people to churn out items that have no connections with their traditional belief system and do not reflect their previous standards of craftsmanship, one feels that the messages conveyed do not express pride and joy, but instead are saying: "We are forced into this to make a living; this is not us; these are not our standards; this is you using us for cheap labor." But we must not always be so cocksure that the creators feel as we might in the same predicament. They may well have their own standards within the new genre, as

Ben-Amos demonstrates (chapter 18) for Benin; they may be proud of their competitive ideas and innovations, as are the Nahuatl-speaking *amate* painters (chapter 8). They may keep separate in their minds the standards of what they have to sell quickly from what they really enjoy doing when they can afford it, in the thoroughly professional way of the painter caste of Nathdwara (chapter 13). Some Canadian Eskimos are not even concerned with such things as they make their famous soapstone sculptures. They sometimes thanked me (as a white person from "Down South") for the fact that the government buys these "lumps of stone," for they can't imagine what the devil we do with them!

Borrowed Identity

But the world moves on: people do not always retain fixed images of themselves or their value to the outside, and new symbols and materials may have greater prestige than the older ones—especially if they are brought by powerful and prestigious outsiders. Symbols of identity may be borrowed, stolen, or even exchanged. Groups may wish to enhance their prestige in their own or others' eyes by taking on the materials, symbols, and regalia of other groups—almost as though a magic power could rub off by imitation; such phenomena are always part of the numerous cargo and millenarian cults around the world. Though some might be tempted to have scorn for middle-class Californians of Indian descent wearing the feather war bonnets of Plains Indians, or for Andean peasants wearing variations of sixteenth-century Spanish costumes,

such practices are almost universal. Indeed, it would be difficult to pick any culture or sub-group whose cultural symbols were totally of their own creation or from their own history. Furthermore, such "borrowed" identities are often useful or functional in a world where old groups are degraded or new categories and ethnicities are being created.

Numerous examples could be cited to illustrate the process by which objects and symbols of one culture have been taken over by another to such a degree that they became part of the public identity of the borrowing group. Such cases constitute the bulk of the Reintegrated Arts in the explanatory diagram (p. 8, above). Apart from the Cuna using imported colored textiles, needles, scissors, and thread to make their distinctive molas, we might cite the cases of the Indians of North-eastern North America, who took up bead-work in place of porcupine quillwork and became well known for it (Johnson 1967). We have already mentioned Navajo silverwork, which incorporated both the Spanish pome-granate blossoms now known as "squash blossoms," and the *naja*, the ancient Moor-ish, and later Spanish, horse amulet for ward-ing off the evil eye. Navajo textiles, like Navajo jewelry, has run the whole route: both the craft of weaving and the weaving materials were initially borrowed from outsiders; then they were integrated into the Navajo way of life and were given Navajo ethnic identity; and lastly, the woven products were sold to outsiders.

Indian beadwork and some forms of Cen-tral and South American ethnic dress have gone through the same process, and in East Africa, certain commercial art forms have be-come the hallmarks of uprooted ethnic groups such as the Makonde, Akamba, and Sō (Coates and Feldman 1973) without ever being truly incorporated into the group culture. A further step is taken in this process of bor-rowing when a previously colonized group comes to power and takes as part of its public identity the arts of its less-educated tribesmen, or even of other still-dominated Fourth World peoples. For instance, government officials in some independent African countries import huge modern Makonde sculptures as symbols of their "African" identity. Another example would be the Canadian Eskimos with desk jobs who now collect modern Eskimo art for their houses, much as middle-class Native-Americans often collect various tribal and modern forms of Indian arts.[3]

Perhaps even more widespread than the above type of borrowing is the almost univer-sal proclivity of modern First, Second, and Third World nations to collect and display the arts of their present and past minority peoples as symbols of their national identity. For in-stance, Mead states, "Everywhere New Zea-landers seem to be 'Maori-fying' the artifacts they produce. The cultural climate in New Zealand is such that Maori art and craft objects

[3]One interpretation of this externally imposed identity is that expounded by Carpenter (1972:98) "The saddest part of this story is that the subject becomes an easier victim. People who have long been denied public identity, or cast in degrading roles, now rush on stage, costumed according to our whim." Although there is some truth in this, it is a truth that applies to all of us, for all human beings try to conform to some aspects of what they think other people believe about them. Further, neither indi-vidual adults nor whole cultures are *tabulae rasae* upon which the "whims" of others can be written without modification or reaction.

are appreciated positively not only for their value aesthetically but also for other reasons . . . [they] serve as distinctive cultural markers to distinguish the New Zealander from, say, the Australian" (chapter 16, p. 295 below). Australia, on the other hand, saturates its public institutions, its souvenir outlets, and its overseas exhibitions with its own aboriginal arts, crafts, motifs, and color schemes (Black 1964).

In the Americas, too, each large nation has taken the arts of its crushed former peoples and erected them as symbols of "national ethnicity" to distinguish each from the other, and all of them from their European homelands (Graburn 1970). Canada and the United States display Northwest Coast totem poles at Expo '70 in Osaka; Mexico and Peru institutionalize the monuments of conquered peoples and encourage the nostalgic commercial productions of their poverty-stricken descendants (chapters 6, 8, 10). In South America, the Spanish immigrants were quick to take up the drinking of *mate*, a Guarani Indian custom, and developed a ritual and set of paraphernalia for its use (Dawson, Fredrickson and Graburn 1974: 62–63). This gave them a distinctive "South American" ethnicity, setting them off from the Spanish, much as the partly Korean "tea ceremony" has become important to Japanese ethnicity and coffee sipping has become institutionalized for the Arabs. The United States, perhaps more than any other nation, has taken over symbols from its Fourth World minorities—from Pontiacs to Eskimo Pie—and used them for such modern "totems" as the Cleveland Indians, Alaskan totem poles, and Boy Scouts' teepees.

A recent cursory survey of the contents of various ethnic arts stores and United Nations gift shops shows that these processes of borrowing the identity of minority peoples—perhaps at the very same time as repressing other aspects of their cultures—is international. Nations choose obscure but exotic cultural features to present as their ethnic markers to others. In a quick look at the dolls for sale, it was noted, for example, that Canada presented dolls made by Eskimos and Cree Indians; the United States, Iroquois dolls and kachinas; Thailand, dolls made by its Karen minority; Russia, dolls made by Siberians and Eskimos; Panama, Cuna dolls; Nigeria, dolls made by the Ibibio; Norway, dolls made by the Lapps; and Guatemala, Brazil, and Peru dolls made by former and disappearing Indian groups, and so on.

One fascinating aspect of artistic expressions of identity in this ethnically complex world is the attempt of one group to portray members of another group using the creator group's symbolic and artistic traditions and attaching importance to those features that are important to the in-group rather than the out-group. This generally results in stereotypic portrayals that are satisfactory to the in-group but hilarious or insulting to the **outsiders portrayed (see figure 95). We all** know the most obvious examples from American literature depicting ethnic subgroups; and the Western world's explorers, for another example, stereotyped the rest of the world in such a way that we can even tell the time period and the cultural influences governing the artist by the way a portrait was drawn. But this also has not been a one-way

process. The Europeans themselves were often portrayed with scathing penetration in the media of the peoples being explored (Burland and Forman 1969); every group, in fact, has conventional and accepted portrayals of its neighbors and enemies (see Lips 1937).

SUMMARY AND CONCLUSIONS

Although the many papers presented in this book cover a wide range of scholarly topics concerning the arts and crafts of the Fourth World, we make no claims to encyclopedic stature. Such a work would presume a static subject matter with well-defined categories and boundaries. To be sure, there are clearly demonstrable processes at work in the production and distribution of Fourth World art; the point that must be grasped, however, is that these processes—indeed, the arts themselves—are "open-ended" and in a continuous state of transition. This book is offered, then, by way of a conceptual itinerary, in the hope that it may provide the reader with a somewhat more coherent framework for evaluating not only the art and the artisans but, perhaps more importantly, the peculiar ethnoaesthetic context in which both creator and consumer come to evaluate each other.

I will recapitulate some of the more specific points mentioned above:

1. It was suggested, first, that previous anthropological and art-history terminology, such as the labels "folk" and "primitive," have outlived their usefulness and are inadequate or detrimental for contemporary art analyses. What is called for is a more realistic and flexi-ble approach, taking into account (a) the intended audience to whom the art is directed; (b) the particular functions (if any) that the art may serve beyond its function *as art*; and (c) the sources of both the formal and aesthetic characteristics portrayed in the art, that is, whether "traditional" or "transitional."

2. Some degree of protracted change or innovation in formal and symbolic systems is a universal feature in human culture. In this sense, art, as a cultural institution, is no different from the political, economic, and religious structures of the society; although each contains vestiges of earlier stages, it is also a reflection, *in statu nascendi*, of the emerging present-day reality of the community. Part of this process, for better or worse, results from the exchange of ideas, goods, and technology that is a natural by-product of culture contact, an exchange that is magnified by large differences in scale between the respective societies, as well as by their particular expectations and demands in regard to one another. A conquered people may, for example, use their arts for ethnic retrenchment or revitalization, or they may capitulate (for either political or profit motives) and imitate their oppressors. Regardless of the immediate psychosocial nature surrounding production activities, once the trade in art and artifacts becomes established as an ongoing enterprise, subject to the laws of the international marketplace, the process of change and innovation becomes ever more accelerated. Depending on the state of the culture, such changes generally take the form of secularization and standardization, although increased cultural autonomy is often reflected in new, exciting, and reintegrated arts. At the same time, low economic

rewards for commercial arts have led, in some cases, to a lowering of artistic standards and cultural self-esteem: this in spite of an increasing rate of attempted innovation.

3. The impetus for innovations may come from inside or outside the Fourth World—as a result of artistic excitement, ethnic revitalization, or simply as an economic response to the *perceived* desires of the consumer. They often emerge from close cross-cultural relationships between entrepreneurial, marginal, or bicultural people of both groups. These are facilitated in new social situations bringing new technical opportunities in their wake. Though the new arts of many peoples are discussed in this book—Eskimos, Xalitleños, Makonde, Cuna, Seri, Peruvians, Akamba, Cree, Aborigine, and so on—the exact cultural origins of these arts are oftentimes shrouded in mystery, an indication that (a) people are not always aware of when they are making a significant breakthrough, (b) if successful, a number of people may jealously claim to be the originators and offer competing stories of their invention, and (c) if the innovation is not successful, no one really wants to remember.

4. Innovation and change in the realm of art can spur social and technical modernization in terms both of the artist and of other unrelated crafts. It may even attract these unrelated craftsmen and workers into art production by holding out the promise of access to a more prestigious role in society, as well as offering them an opportunity to try out new tools and materials in an experimental, nonthreatening, and potentially lucrative activity. Though the art market is as cutthroat and commercial as any other, the arts carry an aura of worth that is not attached to most other means of earning

a livelihood; the same income from the arts, in essence, may have a higher psychological value for Fourth World peoples than if it were earned in manual labor or other commercial trade. Nor is it very much different in a Western society. Since alienation is a cross-cultural phenomenon, any opportunity that allows even a modicum of prestige, respect, and cultural revitalization is not to be dismissed lightly. Concomitantly, these newly successful innovations, having opened the door to further culture contact, new divisions of labor, and new organizational forms, can also have disruptive and far-reaching side-effects. For example, people may be drawn away from their traditional occupations into a craft that may be commercially successful only in the short run. As these modern artisans become entrenched as full-time entrepreneurs and tradesmen, their economy may become irreversibly monetized in ways that often outstrip the ability of the people to manage or maintain, thereby making them targets for urban middlemen and wholesalers. Finally, these short-term rewards, in turn, result in new tastes and new demands on the part of the Fourth World consumer that may substantially alter the nature of their culture in ways that they might be unaware of or that do not meet with their approval, ways which may even hasten the decline or eventual disintegration of the artistic system itself.

5. From an international perspective, the arts hold a special place in the value system of the world powers. All nations, but especially those with a history of subjection to colonialism and oppression, seek to establish a recognizable image based on the most favorable and highly romanticized characteristics of

their peoples. The arts, as portable and visible as they are, are a major tool in this struggle to provide some sort of unquestionable marker, to assert a new identity or reassert an old one, to ameliorate the past and to secure the future.

6. Although the arts, when sold to outsiders, can, indeed, earn a people increased respect and admiration, and even aid in bringing about a better understanding of that people's culture abroad, such external support can cause what is perhaps the final, certainly the most devastating and ignoble, transformation of those very arts. For in the process of achieving such support, without which many of the Fourth World arts and crafts would undeniably have vanished long ago, there is an increasing tendency among the artists to speak *only* to the consumer and to remove those elements of style or content that might prove contradictory, puzzling, or offensive to the unknown buyer. Somewhere in this process an invisible boundary is crossed and, once crossed, it is often difficult to turn back. In the headlong rush to please the tourists and the taste-makers the artisan finds himself in danger of surrendering control of his product. Where this has occurred, it is no longer *his* art, it is *ours*. He is now subject to our manipulations and our aesthetic whims. It is our concepts of "authentic ethnic identity" that will be manufactured and distributed. And not only for consumption in the Western world. The new national governments that dominate many of the peoples of the Fourth World are exposed to the same subtle manipulations and seductions of the marketplace as are the individual artisans. The obvious danger here is

that what is offered up today as a spurious artifact or souvenir might someday reemerge —in the culture of origin—as an authentic representation of one's forgotten ancestors.

It is possible, even gratifying at times, to be able to point to particular villains in this scenario, but to do so may obscure the larger processes at hand, which is to say, not only the exigencies of culture contact between large and small societies but the very nature of change as a universal feature in human culture. That such change may occur as a result of cross-cultural misunderstanding or misperception is, at times, regrettable. Nevertheless, it need not always prove detrimental or patronizing to the self-esteem of the peoples concerned. A certain amount of "revisionism" is also a feature of human culture, in terms both of mythology and of history, and it should not be surprising that art is no exception. Numerous examples in this book testify to the flexibility of any particular world view and to the ability to rearrange the elements of one's sociocultural predicament to one's psychological advantage.

Moreover, if the peoples of the Western world—whether out of genuine appreciation, guilt over past sins, fascination with the exotic, or simply boredom with their own lives—have chosen to view the arts of the Fourth World as significant and worthwhile statements from fellow human beings, then that in itself is a most important result of culture contact. It is hoped that this book will allow the reader to move beyond that point toward a more genuine understanding of the arts and the artisans *on their own terms.*

The Fourth World arts of North America are prototypical of the kinds of arts with which this book is concerned. For the English-speaking world, these arts are written about more and collected with greater interest than those of any other continent. This section could not possibly mention all North American arts, nor even delineate all the developments, because of the breadth and historical depth of the vast literature and the enormous variety of the arts themselves.

The native peoples of North America have been subject not only to colonialization, but to conquest, displacement, and sometimes extinction, yet many of their art forms have been preserved. Of those that are still extant outside of museums, most have become important symbols of ethnic identity, expressing as they do unique and threatened traditions. The totem poles of the Northwest Coast, the feathered dress of the Plains Indians, and the drum dancing of the Alaskan Eskimos are well-known examples. New arts have arisen both for domestic and ritual appreciation—as

kachina dolls and Navajo weaving originally were—and for purposes of providing a livelihood.

GRABURN tells of one of the best-known cases, the soapstone carving of the Eskimos of the eastern Canadian Arctic. Here souvenir crafts and children's toys provided the idea for an art form that has been encouraged and has flourished during the past 30 years, replacing hunting as the main livelihood of many Eskimo adults. The aesthetics and content of this art form strongly reflect the feelings of the artists and their context in the changing scene of North American pluralism.

Other Eskimo peoples in Greenland (Melgaard 1960) and Alaska (Ray 1961; Frost 1970; Burland 1973) have kept closer to some of their old traditions, but have also tried to imitate the commercial successes of the Canadian Eskimos. In addition to the unique soapstone

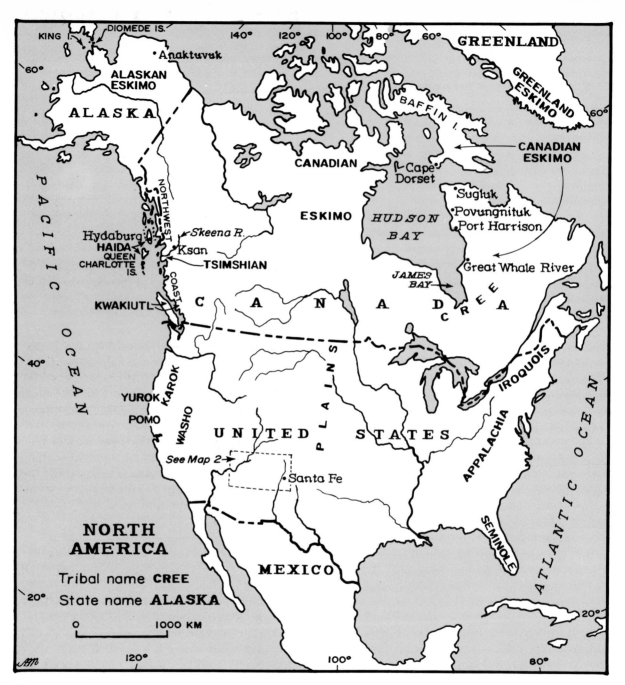

Map 1.

art, nonnative forms, such as jewelry and easel painting, are pursued with some success.

There is a complex relationship between the native and the imported arts. The famous art complex of the Northwest coast, centering on stylized woodcarving, painting, and ceremonial art, has fallen on hard times. There is now concerted effort at revivals, however, such as the new art school and tourist complex at Ksan, and the traditions are becoming institutionalized in new nonnative forms. Alongside the vagaries of these traditional arts has been the emergence of Haida argillite carving, one of the earliest of the tourist art forms that drew upon the stylization and skills of the former functional arts.

KAUFMANN traces very clearly the transformation of content of this early "tourist" art. Instigated by whites finding argillite slate, the skilled Haida carvers made souvenirs with European motifs. Only after further decades of colonialization and missionization did they allow important and sacred subject matter to be portrayed for sale. By the end of the nineteenth century, the vocabulary of their art form included all that had been sacred to the Haida—totem poles, storage chests, shamans, and rattles. This has continued to be a lucrative commercial art form—aided by the exquisite workmanship and "valuable" stone —and has become part of the modern ethnic identity of what is left of the Haida.

California basketry (Barrett [1908] 1970) and eastern beadwork are two other regional arts that have greatly diminished in extent.

Though once flourishing as a practical art, basketry became a favorite souvenir or novelty tradition (O'Neale 1932) that was innovative and imitative, and also subject to promotion and distortion by the vagaries of the market. Though named artists arose and concerted efforts were made to keep the art going (Wharton 1902: 229), it is now more of a historical than a living art. Beadwork, based on the spread of trade beads and the previous porcupine quillwork traditions of the woodland peoples, has had fewer ups and downs. Though the eastern and Plains Indians commercialized some of their art forms, and were also employed to make European fineries such as lace, beadwork has remained a decorative craft, and has been adopted by whites, who admire and use it.

The American Southwest is the region that stands out (Underhill 1953) for its variety and complexity when most people think of Native American arts. The emergence of the Indian "name artist", paralleling European art traditions, especially in the Southwest is illustrated and memorialized by the Monthans' *Art and Indian Individualists* (1975). Some aspects of the history of, and influences on, these arts are the subject of innumerable books and papers- —and of our next three chapters.

BRODY presents a survey and comparison of the three major art traditions of the Indians of the Southwest and the Plains: pottery, weaving, and painting. These are critically examined in terms of their relationships to traditional arts and aesthetics, to personal or tribal associations, and to intended sectors of the Indian art market. He concludes that pottery is

the tradition with the most depth, ethnic attachment, and flexibility. Weaving, though introduced, has become integrated into tribal activities. Painting is a totally market-created "assimilated" genre. The younger Indian artists have realized this and have broken away from the studio motifs and style.

KENT traces the separation and fates of the three textile traditions of the Southwest: Pueblo, Navajo, and Hispanic. The first, indigenous to the area, along with the imported looms, sheep wool, and bayeta of the third, combined to instigate the new tradition of the originally nomadic and raiding Navajo people. This led to the development of a Navajo clothing and blanket tradition. After confinement in the 1860s, during which time they developed their silver jewelry tradition, the Navajo commercialized their textiles for saddle blankets and, by the end of the century, floor rugs. Since then, they have developed new designs, using more muted natural dyes. Moreover, as the craft has gone "from the floor to the wall," it has become an increasingly valuable art form. The Pueblo peoples, on the other hand, for whom textiles were indigenous and ritually important, neither commercialized nor modified their weaving to the same degree. Pueblo and Hispanic traditions—the two older forms—have almost dropped out of sight compared with the flourishing Navajo tradition and its imitators.

GILL examines the ceramic traditions of the atypical Pueblo Indians at Laguna. Although more acculturated than most, they have expressed the long-honed resistance to outside influence by failing to make those modifications necessary for mass commercial popularity, as have the Acoma. After the railroad trade of the early years of the century, the present freeway bypass makes Laguna a backwater, where traditional ceramics are still made and used. Some fine pots are made for sale, but souvenir developments have gone little further than miniaturization and the promotion of some models drawn from the broad tradition.

Perhaps more than any other part of the world, American Indian arts and crafts have been commercialized through both the investment in traditional pieces and the invention of new salable items. The history of modification is seen in every museum and exhibit supported by the huge cult of Indian collectors. Even for the uninvolved American public, the collection of these Fourth World arts is a part-time hobby or an accompaniment to domestic travel. Guides for the nonspecialist buyer appear regularly in *Sunset, Arizona Highways, Arts Canada,* and in the publications of the Department of the Interior and the museums of Colorado and the Southwest.

American culture itself is suffused with elements of the Native American cultural heritage: foods, words, symbolic images, and design forms. Though the symbols of the Plains Indians are most common, those of the Indians of the Northwest Coast and of the Southwest are also exploited for commercial and national purposes. This borrowing of arts

and images suggests that the identity of white America itself leans heavily on its ambivalent relationship with its conquered peoples.

The literature on Native American arts, old and new, is immense. Rather than try to provide a detailed guide here, it is suggested that the reader refer to the many works cited in the five descriptive chapters, and check the bibliography for the general works of such authorities as Dockstader, Dunn, James, Mera, and Tanner, and for such broad guides as Monthan (1975), Feder (1972) and *American Indian Art: Form and Tradition* (1972).

1. Eskimo Art: The Eastern Canadian Arctic[1]

Nelson H. H. Graburn

The Canadian Inuit[2] are the archetypal Eskimos for the English-speaking world—building igloos, hunting sea mammals by kayak, travelling by dog sled, and wearing thick caribou-skin garments. Since their culture has been long and thoroughly researched (Boas 1888; Graburn 1969a; Graburn and Strong 1973:137–177; Hawkes 1916; Mathiassen 1928; Rasmussen 1929, 1931; Weyer 1932;

Nelson H. H. Graburn is Associate Professor of Anthropology at the University of California, Berkeley, and Curator of North American Ethnology at the university's Lowie Museum of Anthropology. He was awarded his Ph.D. in anthropology from the University of Chicago and was employed as a Research Associate of the Department of Psychology at Northwestern University before coming to Berkeley. He conducted research among the Eskimos of the Canadian Arctic in 1959, 1960, 1963–1964, 1967–1968, and 1971, and 1976. Among his numerous books and articles, the following are most relevant to the subject matter of this volume: *Eskimos without Igloos* (1969), *Circumpolar Peoples: An Anthropological Perspective* (with B. Stephen Strong; 1973); "Art and Acculturative Processes" (1967) and "A preliminary analysis of symbolism in Eskimo art and culture" (1972). He was the convenor of the Symposium on Contemporary Developments in Non-Western Arts (San Diego, 1970), the papers from which form the core of this volume, and also of the Advanced Seminar on Contemporary Developments in Folk Arts (Santa Fe, 1973), which was attended by a number of the volume's contributors.

et al.), they are better known than the more numerous Alaska and Greenland Eskimos. The aboriginal life of the Canadian Eskimos was first disturbed almost two hundred years ago by whalers and explorers, whose ships, since that time, have continued to frequent the area and whose trade with these nomadic people has led to the introduction of metal implements and sometimes guns. The Eskimos, however, remained relatively independent until the first few decades of the twentieth century, when the Hudson's Bay

[1]This paper is based mainly on research conducted in the Eastern Canadian Arctic in 1959 and 1960 for the Federal Government of Canada, in 1963–64 for the Cooperative Cross-Cultural Study of Ethnocentrism, and in 1967–68 under grant NSF-GS-1762 from the National Science Foundation. The analysis has proceeded from, and been stimulated by, discussions with a number of colleagues, including George Diveky (UBC), Alan Dundes, Herb Phillips, Lucy Turner, and especially Steve Levinson (UCB). To these people I am more than grateful.

[2]The Eskimo of North Alaska, Canada, and Greenland all speak dialects of the same language, *inukpik* and the Canadian Eskimos call themselves *inuit*, which means (real) people; the term *inuit* is coming to be used more and more in Canada and in literature concerning the Canadian Eskimos and their arts, but for the wider audience I chose to retain the more general designation, Eskimo.

Company set up its first trading posts in the Arctic.

The Hudson's Bay Company (H.B.C.) encouraged Eskimos to trap white fox, usually "grub staking" trappers with supplies on credit in the fall and buying back skins from them at the end of the winter. Gradually, the Eskimos were introduced to a credit system and to such articles of white manufacture as wooden boats, spring-steel traps, store clothing, flour-based foods, and above all, guns. Over the same period, missionaries converted the Eskimos nominally to Christianity and shamans lost their powers. Shamans have now, for the most part, disappeared.

During the 1940s and 1950s, the prices for fox pelts fell and the Eskimos were no longer capable of completely independent lives. More and more Eskimos hung around trading posts, which became "settlements"; fewer families maintained their nomadic way of life. Government aid and welfare grew and government health services were introduced for the, by then, endemic tuberculosis. In the late 1950s, government administrators and then schools became fixtures in the major settlements. More Eskimos clustered round the white agencies and took up full-time wage employment. By the 1960s, the Canadian Arctic became dotted with these multiagency settlements, each with from a hundred to a thousand Eskimos, of whom the subadult generation speaks some English. They hunt with rifles and outboard-motor canoes, and, recently, many have given up dogs for snowmobiles. Yet few adults are educated, even fewer have jobs, and, for the most part, the whites run the important institutions. Within this context, commercial art production has become of great importance.

CONTEMPORARY ESKIMO ART

Until recently, art did not play a central part in the life of these Eskimos (Carpenter, Varley, and Flaherty 1959; Carpenter 1973). In fact, during the past few centuries, as revealed by archeologists (Taylor and Swinton 1967; Melgaard 1960), the artistic output of the Thule Eskimos and their modern descendants was less significant than that of their Dorset and pre-Dorset ancestors. In addition to the decoration of their utilitarian implements, such as needle cases and cuts of skin for clothing, the recent Eskimos of this area occasionally carved small models of creatures from the world with which they were familiar. These soapstone and ivory *pinguak* ("imitation thing" or "toy") were an inch or two long and were used for play by children and for gambling chips by adults (see figure 8). These Eskimos also made lightly carved amulets or charms from whale or bear teeth; shamans wore these in quantity, but most people wore a few attached to their clothing as talismans. The Eskimos did not have a conscious cultural category of "art," but all these manufactures were labeled *sanaurak* (that which has been made [by hand]). The arrival of the white man in North America meant a demand for souvenirs. During the first two centuries of regular contact, this demand was satisfied through trading in the normal manufactures of the Eskimo—

parkas, harpoons, utensils, etc. Few carvings or models were offered. Nonetheless, as long ago as the 1880s, in certain areas frequented by whaling and other ships, carvings were developed distinctly as souvenirs. All these previous art forms differed visibly and sociologically from the contemporary arts that we know in the stores and airports of North America.

Contemporary Eskimo soapstone carving first emerged in 1948–1949 (Graburn 1967b; Houston 1951; Martijn 1964; Swinton 1965). The volume of trade and the size of the carvings grew quickly, and within 10 years there were fears that the market would be flooded and that the "fad" was over. Yet it continues today, along with an even newer art form, lithographic prints, in undiminished volume and with relatively great financial success.

To illustrate the commercial importance of this art, cash income per family has grown from approximately $25 per month in 1949–1950 to approximately $150 per month at the present time in most settlements and to well over $1,000 per month for a few individuals. With over 2,000 Eskimos (out of a total of more than 9,000 adults in Canada) carving at least occasionally, the total income for the Eskimos derived from the sale of arts and handicrafts is well over two million dollars per year. Although in the 1950s carving was not a prestigeful occupation and was only practiced when bad weather made hunting impossible or when money was urgently needed, it became in the 1960s the major occupation of many adult Eskimos; prestige in the community is partly derived from successful

8. Three pre-contact *pinguak* ivory carvings, probably gambling chips. (Aivilingmiut, ca. 1900 A.D., under 5 cm. in length)

carving sales and most of the Eskimos' major possessions such as guns, snowmobiles, outboard motors, and even houses are paid for by the sale of sculptures.

The almost ubiquitous soapstone and serpentine deposits are mined by the Eskimos themselves. In some places the stone is mined in bulk and sold for approximately 10 cents a pound through the stores. The stone pieces are roughed out by axes and saws, carved by chisels, knives, and picks, and finished with files, sandpaper, emery paper, and elbow

grease. The nature of the stone and the style of the carvings vary tremendously from place to place. The carvings vary in weight from an ounce or two to a hundred pounds or more; the subject matter is overwhelmingly figurines of traditional Eskimos and the animals with which they are familiar. Though the subject matter may have reflected the Eskimo life style of 1948–1949, it certainly does not reflect that of the 1970s.

Origins and Differentiation

The antiquity of soapstone carving, like that of many other nontraditional "ethnic" arts, is somewhat cloudy and controversial. An excellent account of the origins and complex development is given by Swinton (1972:119–125). The traditional pinguaks were smooth, small, and multifaceted representations of animals and people; some of them were worn, but most were given to children or lost soon after their manufacture. They were of little value to adult Eskimos. In all the eastern Arctic settlements that I visited, the overwhelming majority of Eskimos claimed that they never carved soapstone before they were encouraged to do so for commercial reasons. In Port Harrison, where soapstone carving first "started" in 1948, the Eskimos say that James Houston, a visiting Canadian artist, asked them to carve soapstone figurines, though previous to that time most of the men had only carved ivory figurines or wooden models as toys for their children and sometimes to sell to white men who lived in the area or who came from visiting ships. This is the consistent Eskimo version; many mentioned that they were very bewildered at being asked to carve soapstone, which they had traditionally used only for seal-oil lamps and cooking pots. They said Mr. Houston made small drawings with a pencil on paper and asked if they could be copied in soapstone, saying that these carvings would be bought; furthermore, they maintain that all their first efforts were very poor and that they have improved with practice.

Mr. Houston himself (1952), and the Canadian Government in its promotional literature, asserted that he found these small soapstone figurines being made by the Eskimos for noncommercial purposes in the late 1940s. After successfully exhibiting them in Montreal, he was prevailed upon to go back to the Arctic the next year to encourage further carving of the same kinds of figurines in Port Harrison and other settlements. Most Eskimos in other settlements told stories similar to those at Port Harrison, claiming that they had never carved stone until Mr. Houston or some other white person suggested it to them and told them they would be able to sell these products.

There are exceptions, however. For instance, at Sugluk, one Eskimo claimed that he started to carve the remains of an old soapstone pot when he had run out of ivory for making souvenir carvings for trade with the visiting ships. This was before the Hudson's Bay Company began to buy soapstone carvings. He found that he could not sell these carvings to the company, but was able to trade them with the ships' crews. Subsequently, two or three other Eskimos in the same area copied him and started soapstone carving on their own. It was not until seven or eight years after this following Houston's visit to the Arctic,

9. Ivory and soapstone animal figurines, from early contact period. (Iglulik, 1930s, under 5 cm. long)

that the Hudson's Bay Company changed its policy and allowed the Eskimos to sell their carvings to the store. This local history is to some extent confirmed by older white residents in the area. It is possible, therefore, that soapstone carving was invented many times in the Canadian Arctic and, in fact, soapstone carvings are known from areas other than those of the eastern Arctic, collected as far back as the end of the nineteenth century. It is fairly clear, however, that in nearly all these cases such carvings were made for trade and sale rather than for local use.

The story of Eskimo printmaking is much clearer (see Roch, Furneaux and Rosshandler 1975). After his successful promotion of soapstone sculpture, Mr. Houston became a Northern Service Officer at Cape Dorset on Baffin Island. He introduced printmaking (Houston 1967) in order to increase the employment and income of the Eskimos of the area. He had attempted many other handicraft innovations for the economy of the area, but printmaking was the only one that met with continuing success. As a result of this, printmaking was also taken up by the Eskimos of the Povungnituk cooperative in 1960–1961 under the direction of a white person. It has since spread to other areas in the Canadian Arctic, including Great Whale River, P.Q., Holman Island, N.W.T., and more recently, Baker Lake, N.W.T. Unlike carving, printmaking has remained an occupation of a limited number of Eskimos in each of these settlements and the products sold to the public remain under stricter control by the white buyers, distributors, and overseers who manage Eskimo art.

Although carvings from the earliest commercial period, 1949–1951, are difficult to

come by, an examination of a few specimens and photographs shows that these early soapstone carvings were similar in size and style to the small ivory pinguaq that were being made immediately prior to this period and during the early period of contact with white civilization (see figure 9). Many are identical in form, whether they are in stone or in ivory, when they are found in the same area. This shows a certain degree of continuity in carving within the eastern Arctic in spite of the material changeover from ivory to stone at the behest of the white man some two decades ago.

Since, and perhaps before, that time, there have emerged regional styles in Eskimo carving. For instance, most interested observers can recognize almost at a glance where a carving was made, without having to turn it over to look for the name or the region-identifying number on the bottom, now required on all commercial carving. Recognition, however, is complicated by a number of factors, of which the most important is the rock. The common stone used for carving is soft soapstone or steatite, known as *qullisak* or *qullisajak*, "material for the *qullik*, or oil lamp," from its traditional use in the area. Various forms of soapstone are abundant in most areas of the Arctic. A harder form was known as *ukusiksak*, "material for the *ukusirk*, or cooking pot." In some areas, noticeably at Cape Dorset and elsewhere on Baffin Island, the term ukusiksak is now used to denote any of the harder stones used for making "soapstone" carvings, even limestone, serpentine, or gneiss. All these forms are distinct from the harder granite or fieldstone known everywhere as *ujaratuinak*, "ordinary rock."

In each region, there are a number of different kinds of stone available, often found close to each other. Some of these may be entirely different kinds, such as the black, bluish, and greenish serpentines found in the region of Cape Dorset, or the grey and the greenish-black soapstones found in the region of Sugluk. Also, the government ships stone from quarries in the south to hospitals where some carvers spend months or years. There are some settlements in the north to which the government also sends the same kinds of stone when local stone is not available. Since often the imported stone is not the kind to which the carver is accustomed, his style does not suit the stone. Transshipment between areas and settlements occurs mainly at government instigation, but also to some extent through the Eskimos' own efforts. For instance, the people of Sugluk have been known to get stone from veins in the far side of Wakeham Bay when whale hunting, and from the south side of Cape Smith when visiting Povungnituk; both places are over three hundred miles from Sugluk itself.

The undoubted connection between regional styles and local stones is complemented by the large amount of intracommunity variations. As Swinton (1965) pointed out, some areas have a regional style with little internal differentiation, whereas in other areas, individuals stand out because of their styles and overwhelm any regional styles that may already be present. One might generalize that individual styles emerge more clearly in larger, more acculturated settlements where more of the community relies on carving as a livelihood and hence more of the peoples are spe-

cialists at this occupation. A further factor is that many Eskimos have changed their residence within the last twenty years, taking their personal styles and influences with them.

Soapstone carving has been, and still is, largely a phenomenon of the southern two-thirds of the eastern Canadian Arctic. It was in this area that Houston first encouraged commercial carving and it still supplies from 70 to 80 per cent of all the carvings produced for sale. Until the late 1960s, in fact, two communities alone, Port Harrison and Povungnituk, supplied more than 50 percent of all the carvings produced. Cape Dorset was third—but first in terms of dollar value. The five major carving regions within this area, each of which to some extent may be delineated by one or more styles associated with the particular kinds of rock available, are Great Whale and the Belcher Islands, Port Harrison, Povungnituk, Sugluk, and Cape Dorset (see map 1).

Socioeconomic Impact

At the time of the introduction of commercial soapstone carving, the majority of the Canadian Eskimos depended upon trapping for their earned income and most had become dependent for their very existence upon manufactured and storebought goods such as guns and textile clothing. They still hunted—but with imported technology—for most of their food and some of their other material resources, and hunting supplemented trapping in securing seal skins and an occasional polar-bear skin for sale. Some Eskimos obtained income through occasional wage labor, such as

unloading ships, and a few had full-time employment as "post servants" to the Hudson's Bay Company.

The Hudson's Bay Company dominated the local economics, trading "essential goods," plus tobacco, tea, and flour, for the pelts with which they made their profit. Trading was usually by credit advance tokens, for the Eskimos rarely handled cash and had very little conception of the monetary system. After 1948, they were granted the Federal Government Family Allowance of a few dollars per month per child, again in the form of credit with the H.B.C. Later on, in the 1950s, similar arrangements were made for widows', old age, and disability pensions. A year after Houston's 1948 discovery, the Canadian Handicrafts Guild granted $3,000 to the H.B.C. posts, first at Port Harrison and then at Povungnituk and elsewhere, for the managers to buy carvings. Many of the managers pursued a policy of encouraging carvings that they thought salable, but limited their purchases to carvings done by successful trappers, thereby insuring the flow of the most profitable goods, the skins. This policy effectively prevented women and disabled men from earning their monetary livelihood through carving, yet these were the very people who needed it most, being unable to trap or hunt.

In the 1950s and early 1960s, the federal government moved into the north on a massive scale; not only did the cold war promote the construction of the immense D.E.W.-line and Mid-Canada-line chains of radar sites, but also national and international political events forced the government to take more direct responsibility for the indigenous peoples within

its boundaries. Federal Day Schools were constructed in most settlements, along with teachers' houses, school and community generators, and hence generator mechanics' houses, etc. All this equipment and activity further necessitated the placement of administrative officers and their clerks and assistants in each region; thus, bureaucracy and suburbia moved north. These institutions were soon followed by nurses and nursing stations, and in some places by small hospitals, docks, and air strips. Though unable to understand English and literate only in their own language, Eskimos were employed on a massive scale in the less-skilled construction jobs, earning far more money than previously. Though most of their pay was deposited as credit at the store, some demanded their checks or cash directly in order to spend it on visiting ships, or through mail-order catalogues, or in gambling among themselves. As education proceeded, more permanent employment was ensured to Eskimos as janitors, interpreters, store and office clerks, teachers' aides, etc.

It was during this period that carving and then printmaking burgeoned as sources of livelihood. With increased incomes but irregular employment, Eskimos' material wants grew; outboard motors replaced paddles, radios replaced story-tellers, wooden houses replaced igloos, and, more recently, snowmobiles replaced dog teams. The total economy became commercialized or monetized (Graburn 1971); subsistence hunting required a monetary income and the byproduct sale of skins became increasingly unprofitable, as did fox-trapping in many areas. The carving of small sculptures for sale had originally been a time-filling occupation between hunting and trapping expeditions, as in bad weather. Very soon it became a more important source of income for "target marketing" when individuals or families wanted to accumulate enough money to buy particular items, such as a gun, a motor, or even a boat. As the demand in southern Canada rose, the size and the prices of each sculpture increased, and hence the rate of return to the carvers. Store managers bought more sculpture, not only from the trappers, but also from other Eskimos so that they would have money to buy from the store goods that would bring a profit to the company.

In the late 1950s, the newly arrived administrative officers were importuned for welfare by "unemployed" Eskimos—such handouts had previously been given out most sparingly by the Royal Canadian Mounted Police (R.C.M.P.) or by the H.B.C., only to avert starvation or to promote hunting and trapping. These new officers, wishing to keep down the welfare rolls and emphasize the "economic success" of their programs in each community, urged the unfortunates to carve, and hence "earn their own living." Thus, disabled and unskilled men, women, and even children became regular carvers, even though they might not have been particularly talented. The dollar volume of carvings grew to the tens and hundreds of thousands per year, to the point where, at times, the retail outlets were unable to sell large quantities of the small, "mass-produced" souvenirs. Occasionally, the company suddenly stopped buying carvings from particular settlements whose products had ceased to move. These were times of sorrow and anger for the Eskimos there, who had increasingly come to rely on

carvings for their earned livelihood; they saw themselves as forced back to an earlier stage of poverty and insecurity. Moreover, many had lost the skills that had enabled them to survive at this earlier stage. In some settlements, the government representative himself started to buy carvings under these circumstances and in others the representative made purchases in addition to, or even in competition with, H.B.C. purchases. Thus, another distribution outlet came into being, channeled through the government.

The custom of selling carvings and souvenirs to the crews of visiting ships as carried over to sales to the more frequent visitors that arrived with air travel in the 1950s and 1960s. Originally, H.B.C. managers had commissioned wooden and ivory souvenirs, but during the 1960s the potential market among resident whites—mainly for soapstone carvings—grew tenfold. In the late 1950s, marketing channels began to be opened in addition to those of the H.B.C. Government officers bought carvings—and in Cape Dorset James Houston started the manufacture of prints—that were shipped south to be sold in outlets other than those of the H.B.C. and the Canadian Handicrafts Guild. Sales were promoted in the United States and in Europe and government promotion in the form of movies, pamphlets, booklets, and traveling exhibits formed a large indirect subsidy that further promoted sales.

First Mr. Houston and later other government representatives and H.B.C. officials promoted soapstone carving as a supplementary activity in all the settlements of the eastern Arctic. Slightly later in the 1950s, and also in the 1960s, similar efforts were made on the west coast of Hudson Bay and then at inland settlements such as Baker Lake and those further north and west in the central Canadian Arctic. Settlements in the east, however, have been carving longest and in much greater volume. In the eyes of the Eskimos, their sculptures are more sophisticated, whereas the majority of those from the west of Hudson Bay are more "primitive," and hence enjoy greater favor with the more "sophisticated" collectors. In the larger settlements of the eastern Hudson Bay, and in some of the smaller settlements all over the north, carving is the biggest single source of livelihood, though trapping remains paramount in others, and welfare in yet others. Only in the least-isolated settlements, those enjoying the most communication with the outside, is wage labor the major source of income. In the other areas, there are just not enough jobs for more than a small proportion of the adult Eskimo population, and hunting has become a money-losing proposition in all but the most favored areas.

In those settlements where carving is important, the majority of the Eskimos say they would prefer full-time wage labor as an occupation because of the security it represents and because it enables them to purchase prestigious material goods. Many of these same people, and others, would prefer hunting as a full-time occupation because of the food obtained if it also brought them money and was not so risky. Trapping is out of favor almost everywhere because with the present prices of skins a large gross income is not possible, and with snowmobiles replacing dog sleds a positive net income is rare; furthermore, trapping requires hard work away from the family and settlement and yet provides

very little meat, which the Eskimos still crave. Thus, only in those few settlements where carving prices are high would most Eskimos still continue to carve if employed for wages. The vast majority in the eastern Canadian Arctic carve *"inurutiksaktuariraku"* (because I have it only as a means of livelihood).

In the late 1950s, an enterprising missionary in Povungnituk started a Sculptors' Association. This unique organization was a guild in which the better carvers were to produce, price, and sell carvings of supposedly higher quality directly to retail outlets, thereby increasing the proportion of the final price that they themselves retained. It became a prestige group to which other carvers might aspire; admission to the group was extended by the initial members to other carvers on the grounds of carving quality. The H.B.C. store continued to buy carvings from the rest of the population and this competition meant higher prices for all the carvers. Similarly, James Houston organized a producers' cooperative at Cape Dorset to market, through government channels, both stone sculptures and the newly popular stencil and block prints. Both these organizations were so socially and economically successful that in the early 1960s both became cooperatives for producers and opened consumers' divisions, including general stores that competed with the H.B.C. This immediately lowered the price of many consumer goods to the Eskimo. The Povungnituk Cooperative later started the manufacture of prints, clothing, and other handicrafts, and more recently constructed a tourist-fishing lodge and took on the Shell Oil distributorship (Vallee, 1967). In Cape Dorset, a similar expansion has taken place. In North-

ern Quebec, the Povungnituk example stimulated the formation of producers' cooperatives organized around the sale of sculptures in all the other settlements, some of which have also opened small general stores. In many settlements of the Northwest Territories, the Cape Dorset example has been followed, though on a smaller scale and far less successfully, with the formation of producers', consumers', and housing cooperatives. All these Eskimo cooperatives were supposed to combine to form a large federation for the purposes of buying, accounting, shipping, sales, and the like, but the only operative multipurpose federation has come into existence through the efforts of the Indian and Eskimo Cooperatives of Nouveau Quebec. The successful producers' cooperatives of Cape Dorset and the rest of the Northwest Territories sell through a Crown corporation, Canadian Arctic Producers, which handles the pricing and distribution of prints, sculptures, and other handicrafts through its headquarters in Ottawa.

These cooperative institutions, especially those in Quebec, are the most important political economic developments in the recent history of the Canadian Eskimos (Graburn 1970). Whether the cooperatives have been profitable or not, they have fulfilled major social functions in providing community organizations of some power, permanence, and purpose. Government efforts to promote viable community councils, etc., met with little success before the cooperatives were formed. Cooperatives have allowed the Eskimos to feel that they have institutions with which they can identify comparable to those controlled by the white man, such as the Hudson's Bay Company, government schools and administrative

offices, the churches, etc. Much of the propaganda constantly put forth by the cooperatives and their mentors has rubbed off, and many Eskimos "shop Coop" because it is "their" institution. Cooperatives provide added avenues of employment for Eskimos at all levels of skill and, perhaps more importantly, they give many opportunities for managerial training and increased occupational status for certain employees. These new institutions, originated and built on the sale of commercial arts, have become the social and political foci of community and regional development in most of the Canadian Arctic.

The Aesthetics of Form and Content

As carving is a principal means of securing a livelihood—in many areas replacing hunting—men are often as competitive in their new endeavor as they were in the old way of life. The Eskimo language expresses explicit parallels between the processes of hunting, male sociosexual behavior, and making good sculpture:

These generalized and traditional Eskimo values are translated directly into the aesthetic qualities of commercial carving by which men and their products are judged. Although women do carve, most of them do not carve such large or difficult sculptures as men and are not as admired or as competitive in this activity as men. Making drawings for prints is, in some places, considered a more appropriate women's occupation, whereas the values in carving are directly related to maleness. For instance, admiration is won for working hard stone as opposed to soft stone, which is known as women's stone, but is also suitable for old people, cripples, and children. One works (*pinasuakpuk*) or attacks the stone with a sharp tool—usually starting with an axe, then using chisels and knives, and finally finishing with rasps, files, and abrasive papers.

A shiny finish is much admired if the stone will take it, but it is considered cheating to achieve the shine through the use of oils and waxes—though some men do so for speed or because they are not very strong. Glossiness or brightness of the surface is more important

	The Search	*The Work*	*Prestigeful End Product*
Hunting	*qinirkpuk* for the right kind of game	*Pinasuakpuk* the animals; with active excitement, with shooting and the animal succumbs	food and by-products, for wives, children, and friends
Carving	*qinirkpuk* for suitable stone	*pinasuakpuk* the stone; active work, exciting realization	sculptures, and hence admiration, money, and goods
Sexual Behavior	*qinirkpuk* for a willing woman	*pinasuakpuk* the woman; exciting activity, the woman succumbs, relief	pregnant wife and many children

than the actual color of the stone, which is usually determined by the local available sources. In Povungnituk and Port Harrison, where the local stone is often a dull grey, the Eskimos invented a technique whereby they polish the surface to a shiny near-black and then scrape parts to reveal the dull gray-white color, creating patterns and striking contrasts in otherwise dull sculptures (see figure 10). This accentuates the shininess of the black and gives an aura of detail or exactness—a quality much admired by the Eskimos but not by the white buyers.

To the sculptors, however, hardness is even more important than color and shininess. Carving of a very hard stone—serpentine, gneiss, etc.—is admired even if it does not

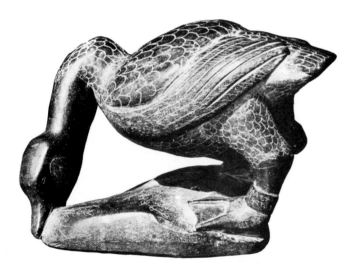

10. Soapstone carving of Canada goose by Davidialuk; note the conscious use of the surface properties (Povungnituk, 1965, 30 cm. long).

have a shiny finish; Eskimo critics "forgive" a rough or inexact carving out of their admiration for the sheer attempt to carve such a hard stone. Only a few men "attack" the harder stone and are known for and proud of doing this. The men of some areas look down upon the men of other areas as "women" because their stone is so soft—which, of course, cannot be helped!

In all areas, stone of even hardness with no cracks is preferred over stone with striations of color or density. The bolder men of some areas claim prestige on the ground that they can and do make carvings with holes right through them—such as between the legs of the Canada goose in figure 10 or the limbs of the woman in figure 12—or between separate figures of a montage, as in figure 11. A lack of boldness that is demonstrated by the parts of the sculpture not being separated is criticized by artists both in their own carvings and in those of others. This criticism is often made of women's carvings—such as the owl in figure 13. Fragility is not admired for itself, though it is an element of the daring involved in making holes and separating elements. Although it is easier to make holes in soft stone, there is more likelihood of breakage, so hard stone is again preferred, even though it takes more work.

The most desired material to work with is walrus ivory, *tugak* (also means tusk), which is very hard, white, dense, and pointed, and is the major component of male weapons such as harpoons, spears, and knives. The desire to use ivory as an adjunct to stone carving is powerful in nearly all areas, whatever the nature of the local stone. Ivory and other local

knives is strong and applies to a degree to such substitutes as bone, antler, baculum (penis bone), or occasionally wood.

We have described above the crucial impact of technological and material constraints on

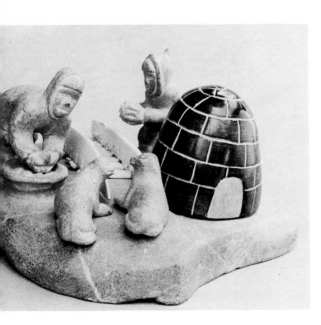

11. Two men feeding their dogs outside an igloo; made from two kinds of soapstone, bone and sinew, by Jimmy Takirk (Sugluk, 1968, 18 cm. across).

12. Usuitulak carves a large serpentine figure of a woman carrying a waterbucket, while he sits outside in the snow wearing winter caribou skin parka. Note the daring and realism for which Usuituk is justly famous amongst Eskimos and whites. (Cape Dorset, 1968)

and contrasting materials are used in stone carvings to depict accessories for men, ulus for women, occasionally faces and eyes, and for teeth in both animals and humans. This tendency, along with the Eskimos' admiration for complex portrayals of typical scenes, is often strong enough to counteract the explicit instructions of the wholesaling agencies who do not like multimedia or multipiece carvings because (1) they break more easily, (2) the accessories get lost in transit, and (3) the dealers have promoted and sell *soapstone* carving (see figure 11). The carvers' desire to represent ivory in such things as harpoons and

the aesthetics of form. Many if not most sculptures override one or more of the major values of hardness, daringness, complexity, and finish, because they are mundane, quickly made, day-to-day pieces, produced to secure a livelihood. The creators criticize their own works on exactly these grounds, whether they are capable of making better things, as most are, or are old or weak or shortsighted and therefore not capable.

The overriding overt criterion for the evaluation of carvings in most places is realism —*sulijuk* (it is true), *tukilik* (there is sense to it), or *miksiqaktuk* (it has realistic sense). Carvings are supposed to represent the things of which they are models, whether the things themselves are "real" or not. The Eskimos examine sculptures not only for technical quality, which is nearly always uppermost in their mind, but also for the sense it makes to them in terms of their knowledge of the world. Some carvers who are considered, and consider themselves, the least lazy and the least "prostitutable" may emphasize exactness to the point of extreme detail—every hair on the head, every feather on the bird—which is the value equivalent of hardness (when the stone is not so hard or rough as to exclude the possibility of detailed representations).

Obviously, absolute faithfulness in detail is well-nigh impossible, so compromises have to be made in nearly all carvings, although the common fantasy-dream of the best and most aggressive—or "macho"—carvers is to do a full-size highly detailed sculpture of something—for example, a bear or a man—in hard stone. Compromise for most people involves an unconscious reduction in detail but a conscious attempt at maintaining proportions, appropriate surfaces, and "life." Many carvings, although detailed and proportioned, are criticized as being *quak* (frozen, not alive, stiff).

A few Eskimos are able to verbalize and make conscious the process through which certain details are selected as significant; we might say that they know the essential symbols or signs, *nalunaikutanga*, for the creature they are trying to model. For a man, it is a harpoon; for a woman, is the *ulu* (semi-lunar knife) or the *amautik* (the rounded baggy part of the parka for carrying a child); for a walrus, it is tusks; for a polar bear, it is canine teeth; and for a hawk or owl, it is talons and beak, and so on. Such aware Eskimos, and others, perhaps unconsciously, use these symbols in their carvings, although there is sometimes an overt conflict between "realism" and "symbolism," for example, should a model polar bear have just four canines or all its teeth?

The concept of nalunaikutanga is also consciously used by some people as a marker for *their* carvings. For instance, Leviraluk always puts the bootlaces on his frequent carvings of male hunters; Pautak puts his name on the side rather than the bottom; Qakak uses such hard rock that nobody else would use it; Siirkjuk's mark is absolute perfection—to a degree obtained by nobody else; his half-brother, Usuituk "B", is famous for his bold naturalism in sculptures of women and animals (see figure 13). Sometimes a person's nalunaikutanga is subject matter: for example, Qirnaujuak's bear-owl, Ainaluk's man-and-walrus, Josi Papi's birds, Niviaksi's polar bears, or the old widower Kiaksuk's model women!

The aesthetic evaluation of sculptures often depends unconsciously on the appropriateness of some or all of the incorporated forms. These may also be designated as male and female, that is, approximately linear versus rounded. Carvings of male-associated creatures or humans must have associated male shapes at the important points. Certain formal themes appear in whole series of carvings; for instance, carvings of women often have the opening of the amautik[3] roughly in the shape of the woman's lamp—or the ulu, or the umiak—whether or not these actual items are included. Carvings of men and male animals are preferred with male, pointed shapes resembling or portraying the pointed parka hood, harpoons, teeth, knives, etc. A carving of a man with an outstandingly female shape somewhere in it would be criticized as being somehow wrong, even though it might be a precisely detailed and realistic carving! Similarly, "female" carvings tend to be more rounded or "all of a lump," or to have the limbs closer to the body or bent so that they form part of a block with the body, as exhibited in figure 13.

Symbolism and realism converge in the choice of subject matter in the more complex carvings. Men and women (and male- and female-associated creatures) are portrayed behaving as they should or associated with accessories signifying their categories. Men often appear with harpoons, knives, kayaks, and spears, etc., and women often with oil lamps, ulus, babies in their parkas, and the like.

[3]An observation suggested to me by George Swinton in private conversation in 1969.

13. Serpentine sculpture of a snowy owl, by Qakjurakjuk (Cape Dorset, 1968, 23 cm. tall).

In multifigure carvings and drawings including a human and an animal, both in realistic representations and in mythological-imaginative scenes, the sexually appropriate relationships are shown. In sculptures of men and animals together, men are usually modelled as aggressive hunters, equals of such creatures as polar bears and walruses, and the two figures face each other. Any of these three species are shown as dominant when com-

bined in multifigure carvings with such hunted animals as seals and birds, and the latter hunted animals face away from the dominant figures. Polar bears and walruses, when shown together, sometimes face each other, though the polar bear is more often shown dominant, even though in actual life they are said to be equals in fighting.

Eskimo drawings (and hence prints), and some carvings, that contain strong elements of symmetry, and sometimes of complementary opposition (Graburn 1976a) are occasionally admired on these very grounds. The essential dualisms of Eskimo life are many, in addition to the most fundamental dualism, that of male and female. Others are land and sea, inside and outside, summer and winter, life and death, and, of course, the natural symmetry of humans and most other creatures. The igloo itself is symmetrical on two axes; across the front to back axis it is exactly symmetrical, but across the middle axis, it is complementary, that is bedding vs. floor, sleep vs. waking, processed things vs. raw food. Nevertheless, there is inherent symmetry in the carvings of most single creature figures and there is very often bilateral symmetry (*idluriik*, two equals as a pair) or complementary symmetry (*aipariik*, two complements as a natural pair) in the multifigure sculptures, the type of symmetry being appropriate to the creatures modelled.

In the selection of subject matter, there are a number of constraints. First, there are those of the market, and Eskimos are quite aware of this, often being able to voice fairly accurately what the white man expects Eskimos to portray. Also, the market expects models from *traditional* Eskimo life, not the present-day world of the artists, which includes guns, snowmobiles, manufactured clothing, and movies.

Secondly, there are the constraints of material and technique: some pieces or types of stone are more appropriate for certain contents, which naturally will be reflected in a subject matter that is characteristic of particular local areas. For example, the Belcher Island rock used there and at nearby Great Whale River comes in small thin pieces with striations and is often turned into birds with their necks stretched out, standing people, and seals. The hard serpentine from Cape Dorset comes in lumps (often because it is dynamited) and lends itself to bulky rounded figures such as figure 13. Intermediate softer rock, such as at Povungnituk, Port Harrison, and Sugluk, allows for almost any creation or shape, as seen in the plasticity of figures 10 and 11.

Thirdly, there are the economic constraints of "efficiency"—the carver always has to balance the expected return against the time and effort taken to create. Complex carvings (the most admired ones) get more money, but take much more time and are more likely to break. Harder stone is admired and takes a better shine, but again takes more effort and wears out more expensive tools. Very small and very large carvings get more money per square inch of carved surface, but each presents special difficulties (problems in presenting detail and getting a good piece of stone, respectively). As a result, most carvings are small to medium in size, not too complex, and rather rounded—such as simple models of seals, walruses, owls, and so on (see figure 13).

The fourth imperative—in aesthetically ad-

mired carvings—is the selection of subject matter that pleases the creator and other Eskimos. Many carvings are obviously idealized self-portraits—the successful hunter, the productive woman, etc. Others represent obvious wish-fulfillments—the carving of beautiful women by single men or the cutting up of large seals by hunters. These themes often combine with a thought uppermost in the minds of Eskimos of all ages—food. Game animals are often carved because of the importance of these creatures to the potential hunter, the Eskimo housewife, and the hungry child. For these and other reasons, such as ease of manufacture, food animals, *niqiksait*, are the most numerous subjects for sculptures—even though the buyers and the market have often indicated their relative overabundance and low drawing power in the stores.

Conclusion

Eskimo aesthetic values, as expressed in the creation and criticism of modern soapstone sculptures, are a blend of traditional and introduced features. Though undoubtedly the art form started from souvenir models and the cheaper objects are still mere souvenirs, the bolder sculptures, even when made entirely for sale, are important to the Eskimos and have become integrated into their modern culture. Thus, they can be said to have risen above souvenir art and to have become works of a "commercial fine art" (see Introduction).

Edmund Carpenter has long questioned whether these commercial art forms are Eskimo art at all, particularly in his *Eskimo Realities* (1973:192–197).

> Its roots are Western; so is its audience. Some carvers have been directly trained by Houston; others follow a Government manual . . . That Eskimo artists have the desire and confidence to improvise is a happy situation. I regret, however, that the new ideas and materials they employ are supplied by us, not selected by them. We let the Eskimos know what we like, and then congratulate them on their successful imitation of us. (*ibid.*:194–195)

Although I agree that carving is an introduced art form, the Eskimos do make their own selections of stones, tools, and subject matter, often in contradiction to market demands. Furthermore, the way they go about carving and the satisfactions they get from it are not imitations of us, but are charged, male, sociosexual activities that have a direct continuity with their former lives as hunters.

2. Functional Aspects of Haida Argillite Carvings

Carole N. Kaufmann

The Haida, together with the Tlingit and Tsimshian, form the northern province of the Northwest Coast Indian culture area (Drucker 1965). They inhabit the Queen Charlotte Islands, separated from the mainland of British Columbia and Alaska by the Hecate Straits and Dixon entrance (see map 1). These islands, like the nearby mainland, have mountains up to 5000 feet and dissected shorelines. The entire area was rich in natural resources. Gigantic red and yellow cedars, spruce, hemlocks, and various fruits and berries grew abundantly there. The surrounding ocean supplied abundant foodstuffs, mostly halibut. Fowl were hunted in the inland marshes of Graham Island. Generally, survival was not difficult in this rainy but mild area. Food-getting activities were confined largely to the summer months; the winter was a time for social and ceremonial activities.

Carole N. Kaufmann was awarded her Ph.D. in art history from the University of California, Los Angeles, for her research on Haida argillite carving. She has taught at the State University of New York in Buffalo, and is now Associate Professor of Art History at Washington University, St. Louis.

As the Haida, along with their northern neighbors, the Tlingit, speak Athabaskan (Na-Déné) languages, the two groups may have both split off from the interior Athabaskan tribes and migrated to the coast in centuries past. According to Haida tradition, their ancestors came from the region of the Skeena River, a river valley that was a known major migration route from the interior to the coast. Their myths also relate, however, that when they arrived on the Queen Charlottes, they found already living there the "old Haida"—a group whose mythology contained no recollections of mainland origin.

In their overall cultural patterns, the Haida resembled other Northwest Coast groups: they were all sea-going peoples who lived in huge wooden houses and were known for their woodcarving, tripartite class systems, and rich ceremonial activities. They also made huge dugout canoes for whaling and trading expeditions. There were no runs of *olachen* (candle fish) on their islands, so they came to the Nass River to trade with the Tsimshian and Niska who reaped a rich harvest of this oil-

laden fish. The Haida came in large red canoes, and brought elaborately carved boxes, flakey dried halibut and their famous chewing tobacco to trade for the olachen. The Tlingit also came south to this area to trade "coppers" (native copper cold-beaten into ceremonial plaques) for the superior-flavored oil.

Like other Northwest Coast groups, the Haida held *potlatches*—ceremonial feasts and giveaways—in which a new chief honored the memory of the deceased chief and validated his succession to the office. Such potlatches were infrequent because of the time it took to amass the wealth that had to be exchanged or given away. Owing to the easy availability of trade goods, potlatches in postcontact times became more frequent and the amounts exchanged or even destroyed grew larger. In their ceremonial life, the Haida possessed the masks and other regalia along with the songs and dances of the Cannibal and other dancing societies, but they used these privileges only to display noble family crests and did not have the complete set of ceremonies as did the Kwakiutl.

In social organization, too, the Haida differed somewhat from other Northwest Coast groups. Like their neighbors, they were divided into two exogamous matrilineal moieties, the Ravens and the Eagles, but there was no federation or clustering of these groups. In fact, each subclan had a separate village, unlinked to other villages, until the advent of governmental pressures in this century forced the Haida to consolidate their dispersed villages into larger communities. Some of the local-clan groups had names containing elements meaningless in Haida but resembling

Tsimshian, suggesting again that there was considerable interchange amongst the three northern tribal groups.

ARGILLITE CARVING

It is plausible to say that Northwest Coast society was art oriented. It was an extroverted society that visually exalted its achievements. There was a clear regard for material objects; in fact, its chief aim was to display and conspicuously consume goods. There was an impetus to do, to act, and to create in an ostentatious way. Artistic activity was no exception. Rank, status, and lineage affiliation were symbolically denoted upon every tangible item, from the ceremonial robe to a utilitarian berry spoon. Consequently, the artistic activity was not confined to functions normally associated with religious acts. Ceremonial events, such as the potlatch, were probably the time of most extreme religious and artistic involvement. But Haida art, and art of the Northwest Coast in general, must be viewed as a symbolic recording device for a society that lacked writing as an abstract activity. Cogent messages were handed down verbally through folk tales and myths, and visually, through sculptured and painted forms.

The argillite[1] activity began around 1820, but it is conceivable that artists carved argillite

[1]Argillite is a carbonaceous shale found at Slatechuck Mountain on Graham Island. It is clan-owned and therefore used only by clan members and their friends. When quarried it has the consistency of soapstone; it rapidly hardens on exposure to air—and therefore must be kept wet. Metal tools were always used in working argillite.

before this date, making, in particular, such objects as charms or amulets (Gunther 1967: 165). An argillite killer whale joined with an ivory charm, as shown in figure 14, may be such an object. Labrets of argillite frequently appear in museum collections. Such artifacts may have been manufactured for indigenous or ceremonial use, but they never gained wide popularity. Apparently, the Haida found no functional use for this stone in their own framework of existence, for argillite is brittle and shatters easily, and thus could not be used in any capacity that required strength and durability. From 1820 on, the stone was fashioned into art objects, which became a lucrative item of trade. Carved argillite objects were among the first forms of curio art in the Northwest, and became popular with sailors and tourists who found their way to the coast.

The most significant function of argillite within Haida society was its use in making sale items. In the nineteenth century, social achievement was measured by economic gain, and viewed from this aspect, argillite may be considered an intrinsic part of the functioning society. Sales of craft products and objets d'art have been a steady component of Indian-white exchange from the time of first contact (Hawthorn *et al.* 1958:257). Quadra and Maurele bought model canoes, wooden frogs, and tobacco boxes (Newcombe 1906:136). Dixon collected a mask, a bowl, and even a labret (Dixon 1789:213). The Haida, therefore, were accustomed to trading objects made by their own craftsmen. No pieces of argillite, however, are extant in early collections, nor is any early mention made of them.

By the 1820s, the sea otter, which had been

the mainstay of commercial hunting and trade, was no longer available and new items were needed for barter. In their desire to participate actively in the Western commercial market, the Haida began making crafts. They sold these either to vessels that stopped at their villages or to forts established by the Hudson's Bay Company. It is not known how much remuneration they received for their efforts, but by the 1820s it was observed that they wanted a considerable amount of cash, and not merely trade objects, in return for argillite products (Scouler 1905:178).

Because the Haida to a large degree, and the other tribes on the Coast to a lesser degree, developed a salable art very early in the days of contact with Europeans, the Northwest Coast was spared the disaster of having its art corrupted into what is commonly designated as souvenir art (Gunther 1967:165).

The creation of argillite artifacts was a dominant artistic activity in nineteenth-century Haida society, particularly from 1820 on. It is recorded that by 1892, wooden totem poles were cut down for firewood, and small argillite ones were the only ones made (Deans 1899:23). Thus, this medium aided in prolonging an established art tradition. Moreover, Hawthorn *et al.* (1958:264) point out that the impact of Canadian settlement would have tended to curtail any material or artistic endeavor, yet the Haida were effectively able to continue the creation of argillite objects until the first years of the twentieth century, indicating that they retained at least some interest in creating symbolic forms of their own culture. Gunther (1967:149) maintains that since slate carving flourished during a period of so-

cial disorganization, it had no place in the so-called established culture. This, of course, poses the question of what the established culture was. It has been demonstrated by Wike (1957) that the traditional culture was very much in existence up to the year 1850 and, in fact, was intensified by the fur trade. The argillite activity flourished from 1820 on. Therefore, to say that this art form was not an established cultural item is to deny the art and its functions within the culture altogether.

A SUMMARY OF HAIDA HISTORY BETWEEN 1820 AND 1910

Effects of the Fur Trade and the Establishment of Trading Posts

The history of the Haida between the years 1820 and 1910 is marked by rapid acculturation. The first significant factor for change was the fur trade, which supplied the Indians with new goods and gave them a more efficient technology. Part of that technology consisted of iron tools, which enabled the Haida to develop and organize their woodworking skills, thereby accounting for the production of totem poles and immense houses. Foreign trade initiated a move away from an economic system that emphasized production for direct consumption. In the early period of the fur trade, an individual hereditary chief served as the principal representative of his clan or tribe in negotiating trades with ship captains. This enriched his own supply of trade goods, and allowed for a concentrated accumulation of wealth. The rich, so to speak, grew richer

(Wike 1957:1093). Such economic activity delineated rank and status more specifically than before. In addition, the taking of slaves through extratribal slave raids became more frequent. Power became consolidated in the hands of a single individual or in that individual's lineage group, which was responsible for maintaining social equilibrium. In some ways, then, the wealth brought about by the fur trade might be credited with strengthening the already existing internal social structure that emphasized wealth accumulation.

By their presence, the fur traders and the whalers also increased the cosmopolitan aspect of Haida life. Such contact introduced diseases that reduced the population by the 1830s to about 6,700—or a drop of about 1,500 from aboriginal times (Work in Dawson 1880: 166B).

The next most significant factor in changing Haida life was the establishment of trading posts, or forts, by the English. The year 1820 marked the merger of the Pacific Northwest Coast Fur Company with the Hudson's Bay Company. In the 1830s this strengthened company began to build more and more posts: Fort Simpson on the Nass River in 1831, Fort McLoughlin on Milbank Sound in 1833, Fort Nasqually on Puget Sound in 1833, and Fort Essington at the mouth of the Skeena in 1835. Victoria was founded in 1843. These permanent posts provided a regular flow of trade goods.

The establishment of these forts worked internal changes on the Haida society, and on the societies of all the Northwest Coast Indians because the individual no longer had to de-

pend on the chief to trade for him. Thus, there was an individual accumulation of wealth and, subsequently, a greater display of public wealth. Potlatching became intensified and widespread. This creation of a *nouveau riche* class caused a breakdown of unicephalic leadership, increased social competitiveness, and was responsible, in part, for intensified intertribal and extratribal warfare. At the same time, there was an increase in slave raids and, consequently, a larger slave class (Collins 1950:336–339). Moreover, the forts, by serving as focal points for trade, further increased the cosmopolitanism of the Haida nation itself.

Up to about 1850, the Indian world regarded the Western world as desirable largely because of its ability to supply trade goods. The superiority of whites was acknowledged only in a limited number of ways; whites were considered socially inferior, and in most technical operations, such as those related to subsistence, construction, and art, the Indians regarded their own knowledge and techniques as superior. Therefore, prior to 1850, despite decimation brought about by disease, there was a prevailing feeling of self-confidence among the Haida (Hawthorn *et al.* 1958:60).

British Colonization and Settlement 1850–1870

In 1849, the British Imperial Government, through a Crown Grant, awarded the Hudson's Bay Company the right to colonize Vancouver Island. This colonization brought new settlers from England and required that the company take strict stands where Indian activities were concerned. James Douglas, who was named governor of Vancouver Island in

1851, maintained the policy of making treaty-like arrangements with Indians and allotted them as much land as they desired (Duff 1956:61).

In the 1850s and 1860s there was increased contact between the Haida and Europeans, including contact on the Queen Charlotte Islands, which became the site of mineral explorations. Unhappy about such foreign intrusions, the Haida fought with the exploration crew members (Rickard 1942:47). It has also been noted that the Haida maintained a predatory attitude towards other tribes at this time (Mayne 1862:74). In addition, there was growing strife within the society itself. Owing to the excess of trade goods on the coast, there was an internal breakdown of traditional controls: anyone could now amass wealth. Thus, not only the head chiefs could potlatch, but also anyone with ingenuity (Drucker 1939:56). Traditional chiefs faced increased competition from their lower-ranking subchiefs. Consequently, the 1860s were characterized by social mobility and an increase in wealth-getting activities. Adventurous young men left their villages seeking to attain individual fortune and to escape tribal responsibilities. Men, desirous of raising their status at home, often sent their wives to Victoria to become prostitutes, and then used their wives' earnings to give larger potlatches (Poole 1872:313).

In 1858, a gold rush brought to the coast unsavory intruders with their diseases and *hoochinu* (whiskey made with blue vitriol). The introduction of this whiskey increased tribal and intertribal hostilities. Prior to this date, the Hudson's Bay Company had kept fairly tight control on liquor distribution, but as their in-

fluence over the Indians lessened, drinking became more widespread. Also, with guns now in their possession, the Haida became the terror of the coast; lives were lost through both drinking and fighting (Crosby 1955:115–6). But far more serious in its consequences was the smallpox epidemic that ravaged the coast in 1862 and decimated the Haida home population (Duff 1956:42). Needless to say, at this time, surrounded as they were by death and disease, confusion and feelings of defeat began to prey on the minds of Haida chiefs and commoners alike.

Final Change 1870–1910

As compared with the previous two decades, the 1870s most clearly illustrate the decisive change effected in Haida society. Ravaged by smallpox and by pulmonary and venereal disease (Dawson 1880:105B), some villages were virtually abandoned. People inhabiting sites located on poor fishing grounds or areas remote from communication left their villages and were absorbed in others (Dawson 1880:177B). The youth, despising old ways, abandoned their homes, leaving the elders to survive as best as they could. At this point, the young Haida looked upon their immediate predecessors with contempt for not knowing ways and techniques that they now took for granted (Dawson 1880:161B), and, as far as possible, they adopted Western dress.

There were numerous signs of a decaying social structure. The institution of the head chieftainship was still in existence, but probably not to the extent it was in former times (Dawson 1880:119B; Niblack 1888:251). Dawson (1880:120B) observed that the title of chief might be passed on even to a sister or niece, if there were no other relatives, whereas in former times, a nephew, or at least a brother, was always available. He also noted that in the later 1870s, totem poles were erected very infrequently; this perhaps can be interpreted as an indifference to old traditions or an inability to maintain them. Tattooing, an indicator of rank, was no longer practiced, and labrets were not worn (Dawson 1880:108B).

Finally, in 1876, missionary activity began on the Charlottes with the arrival of Reverend Collison of the United Church of England. Conversion was no easy task because the Haida, perhaps owing to their island isolation, were more resistant to change than the mainland tribes. Collison's chief weapon was not the Gospel of Christianity but his medical ability. He made immediate converts when he vaccinated the Haida for smallpox and thus enabled them to escape the dreaded illness. His position was strengthened, too, by the fact that lesser chiefs, disillusioned with the old traditions, adopted his teachings, influencing their immediate families and their own age groups. Slaves, too, sought refuge with Collison, and he did his best to intimate that keeping and sacrificing slaves was wrong. Slavery was legally abolished on the Northwest Coast in 1855 (Collins 1950:339). Although the Haida were slow to change old ways, Collison and other missionaries were able ultimately to effect the loss or lessening of the slave class, which weakened the autonomy of individual chiefs.

The 1880s might be viewed as an extension of the previous decade. Missionary activity

was especially zealous and settlement in-creased. The potlatch, with its ritual destruc-tion of goods, particularly incensed the Cana-dian public, oriented to the Protestant ethic. In 1883, a proclamation denouncing the potlatch ceremony was issued, but little was done to enforce the abandonment of the custom (La-Violette 1961:38). The next year, a law strictly banning the potlatch was enacted, making In-dian agents responsible for taking disciplinary measures against those participating in winter ceremonials. The ramifications of such action were felt throughout the coastal area. Tradi-tions, already partially decayed, were now shaken to their very roots. Obedience to this law would force the Indian to change his entire value and prestige system. It would also eli-minate a secure source of economic wealth, especially for chiefs whose families worked for them for potlatches and who received much in exchange. Furthermore, at this period Western values did not really fill this void; they had not been accepted fully into the Haida scheme of things. The creation of this void by the Canadians was intentional. No longer bound to an obligatory debt arrange-ment, all Haida social ranks would be psy-chologically free to become industrious through their own skills and initiative. But in order to succeed in the new society, the Indian had to participate in the Canadian world of industry. Christianity was part of the package; with it came new moral and learning stan-dards.

Even in the 1880s, the Haida were worried about being potentially poor if they adopted Christianity (Collison 1915:153). The chiefs recognized that they stood to lose the most in prestige and wealth. Although the potlatch law was not strictly enforced in the 1880s, its ex-istence did not tend to encourage native ways. Also, since the population of the Haida had by that time dropped to about 800 (Duff 1956:38), white superiority was an ever-present issue.

The years 1890 to 1910 are characterized by a final destruction of native ways. Deans, an important observer of the Haida from about 1850 to 1900, noted that by 1890 the whole way of life had changed. Stories were told differently, totem poles were not erected, and the way to remember the dead was to buy a stone gravemarker from Vancouver. The last potlatch was held in 1891 (Deans 1899:8). This change is reaffirmed by MacKenzie (1891:50), who explains "that they neither erect columns, give potlatches, dance, nor distil liquor—hav-ing decided to follow the advice given them by the government and the missionaries to live according to law and order." Dorsey (1898:167) also notes "that not one of the ancient houses remains in good condition."

By the end of the nineteenth century, the Haida were consolidated into two main village sites, Masset and Skidegate. In 1893, the Gold Harbour people moved to Skidegate, as did the Klue people in 1897 (Crosby 1955:271). The loss of social cohesiveness was demon-strated further by the fact that even in the 1890s, it was so difficult for the men to get wives that they had to go to the Tsimshian. But there was little intermarriage between Cana-dians and Indians on the Queen Charlottes (Hawthorn *et al.* 1958:61). Churches were built through Indian support, and Christian schools were established on the islands. Judicial matters were handled by Canadian-modeled,

native municipal councils and constabulary forces. Thus, the last twenty years of concern in this study reflect the end of an aboriginal way of life and mark the beginning of almost complete cultural change brought about by European contact and settlement.

TYPES OF ARTIFACTS

All objects carved out of argillite were copies of objects made in either the traditional, indigenous society or by the contacting society. Argillite artifacts, as was mentioned above, were made for nonfunctional—hence, aesthetic—purposes. Types of artifacts include:

a. a pipe with a long stem and a round bowl placed at a right angle to the stem. It is West-

ern, rather than Haida, in origin (see figure 15.)

b. an oval pipe common to both the Haida and the Tlingit. The bowl is usually placed near the center of the artifact with intricate decoration placed around the bowl. There is an aperture for a stem and bit to be added.

c. a pipe panel, which may be a horizontal elongation of the oval pipe. The artifact is decorated elaborately, but is drilled for a bowl and bit—thereby having the attribute of a pipe.

d. a panel similar in shape to the pipe panel but not drilled.

e. a dish or plate that is circular and has a hollow depression; it is a Western form.

f. a platter with both a short and long diameter.

g. a bowl that has a deep interior depression; the shape is Haida.

h. a box richly embellished and used func-

Table I. Percentage Distribution of Argillite Object Types Over Time

Year	Oval pipe	Pipe panel	Panel	Pipe	Figure	Carved figure group	House post	Totem pole	Bowl	Dish	Platter	Flute	Cup	Box
	(%)	(%)	(%)	(%)	(%)	(%)	(%)	(%)	(%)	(%)	(%)	(%)	(%)	(%)
1900				3	17	7		21	3	7	39			
1890		1		11	14	13		39	1	8	8			5
1885			2	4	2	29		40		2	16			4
1880						2		64	7	11	2			12
1870					2	2	51	39		5				
1865		7	14	7	27	7	14	14	3	7				
1860		3	33	10						29	6	3	16	
1850		15	15	22						30		15		
1840	4	13	25		29					25	4			
1830	16	74		7										
1820s	31	53			5				11					

14. Charm, 1820 or earlier; carved and inlaid bone man and whale, and carved and inlaid argillite whale (7 cm. long).

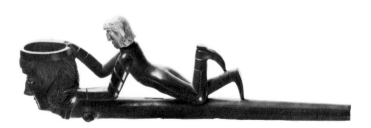

15. Argillite Pipe, ca. 1850, resembling white man; Columbia River, 1866 (18 cm. long).

tionally for Haida ceremonial purposes (see figure 17).

 i. a knife used for cutting food in Western societies; also forks or table utensils.

 j. a drinking cup; Western.

 k. flute; Western in origin.

 l. a model of a Haida house post.

 m. a totem pole (see figure 16).

 n. a single human figure (see figure 18).

 o. two or more figures.

CHRONOLOGICAL DISTRIBUTION OF ARGILLITE ARTIFACTS

Table I shows the percentage distribution for the artifact types over time. The chronology for Haida argillite carvings has been ascertained in Kaufmann (1969). The decade of the 1820s shows a strong preference for oval pipes and pipe panels. The oval pipe was a native form—usually carved out of wood. Pipe panels may be an elaboration of the oval pipe. Barbeau (1953:2) maintains that raven rattles used by shamans were the source for the pipe-panel configuration, a plausible point of view, because similar pose arrangements are found on both rattles and panels. Charmlike artifacts (see figure 14) are found at this time, or even earlier (as is suggested by the style). The nature of these artifacts may indicate that the Haida were initially working in argillite for their own use.

The decade of the 1830s shows an increased popularity for the pipe-panel configuration over the oval-pipe form, a change in shape preference that is coincident with the rise of

Western subject-matter choices (Kaufmann 1969:115). The single figure (usually anthropomorphic) and the Western-shaped pipe (see figure 15) make rare appearances at this time. By the 1840s, however, the oval pipe is virtually nonexistent, the pipe panel and its more decorative derivative, the panel, assuming dominance. The single figure, usually depicting a European or American male, is found in significant numbers. The dish was preferred from 1840 to 1860. Other Western food utensils, such as drinking cups, knives, and forks were manufactured around 1850. Flutes, too, were made at this time.

The year 1865 marks a change in the tradition: nine artifact forms—many of them new in type—join the argillite vocabulary. Typically indigenous models, the totem pole (see figure 16) and the house post, make an emphatic entrance. This is the first time that a relatively sacred object comes into the argillite tradition. The pipe panel and panel make their last meaningful appearance at this point. No Western-introduced object type is utilized to any great extent beyond this period.

The 1870s continue this trend toward the use of indigenous objects. The first flat house-post is popular in the early 1870s and the free-standing totem pole gains preference after about 1875. In the early 1880s, the number of object types again increased markedly, indicating, perhaps, that this phase of the argillite tradition is gaining momentum. The elaborately decorated ceremonial box makes a significant appearance at this time (figure 17). Carvings composed of multiple human figures find their most prevalent expression in the late 1880s, and by 1890 the pipe

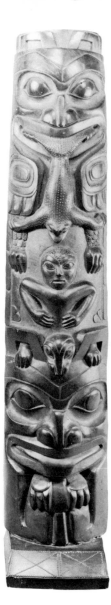

16. Argillite model totem pole, ca. 1870. (20 cm. tall).

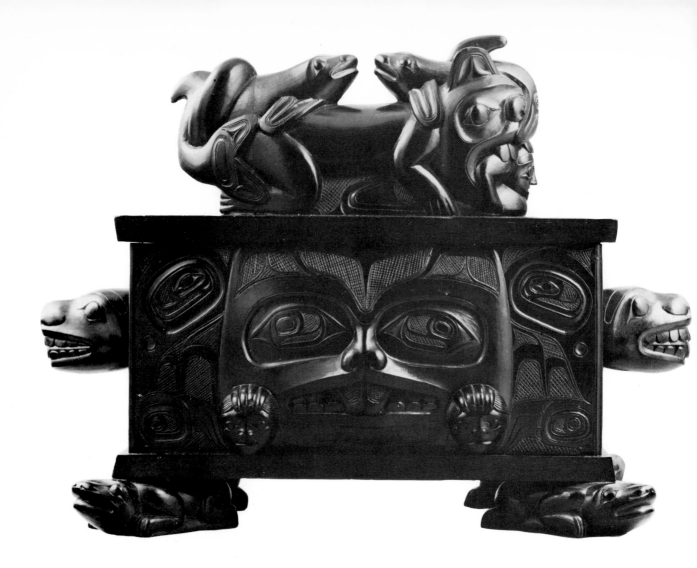

17. Haida argillite chest (copy) ca. 1880, with
Wasco on the lid, four frogs as legs, and
full-faced beaver on front panel (ca. 13 cm. high).

is being made again, this time with more elaborate decoration. Individual figures increase, whereas multiple figure groups decrease in popularity. The totem-pole model is favored until the end of the tradition, and even today. The years 1900–1910 depict a stabilization from the previous period in the manufacturing of figures and totem poles.

THE SIGNIFICANCE OF OBJECT TYPES MANUFACTURED

The types of object carved in argillite during the period of Haida acculturation are characteristic of the changes taking place within the society, thus showing that "art is a reflection of the culture." From the distribution of object choices it is evident that there are three main phases within the tradition: the first from about 1820 to 1830, the second from 1830 to 1865, and the third from about 1870 to 1910. The first phase is marked by a transference of the artistic activity to a new medium. Objects that are carved parallel those made in the more traditional wood carving. The turn to models of Western goods around 1830 is more revealing, and marks the second phase. Both Barbeau (1953) and Gunther (1956) interpret this as a response to the whalers in the area and to their scrimshaw carving. The influence of scrimshaw, however, cannot furnish a total explanation. Haida artists favored Western whole objects as types, and not just as occasional motives, suggesting that they were receptive to them and were perhaps undergoing

a change in social attitudes. If art reflects a preview of the future, then this second, or "Western," period may indicate a desire of the Haida to understand and make their own the Western way of things. This attitude, certainly, was prevalent in Haida society by 1870, when there was already a desire to "get out of the blanket" (Dawson 1880:161B). It seems unlikely that the consuming market, which consisted of more than just whalers, would demand objects of Western rather than Haida origin. The artists in both these two early "phases" carved objects that were profane in nature. Pipes of all types were not part of the sacred paraphernalia, and bowls, even when embellished with seemingly heraldic totems, were just utilitarian food bowls. Carvings from the second period were Western in source and therefore also secular.

The return to Haida sources around 1865 is perhaps more curious. Gunther (1956:152) sees this as a response to the decline of whaling in the area and to a stabilization of Haida society around 1870. But Haida society at this date was anything but stable: internal strife flared between remaining chiefs and subchiefs; disease and social mobility had depleted the home villages; missionary concepts began to filter in; and governmental controls became more stringent. Thus, the reversion to Haida symbols can hardly be viewed as indicative of internal stabilization. To understand this point, the nature of the argillite tradition must be understood. The working of argillite was part of Haida artistic activity, but the objects themselves were created for the external society. These objects, therefore, did not have

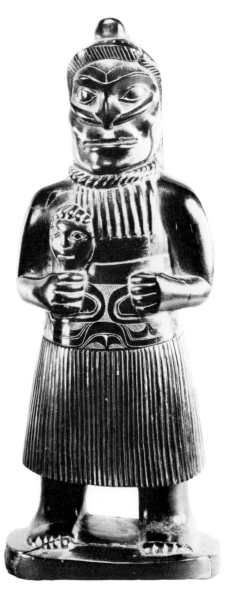

18. Figure of carved shaman holding rattle, ca. 1900? (25 cm. tall).

any internal social, ritual, or totemic function. Hence, objects, themes, and designs having any sacred relevance to the Haida were not translated into argillite until they had lost their revered significance. This view is further reinforced by the choice of object types manufactured in the later years of the tradition. By 1870, the Haida were carving model totem poles, and by 1900, ceremonial boxes with sacred designs and small figures of shamans (see figure 18). All these items were part of the intrinsic and sacred ritual. Shamans, indeed, had been the most esteemed members of Haida society; to depict them literally in a curio medium was to impugn their social significance, to say the least. Thus, this last period must reflect a loosening within the traditional social structure. The introduction of respected items into the argillite idiom hardly can be viewed as an indication of social stabilization.

CONTINUITY IN HAIDA ARGILLITE CARVING

Though the content of argillite carving changed, the activity itself has continued to the present day. After the disruptions of the last century a new stability descended on the Haida as a conquered semidependent minority group within Canadian society. Though fishing and logging were major occupations, a few men continued to carve part-time for the financial rewards and argillite carving itself became for outsiders a well-known ethnic marker of Haida Indians.

From 1910 through 1960, the souvenir mar-

ket was from time to time deluged with small totem poles (less than six inches) that formed the bulk of the argillite production; even for the creators, these constituted a most visible reminder of Northwest Coast Indian culture itself. These items were sold at relatively high prices in gift stores and galleries. Since 1960, due to an intense interest in revitalizing their own culture, along with the growing Pan-Indian consciousness and pride across North America, there has been a "renaissance" in Haida art. Twenty or so Haida, such as Ron Wilson—a most talented and innovative young artist at Skidegate—presently engage in argillite carving to supplement their incomes and maintain a tradition that was almost lost.

Because of the scarcity of stone and the difficulty of obtaining it, any object carved from argillite brings proportionately higher prices than art objects carved from other materials; the average price of argillite objects today is approximately "$40.00 an inch." Totem poles are still the most popular type of object made. Many of the young artists such as Ron, however, are concerned with creating total sculptures—perpetuating their Haida style through technical and expressive excellence rather than having it identified and tied to a specific Northwest Coast model. This intensive activity, comparable to the breakthrough of young Indian painters (Brody 1971; see also following chapter), indicates an optimistic future for Haida arts.

3. The Creative Consumer: Survival, Revival and Invention in Southwest Indian Arts

It is customary to think of art producers as the form-creators but art consumers also play a form-creative role, most obviously by accepting or rejecting art products. In the industrial, urban world, a network of institutions and individuals is interposed between producer and consumer—including museums, galleries, auction houses, publishers, and professional critics. Rather than being a third form-creating factor, this network acts as surrogate for the other two, and it is mainly through its agencies that information is exchanged between artist and audience. Less complex feedback mechanisms exist where producers and consumers live in the same small community as in some nonindustrial, nonurban societies. Information then is exchanged on a more personal and direct level. In both situations, the result of these ex-

J. J. Brody was awarded his Ph.D. in art history from the University of New Mexico, and is presently Director of the Maxwell Museum and Professor of Anthropology at the University of New Mexico, Albuquerque. He has done extensive research on the traditional art of the Indians of the Southwest and the Plains, and is particularly known for his book, *Indian Painters and White Patrons* (1971).

changes is to alter the forms, and perhaps the functions, of an art. To assume that form change in art results from historical forces or events is to acknowledge the creative effects of this interaction, for otherwise history is irrelevant to art production.

All modern, nonurban, nonindustrial societies have been more or less affected by the expanding industrial world, and their arts in consequence have been altered. At times, deliberate efforts have been made to preserve, conserve, revive, or otherwise assist art production in these societies. No matter how conservative their intentions, these efforts must further alter the patterns of interchange between artist and consumer, with sometimes radical effects on the target art forms (see, for instance, figure 19). For many reasons, these efforts can be expected to continue, therefore comparative data are badly needed to judge their results and assess or forecast their consequences.

Native arts of the American Southwest (see map 2) have been the focus of a variety of survival, revival, and preservation schemes

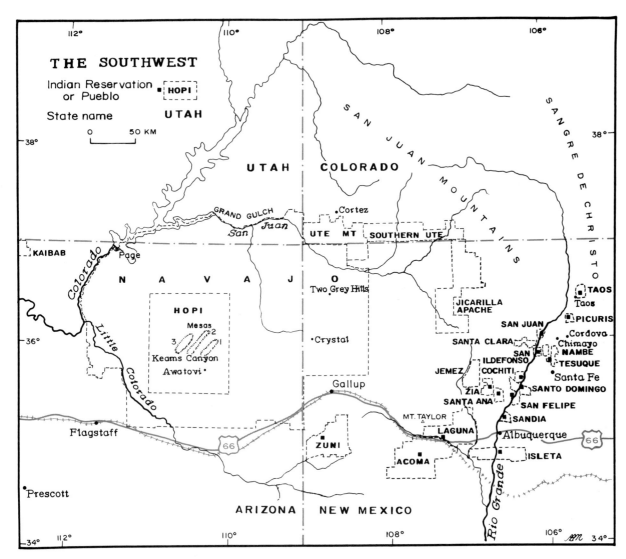

Map 2.

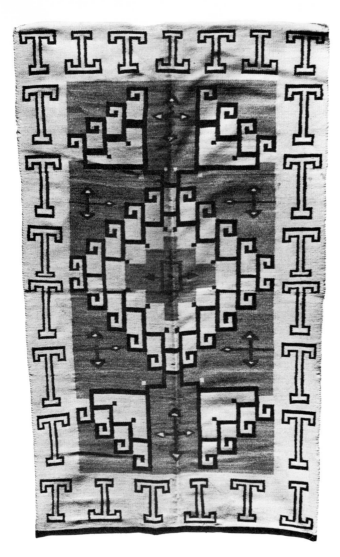

19. Moore Crystal Navajo blanket, handspun local wool, ca. 1915. T- and hook-shaped elements are typical of the period and, like many other aspects of twentieth-century Navajo textiles, were introduced by traders.

since about 1885. Studies of the affected regional arts rarely focus on the creative roles of the art consumers or their surrogates. Thus, they document history but tend not to analyze or to explain form change and therefore provide little useful comparative or predictive data. The brief historical reviews of the Southwestern art forms that follow—as well as the studies by Gill on Laguna ceramics and by Kent on Navajo and Pueblo weaving in this volume—are intended to demonstrate the potential value of consumer-oriented art studies as analytical and predictive tools.[1]

PUEBLO POTTERY

The Pueblo people of the American Southwest inherit a 2,000-year-old pottery-making tradition. Their ceramic products made during this time have mostly been containers for storage, cooking, or food-serving purposes. The low-fired local clays have been handformed, usually by women, and intended for use in the potters' own villages. The complexity of local and regional subtraditions is enormous, and every contemporary pottery-making village has its own unique ceramic history. Nonetheless, since certain characteristics have always transcended temporal and regional variants, valid generalizations about a Pueblo pottery tradition can be made.

[1]Originally Professor Brody had included a section on Navajo weaving in his draft chapter. This paralleled parts of Professor Kent's chapter so closely, however, that it was eliminated from Brody's chapter, the relevant photographs being incorporated into Chapter 4.

In the past, decorated pottery was either painted or had a surface texture. As techniques and technology were about the same everywhere, most of the many forms are variations of either of two basic shapes—a hemispherical bowl, or a globular jar. Aesthetic concern at most places and during most periods was with painted pottery, so the plastic and tactile values of clay were rarely intensively exploited. Painted decoration was usually linear and non-representational in black on a polished white or red slipped surface. The entire surface of a vessel was considered as a design field to be symmetrically and architectonically subdivided. Sectioned areas were usually filled with repeated motifs, each composed of a few linear geometric elements. Until the fifteenth century, with some notable exceptions, elements and motifs were usually nonsymbolic (figure 20).

Craft values varied greatly, ranging from the slovenly to mechanical precision. Small quantities of pottery were traded, usually between pottery-making towns of about equal capabilities. Thus the primary value of trade may have been aesthetic, and it germinated and cross-fertilized decorative ideas. With rare exceptions, all pottery was made by non-professional, part-time craftswomen for specific utilitarian purposes.

At the time of the sixteenth-century Spanish occupation of the region, there were hundreds of pottery-producing Pueblo towns. Regional and temporal variations made before then are easily recognized, but visual differences between places that shared a regional tradition are minimal, and those between potters of a single village are impossible to define.

20. Design of Classic Mimbres black-on-white bowl, star pattern.

From the sixteenth to the twentieth century, the number of Pueblos and their total populations radically declined, reaching a nadir in the nineteenth century. Pottery manufacture continued at most places, but differed sharply from past traditions. Design arrangements were less architectonic, lines tended to be loose and imprecise, and vessel forms were more elaborate and less elegant than in the past. There was increased use of dominant, nonrepeated motifs that were often representational or symbolic of native religion. Color became a positive, decorative element. Throughout these centuries, regional differences increased and some villages developed

their own peculiar and easily recognized decorative traditions.

By about 1885, railroad transport made cheap industrial goods available and metal or glazed china imports replaced handmade pottery articles, except for religious items and some specialized cooking and service wares. Depending on proximity to urban or rail centers, replacement occurred at different times, but the process was substantially completed before World War II. At the same time, the shift to a cash economy was hastened by the desire for those imports, so Pueblo people had to find means to convert their own manufactures and services into money. Handmade pottery became a marketable commodity, and before 1900, some Pueblos were selling almost their entire production for cash to white tourists. Potters found that sales were made more quickly and profitably if the goods were small and exotic, and that craft qualities were of little value to their unsophisticated customers. Thus, in many towns, the manufacture of serviceable pottery gave way to that of badly made, badly fired, cheap, and exotic articles.

A more sophisticated, art-oriented market was also developed. Before the turn of the century, at the First Mesa Hopi town of Hano, the potter Nampeyo taught herself first to imitate and then to elaborate on the forms and designs of a local prehistoric ware, Sikyatki Polychrome. Archaeologist J. Walter Fewkes encouraged Nampeyo, as did her husband, who worked as a laborer for Fewkes and brought examples of the pottery to her. The nearby trading post at Keams Canyon marketed her pottery to occasional retail customers and wholesaled greater quantities to shops in more favorable locations closer to tourist centers.

Sikyatki ware is among the finest and visually most striking of prehistoric Pueblo ceramics, and its decorative motifs are almost always symbolic. Marketing of Nampeyo's pottery was no doubt made easier because it was painted with representations of masked supernaturals and conventionalized bird wings and feathers. Keams could hope to attract fine-arts customers as well as those who might later learn to recognize and pay for superior craftsmanship. Within a decade Nampeyo's success, as measured by increased income, inspired potters in all of the Hopi towns to participate in a craft revival that continues to the present.

Each of the other Pueblo pottery-making survivals or revivals has its own peculiar history, all with important points of correspondence to and differences from the history of the revival of Navajo weaving (see chapter by Kent). Major distinctions occurred in the respective marketing systems. Because of weight and fragility, shipment of pottery is difficult and expensive, and neither Keams nor any other dealer was ever able to export quantities of it to coastal and midwestern urban centers with expectations of making large profits. These huge marketing areas, so successfully exploited by Moore, Cotton, and other dealers in Navajo textiles, were effectively closed to the pottery trade. Pottery dealers were further inhibited by their inability to discover new utilitarian purposes for the product, and by proximity of many craftswomen to diverse marketing centers and opportunities.

Navajo textiles could become floor cover-

ings, but Pueblo pottery containers have no appeal to utility-minded consumers of the urban-industrial society and are useless except as decorative objects. Meanwhile, Pueblo potters, especially those of the Rio Grande Valley, who were the most productive, could sell directly to consumers in the streets or at railroad stations, or indirectly through any of a number of competing dealers at nearby urban centers. Another important market available to them was at summer dances held in the various Pueblos. Potters from many towns brought wares to those dances, which attracted large audiences, and, in direct competition with each other, sold to the consumers. Finally, unlike Navajo Reservation weavers who were often difficult for tourist buyers to locate, most Pueblo potters were easily found and consumers went to their homes and made purchases from them there. The result of all this was that Pueblo potters more often established artist-patron relationships than artist-dealer ones, whereas the isolation of Navajo weavers made their dependence on specialized salesmen and traders inevitable.

Fewkes was only the first of many patrons. In almost every Pueblo that had an art-oriented pottery revival, an anthropologist, art collector, artist, or art-associated institution was involved. Most patronage centered around Santa Fe, New Mexico, with three institutions—the Museum of New Mexico, the School of American Research, and the Indian Arts Fund—the focal points. With so many of these also having antiquarian interests, the archaism first displayed by Nampeyo also characterized later revivals. At San Ildefonso, Santa Clara, San Juan, Acoma, and elsewhere,

21. Acoma black-on-white seed jar based on Mimbres design, by Anita Lowden, 1968 (ca. 18 cm. diameter).

artists, anthropologists, and museums made information and collections available to the potters that helped authenticate archaistic revivals (figure 21).

The art patrons were also largely responsible for dramatic changes in the social relationships of potters. Until the second decade of this century, with the possible exception of Nampeyo, potters were all nonprofessionals, anonymous outside their own communities, who gained no particular distinction through practice of their craft. At San Ildefonso Pueblo, between about 1910 and 1920, the potter **María Martínez** and her decorator husband Julian came to be isolated by art patrons as

prestigious personalities. With increasing frequency since then other potters at other towns have also found themselves the focus of special patronage. The most visible sign of acceptance by potters of their new role as artist/craftsmen first occurred in the 1920s, when María and Julian began to sign their products. Today, most potters sign their works, and, as in the art markets of the dominant society, signatures sometimes become as important as the art product in establishing monetary value.

An effect of this emphasis on personality has been to increase competition among potters and patrons both. It is probable that a certain low level of competition had always existed between potters, and also between villages, but this has intensified dramatically during the twentieth century. A factor in the intensification has been the competition that exists between patrons, who for their own reasons are anxious to promote particular potters or to play a creative role in a revival movement. The social consequences of this competition have been almost entirely negative, fragmenting village solidarity and establishing cliques centered about different potters.

Form changes in revival Pueblo pottery were generally more subtle than in Navajo weaving, possibly because the new function of pottery carried no particular form requirements. Reduced scale, great emphasis on mechanical perfection, and mathematically precise layouts characterize most of the many pottery traditions of the last eight decades. Archaic tendencies and heavy use of symbolic motifs have already been mentioned. Though

these characteristics are favored by art-oriented consumers, specific innovations more often than not have been suggested by the potters rather than their patrons, and market-testing is the mechanism through which innovations are filtered.

The greatest volume of Pueblo revival pottery has been sold to the casual tourist market. This market, however, has been a relatively minor influence during the last four or five decades, with tourist pieces recognized mainly by shoddy craftsmanship. Nonetheless, the existence of two market audiences has helped to foster community and individual specialization, with some towns and some potters designing its production for one or the other class of customer. The trend toward village specialization has also been reinforced by art collectors. When unable to afford a vessel made by a "name" artist, they often willingly buy from other potters of the same village, if the work conforms to a preconception of what pottery from that place is supposed to look like.

Although revival pottery is not, on the whole, far removed from Pueblo traditions, new market forces have been responsible for its very existence, for some formal changes, and for other, more fundamental changes in the attitudes of the potters toward their craft. Many potters now frankly and self-consciously produce art for an international market rather than utilitarian objects for a local one. Even though some of its social effects are negative, the value of the industry to the Pueblos is more than as an income producer. In a very real way, the survival of the craft symbolizes the survival of the people. Patrons

are interested in archaic patterns, but the potters' involvement with tradition is far more basic, conserving even those craft techniques whose effects are invisible and whose utility is obsolete.

INDIAN PAINTING OF THE SOUTHWEST

Other than on pottery, painting in the Southwest functioned mainly in ceremonial contexts, and with one exception survival of ancient pictorial traditions is in terms of ancient usage. The major pictorial arts of the region—Pueblo mural painting and Navajo sand-painting—have been insulated from foreign influences, and their modern consumer-producer relationships are essentially identical to those of preconquest times. Outsiders are not permitted to see Pueblo wall paintings and there are technical prohibitions to the recording of Navajo sand-paintings. The many copies that exist of the latter were generally made from memory, and because of differences in media, scale, and environment, are quite unlike the sacred pictures. Reproductions of these copies made for sale to outsiders are the only exception to the stability of traditional consumer-producer relationships noted above. Manufacture of these reproductions is an offshoot of the sand-painting tradition, but occurs independently of it, and feedback from non-Navajo consumers does not extend to the sacred paintings.

Since about 1910, many thousands of easel paintings have been made by Southwestern Indians of all tribes. With no ceremonial meanings and made for sale to non-Indians, these obviously are modern innovations, but their history differs in important respects from that of Navajo weaving or Pueblo pottery revivals. Whether easel painting developed as an offshoot of ancient pictorial traditions or independently of them is a critical question, for radically different interpretations of the phenomena depend on how it is answered. If nothing else, a discussion of Indian painting illustrates the importance of perception and perspective as factors in interpreting history.

The art has gone through three quite distinct phases, each overlapping with all of the others. The initial group of artists were self-taught young men from some of the northern Pueblos who made pictures with watercolors, ink, or crayons on paper. They were supported by consumer-patrons, mostly the rich or elite from around Santa Fe, New Mexico. There is not the slightest indication that any of their first easel paintings were made for Pueblo consumption. Most artists of this group were born in the last decade of the nineteenth century, and their art reached its maturity about the time they did, from about 1915 to about 1925. During the 1920s, there was a decline in creative vitality, and shortly thereafter a radical decline in quantity.

The second phase began in 1932, when formal instruction in painting was institutionalized at the Studio of the Santa Fe Indian School. Because it was a boarding school for all tribes, instruction there inevitably produced a pan-Indian art. As the first studio-trained painters were mostly born late in the second decade of this century, the creative apogee of the phase occurred about 1937,

22. Prehistoric mural painting from Awatovi
Kiva, Room 529.

when they were approaching physical maturity. Instruction in painting became standard at other Indian schools after about 1940, thereby perpetuating the opaque watercolor painting style of the Santa Fe Studio. Paintings of this phase were sold mostly to non-Indians, and curio shops became important marketing outlets for them.

The third phase is in many respects the most interesting and the most difficult to describe for it involves the art training of Indians at professional, nonsegregated schools, and resultant assimilation of international painting modes. It began about 1945, with some graduates of the Santa Fe Studio who had continued their education at universities, colleges, and professional art schools, but its effects were not felt until about 1960. Paintings of this phase are sold mostly to art collectors and are marketed through the normal fine arts distribution system of the dominant society. The tribal backgrounds of the painters are, of course, irrelevant to the forms of their art.

During the self-taught phase, artist-patron relationships were a major factor in defining both form and content of the pictures. Patrons often were identical to individuals and institutions simultaneously involved with pottery revivals, but their influence on picture-making was much more pervasive than on pottery. At first, the Indian artists worked in a naïve manner analogous to that of untutored artists of the dominant society, giving a Sunday-painter quality to some of their pictures. Their concern was to render images of perceived reality as precisely and illusionistically as possible. To this end they used a rough kind of linear perspective and attempted to model three-dimensional figures with light and shade.

Early paintings show figures in action vignetted against backgrounds that are devoid of environmental detail. In that respect, they are superficially like aboriginal Pueblo wall paintings in which perfectly flat figures are shown in perfectly flat, undetailed environments. The two-dimensional space of the murals, however, is absolutely consistent—objects interact with the space around them and there are no ambiguities that require viewers to imagine environmental details (figure 22). In contrast, the three-dimensional figures of Pueblo easel painting occur in non-dimensional ambiguous space that compels viewers to invent suitable environments for them. The difference is conceptual, demonstrating that rather than being translations of Pueblo pictorial traditions, the early easel paintings were experiments with the pictorial conventions of European art. This became explicit about 1920, when some of the artists pictured the environments in which their figures were placed. The spatial conceptions of these paintings are those of the Renaissance, and their exotic character is a function of both their subject matter and the inability of untrained artists of master novel and sophisticated conventions (figure 23).

For about a decade, most men at San Ildefonso Pueblo painted pictures at home in settings similar to those in which craft industries were conducted; some were also involved with the pottery revival as painter-decorators. At the other Pueblos, only a few people ever worked as painters, and in at least one town easel painting was forbidden. Elsewhere, neg-

23. Painting of women grinding corn, by Ma Pe
Wi of Zia Pueblo, ca. 1920 (ca. 60 cm. x 40 cm.).

ative attitudes convinced some artists to paint
their pictures in Santa Fe or some other urban
or tourist center rather than at home.

About 1918, and for several years there-
after, artists from several Pueblos and from
the Santa Fe Indian School made pictures in
studios provided for them at the Museum of
New Mexico. There, in the early twenties, an
archaistic style shift occurred that was an
intellectual retreat from the specific and volu-
metric realism of only a few years before. The
resultant paintings were flat, mannered, and
highly decorative. Some few painters contin-
ued to refine illusionistic pictorial techniques,
and the mode survived at Hopi and was later
revived at San Idefonso. By about 1935, most

artists of this generation had stopped working, and the San Ildefonso crafts analog disappeared.

Consumer-patrons were directly and indirectly responsible for defining the subject matter: illustrations of Pueblo dances or Pueblo genre scenes. Sales were promoted by patrons and patron institutions, and art exhibitions in museums became major publicizing and merchandizing devices. But since no permanent gallery or other art-dealer operated channel to a buying public was ever developed, painters generally sold their own works di-

rectly to consumers for modest sums. Prices were normally established in relation to the time it took to make a picture rather than to variations in pictorial quality. The absence of a sophisticated marketing system was crucial to keeping prices low and undifferentiated. Equality of prices meant that all paintings were of equal value; those offered to collectors were identical to those offered to tourists. The inevitable result was production of safe mediocrities. Low prices also meant that artists stopped painting whenever better economic opportunities—probably including Depres-

24. Painting typical of the Santa Fe Indian School Studio style; note the sentimental approach to an inherently violent scene. Navajo, artist unknown, ca. 1939 (72 cm. x 38 cm.).

sion years relief checks—came along. Toward the end of their employable lives, some artists of this generation returned to the practice of painting, much as retired doctors and postmen do, reinforcing the image of the entire phase as a group effort of highly specialized Sunday painters.

The young people introduced to art at the Santa Fe Indian School Studio from 1932 to 1937 went through an entirely different set of experiences. By 1935, these teenagers, with the encouragement of their teacher, Dorothy Dunn, had developed a pan-Indian pictorial manner that afterward became the traditional modern Indian mode. It is characterized by the flat application of decorative colors, by delicate lines delineating form and isolating color areas, and by subjects that are nostalgic and sentimental. Commonly, a few stylized plants or rocks symbolize a landscape in which is shown some highly idealized aspect of reservation life, or an imaginary and romantic ancient tribal activity (figure 24).

The Studio artists knew that they were supposed to produce works of art rather than curios, but as their pricing, marketing, and patronage systems were only slightly different from that of the earlier easel painters, the end result was much the same. Few developed relationships with individual patrons; all were promoted by institutional ones, including the Indian schools, regional museums, and Indian craft fairs; and some worked for urban and Reservation curio dealers and traders. Within a decade of its beginnings, the Studio tradition was devoted to the manufacture of decorative craft-curios. Some of the group, however, retained fine-art aspirations, and entered professional art schools in the years after World War II. Most of them completed their advanced studies by about 1955, and in the next decade revolutionized all earlier concepts about easel painting as an Indian art.

In 1962, the Institute of American Indian Arts was established at the Santa Fe Indian School to train young Indians from a variety of backgrounds for entry into university, college, and professional art schools. It made no pretense of being more than a preparatory institution, tacit recognition that professional artists are highly specialized craftsmen who receive their training at highly specialized institutions. It also acknowledged the unpleasant reality that many are called but few are chosen. Drop-outs were to be expected and no more than a few of its students could hope to succeed as professional creative painters. Its faculty included some Indians who had been trained at professional art schools; their success as mainstream artists and that of other Indians who received professional art training defines the phase. In it, paintings by Indians are fully integrated as an urban-industrial art and are marketed in the same manner and through the same agencies that act as surrogates for other international artists.

Except for a few years at San Ildefonso Pueblo, Indian easel painting was always a nontribal art with only the most tenuous roots in any tribal art system. Produced for urban-industrial consumers, even in its first phase, it was mostly made in urban environments. During its second phase, it was fostered by non-Indian institutions overtly or covertly devoted to integrating Indians into the dominant society. Its patrons expected it to be

a fine art, but since it was marketed like a curio, its products soon became nothing more than curios. It was assumed to be tribal, but as it developed in nontribal, antitribal, or pan-Indian environments, its forms could never be anything but nontribal, antitribal, or pan-Indian. If ever an art can be described as schizoid, it was Indian easel painting until it reached its most recent phase. In this phase, the problems cease to exist: it has no style, manner, tradition, or anything else that identifies it as Indian; the artists simply happen to be Indian.

CONCLUSIONS

Two of the three major art forms of the Southwest that we have considered, Navajo weaving and Pueblo pottery, have been economically and aesthetically successful during their revival periods. Both survived within tribal contexts as extensions of ancient traditions, and their revivals depended on development of new audiences at about the time that the craft products became obsolete within the Indian communities. Forms and functions were redefined, new marketing systems evolved, and economic production motives replaced the utilitarian ones of the past. Their potential exchange value made craft products particularly important during periods of transition to a cash economy. Economic considerations remain a survival factor, but admiration by outsiders also is of great value to the producers and their communities. The objects are given symbolic importance as links to the past, evidence of present vitality, and, as prices spiral upward, as suggestions that the future holds something more than mere survival.

Despite some radical formal changes in both crafts, technological traditions and artisan training systems within the respective communities remain stable. Thus, production continues in organic relationship with the whole of each society. For that reason, these crafts may survive current trends toward specialized production for art consumers at the expense of market variety. If the trends continue, they will disrupt marketing procedures and consumer-producer relationships. Since these have differed all along, even though the two crafts have had parallel success, it is obvious that not all of their details are necessary to vitality. Points of similarity that are of critical value should be isolated and examined.

First, both traditions were still active at the time of transition to a cash economy. Numbers of artisans at scattered locations were therefore able to market-test varieties of new forms and new products at little cost in time or energy. Even though innovative failures probably outnumbered successes, sheer numbers mitigated against any one failure being of excessive importance. Thus, low-cost, experimental, and market-testing opportunities were available in both cases.

Second, positive responses to different experiments had the result of creating several markets for each craft. Each market had its own specialized products, aesthetic, sales system, and pricing system. This variety guaranteed artisans ample opportunities to develop their skills in any of several alternative direc-

tions. It also was a guarantee of continuous critical evaluation at several levels, thus stimulating all artisans regardless of their market aspirations.

Third, each craft had fine-arts consumers as one of its market forces. Potters communicated with them through the agency of patrons, and weavers through that of dealers, but the effects were much the same. Because of market variety, fine-arts consumers could get the quality they desired only by offering **high prices, and a corollary was established** between high aesthetic and high economic values. The fine-arts focus was essential to establishing aesthetic and critical guidelines. By raising prices, and through its elitist implications, it also confirmed the positive symbolic value of craft products to the Indian communities.

The points of similarity are: (1) an organic relationship between craft production and tribal communities; (2) positive symbolic value of craft products to the Indian communities; (3) market-testing with a variety of formal and functional experiments; (4) pools of trained artisans in several different marketing regions; (5) a variety of consumer markets, including a fine-arts, standard-setting component; and (6) correlation between product quality and price differentials. The importance of all or most of these factors can only be emphasized by comparison with the far less successful easel painting industries.

Easel painting had no organic roots in any of the tribal communities to which the artists belonged. In its first phase, the pool of artists was small and clustered in one market area. Painters were inexperienced, therefore their investment of time and energy was high and opportunities for experimentation were limited. There was consumer variety with a fine-arts component, but since qualitative differences were not correlated with price differences, it was an ineffective creative stimulant. Some factors changed in later years, but the pattern was established and hard to break. Among the obvious changes, the expansion in the number of producers during the institutional phase merely emphasized the nontribal nature of the art.

Fine-art consumers formed a larger proportion of the easel-painting audience than of either of the crafts, therefore their inability to act as creative stimulants to the painters requires further explanation. Indian easel painting was a simulacrum of a specialized, expensive, luxury product of the urban-industrial society, but it had no equivalent marketing or prestige-creating institutions. Did its patrons lose credibility and unconsciously denigrate the art by insisting on its equality, despite the evidence of grossly unequal monetary values, and by supporting segregated—and therefore second-class—promotional activities? If it was not tribal, and not greatly valued by its patrons, the art could have had no value to the Indian communities beyond whatever income it brought to them. In that event, full integration by third-phase artists was the only logical and sensible course for them to take if they wanted to make art.

4. Pueblo and Navajo Weaving Traditions and the Western World

Kate Peck Kent

Since the seventeenth century, the American Southwest has been the scene of interaction between three weaving traditions—Pueblo, Rio Grande Colonial, and Navajo—all subject, after 1850, to influences from the Anglo-American world. In this chapter, we will explore the differing rates and types of change in the two Indian traditions under acculturative pressures. Some knowledge of the position of Rio Grande weaving (a folk art), however, is necessary to an understanding of the events involved.

The "Southwest" is here defined, roughly, as Arizona and New Mexico, with adjacent parts of southeastern Utah and southwestern Colorado. The Pueblo Indians represent descendants of the indigenous inhabitants (re-

Kate Peck Kent did her graduate work in anthropology at the University of Arizona and is now Professor of Anthropology at the University of Denver. She has done extensive research among the Indians of the Southwest and is well known for her many authoritative publications on their textiles, especially the *Story of Navajo Weaving* (1961). In the past decade, she has done additional field research on textiles in West Africa and made fruitful comparisons of the two subcontinental traditions in her paper for the Advanced Seminar on Contemporary Developments in Folk Arts in Santa Fe (1973).

ferred to as the Anasazi) of the northern part of this area, who were established in farming villages when the Spanish entered the upper Rio Grande Valley. These villages of mud-walled houses were, with some differences, situated in the same locations as those indicated on map 2.

"Rio Grande Colonial" refers to Spanish-speaking colonists from Mexico who took control of the Rio Grande Valley and the surrounding area after 1540. They were driven out by the rebellious Pueblo people in 1680, but returned in 1692, to remain in power until the United States took over in 1846.

There is no solid evidence for Navajo presence in the Southwest before 1500 A.D., when they appear to have entered northwestern New Mexico (Carlson 1965:97–101). Related linguistically to the Athapaskan peoples of the sub-Arctic, and, more closely, to the Apache of the Southwest, the Navajo probably came as simple hunting bands; early Spanish chronicles fail to distinguish between the Navajo and the Apache. Contacting the Puebloans, they adopted agriculture and many new

25. Prehistoric black-and-white painted cotton blanket from Hidden House, Verde Valley, Arizona (ca. 1250 A.D., 162 cm. x 148 cm.). The larger dimension of this piece, as in the case of modern traditional Pueblo shoulder blankets, runs with the wefts. Both the shape and the complex design should be compared with the Hopi rug illustrated in figure 26b.

tional single-family earth lodges, or hogans, scattered widely so that they could be near their small fields of corn and flocks of sheep.

THE HISTORY OF WEAVING TRADITIONS

The Mingling of the Three Traditions, 1540–1850

Of the three weaving traditions under consideration, that of the Pueblo Indians is the only one truly indigenous to the Americas. It is part of a New World industry of great antiquity that spread from Peru throughout Central America and Mexico to northern Utah. Based on the use of cotton and the true loom, this complex reached the Southwest about the time of Christ, having originated perhaps in Northern Peru, two to three thousand years before that time. Introduced into the Four Corners Area by at least 500 A.D., the new fiber and tools blended with the preexisting, non-loom textile arts of the Anasazi, modifying and expanding them. Enough archeological material remains to establish that regional differences in technique and style had developed by 1450 (see figure 25). There was a wide range of highly decorative, complex weaves and patterns. Murals in the Hopi town of Awatovi (see figure 22) show that just prior to Spanish intervention, textiles in that area had undergone considerable change through southern influences, leading to marked elaboration of design, at least in ceremonial costuming. These influences probably stemmed from Casas Grandes in what is now northern Chihuahua. Early Spanish statements indicate that the

customs. After the introduction of sheep by the Spanish, these too were added to their cultural inventory, so that they became the semisedentary "pastoral horticulturalists" of historic times. They did not adopt the village community pattern, or house-type of the Puebloans, preferring to maintain their tradi-

Hopi towns may have been a major source of supply of cotton fiber and woven cloth for the Rio Grande Pueblos, supplementing the weaving done there (Jones 1936:51–52; Kent 1957).

Impinging on this Pueblo craft after 1540—most strongly in the Rio Grande Valley—were the influences brought by Spanish-speaking settlers from Mexico. These people brought the European spinning wheel and the treadle loom. More significantly, they introduced sheep, so that a new fiber became available, and, along with this, indigo blue and possibly other dyes imported from Mexico. A fragment of knitted wool textile from a cliff ruin in Frijoles Canyon that had been reoccupied by Pueblo refugees from the Spanish after the 1680 rebellion, indicates that this particular European technique had been taught to the Indians before that time. Floral patterns may have been adopted in the seventeenth century. It is probable also that the Spanish taught the Puebloans to weave the long, narrow blankets they preferred rather than the traditional "square" Pueblo shoulder blankets, thus introducing a completely nontraditional form. Not only the shape, but also the plain-weave tapestry technique, in which warps are completely concealed by wefts, were new to blankets. Elaborately patterned, plain-weave, and twill tapestry articles are found prehistorically, but, with one exception, they are small. Blankets were usually of an open plain weave or twill in which warp and weft may both be seen. The exception is a twill tapestry weave blanket from Grand Gulch, Utah (Kent 1957:547).

Added to these direct, material influences was a social phenomenon of some importance—the exploitation of Indian weavers through a system of forced labor. Quantities of cloth, demanded as tribute to the Spanish Crown, were sent annually from the Rio Grande Valley south to New Spain. Although this certainly increased the volume of weaving among the seventeenth-century Rio Grande Pueblos, it was an enforced, artificial increase that did not benefit the people economically or in any other way. With the return of the Spanish to the valley, after the rebellion, eastern Pueblo culture was again hard pressed. The population declined sharply (Spicer 1962:152–168), and weaving, consequently, must have decreased rapidly in importance. By 1846, when the United States moved in, the people were probably making only some articles of clothing for themselves and a few Spanish-type blankets for sale or trade.

A number of factors other than general cultural demoralization were probably involved in this early demise of Rio Grande weaving. For one thing, the art may never have occupied as central a position in the lives of the people there as it did among the Hopi. The need for traditional articles could have been met by reinforcing the patterns of trade with the Hopi, and to a lesser extent the Zuni, that had been established in pre-Spanish times. Stevenson reports that as recently as 1879:

> . . . the manufacture of cotton embroidered ceremonial blankets, dance kilts and sashes of the same material, white cotton blankets with red and blue borders, worn principally by women, women's black diagonal cloth dresses and wraps of same, and women's belts was a great industry among the Hopi Indians. The trading of

these articles to all the Pueblo tribes from Taos to Isleta dates so far back that there is no knowledge handed down of the time when the Hopi goods were first introduced among the other Pueblos. The Zuni, too, although perhaps their trading was not to be mentioned in comparison with the Hopi, carried the women's dresses, wraps and belts to Taos and the other villages (p. 118).

European cloth was readily adopted for everyday wear when it became available in the late 1700s and 1800s. Navajo weaving, too, represented a growing local source of supply after 1700. "The virtual cessation of Navajo-Spanish warfare had an important effect upon intertribal relations. It stimulated trading between the Navajo and the 'Christianized' Pueblos as well as the Spanish. A number of the testimonies mention extensive commercial activities with the above peoples. The primary Navajo trade articles consisted of woven woolen blankets, baskets, and buckskins" (Hill 1940:397).

The western Pueblos, Zuni, and the Hopi towns, after initial bitter skirmishes with the Spanish, were left relatively free to go their own way. Weaving, as well as other cultural forms, retained its vitality into the early 1900s at Zuni, and is still important among the Hopi. Elaborate embroidery with wool yarns replaced pre-Spanish fancy weaves such as weft-wrap openwork, brocade, and twill tapestry. Some of the traditional designs and motifs were perpetuated in this new technique, and floral patterns were added at Acoma and Zuni, probably owing to mission influence. For some reason, weaving shifted to the hands of women at Zuni Pueblo, and the European reed-heddle was adopted for weaving belts.

In the Hopi towns, a new wrapping technique called "Hopi brocade" was employed for decorating the ends of dance sashes with colored wool yarns. Either an original invention or one based on prehistoric weft-wrap, this technique is similar to the process hand-loom weavers know as "soumak" (Douglas 1938).

In brief, by 1850 wool had replaced cotton in many textiles; certain prehistoric techniques had died out; indigo, cochineal, and bayeta[1] had been accepted; and there was a trend toward the use of European cloth for everyday clothing, especially among the men. As in the case of the eastern Pueblos, crocheting and knitting early replaced the finger weaves—looping, twine-plaiting, and one form of braiding—that were used prehistorically in the manufacture of footwear, bags, and openwork shirts. Spanish-type blankets were woven for home use and trade at both the Zuni and Hopi Pueblos, but on the whole the articles woven were essentially the same as those first seen by the Spanish.

We know little of Rio Grande Colonial weaving from 1540 to 1850 as nothing has survived the ravages of time. According to historic documents, the people wove wearing blankets, floor coverings, and plain, coarse homespun for clothing, mattress covers, and other articles (Boyd 1959:16–20). Their dyes were imported from Mexico, although local

[1]*Bayeta* is the Spanish name for a cloth of English manufacture—baize—that was brought into the Southwest via Mexico and traded by the piece to the Indians. Red bayeta, in particular, was ravelled and the threads retwisted for weaving yarns.

plant resources may have been explored. Colonists supplemented their own production with Pueblo-woven mantas and blankets at first, and by the mid-1700's, with purchases from the Navajo. An effort was made to upgrade the quality of Rio Grande weaving in 1805, when the Bazan brothers were sent from Mexico to Santa Fe to teach improved methods and apparently to further the use of cotton (Boyd 1964:23). Yard goods were imported from Chihuahua in growing amounts after 1800.

And, finally, what of our third weaving tradition? "Navajo" and "weaving" are practically synonymous in the minds of collectors and many students of the Southwest, yet the art was adopted relatively recently by them. It is an "innovation," if one views New World weaving in long-term perspective. Few will argue, however, if we consider it a "traditional" art. Certainly, in spite of its strongly assimilative character, there *is* a distinctive, recognizably Navajo style of weaving.

The Navajo probably did not begin to weave until after 1700, when they had the opportunity of learning the skill from Rio Grande Puebloans who moved into the Gobernador area to escape Spanish reprisals following the Pueblo revolt. The two peoples lived together in "refugee" sites for about two decades, long enough for Navajo women to become well versed in the weaving of articles they formerly must have acquired through trade with the Pueblo—striped shoulder blankets, men's shirts, breechcloths, knit socks, and belts. Rather than adopting the one-piece blanket dress of the Pueblos, the women invented their own style, consisting of a front and back panel, caught at the shoulders, and held at the waist by a belt.

In aboriginal times, Pueblo weaving was a masculine social activity that took place within the confines of specialized rooms that were at other times used for important ritual events. The vertical looms were easily put up or taken down, but were not usually transported from place to place. In contrast, Navajo weaving was a more-or-less solitary female activity that often took place outdoors, whenever and wherever available time coincided with a desire to weave. The looms were treated as fully portable tools, to be moved as often as necessary. Among both groups, the craft was taught to young people of the appropriate sex in the ordinary course of events.

Cotton, embroidery, and certain other techniques were not adopted by the Navajo, but the few scraps of woolen cloth that survive from the early nineteenth century indicate that Navajo and Pueblo weaving in wool were almost identical. This means the Navajo had indigo and probably cochineal and access to bayeta, which could be unravelled for yarn.

Almost immediately, the Navajo began to weave surplus blankets for trade to the Spanish, Pueblo, and other Indians (Hill 1940:400–413).

Navajo-Rio Grande weaving traditions blended most strongly in the first half of the 1880s, when Indian women, taken as slaves, adapted the design ideas and colors of their Spanish-speaking captors to their own looms.

Although each tradition remained distinctive in some respects, Pueblo, Navajo and Spanish *all* wove the long, rectangular blankets, which we have stated to be a non-Indian

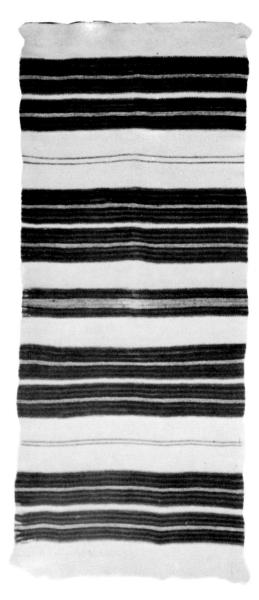

26a. Rio Grande Colonial blanket probably woven around 1870. Handspun wool; indigo blue, natural brown and white (102 cm. x 232 cm.).

26b. Modern Hopi rug. Handspun wool; natural gray, brown and white, vegetable-dyed yellow, tan blue and green. Woven in 1963 by Sequoptewa, Hotevilla (95 cm. x 146 cm.). The shape, sober striped pattern and use of indigo blue all show Spanish influence.

form introduced into the Southwest from Europe via Mexico. These blankets met in the marketplace, and it is remarkable how similar many are in appearance until about 1875; a thorough understanding of the technical idiosyncracies of all three industries is needed to distinguish any given blanket's maker.

All groups produced two qualities—lightweight wearing blankets, and coarse, heavy blankets, probably for bedding. The latter

were simply, sometimes sparingly, adorned with stripes—often just natural white, black, or brown. Called *di-yu-ge* by the Navajo, this coarse type was later (by 1890) modified into floor rugs for tourist sale. Lightweight wearing blankets were patterned in two ways. In some, wide, white bands alternated with design bands, each containing several narrow, colored stripes. Colors are black, brown or indigo blue, with a sparing use of red. The second style, patterned in very narrow stripes of the same colors, is called the "Moqui" (i.e., Hopi) pattern, early traders apparently having credited these (or the style itself) to the Hopi. Both patterns have been carried over into twentieth century rugs, with the same conservative color set, among the Hopi. Coarse saddle blankets were also woven, an art that persists and has led to the development of twill weaving (figure 26b).

Diverging Traditions, 1850–1971

Rio Grande weaving: From the mid-nineteenth century until the present the three weaving traditions have diverged with increasing sharpness. Rio Grande weaving need no longer engage our attention, as its influence on Indian work was shortly replaced by a number of new factors. It should be pointed out, however, that largely because the same new commercial aniline dyes and Germantown yarns were available to all three peoples, many of their blankets continued to be very similar in appearance until the end of the century (see figure 26a). The designing of blankets with a central diamond was probably introduced from Mexico via Rio Grande weavers in the 1860s. Rio Grande artisans

wove for their own people into the twentieth century, but their craft is carried on now only in Chimayo, New Mexico, as a resource for discriminating tourists.

Pueblo weaving: A survey of weaving at the Rio Grande Pueblo in 1939 shows that very little was done after the 1880s. By that time, "Pueblo weaving had begun to decline in general because of the coming of the Rio Grande and Santa Fe railroads and the introduction of commercial cloth by them to the Indians" (Douglas 1940:175). A few simple belts are still made for sale to tourists, and traditional embroidery patterns are worked on machine-woven cloth—some for dance costumes, and some as tourist articles. A *few* crotcheted leggings and shirts are also made.

Zuni weaving is a thing of the past, though enough was being done in 1916 for Spier to record the making of dresses and belts. Some embroidered dance mantas were made in the early thirties and there are plain-striped, heavy, tapestry-weave blankets—probably intended for rugs—from Zuni in the Taylor Museum collections in Colorado Springs. These, judging from yarns and dyes, may have been woven quite recently—perhaps in the early thirties. One wonders how much of the weaving at Zuni in the twentieth century should be credited to the Hopi, in view of Spier's remarks that, "I found no men who were weaving or who had woven, yet several blankets were purchased which were said to have been woven by old men.—I am not certain that the men referred to were not Hopi residents of Zuni.—It is interesting to know the Zuni attitude toward Hopi weavers resident at Zuni" (Spier 1924:190).

The manufacture of many traditional articles continues among the Hopi (figure 27b). These include the "big" sash, or rain sash, the "maiden's shawl," with red and blue borders, embroidered dance kilts, brocaded dance sashes, white cotton blankets with embroidered borders, hair ties, garters, belts, a few plaid or check man's shoulder blankets, and a few narrow-braided belts worn by boys at their initiation. No black dresses were noted this year at the Hopi Craftsman Show. In 1942, there were about two hundred weavers. In 1970 there were an estimated twenty. The art is traditionally practiced by older men and those men unable to work in the fields.

Much Hopi weaving goes to the Zuni and to the Rio Grande Pueblos for ceremonial use, as it did in the remote and recent past.[2] The practice of weaving traditional items with an eye to selling them to white buyers does not appear to have operated as a factor in their survival. With the exception of the brocade dance sash—modified to be suitable as a table runner—few concessions were made to white taste (see figure 27a). An analysis by Dr. Alfred Whiting (1942) of sales at the Hopi Craftsman Show, Museum of Northern Arizona, Flagstaff, for 1931–1941 shows that very few purchases were made by nonprofessional museum visitors. Much of the material put on display at these shows was marked "not for sale" by the owners. There seemed to be a desire to compete for awards, but not to sell.

[2]According to a letter from Dr. Alfred Whiting (25 September 1970), the market is "to a considerable extent internal, to satisfy ritual needs." This observation is confirmed by Edward B. Danson (8 September 1970): "There are Hopi who make their living or part of it weaving and selling their products to the Rio Grande Pueblos who no longer do this work."

27a. "Brocade" table runner (33.5 cm. x 118 cm.). Woven for tourist sale in 1940, this represents one of the few modifications of traditional textiles undertaken by the Hopi. Brocading is traditionally done on the ends of the long narrow two-piece dance sash. The technique, aniline-dyed commercial wool thread and cotton twine warps are post-Spanish.

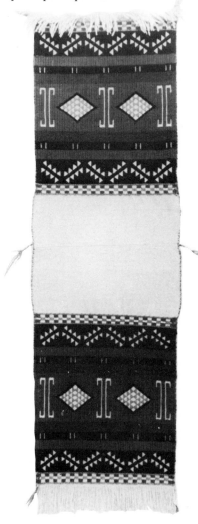

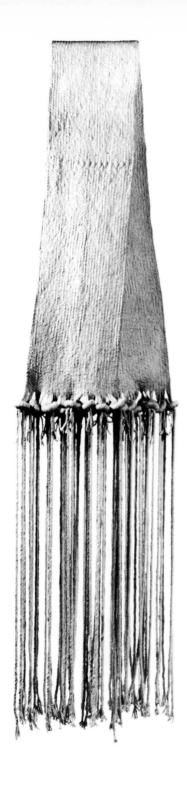

The *non*traditional Spanish-type blankets woven by the Hopi in the 1800s were converted to rugs to meet the demands of the white market probably before 1900, as in the case of the Navajo. They never exhibited the complex designs or riotous color combinations of Navajo rugs. Hopi weavers employed by the Harvey House at the Grand Canyon did make "Navajo-style" rugs for sale, but apparently did little experimentation on their own, except for weaving kachina masks into a few small rugs. Most of their work is characterized by the sober stripe patterns of the mid-nineteenth century (figure 26b). The last *rug*-weaver is an old man, blind and feeble. When he dies, it is problematical if anyone else will take over the weaving of this nontraditional class of textiles.

The quality of weaving as a whole, and of rug dyes, was influenced by the efforts of Mary-Russell F. Colton and the Museum of Northern Arizona after 1929. Mrs. Colton encouraged the use of natural indigo and local vegetable dyes. The museum instituted the Hopi Craftsman Show where the best of Hopi arts were collected for display and sale.

It is possible, of course, that with the rising tide of tourism in their country, the Hopi may capitalize on their skills and begin to exploit the market either by innovating, which seems unlikely in view of the record, or by weaving more traditional items for sale to non-Indians. As Whiting (personal communication) says, the appearance of narrow braided initiation sashes on the market this year may signal the

27b. White cotton frame-braided Hopi "wedding sash," 19th century (260 cm. length).

start of this trend. Dr. Wheat's account (personal communication) of recent tourist offerings in the summer of 1970, apart from the Hopi Craftsman Show, is not encouraging. According to him, only one maiden's shawl was brought into Keam's Canyon for sale. This appeared to be an old one, not of recent manufacture. Only four kilts, three poorly woven, were sent to Watson's Trading Post at Cortez. There were two rain belts, woven—not braided—of commercial cotton twine. Most of the Hopi-style belts handled at Cortez were Navajo-made. Other traders report a similar lack of good Hopi textiles in recent years. There were only fifteen Pueblo textile entries at the Gallup Ceremonial Crafts Show this summer (1970) and the class will probably be discontinued. By the *end* of the summer (and therefore perhaps not diagnostic) the Hopi craft shop on Second Mesa contained two women's black dresses made from trade cloth and two poorly woven kilts.

The Navajo tradition: Shortly after the United States moved into the Southwest, the Navajo, who had been harrassing Rio Grande and Pueblo people, were rounded up and sent to Bosque Redondo at Fort Sumner in central New Mexico, where they were kept from 1863 to 1868. The effects of this traumatic experience on the textile arts were many-fold. The weaving of clothing for their own use virtually ceased at this time. The blanket-dress was replaced, to a great extent, by the long, full, cotton skirt worn by white women during the Civil War era. Factory-made Pendleton blankets replaced the native-woven shoulder blankets. Saddle girths, saddle blankets, knit stockings, and belts were still made for the

native market, but the increasing awareness of the white world, coupled with the extreme poverty faced after their return to the Northern Arizona Reservation, combined to orient the women towards weaving for sale. It was also in this relocation period that the Navajo learned from Mexicans the silversmithing for which they are famous (Adair 1944).

In 1881, with the coming of rail transportation, and under the growing influence of white traders, the Anglo-American market was opened wide to Navajo textiles. Aniline dyes and commercial yarns became available in quantity, with profound effect on the appearance of textiles. Indeed, the years since 1881 have seen so many modifications in design style and character that contemporary rugs and the classic blankets of the early nineteenth century must be recognized as the work of the same people, chiefly on the basis of technical characteristics stemming from handspinning and various processes associated with vertical-loom weaving.

The history of all these changes to 1930 has been told in detail by Amsden (1934) and updated in semipopular pamphlets by Dutton (1961), Kent (1961), and Maxwell (1963). Only a few essentials have been repeated here. Major changes can be assigned to three sources: innovation by Indian weavers, trader influence, and the interest of various "friends of Navajo weaving" (see figure 19 above).

Innovations by Weavers

The general impetus for style changes in Navajo blankets and rugs seems to have been—and to be—"weave to please your public." The wishes of the "public" have been

mediated to the Navajo by traders concerned with promoting things that would sell. One tends to overlook the fact that, even as they met the demands of the market, certain weavers were highly innovative. Between 1870 and 1890, for example, wedge weave and two-faced weave were "invented" and more twills were woven; experimentation with aniline dyes and Germantown yarns led to wild new color combinations; and some women expressed their fascination with their changing world and their medium itself by weaving pictorial blankets—featuring railroad cars, letters, American flags, and other new items. Although the idea of weaving figures into blankets goes back at least to 1864 (Mera 1948), it didn't really take hold until the 1880s. By the early 1900s *yei*, or Navajo deities, were woven into rugs against strong tribal opposition (James 1920:139–140). In the 1920s, a Navajo medicine man, Hosteen Klah, himself a weaver, wove the first of the sand-painting blankets (Maxwell 1963:47). At present, picture rugs and wall hangings are extremely popular, and include regular compositions (figure 28).

Those who have worked closely with the Navajo insist that, in spite of the fact that economic gain is the major reason given by women for pursuing the craft, "income is not separate from enjoyment" (Mills 1959:63). Reichard's intimate portrayals of Red Point's family (1934, 1936) certainly leave one with the impression that the women were deeply interested in their work:

> Handcraftsmanship must be reckoned not only in dollars and cents but also in satisfaction. There is something about making a beautiful object which cannot be measured tangibly.

28. A Navajo rug, showing the recent practice of composing a picture in weaving, 1960s.

> There is no doubt that the weavers feel this. I sincerely believe that Atlnaba and Maria Antonia would weave if they never received a cent for their blankets. Their artisanship is to them a pride and a joy. They try to get as much money as they can for it, but that is a matter distinct from their aesthetic reward (Reichard 1936:187).

The proportion of creative artists among Navajo weavers is hard to assess, since new ideas that don't sell don't survive. I suspect that a great many weavers do enjoy playing with their technique. Mills gives the example of a woman near Rim Rock in 1951:

> Many weavers said they do not repeat designs, and look forward to experimenting with color and composition. . . . One of her blankets had a pair of cowboy boots in each corner with "boots" spelled out. In the center was the inscription, La Pena, New Mexico. She did this, I believe, despite the trader's disapproval. Betty made a saddleblanket with a rounded end, like a manufactured saddle pad, that had to be finished with a special binding (Mills 1959:65).

Perhaps one should consider Navajo eclecticism—the willingness to change, to adopt new ideas and materials, to meet new demands—as a form of creativity, rather than expediency.

Trader Influence

Trader influence was especially marked after 1890. It brought about the shift from blanket to rug, discouraged the use of non-Indian Germantown yarns and cotton-twine warp, encouraged the use of better-quality handspun work, and outlawed certain garish colors.

Two especially significant examples of the far-reaching character of these influences should be at least briefly noted: that of John Lorenzo Hubbell of Ganado and Keams Canyon, and that of J. B. Moore of Crystal, New Mexico, and his successor, A. J. Molohon.

Lorenzo Hubbell, in the early 1900s, had about three hundred women weaving for him who made rugs to order. In 1920, a spectacular rug, 24 by 36 feet in size, and allegedly produced by four weavers working four years, was woven at Ganado (Morrall 1971:32). Weavers were encouraged to reproduce the patterns displayed as paintings in the Ganado Trading Post. These, for the most part, were genuinely Navajo in style. Hubbell also encouraged, in somewhat modified forms, the revival of certain classic types, such as the man's shoulder blanket (the "chief" blanket), the Moqui-pattern blanket, and the woman's dress with red border; these were woven with Germantown yarns. He published in 1902 a catalog of prices and styles for circulation in the East. In the twenties and thirties, many dealers simply ordered the types of rugs they felt would sell from a set of plates supplied them by Hubbell.

The influence of J. B. Moore and his successor, A. J. Molohon, at the old trading post of Crystal, New Mexico, between 1897 and 1911 followed an entirely different tack. They introduced complex new non-Navajo designs, probably partly inspired by Oriental rug patterns. Hubbell employed the artist E. A. Burbank to design a series of rug patterns to be copied. These factors may underlie the currently popular Two Gray Hills rugs marketed through Ship Rock, and probably the design known as the "storm pattern" that is now a specialty in the Tuba City region to the west (James 1920:figures 203, 217, 231, and others). Moore is probably also responsible for encouraging the weaving of solid borders enclosing the design and of the use of natural gray, black, white, and brown colors. He developed a vigorous mail-order clientele, es-

pecially after the publication of a full-color catalogue in 1911.

Influences of the "Friends of Navajo art"

There have been many efforts, especially since 1920, by connoisseurs, discriminating collectors, and certain intelligent government officials to improve the quality of yarns and dyes and to upgrade Navajo weaving in general, with the idea of keeping it alive and salable. These efforts were made *with*, not *exerted upon*, the Indian weavers. The increasingly widespread use of vegetable dyes bears witness to the success of some of these efforts, as does the emphasis on simple stripe or banded patterns, like those of the first three-quarters of the nineteenth century, which appear in the Crystal, Wide Ruin, and Chinlee section of the Reservation.

Change continues, and the dominating force is white taste—since Anglo-Americans are the buyers. Our emphasis on individualism had led to the cult of "name weavers," the best known of these commanding extraordinarily high prices for their work. Moreover, to own a piece woven in a certain style, like a Two Grey Hills rug, gives one status as a collector. Since the weavers are sensitive to this development, one finds the black-white-gray-tan palette and involved geometric patterns of that style influencing weaving on many parts of the Reservation—and incidentally, influencing Chimayo weavers, too. The white stereotype of Indian art as somehow mystical or symbolic, fortifies the popularity of *yei* blankets, sandpainting rugs, and the storm pattern with its legendary explanation. Many white buyers refuse to purchase rugs lacking the "spirit line" —that imperfection in the weave that they have been taught to believe the weaver leaves to let the spirit out. A rug without it is felt to be a fake, and so Indian weavers must remember to put it in.

Trader influence and weaver innovation have never ceased. For the past ten to fifteen years wool has been sent from Ganado to Ohio for scouring and dyeing and returned to the weavers as roving, to be spun by hand. Much of the yarn in Two Grey Hills rugs (figure 29) is scoured in Salt Lake City. At Window Rock (summer 1970) one woman revived the art of wedge-weave and is now weaving a rug in abstract designs with acrylic yarns. Experimentation with dye sources is apparently endless, the latest innovation being the use of burned flashlight batteries as one ingredient in a black dye.

Right now, Navajo rugs are considered to be a good investment. They, and Indian art in general, are being pushed by decorators. The demand exceeds the supply and prices continue to rise, so that small dealers anticipate excluding rugs from their stock before long. There is general agreement—but I have no hard facts—that women are ceasing to weave as other sources of cash become available, and that very few young women are learning the craft. Dr. J. B. Wheat (personal communication) reports that the summer of 1970 saw markedly fewer rugs being brought to trading posts. At Tonalea, for example, it was estimated that in 1968 some 150 to 200 textiles were received, as against 30 to 40 in 1970. All but about six of the latter were crudely woven single saddle blankets. One reason

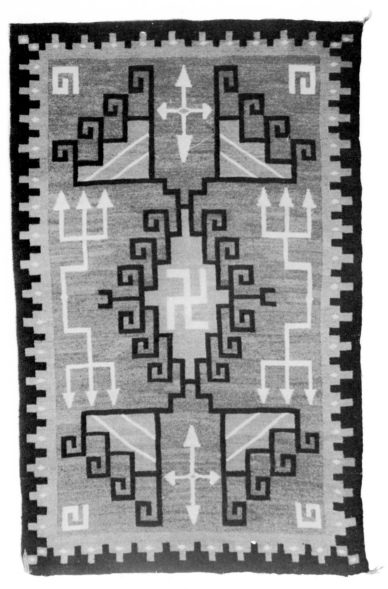

29. A Navajo rug of the Two-Gray-Hills type. Woven about 1940. Handspun wool, natural gray, brown, white; vegetable-dyed gray-green (140 cm. x 206 cm.).

given for the reduced quantity of rugs in stock was that a government agency was paying a subsidy of $100 per rug, regardless of quality. Some women were buying back rugs in the $25 to $35 range for resale at a profit.

CONCLUSIONS

How shall we account for the differing reactions to acculturation shown by Navajo and Pueblo weavers? If the Navajo could achieve fame as weavers, and develop their borrowed art as an economic resource, why couldn't their skilled Pueblo instructors do the same? The tendency to explain this solely as the result of different personality types—conservative Pueblo and progressive Navajo—is too facile. It overlooks the contrasting nature of Pueblo interaction with whites during the past four centuries, and, more significantly, it fails to recognize the position of the craft within each culture.

In the case of the Navajo, loom products, as far as I know, were, quite simply, always economically expedient. During the period from 1700 to 1863, weaving met the clothing needs of the people and also served as a trade item. This made sense, in that the wool of Navajo sheep was effectively utilized. If Navajo weaving is granted the status of a "traditional art," this period would be the baseline. From 1870 on, the art has been in a chronic state of change. It almost seems that in spite of its economic importance weaving has been peripheral to the culture. Certainly it is one of the category of items that can change rapidly

and without individual maladjustment (Keesing 1958:411–412). It will cease, except as a hobby, as Navajo women find less arduous means of support, *or* if white "faddism" and purchasing power is directed elsewhere. When it disappears, the loss may be more strongly felt in segments of white society than among the Navajo themselves.

In contrast, weaving was locked into Pueblo culture in a variety of ways long before the coming of the Spanish. Traditional textiles still have meaning and value that are not solely economic in nature.

At Zuni, until very recently, the traditional black blanket-dress and red belt were two of a woman's most highly valued possessions. These were presented by the fiancé before marriage, and the girl's response was to grind corn and present it to her future family-in-law. The dress and belt were her very own, and she took them with her to the grave. If she had not paid for them with corn while she was alive, however, her in-laws would take them from her in the afterworld. Evidence of the identification of dress and belt with a woman's personality is found in a case of witchcraft occurring around 1880 (Smith and Roberts 1954:40, 100). The accused man admitted cutting off a bit of the belt fringe of a girl who refused his advances. He hung this in a place where evil spirits lived, and thus brought sickness, and subsequent death, to the girl, the mechanism being a form of sympathetic magic. So highly valued were these articles that they were sometimes rifled, along with turquoise jewelry, from graves. Payment of fines requested by the offended women in cases of rape or slander between 1880 and 1951 are headed by these two items (Smith and Roberts 1954:52–58).

The importance of the black dress and red belt in Rio Grande Pueblos is made clear in Parson's "Isleta Painting" (1962). All women are shown wearing this costume.

Stephen's "Hopi Journal" makes abundantly clear the importance of cotton, weaving, and certain kinds of textiles in Hopi culture in the early 1890s (Stephen 1936). The cotton fiber symbolized clouds and lightness, as the following quotations show:

> over the [War Society] altar are suspended three "clouds" covered with raw cotton (87).

> [At death a] mask [is] made of raw cotton teased out into a mat about large enough to cover the face, and in this mat holes are made with the fingers for eyes and mouth.... The mask is placed on the face of the corpse with the idea of making the body [breath body] light, not heavy ... (*ibid.*:825–829).

Certain garments and designs had symbolic significance, much of which, according to Stephen, the weavers had forgotten. He was told, however, that:

> The large, undecorated, white, cloth blanket, is [typifies] the white cloud [that precedes rain]. The *wuko kwe wa*, big belt, with its spheres and dangling fringe, is [typifies] the rain, the falling rain. The cotton blanket is not used to sleep upon [I think it must have been at one time], but is preserved by the bride to be her winding sheet. When a woman dies she is wrapped in the cotton blanket before burial in the cliffs.

> The larger design [on the brocaded dance sash] is a convention of the Broad face kachina mask. The zigzag is his teeth mark; the lozenges are eye marks. The hooks are called angular marks. The

straight white lines in the black band are called, indifferently, *Pu'ukonva'adta* or *Tai'owave'adta*; but in fact, these "face marks" are those typically pertaining to *Pu'ukonhoya*. Like the potters the men weavers have, to a great extent, lost the significance of many of the designs in textile fabrics (*ibid.*,35,n.1).

Textiles were worn in dances and used in many ceremonies: [At death] the prayer sticks were then rolled up in a white blanket by *Kwa'chakwa* and slung over Sa'mi's shoulder and he set out across the valley eastward to the Sun Shrine (60).

The Sun prayer-sticks as last year were wrapped up in a cotton blanket and he carried them on his back to the Sun Shrine.... The white woolen blanket with its colored border may not be used to wrap these prayer-sticks, nor may any fabric which had dyed yarn in it. The smell of the urine used in the dye is offensive to the Sun (82).

The last statement indicates that tradition may prevent or deter innovation in subtle ways. The plain white blanket had apparently been used on these occasions before indigo and the practice of setting it with urine was introduced by the Spanish. Three hundred years later, white blankets were *still* the only correct vehicle. There must have been a reason of this sort for the belief that only black and white should be used for children's clothes, i.e., the boys' plaid shoulder blankets and the small girl's white bordered shawl (Colton 1938:9). Contemporary dance costumes undoubtedly perpetuate pre-Spanish conventions. They are almost duplicated in Awatovi mural paintings, and some of the articles worn can be matched with archeological finds. The braided sash, so significant today in many contexts, appears to be a very early textile

form indeed. There are examples from Basketmaker II (300 A.D.) caves in the Lukachukai Mountains (Amsden 1949:3, pl. 3). (The yarns are wool—white dog hair and an unidentified brown fiber). Items anchored so firmly in the belief systems of a people tend to persist unchanged through time.

Quite apart from their ceremonial significance, weaving and textiles entered into social life at many points. Most marriages were solemnized in the winter months, beginning in January. At this time, the men of the groom's lineage, relieved from farming tasks, could weave the articles required as bridal gifts. These included two white cotton blankets, a dark dress, a blue woolen blanket, the big belt (rain sash), a wool belt, and a white blanket with red and blue borders. Kivas were the scene of ginning, spinning, and weaving activities. Stephen writes of a spinning "party" in which fifty men participated, to be feasted by their host when they had finished carding and spinning his raw wool (Stephen 1936:372). As final evidence of the value of textiles among the Hopi, we read that, as at Zuni, they were liable to be stolen from the dead. Before burial, the clothing and blankets in which the corpse was wrapped were purposely slashed to render them worthless (Stephen 1936:829). At present, some eighty years after the period described in Stephen's account, we find the weaving of traditional textiles still important.

The differing rate and types of change in Pueblo and Navajo weaving may be summarized as follows:

Two processes of change must be distinguished among the Pueblos—that in the Rio Grande and that in the Hopi towns. (Zuni lies

somewhere between these contrasting poles.) For a number of reasons, weaving died out early in the Rio Grande villages: it probably was less marked among them prehistorically, Hopi weavers having supplied many of their needs; cultural demoralization and population loss under the Spanish domination hastened the process; and finally, the tourist market developed after most men had ceased weaving.

Weaving, however, did not disappear from the Pueblo world, it simply became localized in the Hopi towns, following a trend established prehistorically. An integral part of custom, weaving's resistance to change parallels that of the culture as a whole. As long as Pueblo tradition retains validity for the people, certain classes of handwoven textiles will be made. Pueblo cultures are characterized as having closed systems with many boundary-maintaining mechanisms. Isolation emphasized these characteristics in the case of the Hopi. They were subject to fewer negative pressures than were the Rio Grande people, and, unlike the Navajo, they were not knocked off their subsistence base. They were not exposed early to tourism and the white market system, which was never exploited by more than a few Pueblo blanket-weavers. Most weavers are older men, preoccupied with producing their own textile forms for a Pueblo market. The high evaluation of traditional articles has been reinforced since 1930 by anthropologically oriented whites at the Museum of Northern Arizona. Subsequent change in Hopi weaving will depend on their own conscious efforts to exploit the tourist market for cash, coupled with innovation—either from an outsider or from a Hopi man or woman who stands apart from his culture.

Navajo weaving has no deep historical roots in cultural tradition. Essentially, it has always been a commercial link with other Indians, Spanish, and Anglo-Americans. As such, it has thrived on innovation, change, and outside contacts.

5. Ceramic Arts and Acculturation at Laguna

Robert R. Gill

The American Southwest is one of the most culturally pluralistic areas in the United States. Its heterogeneity has been the result of successive wars between invaders and settlers, who clashed for a time and then usually settled down in some sort of workable adaptation. The present blend of these vying groups in the state of New Mexico involves the English-speaking urban majority (Anglos), representing the currently dominant society, the rural and suburban Spanish-speaking people, representing the formerly dominant society, and the many groups of Native Americans, representing the aboriginal societies Europeans met on contact.

For the most part, Anglos are concentrated in the great urban centers such as Santa Fe and Albuquerque and in the lesser towns and

Robert R. Gill did undergraduate and graduate work in anthropology at California State University at Hayward. He is an anthropologist and photographer who has done research in Laguna Pueblo and among Native Americans in the San Francisco Bay Area. He has worked as curatorial and photographic assistant at the Lowie Museum and is now codirector (with Clark Akatiff) of the Saklan Institute of Anthropo-Geography in Berkeley.

cities. Spanish-speaking people predominate in the rural areas, having settled mainly in small towns and villages in the mountains of the north.

Native American groups in the area include the Navajo and Apache groups (Athabascan speakers) and the various groups of Pueblos. There are two large Apache reservations in the state of New Mexico, one north and one south of the Pueblos. Some Navajos are scattered in three small areas, but for the most part they are concentrated on the part of the greater Navajo reservation jutting into the state from Arizona on the west (Smith 1966:49–50).

The Pueblos inhabit a line of villages, village complexes, and reservation areas that run from Taos in the north of New Mexico down the Rio Grande to Albuquerque and then westward, ending with three Hopi mesa-top settlements in northern Arizona that are completely surrounded by the Navajo reservation (see map 2).

The Laguna Pueblo is situated in the middle of this line on the western side of Albuquerque. In the usual scholarly division of

Pueblo cultures into two subtypes, it is sometimes placed among the "western Pueblos" (Eggan 1963:253) and sometimes among the "eastern Pueblos" (Spicer 1962:182). In geographic distances, however, Laguna is far closer to the Rio Grande Pueblos than to Zuni and Hopi in the west (see map).

Laguna is a Keres-speaking pueblo and therefore is linguistically related to five of the Rio Grande Pueblos, as well as to nearby Acoma. Use of the Indian language is still common, in spite of recent generations having gone away to Indian school and although many adults live outside the state for extended periods. Old people tend to speak Spanish and Laguna, whereas middle-aged persons and adults in general speak Laguna and English. As a consequence of recent education and other mechanisms of acculturation, the youth and children speak English and understand Laguna when it is spoken. Ideally, they learn how to speak Laguna when they reach adulthood, since all important matters are discussed in the native tongue. For instance, council meetings are conducted entirely in Laguna, though an appointed interpreter for English-speakers is present at all times.

Laguna's main economic enterprises are farming and cattle raising. As at other pueblos, this has influenced the development of the village into a village complex with several subvillages or hamlets located around the original nuclear settlement, which is now known as Old Laguna. These smaller villages in the past were merely summer settlements close to the corn fields. There were seven such settlements, which grew larger until they became occupied all year round. Old Laguna is now considered the administrative and ceremonial center of the whole complex, but the peoples of the outlying villages share equally in participation in tribal affairs with those still living in the old village.

LAGUNA ARTS

A common occurrence in acculturation situations is the severe disturbance of the native art traditions when they are enveloped by a more dominant one. Often the effects of the dominant culture are so pervasive that the arts-and-crafts production of the dominated culture stops altogether or is so radically altered as to lose all continuity with traditional output and techniques. I have seen examples of this among the artifacts of various peoples in New Guinea and the Pacific Islands and along the Western coast of North America, including specimens that strongly reflect the overbearing influence of neighboring peoples or of a dominant industrial-commercial society, as well as specimens now rarely produced. Those native California peoples whose basketry traditions have to all intents and purposes become extinct as a result of successive contact with Spanish-speaking and Anglo societies offer an extreme example of this phenomenon.

The continuance of native art traditions can act as a basic indicator of the degree to which acculturation has taken its toll of the native integrity of the dominated culture. The greater the pressures to assimilate, the smaller the chances are that the native art tradition will

survive intact. In fact, it is often said that in times of dire acculturative stress, the native art traditions are the first cultural components to undergo drastic change. Dominant societies (in modern history) usually have made their initial impact by substituting industrially made consumable items for objects of native manufacture.

Instead of disappearing under the stress of acculturation, however, many native art traditions avoid succumbing to the pressures of the dominant culture, and a synthesis occurs in which the tradition continues its own development though decidedly influenced by the alien presence. Inappropriately termed the "arts of transition," since they do not constitute merely a temporary phase towards assimilation, such traditions are more aptly termed "arts of acculturation," and characteristically, their "continued production . . . often acts as a positive or mediating influence in an otherwise chronically pathological situation" (Graburn 1969a:1, 2). A basic hypothesis, then, is that the appearance and development of these arts of acculturation represent a type of acculturative phenomenon in which the native art tradition is utilized as an adaptive measure and must be seen as an integral part of the greater contact situation as a whole. In other words, it is insufficient to set up a simple dichotomy between the twin alternatives of native art extinction or "airport art." A good deal of understanding may be lost if the total interethnic context in which arts of acculturation occur is minimized or overlooked completely.

This complexity becomes quite evident in the study of the pottery tradition of the Pueblo Indians in Laguna, New Mexico. Commonly believed by local Anglos to be the most "progressive" of all the pueblos, Laguna has had to bear some of the greatest pressures to assimilate found in the Southwest. Yet its tradition of pottery making has maintained itself to the present day, though it has often been virtually written off in the past literature (Bahti 1964:26; Underhill 1953:89–91; Wormington and Neal 1965:55). Even now, it shows signs of preparing for a new stage of resurgence. At the same time, however, a good deal of the material culture of dominant Anglo society has been readily accepted at Laguna and potters there who make traditional, functional wares do *not* refuse to turn out souvenir pieces as well, nor have they been hesitant about selling what they consider salable. Laguna represents not only a case of acculturative stress with a continuance of the native art tradition, but also one of the commercialization of art without wholesale transformation into "airport art."

Examined as an art of acculturation, the Laguna pottery example loses some of its complexity. An overt ameliorative or mediating function for pottery at Laguna is not immediately reflected in direct rewards to individual potters, either in the form of greater prestige or of substantially increased economic support. Nor has the pottery-making tradition of Laguna brought widespread fame to the village, thereby providing a focus of ethnic pride that could offset the demeaning status in which non-Anglos are generally held by the dominant society.

Acculturative Pressures

But the entire long-range acculturative process must be taken into account for an adequate understanding of the matter. On the

by the demands of commercialization are often impossible for tradition-bound activities, especially if the products are associated with ceremonial functions. Not only was this true at Laguna, but, in addition, the existence of a highly successful commercial pottery production in nearby Acoma (see figure 21) precluded the establishment of a commercial fine arts tradition in the village. Contrary to Brody's contentions (chapter 3, page 74), industry did not provide acceptable substitutes for traditional items, and native production was forced to continue. The people of Laguna may have accepted the substitution of metal and china utensils and containers, but evidently there was no substitute for native-made water jars, gift pots, or ceremonial bowls.

Such equilibrium is not static and is likely to change in the future. Often a native art tradition will serve a sociocultural function as an "identity-maintaining mechanism" (Graburn 1969b:467). Regardless of its success in combating acculturative stress, Laguna has had its share of assimilationists in the past, but, as with other Native Americans, many individuals are joining the surging Indian renaissance currently in progress and are casting about for something with which to express their "Indianness." By 1969, efforts were being made to teach pottery making to children participating in the Headstart program of the O.E.O. at Laguna. Recently, according to informants, a highly assimilated former potter was approached by her grandchildren because they wanted to learn the craft in order to regain some of the ethnic identity they had lost through acculturation. It is likely that this phenomenon will continue and that a resurgence will occur in the native art tradition of pottery making. In this case the present balance of production between functional arts, commercial arts, and souvenir ware may be rearranged.

PART II/MEXICO AND CENTRAL AMERICA

Mexico is a country very proud of its indigenous traditions. The Mexicanness of Mexico comes from the feeling and expression of *indigenismo*, i.e., that which is Indian and not European. The indigenous high arts, the monumental and architectural traditions of the Olmec, Toltecs, Maya, and Aztecs, have been explored and preserved, but many other traditions, such as goldwork and featherwork, were all but destroyed by the conquest (Tibol 1964; Keleman 1969). Regional art production, for local trade and use, have perpetuated the preconquest tradition of craft-specialized villages and towns, to appear in fairs and markets; prominent among these are textiles, especially in Oaxaca and Guatemala, and pottery (see Murillo 1922).

CHARLTON describes both the continuities and changes in central Mexican ceramic traditions, choosing the Teotihuacán Valley as a microcosm of the whole of Mexico. He shows how the traditional customs of specialization and interregional trade have been greatly facilitated by improvements in transportation, mainly from trucking, in the twentieth century. The greater range of regional wares available is supplemented by the production of new types not only for *gringo* tourists but for the increasingly affluent Mexican market itself.

Pottery, textiles and other arts have been modified and expanded for sale to Mexican and foreign tourists, but many traditions have suffered from competition from industrial manufacturers and re-manufacturers (Kassovic 1974), particularly in the fields of containers and textiles of all kinds. Many local art items, such as pottery, masks, toys, figurines, paper crafts, day-of-the-dead objects, laquered woodware, etc., continue to be produced for local consumption, and may have even been spurred on by poverty or encouraged by outside interests. These products, with their bright and humorous approach to life, have recently begun to show more of a trend toward the frightening and fantastic, perhaps in the tradition of Aztec beliefs.

Map 3.

STROMBERG describes the recently invented art form of painting on *amate* (fig tree bark paper) in mountainous Guerrero. This was inspired by the transfer of the typical "fauna and flora" pottery style of the local Nahuatl-speaking peoples onto the new medium, though there is considerable controversy about the actual origins. In the past decade and a half the new tradition has shown many innovative tendencies: the paintings have increased in size and complexity; new designs have been transferred back onto ceramics, onto *cartulina* paper, into mixed-metals silverwork in Taxco, and even onto the bright municipal oil-drum waste containers there! Recently, the style has developed borders, evolved rural scenes, and added signatures. Psychedelic colors and *fantástico* elements, encouraged by national government agencies have presaged the emergence of supposedly Aztec themes in this fast-moving commercial art tradition.

New art forms have been invented for commercial purposes. Many of these, such as *amate* painting, Huichol yarn painting, Ocumicho pottery, and Seri ironwood carving have recently come under the benign influence of the Banco de Fomento Cooperativo (BAN-FOCO), competing with local and *Yanqui* dealers.

RYERSON recounts the history of one of these, the ironwood carving of the Seri of Sonora. Like American Indian arts, these were first instigated and promoted by Americans, but have recently come under the wing of BAN-FOCO. After a serendipitous origin, the poor Indians have developed a popular art form suited to the tastes of tourists and *Norte Americanos*, and have become considerably richer and more consequential in their area. Though the supply of dead ironwood trees is dwindling, prices continue to rise, individual signed styles have emerged, and other local crafts such as beadwork and basketry have begun to supplement the Seri's considerable cash income.

The Mexican government, and to a lesser extent the governments of central American countries, have had much to do with preserving, promoting, and innovating in local arts and crafts traditions. In addition to BANFO-CO there is the Secretaría de Industria y Comercio (SIC), Instituto Mexicano de Comercio Exterior (IMCE), the department of tourism, and many state agencies, such as those now involved in the immense developments in Yucatan. The government concerns include:

1. Tourism: promoting a favorable image of regional Mexico and providing salable crafts for tourist dollars and pesos.

2. Poverty: these extra incomes are supplementary but necessary for the burgeoning rural populations from areas that are neither industrializing nor able to provide more than a meager income from agriculture.

3. National identity: Mexico has long differentiated itself from European Spain and from other Latin American countries; it has glorified the arts of the conquered civilizations and is now showing concern for the plight of their descendants, the culturally and economically depressed Indians. The government supports many exhibitions, collections, and

museums for the *artes populares* and in the more remote areas, regional and local differentiations are still expressed in viable art forms (Cordry and Cordry 1968; Gayton 1967).

Carefully selected items from traditional art forms are being incorporated into the Mexican national "ethnicity," as expressed, for instance, in the Ballet Folklorico; other non-Indian art forms are promoted as national arts, such as the gold and silverwork industry of Taxco. These are supplemented by a spectrum of cheaper items, great and small *talleres* and thousands of craftsmen annually are drawn from the countryside to try to make a living from the commercial arts. Need, a multiplicity of traditions, and a gay willingness to experiment will keep Mexico in the forefront of ethnic and tourist arts. For a comprehensive guide to recent commercial arts, see Toneyama and Espejel's *Popular Arts of Mexico* (1974), or the simpler Norman's *Shopper's Guide to Mexico* (1966), and for both old traditions and new developments, issues of the excellent journal *Artes de México*.

6. Seri Ironwood Carving: An Economic View[1]

Scott H. Ryerson

The Seri Indians, or *konkaak*, 'the people,' as they call themselves, inhabit a coastal strip of desert along the Gulf of California in the state of Sonora, Mexico (see map 3). During the sixteenth and seventeenth centuries, they inhabited or controlled a territory running from Guaymas north more than 200 miles to Puerto Libertad and stretching, at places, 100 miles inland from the Gulf. Most of this land was slowly wrested from them by the frontiersmen of Sonora, so that by the end of the nineteenth century they had been restricted to Tiburón Island and a narrow coastal zone approximately one hundred miles long. Today they have lost even the island,[2] their last fortress of isolation, both physical and psychological, against the foreign world.[3]

Because of the desert nature of their habitat and their warlike activities, the Seri remained essentially isolated until the late 1920s. What contact there was during the nineteenth century was usually unfriendly. At various times during the 1700s and 1800s, many of them were confined, under the Spanish and, later, Mexican reduction programs, to a small pueblo near Hermosillo; but they gradually filtered back to the coast. On the whole, their contact with Mexican society, and especially with urban Mexico, was limited, although they occasionally sold their wares, such as pottery

Scott H. Ryerson did graduate work in anthropology at the University of Arizona, Tuscon, where he now owns and operates an ethnic arts store, the Tepopa Trading Company. He has worked among the Seri Indians of Sonora, and more recently also among the Indians of the American Southwest.

[1]The fieldwork for this paper was first undertaken in Desemboque in the summer of 1969 and was completed during many visits to the Seri since that time. I would like to acknowledge a grant from the Doris Duke American Indian Oral History Project which made the major portion of this work possible. My gratitude is also due Keith H. Basso, Bernard L. Fontana, Thomas B. Hinton, B. Alan Kite, Edward H. Spicer and Clara Lee Tanner, all of the University of Arizona, and especially Edward and Mary Moser of the Summer Institute of Linguistics, for critically reading various drafts of this paper. Though this paper was originally written in 1970, it has been revised several times, most recently in 1975.

[2]Recently, the Seri have reacquired many of their aboriginal rights in this island.

[3]Spicer (1962) and Bahre (1967) have summarized the available historical data; see also the article by T. Bowen in the forthcoming edition of the *Handbook of North American Indians*.

and baskets, in Hermosillo and Guaymas. Even today, because most economic negotiations in which the Seri are the sellers take place within their own territory, much of their isolation from the mainstream of Mexican society has been maintained.

At present, the Seri number about four hundred people, which is perhaps from 15 to 20 per cent of their population in, say, 1600. The current figure, however, represents a doubling from the low point of 170 that occurred slightly less than 40 years ago (Smith 1968).

For at least the last two decades, the Seri have lived in two year-round camps, Desemboque and Punta Chueca, and in a third, Viboras, which is usually inhabited in all but the summer months, when it is abandoned because of the prevalence of insects. During two past winters, a number of families have reestablished a camp at the resort town of Kino Bay, to facilitate the sale of their crafts to the tourists there. The permanency of this camp will depend on the success of the craft industry. In addition to these four localities, there are a number of other sites that may be inhabited by one or two families on a temporary basis.

The Seri language, an isolate, is regarded as a member of the Hokan language phylum, although Turner (1967) feels that this position has yet to be adequately demonstrated. If Seri is Hokan, its closest geographical relatives would be the members of the Yuman family along the Colorado River in southern California and across the Sea of Cortez in Baja California. As nearly as can be determined, the aboriginal Seri were divided into several dialect groups. These groups were then further subdivided into bands that utilized different aspects of the environment, including the sea (Moser 1963). Over the past three hundred years their territory has been reduced, forcing together several of these original groups. What effects this change had on the political structure of Seri culture is not fully known; there is very little reliable information available on the Seri until about 1930. It appears, however, that during the nineteenth century, if not before, the military pressure exerted upon the Seri enhanced the tribal (pan-band) role of "war chief," an overall leader in times of crisis. This position did not exist during peacetime. The last person who was so recognized by the Seri is said to have died about 1940. Today there are several Seri who have been given titles of authority by the Mexican government at one time or another, but they exercise little power and are not leaders in any meaningful sense.

One facet of Seri culture that has changed drastically is religion. Until 15 years ago the Seri had active shamans, and until four or five decades ago the vision quest was an important event in the life of every young person. Then, in the early 1950s, a Mexican evangelical church was established among the Seri, and two or three other religious-based groups took an interest in these Indians. The evangelical church met with surprisingly rapid acceptance, so much so that today the Seri are the only predominantly evangelical tribe in Mexico (Smith 1970). The last socially recognized, practicing shaman died in 1968 (Moser, personal communication).

The family was, and is, the main unit of Seri

social organization. The household unit consists of the nuclear family, though many of the economic activities, such as fishing, take place on an extended family basis. Siblings and immediate collaterals think of themselves as a social group and contribute to each other's economic well-being. Several authors (McGee 1898; Coolidge and Coolidge 1939) have attributed principles of lineality to Seri social structure, and even Griffen (1955, 1959), who has conducted the most extensive investigation of kinship among them, feels that various practices might be remnants of a unilineal system. But an analysis of the terminological system, which takes into full account the presence of Hawaiian cousin terminology (Murdock 1967), gives no obvious indication of lineality. Although the question is by no means settled, a basic bilateral theme, reflected in both the economic functions of the extended family and in the kinship terminology, is evident in Seri culture.

As noted above, the family functions as the main economic unit. Traditionally, the men hunted and fished and the women gathered the products of the desert and seashore. There were few specialized roles, except for shamans, and even in this realm many of the older people, both men and women, had knowledge of various cures (Griffen 1955). In order to cope better with the inhospitable desert and sea environment, the Seri had several institutionalized systems of reciprocity. These facilitated the distribution of any existing surplus to the extended family and beyond. Today, with the changeover to a cash economy and greater economic stability for everyone these systems of reciprocity are being called upon less and less. Consequently, they are breaking down, although when a family is in need, these systems are activated in an attempt to alleviate the crisis.

Most of the Seri still live on a day-to-day basis and few have adapted to the seasonal nature of the craft industry. Most cash earnings are spent quickly, though some savings are put away for large expenditures and emergencies. One family, at least, has mastered the intricacies of a money economy to the extent that it has been able to save $1,000 (U.S.) to buy a used truck. A half dozen other families have purchased less expensive used cars, a new and important status symbol for young males.

Traditional Seri material culture was rather meager. Mobility was one of the keys to survival in this desert habitat, and consequently possessions were kept to a minimum. The Seri's use of easily constructed brush huts and ramadas, their only preacculturation type of architecture, is one indication of this emphasis on residential impermanency. In and around a small clustering of these structures might be found the few articles that were manufactured: the men's bows, arrows, and harpoons; the women's baskets, head rings for balancing the baskets, and pots; a balsa raft pulled up onto the beach nearby. There might also be a carrying yoke, a violin, fire drills, cradle boards, and the ever-present turtle shell, which still serves the Seri as an all-purpose, disposable container. In addition, there would be the few religious items, such as a shaman's *corona* or crown, carved santos (see below), and a set of bullroarers. Various other occasional items would complete the inventory of traditional

Seri material culture. Little of this required a specialist for its production. The santos were the most notable exception, being made by and rented from the shamans (Griffen 1959).

CONTEMPORARY SERI CRAFTS

Today the Seri material inventory has changed radically. Metal and plastic items have replaced many of the artifacts formerly used. Even the various crafts that remain have been modified. If one excludes such functional crafts as boat building and dressmaking, Seri craft items today can be grouped into four categories: necklaces, baskets, ironwood carvings, and ethnic miscellany (including dolls). This last grouping consists of such items as musical instruments, bows and arrows, coronas, bullroarers, pottery, gambling games, toys, wooden harpoon points, etc., all of which are seldom produced. In the past, these items were made and used by the Seri; today they are rarely used, and therefore seldom available. They can be obtained, however, by having them made on request.

Necklaces

In contrast to these scarce ethnic items, necklaces made from shells, seeds, bones, clay balls, flowers, pieces of reed, etc., are produced by the hundreds. They have been used as adornment since at least the late 1600s, as evidenced by the report of Father Gilg (DiPeso and Matson 1965). For the past several decades they have served as a trade item and have changed in both form and design during this period. Although they have never been described in detail—Johnston (1970) being the only writer to make more than passing mention of them—information is available from contemporary Seri and several series of old photographs exist.

The changes that the necklaces have undergone may be briefly summarized as follows: they are now made of a much wider range of materials; they are often more massive and ornate, even garish; and, for the Seri, they serve almost solely an economic function. The evangelical church discouraged the wearing of jewelry as well as the practice of face painting, "...the most outstanding adornment of the Seri, [which] in its highly stylized and beautifully executed patterns ...approaches a true art" (Xavier 1946:16). Face painting is very rarely seen today, although the old designs do occur decoratively on the sides of violins; necklaces, on the other hand, are omnipresent because of their economic value.

All necklaces made today are produced solely for sale to the tourists and commercial buyers, who pay five pesos (40 cents) each or occasionally 10 pesos for a large one. By the time they reach the United States, the price has risen to at least one dollar wholesale, and from two to five dollars retail. Once in a while a "fine" piece will command an even higher price. It is unfortunate for the Seri that a larger market for their necklaces does not exist, since they can always be produced and, in contrast to the ironwood carvings, the supply of raw materials is essentially unlimited. Although it takes some time to gather and prepare the

shells and other materials and the price per item is low, necklaces yield a higher hourly return than most baskets and could be much more remunerative to the artisan if there existed a sufficient demand. The fact that the few Mexican women who live in the Seri villages make "Seri" necklaces in indicative of the craft's economic value. In simple economic terms, the supply far exceeds the demand at this time, in contrast to the situation that exists for carvings and, especially, for baskets.

Baskets

Basketry is also a very old craft among the Seri. It has been replaced functionally by galvanized pails and basins, although occasionally a Seri woman is still seen bringing in a basket load of firewood on her head. For the most part, all baskets are sold to Americans immediately upon completion or even before, the demand being very high. A great deal of time and effort are required to produce a basket, and since the monetary reward per unit of time spent is not so high as it is with ironwood carvings, only a small number of baskets are produced. In 1969, the Seri received about 10 dollars for a basket approximately 20 inches in diameter that required from three to four weeks of labor; a much larger basket would bring up to 80 dollars. Relatively few baskets were made until recently, but in the past few years the price has risen 300 to 400 per cent. For instance, in 1972, one very large basket was sold by the maker for $360 (U.S.). In the United States the wholesale price is approximately twice the cost of acquisition and the retail price is double the wholesale price. (This

practice of doubling and then redoubling the price in the United States applies to carvings as well as baskets and necklaces.)

Although there are still a few women and adolescent girls who do excellent work, the skill required to make baskets, especially those of high quality, is not as universal as it once was. This craft has also undergone

34. Teenage Seri girl weaving a very fine large basket dish or *corita*; note the deerbone awl, and materials soaking in bowls of dye in the foreground, 1969.

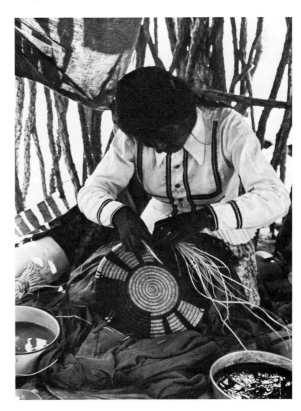

changes—mainly in size, design, and quality of workmanship—owing to contact with the United States and Mexican markets (figure 34). The Seri have 14 named types of baskets, eight of which they consider to be solely for the tourist trade (Moser 1973).

From this brief discussion of the characteristics and changes in Seri necklace and basketry manufacture, it is apparent that both these crafts fall into Graburn's definition of arts of acculturation. Both the necklaces and the baskets have changed "... significantly from [their] traditional expressions in form, content, function, and ... medium" (1969b: 457). In order to clarify the concept of medium, it should be noted that in the necklaces a wider selection of shells and other materials is used than was used traditionally, and that in some of the baskets of recent times commercial dyes have been used, a practice frowned upon by most buyers.

Ironwood Carvings

The third major craft, the carving of ironwood (*Olneya tesota*), is a recent innovation. It was begun by one man a decade ago and has become so successful that today it can be said that nearly every adult Seri is a wood-carver. Many of the early historical data have been recorded in two articles by Johnston (1968, 1969),[4] and the information compiled as a result of my fieldwork confirms in all important aspects that presented by Johnston.

One of the most interesting features of Seri ironwood carving is that the form arose

35a. Pre-commercial ironwood bull-roarer, 1941.

essentially *de novo*. Traditionally, the Seri did some carving, but they used very little dead ironwood (*ʔésseen*). The very dense nature of ironwood makes it rather easy to work, as in the working of the cryptocrystalline silicates (flint, chert, etc.) in stone knapping, for the density allows the desired amount of material

[4]To the best of my knowledge, the carvings were first mentioned by Griffith (1967).

to be removed from the area that is being worked without fear of splintering. Formerly, it was used to make a few utilitarian items such as bullroarers (figure 35a), balls for foot races, big knives used in fighting, sea-turtle clubs, musical rasps, etc. (Felger and Moser, n.d.). Other carved items were of softer wood, either that found in the area or commercial woods, such as pine, obtained from the Mexican fish buyers or scavenged from wooden crates. From these softer woods the Seri made children's toys, shoulder yokes, santos or fetishes, boxes, etc. Many of the toys are rather interesting, and include such items as boats (some of which are skillfully done scale models), airplanes, trucks, and other items of non-Seri material culture. From what I have observed, toy making has completely died out, with the possible exception toy-boat manufacture. This may be because the Seri are now preoccupied with ironwood carving and Seri children now play with plastic and metal toys, or because many Seri adults today have some of the very items they used to miniaturize as toys for their children.

The santos are another interesting item of Seri material culture, which, although they are little studied, are mentioned by Smith (1970) and Griffen (1959). Their production was specialized in that, ideally, only the shamans carved them. They were carved both in the round and in high relief, and were usually painted predominantly in red and blue. These santos were carvings of the supernatural spirits or "little people." Griffen (1959:52) distinguishes three different types: (1) "those for protection and welfare of the home," (2) "those for personal benefit," and (3) "those

used by shamans for curing." The first two types were made by the shaman and rented to the user; the last type was used only by the shaman. In addition to these good-luck and curative functions, the santos also played a part in the vision quest, being placed at the entrance of the cave in which the initiate underwent his ordeal. They have existed for at least 150 years (Hardy 1829), and Smith (1970) believes they are depictions of the Jesuits who

35b. Bowl (35 cm. long) and spoon (29 cm. long) by Jose Astorga, from the early 1960s.

visited the Seri in the seventeenth and eighteenth centuries. As a result of the lack of shamans, the abandonment by the Seri of much of their traditional religion, and the discouragement on the part of the evangelical church of what remained of this religion, the santos are rarely made today.

It was from this rather meager sculptural heritage that today's carving tradition arose. Its inception is credited, by both Seri and non-Seri, to one man, José Astorga. Astorga began experimenting with ironwood around 1961, and for two or three years produced such items as bowls, spoons (figure 35b), hair barrettes, and one or two paperweights (Johnston 1968). It is most likely in 1963 or 1964 that he began to include depictions of life forms—such as seals, dolphins, and turtles—that tourists found pleasing. This innovation may have been suggested at Puerto Libertad in April of 1963 by an American woman who was working with ironwood while staying there. She told Astorga that she was making a desert tortoise to use as a doorstop for her home, and he responded that he, too, knew how to work ironwood. It is not certain whether this brief conversation gave Astorga the idea of producing life forms, but he would be very likely to pick up and use such an idea, and it is thought that this conversation took place before Astorga first made animal carvings.

For some four or five years after Astorga had produced his first life-form creations, the manufacture of carvings was restricted to perhaps a half-dozen families. These people sold their work, but the demand remained small until the fall of 1968, when the market sought out the Seri. Two or three University of Arizona students began making monthly trips to the Seri villages and buying for resale everything they considered to be of sufficiently good workmanship. This expansion of the market was soon followed by an increase in production. New families began carving, and within the families that already had carvers the women also began to learn the craft. Even some of the children helped out with such tasks as oiling and polishing.

These commercial buyers were also instrumental in expanding the market in the United States. This larger demand encouraged others to go to Desemboque on buying trips, resulting in a still larger market for the Seri and a corresponding increase in production. This cyclical process is still taking place. Economically, this new enterprise began at a most opportune time. The Seri's economic situation during the early 1960s was anything but stable. Had it been more secure, ironwood carving might not have achieved the popularity that it now has among the Seri as a means of earning cash income, but this is only speculation. It should be kept in mind, however, that the Seri are definitely an economically oriented people. For the past 50 years, Americans have customarily paid the Seri for almost any service rendered, whether it was posing for a photograph or providing information, food, or whatever. This policy has become so firmly entrenched that it is now very difficult for an American to be on anything but economic terms with the Seri. It should also be remembered that the expansion of the market provided the Seri with a great deal of rather easily obtainable money. They are frankly amazed at the prices that the Americans

are willing to pay, joking about it among themselves, and all the while taking advantage of the opportunity.

ECONOMIC FACTORS

The Seri's economic system was unstable at the time the carvings became popular for two main reasons. First, the creation of a hunting preserve on Tiburón Island in 1965 upset the traditional Seri economy, greatly infringing upon the Seri's utilization of the island's resources and thereby restricting their seasonal mobility. In turn, this restriction encouraged a more permanent form of settlement on the mainland, a process initiated 35 years earlier by the commercial fishermen, but greatly accelerated by this decision.

The second reason for economic instability was that two events threatened the Seri's cash income from commercial fishing. In the first place, according to Smith (1970:13), the institution of changes attempted by the Protestant mission groups and by the Instituto Nacional Indigenista caused "... the rapid breakdown of the vital fish economy. The fish buyers, uncertain as to what direction the newly introduced cultural changes might take, discreetly refrained from further investment in the commercial development of the fish industry in the Seri region." Other people who were intimately acquainted with the Seri during this same period feel that this statement is an exaggeration. They maintain that concrete plans for an expansion of the fishing industry along the Seri coast had never existed. This question has not yet been fully resolved.

There is no disagreement, however, regarding the detrimental nature of the second event. In the late 1950s, commercial shrimp boats from the fishing ports to the south began working in Seri fishing waters. These shrimpers dredge the bottom of the gulf, which drastically disturbs the ecology of the ocean floor. Repercussions on the other marine ecosystems result in there being fewer of such commercially desirable fish as sea bass and red snapper, adversely affecting the Seri's commercial fishing operation.

While the Seri's primary source of cash income was thus being depleted, Kino Bay, the Mexican fishing village at the southern end of Seri territory, was steadily growing in popularity as a tourist resort among Mexicans and Americans, and, consequently American-Seri contact increased dramatically. In summary: The Seri were in need of more cash. Many American tourists, and then commercial buyers, arrived with cash and found the Seri living in more permanent settlements, which were more easily accessible to outsiders. The carving industry seems ready-made for this situation. Ironwood figures can be produced quickly and easily and bring a good price. If the market for them existed throughout the year, in the long run carving would be at least as profitable as commercial fishing, if not more so. Until recently, however, fishing, along with turtling, remained the Seri's major source of cash income.[5]

[5]In addition, during 1971, the Seri were not allowed to turtle commercially until 1 October, because of the placement of the turtle on the endangered species list. Furthermore, turtling may be regulated for at least the next five years. Turtling represented the main source of summer income for the Seri until 1974, when Banfoco became a year round large-scale purchaser of Seri arts.

INNOVATION AND THE INNOVATOR

Graburn (1969b) has noted that the role of the innovator is an important one for the successful development of an art of acculturation, and he goes on to mention the innovator's various characteristics and functions. Most of these do not appear to be applicable in the specific case of José Astorga, the innovator of Seri ironwood carving. In the first place, from what can be learned about Astorga's history, it would appear that he had no "intimate and unusual contacts with another group" (Graburn 1969b:464). His contacts with both Mexicans and Americans seem to have been about the same as those of any other male member of his generation. Also, there is no evidence that he got the initial idea of carving ironwood from any outside source; but, as we have seen, he may have got the idea of making animal figures from a tourist. Once he had started carving, however, he utilized outside ideas, especially with regard to form and function (i.e., from such utilitarian items as bowls to purely decorative items).

Even though Astorga has had no extraordinary outside contacts, it should not be inferred that he is just a "typical" Seri. This is not the case. The Seri are very astute in money matters, but Astorga has specialized in this area. He appears to be greatly concerned about obtaining the most return for the least amount of work, and he has met with fair success in this endeavor. These attempts have led him outside the traditional Seri economic structure, often into the Mexican one. He is the only Seri to maintain a garden, to own horses, donkeys, and goats, and to have fenced in a plot of land for farming. In addition, he was one of the first to build a cement-block house. Astorga is receptive to change and is an innovator in his own right. Not only did he begin the ironwood carving in the early 1960s, but also, a decade earlier he had started carving small animals out of pumice (Johnston 1968). When the situation demands it, such as when a buyer is in town, he can be very industrious. Under his direction, his family members became the first essentially full-time carvers as a response to the changing economy.

With regard to Graburn's second point, it seems unlikely that anyone had to "spread the idea that there was an available market" (1969b:464). As we have seen, the art form did not blossom until the market existed, but the production increase was probably as much a result of the Seri's realizing the existence of a market through their own economic acumen, as it was of the student buyers' or the resident linguists' encouraging or promoting production. The Seri have a history of being able to adapt to a cash economy and have gained the reputation, at various times, of being keen traders, tenacious beggars, and mischievous thieves. Smith (1970) points out that they have been economically astute enough to learn sufficient Spanish to carry on their commercial fishing and purchasing activities, with the result that none of the Mexican traders have had to learn much Seri. This situation contrasts with many others, such as in the American Southwest, where the traders have often had to learn at least enough of the native language to conduct business.

The third function Graburn attributes to the innovator, although not in every case, is "to

introduce the necessary techniques" (1969b: 464). For the Seri, an innovator was necessary for only part of this process. They had not done extensive carving previously, but they had built their own boats for at least two generations, and thus, although they were only somewhat familiar with hardwoods like ironwood, they were skilled in many of the general techniques of woodworking and carpentry. The acquisition of most of the new skills needed for working ironwood appear to have been picked up in a trial-and-error fashion. For example, Astorga went through considerable experimentation before producing a dolphin shape he felt was satisfactory (Johnston 1968). The one area in which a non-Seri innovator seems to have played a significant role is in finishing. While vacationing at Kino Bay in 1968, a carpenter from the United States, known only by the nickname "Slim," refinished several pieces he had bought. At this time the Seri's use of kerosene and vegetable shortening for this purpose gave their carvings a dull finish. The Seri were impressed with Slim's results and have since used the fine wet-and-dry sandpaper and the paste wax (today shoe polish) that he introduced.

The examples given above show that the general characteristics and functions that Graburn (1969b) attributes to the innovator in the other arts of acculturation are only in part applicable to the specific case of Seri ironwood carving. Astorga had not had any exceptional contact with another culture. Few new techniques were introduced. And with respect to the idea of the available market's originating with an innovator, on the basis of present in-

formation it appears that this was true of Seri ironwood carving only to a slight degree, if at all.

COMMENTS AND OBSERVATIONS

Many of the ironwood carvings first produced by the Seri were much cruder than

36. Jose Manuel Romero roughing out a turtle; note chalk outline, an unusual procedure, 1972.

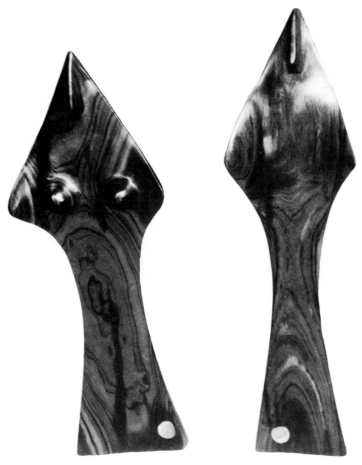

37. Two human figures, female and male, modelled after archeological ceramic figures (36 cm. tall), 1970.

successful working of ironwood (figure 36). Secondly, efficient woodworking tools, which also allowed for quicker production, were not available until Americans began to supply them in quantity. These new tools, together with Slim's instructions for finishing, account for the much finer finishes that appear on to-day's pieces.

Another stylistic change in the carvings has been a shift from a more "naturalistic" rendering to a more "abstract" one. Many of the first life forms had mouths sawn in, nailheads for eyes, and in general there was an attempt at a more "realistic" depiction of the animal. Today's pieces are far more stylized (figure 37), although the carvers often still include lines indicating various anatomical features of the animal. The Seri carvers whom I have questioned attribute this change to two factors. First, they say it saves time to omit, or at least deemphasize, these details. Second, they point out that the tourists prefer the more stylized forms. Some of the Seri have gone on to say they themselves prefer the more realistic carvings, that they are better, more attractive.[6] When asked what he thought of a

present-day pieces; they had neither the smoothness of line nor the finish of today's work. There are two main reasons for this. First, it took time for the carvers to become familiar with the techniques needed for the

[6]It should be noted that the clay figurines found archeologically in the area and that are generally attributed to the Seri, although not by themselves, are quite abstract (Moser and White 1968). Today's "modernistic" human figures of ironwood, one of the earliest forms produced, have been copied from these earlier clay ones. It could therefore be argued that "Seri art" tends to be abstract, i.e., that the Seri's aesthetic preferences are more toward the abstract. I feel, however, that little present evidence supports this hypothesis. Until there is better temporal control of the archeological material and until there are some data pertaining to the possibility of differential artistic renderings of animal versus human (or perhaps supernatural) forms (i.e., humans treated abstractly; animals naturalistically), it will be premature to speak of a Seri artistic "style."

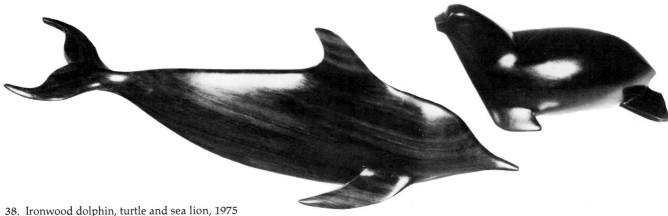

38. Ironwood dolphin, turtle and sea lion, 1975 (17, 14 and 16 cm.).

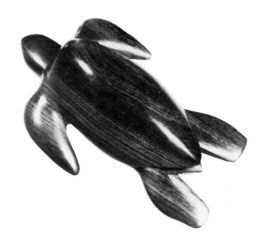

piece, theoretically without knowing who had carved it, a Seri might respond for example, "Well, it's not a bad turtle, but back here by the hind legs it's not quite right. A turtle isn't really shaped like that. It should be more rounded." Comments of this nature have led me to the conclusion that the aesthetic criteria of the Seri, as yet poorly understood, have been partly obscured by those of the market. This phenomenon has probably not occurred to the same extent in basketry; it has, however, made itself felt in necklace manufacture. Whether this submergence of the artist's aesthetic criteria to those of the consuming group is a common feature of the arts of acculturation I do not know. This is, however, a possibility worthy of investigation.

Many of the carvers have developed and are able to maintain their own distinctive style despite attempts by others to copy it. The work of José Astorga and his family is the best example of this. Their seals, for example, all bear a striking stylistic resemblance to one another, as do their dolphins (figure 38), whales, rays, human figurines, and rams' heads, albeit less so for this last category. Several other carvers have one or two forms that bear their individual stamp, although their other forms may be indistinguishable from the

39. Ironwood quail and roadrunner, 1975 (15 cm. and 26 cm.).

work of others. These individual styles are generally more characteristic of the better carvers.

One interesting, and not totally explainable, phenomenon is the temporally nonrandom distribution of the forms in production. One week everyone will be carving seals and the next week seals may be nearly impossible to purchase. For several months after Thanksgiving 1970, carvings of birds, especially roadrunners, were common (figure 39). During this same period, very few sting rays were produced. These fads are in part the result of the market's demands, but not entirely. During the summer of 1969, when I was essentially the only American in the area, I noticed this type of fluctuation, particularly in the production of seals and turtles, although my demand remained constant over this period.

The market has directly influenced production through the differential pricing of various forms. Some of these prices do not seem to reflect the general criterion of size used by the Seri in determining the selling price of a carving (see below). Higher-priced forms are most notably male and female figurines, rams' heads, and, since 1973, winged birds. These pieces are often priced from 25 to 35 per cent above the more common animal forms, such as seals and dolphins, of equal size and workmanship. This differential pricing appears to be the result of a greater demand. For example, I was recently contemplating whether 80 pesos was too much to pay for a male figure. To aid me in my deliberations and to ensure an affirmative decision, the maker assured me that 80 pesos was a fair price, adding that, "If it had breasts it would be worth 100." Female figurines are more in demand by Americans than are male ones (see figure 37).

This anecdote raises a specific question. For the Seri, what are the determining factors in

establishing the value—that is, the selling price—of a carving?

When asked why a certain piece is worth 50 pesos and not 60 or 40, a Seri's usual response has to do with its size, the larger the carving, the higher the price. Quality of workmanship is distinctly secondary. It should not be inferred from these remarks that the larger pieces are not of good quality, only that when questioned the Seri always emphasize size. From their standpoint, larger carvings have four advantages.

First, the carvers maintain that it is easier to make a large piece than a small one. They feel that the smaller pieces, especially the very small ones, are more difficult to carve. Larger carvings do have the second advantage of bringing a higher price. Although I have never actually tested this, I feel it would take less time to produce a carving that would sell for 300 pesos than it would to make four that would sell for 75 pesos each. The larger carvings, then, bring the Seri a higher monetary return per unit of time spent. The third advantage of larger carvings is that their sale brings in a large sum of cash at one time. Since, as noted above, most of the Seri have not yet mastered all the techniques of a cash economy, such as the art of saving money, the substantial sum from the sale of a large carving enables them to purchase items they would otherwise not be able to buy.

A fourth advantage is the more efficient utilization of material the larger pieces afford. The Seri do not yet make the most efficient use of a piece of ironwood. Often at least half the wood is lost in chips, in part because the Seri lack the tools (such as an electric band saw) that could effectively remove large pieces of wood at one time, and thus allow other carvings to be made from the sections removed. Some wood could be salvaged by more judicious use of the hacksaw, a tool that I have never seen a Seri use in the initial stages of work, but the density of ironwood makes it easier to work with a hatchet or machete than with a hand saw. These considerations would be of little consequence were there an inexhaustible source of ironwood, but the supply is limited in this barren desert area, as is also the Seri's mobility. Almost all the ironwood within walking distance of the villages has been used, and much of what is now being carved is brought in by Mexican truckers. The cost of this service has risen sharply, which is one of the reasons for the concomitant increase in the selling price of carvings. The Seri now have to buy much of the ironwood, and the larger carvings are more profitable because their manufacture more efficiently utilizes this resource.

Whether the potential supply of ironwood is sufficient to meet the demands that will be placed upon it in the next decade or so remains to be seen. Ironwood carving is the backbone of Seri craft production. If the craft industry is to continue as a vital part of the Seri economy in the future, a shift to some other type of wood, or even to stone, may be necessary. If the Seri economy should continue to expand at its present rate for the next few years, and if it were then to crash, because the ironwood supply had run out, and hence wood carving had stopped, the resulting effects upon the Seri would be disastrous. Although it is to be hoped that this will not occur, the solution to

this potential problem of an economic collapse is not forseeable at this time.

As noted above, the Seri consider the size of a carving to be the primary determinant of the value or price of the piece. Their viewpoint as producers, however, is only one side of the coin; the buyer must also be taken into account. Most buyers of Seri ironwood carvings are Americans who fall into two categories. The first is the tourist, who wishes to acquire a few pieces as souvenirs of the Seri Indians; the second is the commercial buyer, who resells the carvings to shops in the United States. Each group, naturally, is seeking a different type of carving.

There is such a great demand created by the tourists in the area of the Seri that sooner or later any carving, good or bad, large or small, can be sold, often for a price that approaches the wholesale price in the United States. At the peak tourist period, Easter vacation, it is not rare to hear of carvings selling in Kino Bay for the same price they would retail for in the United States. During a year's time the tourists are responsible for the majority of the carving purchases, both quantitatively and monetarily. Since the commercial buyers pay no more than half their wholesale price, it is obvious that the tourists are the better customers as far as the Seri are concerned. Commercial buyers, however, buy in large quantities and often come when there are few tourists, in the extremely hot and relatively humid summer months, for at such times there is less of a demand and consequently lower prices.

I feel that the commercial buyers, as a group, usually try to be more discriminating in their choice of carvings than the tourists, for the simple reason that what they acquire must be resalable. In addition, they are more aware of the range of quality available and of the existing price structure. For them, quality of workmanship, rather than size per se, is the primary consideration. Nonetheless, they usually try to keep a large percentage of their carvings under 25 dollars retail, for many shops, especially those that handle a large quantity, have found that these sell the best. For a myriad of reasons they are not always successful in obtaining what they would prefer.

It should be obvious that the Seri values often are at odds with those of the commercial buyers. As a rule, the buyers would rather purchase a smaller, well-executed piece (for a lower price), whereas the Seri would rather make a larger piece (and sell it for a higher price). Since the tourists' preferences tend to reinforce the Seri values and, in addition, because the tourists as a group annually buy substantially more carvings and at higher prices,[7] the commercial buyers have little effect on the price structure of the carving industry.

This situation contrasts with that in the American Southwest, where the middleman,

[7]One might roughly estimate that during 1971, more than 1,000 carvings were imported into the United States for resale, with a total retail value of over $20,000. This represented a $5,000+ income for the Seri. In contrast, the volume of tourist sales may have been (conservatively) three times greater. Couple this with the fact that tourists paid a higher than average price per carving, and the Seri's income from this outlet reached an estimated $25,000, or a total annual (1971) income from carvings alone of $30,000. In other words, the mean income *per carver* (an estimated 150 carvers) was over $200, a figure that has risen continually every year since then.

usually the proprietor of the trading post, has had a fair amount of control over the cost of craft items, at least until recent years. Although there are Mexican storekeepers in the Seri villages who could have at least attempted to assume this role, none of them did so. The Seri sell directly to the Americans. Any car that arrives is immediately surrounded, usually by the women trying to sell their wares. If the sightseer is interested in buying, the crowd can remain large and boisterous for a considerable time.[8] Many first-time visitors find the forwardness of the Seri's selling methods overwhelming and generally in contrast the those encountered in other areas of the United States and Mexico. Although somewhat unorthodox, this approach has allowed the Seri to receive a much higher return for their work than they would have if the Mexican storekeepers had assumed the role of middlemen.

Most of the carvings purchased commercially are taken to the United States. A few are sold at the motels and restaurants in Kino Bay and the tourist shops in Hermosillo, and some may also have been taken to Mexico City. Several thousand carvings[9] have been brought to the United States both for personal use and for resale. Although they are a recent addition to the "primitive" art market, they have obtained a wide distribution. Shops in Tucson, Phoenix, Gallup, Albuquerque, Santa Fe, Los Angeles, San Francisco, Chicago, and New York either carry them as a standard item or have handled them at various times.

No systematic study has been undertaken regarding the appeal of these carvings to the "average" buyer, but it would appear that many people think rather highly of them, for individuals often buy more than one. There are, however, three factors that inhibit the sale of the carvings. First, having recently appeared on the "primitive" art market, they are not yet as well known as other ethnic art forms from the Greater Southwest, such as Navajo rugs or Hopi Kachina dolls. A second and related consideration is that many buyers prefer something they think of as "Indian," not Mexican; for such buyers, there are no Indians south of the United States border! The third factor is that their sleek lines and high polish do not fit preconceived ideas held by some of what "primitive" art should be. These factors, however, do not seem to be serious deterrents to the sale of the carvings.

SUMMARY AND PROSPECTS

In conclusion, it can be said that today Seri ironwood carving plays a vital role in that society's changing economy. Predictions of future trends are bright but speculative. Since its inception and encouragement, mainly by importers from the United States, Seri art has shown continued volume growth. It was not until the 1970s that the government of Mexico began to take a promotional interest in these arts and encouraged sales drives and exhibitions. By this time, the Seri had already gained

[8]This behavior is not a recent development in response to the increase in tourism. The Coolidges (1939) encountered a similar forwardness when they visited the Seri in 1932.

[9]See note 7.

some renown, especially abroad, and were economically more secure and independent than most Indian peoples in rural Mexico.

In 1974, the Mexican government agency, BANFOCO, stepped in to become a large-scale buyer in competition with the North American clientele, with the expressed aim of providing a minimum monthly income as well as more regular demand, ironing out the previous seasonal lows. This has relieved the Seri of much of their dependence on fishing and turtling, and, along with a steep rise in the price of baskets, it has greatly increased their annual cash income. At the same time, the Seri have become more of a recognized power in their area and have regained some of their former rights to their aboriginal homeland on the island of Tiberón. With the increase in volume, ironwood has to be trucked in from further away, but the mainland supply is dwindling, leaving the uncut stands on Tiburón as a last possible resource.

The future depends upon other considerations, such as Seri land tenure, Mexico's plans for the development of the entire Sea of Cortez area, and the Mexican government's continued interest in Indian affairs. Such factors as these and the Seri's eventual acculturation into the general milieu of the state of Sonora can only be mentioned in passing.[10]

[10]Neither can this paper explore other factors, such as the effects of settlement pattern (denser and more permanent living conditions), of Seri health (dietary changes, garbage accumulation, potentially easier communicability of disease; but at the same time, greater accessibility to medical care), or on social organization (inflation in the bride price system) of this change-over to a cash economy.

7. Modern Ceramics in the Teotihuacán Valley[1]

Thomas H. Charlton

The Teotihuacán Valley, which is located in the northeast section of the Valley of Mexico (see map 3), runs 22 miles from northeast to southwest, sloping gently to the southwest. On the south, the valley is limited by the Patlachique range, a westward extension of the Sierra Nevada, the eastern border of the Valley of Mexico. The eastern edge of the valley is defined by a low range of hills that separate it from the Apan Basin. To the west, the valley ends with the shore of Lake Texcoco. On the north, a series of ancient, isolated volcanoes provides an easily defined border.

The valley floor has an elevation of 2,240 meters (7,351 feet) at the edge of Lake Texcoco and gradually rises to 2,350 meters (7,712 feet) near the town of Otumba. The maximum elevation to the north is 3,050 meters (10,010 feet), the peak of Cerro Gordo; to the south, Cerro Patlachique reaches 2,760 meters (9,058 feet).

The Teotihuacán Valley had an estimated Aztec population of 110,000 in 1520 (Sanders 1965:figure 14). Following the Spanish conquest in 1521 the population declined, reaching a nadir of about one-tenth of that size by 1650 (Gibson 1964:141). The population in the area has increased since 1650 and now reaches about 55,000, according to the 1960 Census.

The present population is derived from the Aztec occupants but has been heavily influenced both biologically and culturally.

Thomas H. Charlton was awarded his Ph.D. in anthropology from Tulane University and is now Associate Professor of Anthropology at the University of Iowa. He has carried out archeological and ethnohistorical research in the Valley of Mexico for nearly a decade and has written numerous papers on the subject.

[1]The research upon which this paper is based has been supported by the Canada Council (1966), The Associated Colleges of the Midwest (1967), the University of Iowa (1968, 1970), and the National Science Foundation (GS 2080, 1968–1971). I wish to express my thanks and appreciation for the support received.

My thanks are also expressed to the following students who have participated in the archaeological and ethnographic work upon which this paper is based: R. Alex, J. Ball, K. Bell, D. Brodkey, C. Carney, R. P. Carney, J. Easton, N. Ewart, P. Hubbard, L. Lasansky, G. Mayberry, M. O'Dea, J. Rauh, M. Spriestersbach, and L. Zimmerman.

Research into Mexico was carried out with the permission and help of the *Depto. de Monumentos Prehistoricos* of the *Instituto Nacional de Antropologia e Historia*. Ignacio Marquina, the Director, and Eduardo Matos M., and sub-Director of *Depto. de Monumentos Prehispanicos* helped and encouraged the research.

There is no "Indian" cultural component in the valley today. All speak Spanish, with little or no Nahuatl being used. Spanish probably became the major language only in the nineteenth century with the introduction of federally controlled schools.

There are two urban communities in the Valley, San Juan Teotihuacán and Otumba, and six incipiently urban communities (Sanders 1965:49). About 30 per cent of the total population resides in these communities, the rest living in smaller, subsistence communities. The urban communities are located on the Valley floor, and the more rural communities tend to be situated on the surrounding hillslopes.

A Summary of Anthropological Studies

The Teotihuacán Valley has been the focal point of a long series of anthropological studies. The sustained interest in this small sub-valley within the larger Valley of Mexico has been due largely to the impressive ruins of the city of Teotihuacán. The first scientific excavations began in 1864 and have continued at irregular intervals to the present.

Although archaeological studies in the Teotihuacán Valley have a long history, ethnological studies are relatively recent. Gamio (1922) reports the first such studies done in the valley, and includes a brief discussion of ceramics. Later studies by Sanders (1957), Millon (1962), Millon, Hall, and Diaz (1962), Nolasco Armas (1962), Charlton (1966), Diehl (1966), Casanova Alvarez (1966), and Ortiz and Aparicio (1966) have emphasized agricultural technology, settlement patterns, and social organization. One of Sanders' students studied pottery making in San Sebastian (Sanders 1963:77), but no report has been published. The most complete study of this area is to be found in *The Cultural Ecology of the Teotihuacán Valley* (Sanders 1965).

Anthropological interest in Mesoamerican ceramics began in the nineteenth century and has continued with research on both earthenwares and more sophisticated *majolicas* (Foster 1967a; Goggin 1968). Studies have utilized a variety of approaches to the materials, including esthetic appreciation, stylistic analyses, focus upon the artist and his product, technology, and the socioeconomic framework surrounding pottery making. There have also been efforts by archaeologists and others interested in archaeology to utilize modern pottery manufacturing and distribution data to understand better the ceramics of the past (Thompson 1958; Friedrich 1970).

Foster (1965) has taken one step beyond the study of individual styles of local areas and their associated technology and socioeconomic framework. His summary of a wide variety of studies is accompanied by a new framework for studies of Mexican pottery, that of the emerging and still changing tourist impact—both Mexican and American. This impact has resulted in greater contact between producers and distant markets and has increased pressure for stylistic changes.

CERAMIC TRADITIONS IN THE TEOTIHUACÁN VALLEY

In 1967 I began studies of modern ceramics sold in the two major weekly markets held

in the Teotihuacán Valley, the San Juan Teotihuacán market held on Mondays, and the Otumba market held on Tuesdays. These studies were part of a comprehensive project designed to provide archeological, ethnohistorical, and ethnographic information on the postconquest colonial and republican periods, 1521–1968, of the eastern Teotihuacán Valley (Charlton 1968). I continued my research through 1969 and during the summer of 1970 and although it is not complete, I shall present in this paper some of the emerging results and remaining problems.

San Sebastian Teotihuacán

San Sebastian, a town of 1,013 people in 1960, is the only community producing ceramics within the Teotihuacán Valley. The town has a number of pottery-making specialists and brick-making specialists. It appears to be an agricultural community, with the bulk of the population relying on subsistence agriculture for support, but no detailed studies to determine this have been carried out.

Two basic kinds of pottery are manufactured in San Sebastian. One is a glazed domestic pottery, which may be either decorated or undecorated. The decorated pottery is either a bichrome black-on-orange decoration or a polychrome black-and-white-on-orange decoration (figure 40). The white of the polychrome turns yellow after the glaze is applied over the decoration. The other basic kind of pottery is unglazed but usually quite well burnished. (Burnishing is the postfiring polishing of the surface of the unglazed vessel with a hard object, probably a stone, which results in a high gloss or sheen on the surface.)

One variety is polished red with buff designs that are frequently accented with incisions or engravings made after the firing; another is polished black with incised designs into which a white pigment has been rubbed. In 1970, there appeared on the stands for the first time a polished buff ware with white accented incisions identical in both form and design to the polished black with incised designs (figure 41). This ware appears to be the polished black ware fired in such a way that the clay does not turn black. The forms of the unglazed pottery vary, but frequently emphasize "archaeological" themes such as pyramid forms, dishes

40. San Juan Teotihuacán Market, San Sebastian domestic pottery with polychrome decoration.

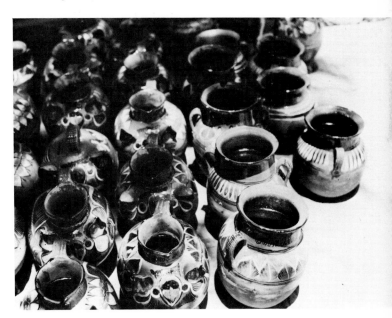

41. San Juan Teotihuacán market, San Sebastian tourist pottery.

with variations on the Aztec calendar stone, elaborate figurines, and vessels with figurine heads applied as decorative elements. These wares appear to be designed for the tourist trade rather than for domestic use. The ruins of the city of Teotihuacán are frequented by Mexican tourists from Mexico City on weekend outings. Most of the tourist wares are sold in San Juan Teotihuacán on weekends and at *fiestas*. The incised white-on-black ware dates back at least to the 1880s and may have started as early as the beginning of the nineteenth century. Even during this period, there were tourists, who, according to Holmes (1886, 1889), were Americans and Eu-

ropeans; some of these imitation vessels were even sold to the National Museum (Holmes *op. cit.*; Charnay 1885:38).

Imitation figurines and reproduced archaeological figurines are also made locally and sold as part of the tourist-ware complex in San Juan Teotihuacán. On the one hand, imitation figurines are completely modern, being made with new molds or by hand from the artists' imagination of what pre-conquest figurines looked like. Reproduced figurines, on the other hand, are made by using the original molds but are manufactured recently and treated artifically to give them an "aged" appearance. These old molds are usually Teotihuacán but the whole topic of reproduction needs more intensive study. According to Gamio (1922), this type of manufacture has been going on since early in the twentieth century.

There is a possibility that some of the obvious tourist wares are made in San Francisco Mazapan, a town located slightly to the north of San Sebastian. At least one potter in San Sebastian, however, produces both the domestic glazed wares and the polished black ware with the incised white designs.

In the spring of 1969, I directed the study of the methods of one potter manufacturing glazed wares in San Sebastian. Eight different mushroom molds were used to construct the variety of pot forms. The clay is first patted out into a circular flat piece, and after the mold is covered with a white powder made of crushed *tepetate* (a local volcanically derived and fluvially deposited subsoil conglomerate) the piece of clay is centered over the base and tapped onto the mold. The potter smooths the

surface of the clay by holding the mold in one hand and turning it against a damp cloth in the other hand. Then both mold and clay are set aside for about 10 minutes, after which the clay separates from the mold and is removed. If a jar is being made, two molded forms are joined at this time. These molds dated back to 1928 and were considered very valuable, since they had been fired at an extremely high temperature and were purchased from a now-deceased specialist in San Sebastian; it was claimed that only he knew how to make them. The family making the pottery said that they either dug the clay themselves, locally, or purchased it from someone who came by monthly. (I should note that they were reticent about going into detail in discussing the clay and the molds.) The actual construction of the pottery was carried out by a married daughter of the potter.

Once constructed, the pots are left to dry for two days in the house on a floor of dampened mud, which prevents too rapid drying that would result in cracks in the walls of the vessels. After they had dried, the pots were painted by the potter, his young son, and (on the occasion of my visit) by an acquaintance who happened by (figure 42). The materials used to make both pigments and glaze were probably purchased in Mexico City, but again there was reticence about the exact sources and costs.

In painting, about fifteen human-hair brushes were used, each when wet forming a tear shape with a very fine point. Two colors were applied, black and white. There was no preferred sequence of application, although one would be allowed to dry before the other

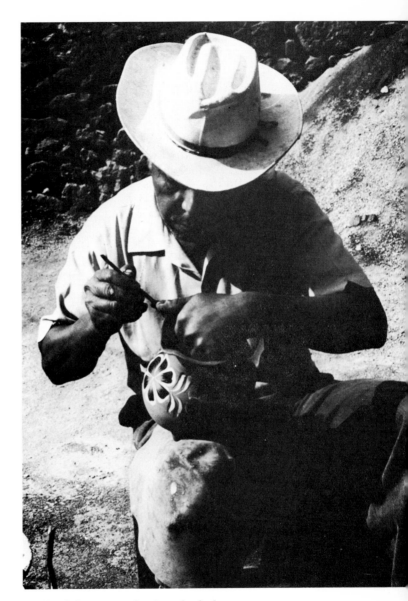

42. San Sebastian, application of polychrome decoration.

was applied. Two pots were painted at the same time. To apply horizontal lines the vessel was moved against the brush and rotated by one hand inside the pot. After the outline of the decorative zone was finished the main decoration was applied. Names picked at random as a sales-enhancing device were painted on some of the jars, the lettering being done with greater care than the application of the horizontal lines (see figure 40). Folk aesthetics was not the focus of the study, but we observed that the application of designs appeared to be done with as much speed as possible and that a number of persons with vary-

ing degrees of competence actually carried out the decorative process.

When the decoration was completed, two firings were done. The first, lasting for about two hours at a relatively low firing temperature, is a bisque firing to dry the pots thoroughly so that the next firing, at a much higher temperature, will not cause crackling, which results from moisture in the clay breaking the glaze. After the first firing, the pots were glazed and then fired a second time at a much higher temperature for about 45 minutes.

This family sold very little of their pottery directly in the markets, but instead delivered it to a specialist middleman, who took it to market and sold it on a commission basis.

43. San Juan Teotihuacán market, stand of commercial vendor.

Markets and Ceramic Distribution

The major sources of pottery bought by the inhabitants of the Teotihuacán Valley are the markets held in San Juan Teotihuacán and in Otumba. Pottery is also always available at the permanent fruit and vegetable stands in the Teotihuacán market building and in stores in both San Juan and Otumba, which obtain their pottery from vendors at the weekly markets. Frequently, pottery sold by a random itinerant vendor is available in the stores for weeks afterwards. A permanent stand specializing in tourist wares from many different parts of Mexico has recently been established in the market building at San Juan.

Some pottery purchased at the weekly markets is also sold in the stores in the many small towns around San Juan and Otumba, and occasionally pottery-sellers set up stands in the plazas. The sources of their pottery vary.

In one instance, it had been bought from a potter at Santa Cruz de Arriba, near Texcoco.

In the two major markets, at San Juan and Otumba, there are two basic kinds of pottery vendors, the local San Sebastian potters who sell pottery they have manufactured themselves, and commercial vendors with their own trucks who bring pottery from many different communities.

In the San Juan market, there is usually one woman from San Sebastian selling her own ceramics, along with a good admixture of tourist wares from other parts of Mexico; but she sells no tourist wares from San Sebastian. There are two commercial vendors in the San Juan market (figure 43). Most of their domestic pottery comes from Michoacan or Real del Oro, a small town on the border between the states of Mexico and Michoacan. Technically, these types of pottery are identical and are typical of that general region, as described by Foster (1955). These vendors also sell some pottery produced in a *barrio* of Texcoco (Santa Cruz de Arriba). Occasionally some of their pottery comes from San Marcos Acteopan, a small pottery-making town in southwestern Puebla near the Volcanoes (Lameiras *et al.* 1968). In addition, they sell tourist wares originating in the town of Dolores Hidalgo, in the State of Guanjuato. This town supplies most of the tourist wares sold in the permanent stand in the market building.

On Tuesdays, the two commercial vendors move from San Juan to the Otumba weekly market. There, two potters from San Sebastian, one man and one woman, sell their products. Two other stands in the Otumba market are stocked with wares from Tulancingo (Hi-

44. Otumba Market, stand of local commercial vendor with trade wares; Oaxaca *majolica* in the foreground.

dalgo), Toluca (Mexico), Oaxaca (Oaxaca), and Dolores Hidalgo (figure 44). At one time (1966), a potter from Almaloya (Hidalgo) had a stand in the Otumba market, but she was no longer there in the summer of 1968, nor in 1969 or 1970.

Into this pattern (observed during 1969 and the summer of 1970) there appear upon occasion itinerant vendors who come to either or both markets for one or two weeks and then are not seen for months. These vendors come relatively great distances by truck. During the summer of 1970 one brought pottery from the

45. Otumba market, Tepalcingo pottery trucked
in from Morelos by an itinerant vendor.

well-decorated wares. The Oaxaca pottery consists of the Majolica described by Goggin (1968:201) in bowls and mugs. The Dolores Hidalgo wares include earthenware bowls with polychrome interior designs and a majolica so far unstudied. Pottery from the other sources includes domestic earthenwares in the form of bowls, basins, *ollas*, and jars. The main distinctions are to be found in designs, which are executed in black, white, and green, with black being the predominant color. Pots from Tulancingo frequently have incised designs as well as painted ones.

An examination of the pottery sold in the two markets indicates that the range of pottery available in Otumba is greater than that in San Juan. Not only are more traditions of domestic wares represented in the pottery sold in Otumba, but also traditional forms with pre-conquest antecedents, such as *comales*[2], and *molcajetes*,[3] are more readily available there. This pattern probably reflects the fact that San Juan is more urbanized and acculturated than is Otumba. San Juan, with its barrios, has a population of about 5,000 (1960). Otumba has only about 1,900 (1960) inhabitants. Both are seats of municipal government with transportation, communication, schools, and other services available. Otumba is farther from Mexico City and appears to be less prosperous than San Juan. Since San Juan lies at the end of the

Morelia (Michoacan) region to sell in San Juan. In Otumba in 1969, a vendor came from Atixtlan (Puebla) with pottery from that town and set up a stand for one week. During the summer of 1970, a vendor came from Tepalcingo (Morelos) with pottery from San Marcos Acteopan and sold it for several weeks in Otumba (figure 45).

Pottery from Oaxaca and Dolores Hidalgo tends to be restricted to a few forms in

[2]*Comales* are flat clay griddles with roughened bases used to cook tortillas.

[3]*Molcajetes* are hemispherical bowls with annular bases or tripod supports. The interior is incised in a cross-hatched pattern for the grinding of condiments, including chiles.

toll road, many people commute daily to work in Mexico City and the community has a weekly influx of tourists from the capital.

Summary of Available Pottery

Pottery for domestic use in the Teotihuacán Valley originates in several areas and ceramic traditions. Included are local wares produced in Texcoco or San Sebastian, wares of the Michoacan complex, and wares from Tulancingo. These make up the bulk of the domestic-type wares used in the valley. More elaborate wares, but still domestic in use, come from Dolores Hidalgo and Oaxaca. These are not as prevalent as the other wares, but still form a recognizable part of the pottery available.

The markets of San Juan and Otumba differ somewhat in their ceramic assemblages. Pottery in the Otumba market tends to have more affiliations with sources to the east, northeast, and south than does pottery in the San Juan market, which tends to have a west and northwest orientation. This is particularly true of the pottery sold by random itinerant vendors. Traditional ceramic forms are more easily obtained in the Otumba market, including such items as molcajetes and comales, mentioned earlier. These are derived directly (although there are some modifications) from the prehistoric Aztec wares.

Pottery is transported from towns as distant as 200 miles, although a distance of 100 miles from source to market is more common. Probably the toll road from Mexico City to Queretaro, recently widened to four lanes, has influenced the influx of more Dolores Hidalgo

wares into the markets of the Teotihuacán Valley.

MODERN POTTERY AS AN ARCHEOLOGICAL COMPLEX

Although it is possible to identify with relative ease the sources of whole vessels, the problem becomes much more complex for the archeologist in dealing only with sherds. Glazed earthenware sherds fall into one of three possible classifications: they are monochrome, bichrome, or polychrome, according to the number of colors used in the decoration. Of these earthenware-glazed sherds, only the polychromes can be easily identified. Some of the more exotic trade wares from Dolores Hidalgo and Oaxaca also lend themselves to easy identification. Bichromes and monochromes, for the most part, are unidentifiable as to origin. The very obvious ethnographic complexity of the sources of contemporary pottery used in the Teotihuacán Valley becomes lost in the archeological record of these wares. When pottery is examined in complete forms in the markets today, it is possible to determine sources of most of the vessels through the identification of design variants and occasionally of techniques of construction. When the same pots are broken into fragments, it is possible to identify the sources of only a few of the sherds because the design has been lost in the breakage.

The problem is complicated by the nature of the painted designs, most of which are

simple, lack detail, and accent the parts of the vessel on which they occur. Thus the chances of a recognizable fragment of a design being preserved on a sherd are quite small. The designs painted on modern ceramics are found on the interior rims, the exterior necks and shoulders of ollas and jars, and on the interiors of bowls and basins. The least distinctive of all designs are made up of black lines or smeared blobs that are similarly arranged on many different wares. The addition of a third color, usually white but sometimes green, provides a more positive way of identifying the source. Here again, however, the designs seem to be conceptualized in terms of the entire vessel as one field, with large motifs that are not readily discernible on small broken sherds.

The designs on preconquest and early postconquest Aztec pottery were quite detailed, complex, and covered entire surfaces of vessels (Parsons 1966). The Aztec designs, particularly black-on-orange, were painted with repeated motifs, usually on the exterior or interior rim of a vessel, but occasionally over the entire interior surface. With this type of design, usually linear but occasionally realistic, it is possible to determine the design from even a small sherd. This is not possible with modern ceramics.

Fischer (1961), in his paper "Art Styles as Cultural Cognitive Maps," has suggested that there are certain sociocultural correlates to features of art styles. The differences between Aztec and contemporary pottery designs should be examined systematically to determine if there are any significant correlates with differences in sociocultural organization.

The pottery manufacture and pottery distribution of the Aztecs was a more complexly organized procedure than at present. Guilds probably controlled both production and sales. The uniformity of the complex Aztec ceramic designs over a wide area within the Valley of Mexico after Aztec II suggests "the production of at least major decorated pottery types in large regional centers, and the distribution of this material outward to all sub-regions of the Valley of Mexico by means of a complex system of periodic markets and specialized producers and distributors" (Parsons 1966:462). Today, pottery making is a very simple home craft that utilizes several varieties of distribution. It is possible that the shift from complex to simple designs may be related to a parallel shift from complex to simple organization of production and distribution.

There is no need to assume, as does Foster (1965), that the simple type of production and distribution present today represents various situations in the preconquest civilizations of Mesoamerica. Since it is likely that major changes have taken place, it is misleading to use the ethnographic situation to comprehend the archeological data in this instance.

The Archeological Background

Following the Conquest in 1521, the decorated black-on-orange ceramics of the eastern end of the Teotihuacán Valley initially underwent a florescence, resulting in the production of styles usually referred to as Aztec IV or Teacalco (Parsons 1966), and previously considered to have been preconquest. The preconquest styles continued along with the

new styles and survived them, lasting into the eighteenth century. After 1600, however, most decorated wares were not produced in any quantity.

Between 1650 and 1720, majolica and monochrome glazed pottery were introduced into the area, probably from Mexico City where there is evidence that such pottery was present in the sixteenth century after 1521. The monochrome glazed pottery gradually increased in frequency during the eighteenth century, replacing the plain orange ware of the Aztec ceramic complex.

Decorated glazed ware (earthenwares) did not appear in the eastern Teotihuacán Valley or in Mexico City until the beginning of the nineteenth century. The decorations were simple bichrome black-line decorations. The introduction of this type of decoration may be seen in the many paintings of kitchens dating from the nineteenth century. It is also represented in dated archeological samples. During the latter part of the nineteenth century, the San Sebastian polychrome style emerges and is fully developed by 1917–1922, when it was recorded by Gamio.

During the twentieth century, the main development in the Teotihuacán Valley has been the introduction of ceramics from many other parts of Mexico. It is possible that an elaborating ceramic sequence, one in which more and more types of pottery appear over time, also took place in those areas, and that with the introduction of improved transport greater quantities of pottery began to be exchanged. I do not think that too many ideas are exchanged or acquired through market contacts between potters, although I have never studied this aspect of the problem. Given the number of nonpotter vendors, the *commerciantes*, it would seem likely that the main influence would not be on designs and innovations but on the production of items that sell, as seen by the vendor and communicated to his sources of pottery.

SUMMARY AND CONCLUSIONS

Today the Teotihuacán Valley may be viewed as a microcosm of ceramic distribution in Mexico; large amounts of pottery are brought great distances to be sold in the area and include not only utilitarian domestic wares but also trade or tourist wares, sold to the tourists who visit the site of Teotihuacán on weekends. In part, the variety of pottery sold in the valley may reflect the continued importance of this area as a natural route into and out of the Valley of Mexico.

Yet this pattern of pottery distribution within the Teotihuacán Valley appears to have existed no more than 70 years. It is dependent upon good transportation and an increasing indigenous tourist population.

The possibility of applying this model of manufacture and distribution to the preconquest period seems remote when both the archeological record and the nature of the designs are considered. The implications are that the system of production and distribution of Aztec pottery was much more complex than that for modern pottery. The Aztec system collapsed after the conquest and a new system, with its own patterns of manufacturing and

distribution, developed. The development of this system is a reflection of the reintegration of Mesoamerican society on new bases during the colonial and republican periods.

The local San Sebastian potters have recognized the tourist market for about a century. They have produced the various incised and unglazed polished red, polished black, and polished buff wares for both Mexican and foreign tourists visiting the pyramids. These wares are sold in the Teotihuacán Valley only at San Juan. In addition, they have produced various forged and reproduced figurines for the same market (discussed above).

Recently, the permanent stand of pottery in the San Juan market building has added immense quantities of Dolores Hidalgo majolica, apparently to sell to the same tourist market. This ware, the polychrome bowls from the same town, and the Oaxaca majolica may be considered exotic imports. They are sold in both markets on a regular basis, along with more conventional domestic earthenwares. The earthenwares sold throughout the area appear to compete with each other and with the local products for the local domestic market. In addition, they all compete with the whitewares and metal vessels sold in both markets. As far as I have been able to determine, the earthenware pottery from other areas sold in the valley is not produced especially for that market area but is the same ware as that sold in the areas where it is produced.

8. The Amate Bark-Paper Painting of Xalitla

Gobi Stromberg

The development of the bark or *amate* paintings in Xalitla and in four surrounding communities in the State of Guerrero, Mexico, is notable for its remarkably rapid spread to markets throughout the world. Although the origin of the bark-paper paintings dates back only to approximately 1959, the majority of the adult members of these communities and many children as young as seven or eight are engaged in their production. For the past decade the sale of the paintings has constituted an important if not a primary source of income for the entire community.

This new art form, which initially consisted of transposing the traditional ceramic designs onto amate or bark paper found a very positive response from the market. The "primitive" quality of the colorful fauna and flora designs was accentuated by a type of paper going back

Gobi Stromberg did her graduate work in anthropology at the University of California, Berkeley, where she is now completing her dissertation on the silver industry of Taxco, Guerrero. She has lived most of her life in Mexico and has done considerable research on the commercial arts and crafts of Mexico.

to pre-Columbian times, and unlike fragile ceramics, the paintings could be easily shipped abroad for foreign consumption.

As the production of paintings developed, the promising future of this new enterprise, its beginnings as a progressive artistic tradition, and its function as a channel for the rural artists to participate more actively in the national economy were severely threatened. What rapidly ensued was a shift to the mass-production of relatively standardized designs and ever-smaller profit returns for the painters.

The recent origin of amate painting provides an unusual opportunity to follow the conditions that have led to or accompanied the processes that the artwork has undergone since its inception.

Bark paintings are currently being produced in the communities of Xalitla, Maxela, Santiago Ameyaltepec, and San Agustín Huapa, but it is in Xalitla that bark painting has received its greatest impetus. These communities are all within a day's walking distance of each other and are located in the northern

portion of Guerrero, approximately 150 kilometers from Mexico City (see map 3).

The Area

The State of Guerrero possesses certain characteristics that distinguish it from the nation as a whole. Although the state contains two of the nation's major tourist sites, Taxco and Acapulco, and possesses vast and rich mineral wealth, it receives one of the lowest governmental subsidies and ranks among the poorest states in the republic. Furthermore, although Guerrero, particularly in the northern portion, assumed an active role in the Mexican Revolution of 1910 and in the institution of agrarian reform, support and assistance from the government has been only rudimentary. The Guerrerenses' response has been to adopt a defensive position toward governmental agencies and outsiders. Within Mexico, Guerrero is viewed as being a region of violence, bloodshed, and family feuds. This reputation correlates with a marked paucity of anthropological research in the area.

On a more pragmatic level, these attitudes are reflected in a negligible extension of legal and political control in the area, as well as in the physical isolation of many regions, until recently cut off by the absence of communications and roads. In spite of their proximity to the Mexico City-Acapulco highway (the state's major line of transportation), these communities still maintain many features of "Indianness": monolingualism (Nahuatl), traditional Indian dress and customs, and religious syncretism. A greater integration into the national culture has taken place in Xalit-

la, however, than in the more isolated communities.

The older members of the community can trace Xalitla's history to the pre-Hispanic period, when it bore the name of Xochicueltla (which translates from Nahuatl as "the flower which hangs"). The government's grant of *ejido* lands provided additional lands for the community; however, in the government's recent redefinition of community boundaries, Xalitla lost much of this land (some say as much as 50 per cent) to the adjacent villages, leaving many of the Xalitleños without land.

Until the last decade, the people of Xalitla and the surrounding communities relied almost exclusively upon the land for subsistence and cash income. The primary crops were corn and sugar cane—both of which provide relatively low returns on the invested time and labor. Marketing and trade have been restricted until recently to the towns and villages in the surrounding areas and in the cyclical *ferias* (fairs).

One of the first instances of trade with "outsiders" was in the 1940s with the sale of pre-Columbian artifacts to William Spratling, the promoter of the silver industry in Taxco. In an effort to expand his private collection and to insure a "first choice" of the pieces, Spratling purchased almost everything the people brought to his ranch, regardless of style or quality. As the Spratling collection grew and more pieces became available, the "rejects" were offered by the peasants to other collectors and tourists on the streets in Taxco and Cuernavaca.

Another source of monetary income, which arose in the 1950s, was the sale of live iguanas

to tourists on the highway. In both enterprises, the people of Xalitla were most actively involved. Today, the sale of paintings has come to be the major source of income.

CONTEMPORARY ARTS AND CRAFTS

Little has been written on the social life of the Guerrerenses, and even less has been reported on their traditional arts and crafts. Although the crafts of Guerrero have not received the attention given to those of the better-known craft centers of Michoacán, Oaxaca, or even Puebla (Foster 1967a and b, Gayton 1967, Manrique 1969), they do in fact represent a substantial contribution to the craft production of the country. The more outstanding Guerrero crafts include the lacquerware of Olinalá (Jenkins 1946), the goldwork of Iguala, and the silver jewelry industry in Taxco (Davis 1964; Stromberg n.d.). There is also a variety of ceramic traditions, basketry, the carving of wood and masks, and an abundance of souvenir art from Acapulco made from seashells. The type of crafts produced in the communities neighboring Xalitla consist mainly of ceramic wares, clay figurines, and basketry.

Until recently, the people of Xalitla did not produce any pottery of their own, but relied upon the potters of San Agustín Huapa for their ceramic household utensils. The style of painting on these ceramics is important because it was precisely this style that the Xalitleños copied when they began to paint on bark paper.

Until the 1960s, the ceramic style of painting characteristic of the area had consisted of cursive faunal and floral designs, primarily animal figures, in a reddish-brown slip on an off-white base (figure 46). (For an elaborate description and analysis of the motifs and designs on these ceramics, see Golde 1963; Golde and Kraemer 1973). During the initial stages of *amate* painting, the designs closely adhered to those of the ceramic pieces, emphasizing the

46. Original brown on white "Fauna and Flora" ceramic design, alongside new more complex polychrome design developed on *amate* and transferred back to ceramics.

floral motifs, and later including other zoo-
morphic figures. As the painting developed,
the animals became more stylized—for exam-
ple, the birds assumed the forms of peacocks
and birds of paradise, with long tails and ela-
borate plumage. This stage also included the
filling in of space with smaller swirls and suc-
cessive dots, reminiscent of *art nouveau* motifs.
The origins of this art style are difficult to
ascertain, but several interesting possibilities
exist regarding its scope and background.
Parallels and similarities in the designs and
motifs on the ceramics produced by Xalitla's
neighbors and those of Tonalá, Jalisco, sug-
gest that common ideas pertaining to artistic
representations are present in both areas.
These similarities can be explained by (1)
contact and exchange at the Indian ferias, or
(2) a common, or at least a long-standing, tra-
dition, dating back to the precontact period.

The inhabitants of both northern Guerrero
and the Michoacán-Jalisco region participate
in the traditional ferias. Although these ferias
take place in the context of a cycle of religious
celebrations, commercial transactions are of
major importance on these occasions. While
assisting Guillermo Bonfil Batalla in his re-
search of the ferias (1972), we found that these
events are an important vehicle for the disse-
mination of ideas regarding artistic designs
and production techniques. In addition, the
exchange of arts and crafts across ethnic
boundaries constitutes one of the major acti-
vities at the ferias.

If it is true that the locations and move-
ments of the ferias closely parallel those in
existence prior to the Conquest, this would
suggest that ideas regarding artistic processes
have been exchanged through many centuries.
It should also be noted that contact between
these two areas existed prior to the Conquest,
when the Nahuas from the Jalisco-Michoacán
region migrated to the northern portion of
Guerrero (Vivó 1958).

The Use of Bark Paper

The *amate* or bark paper for these paintings
is obtained from the wild fig tree (*amaquahuitl*,
in Nahuatl). Amate paper has been used for
contemporary paintings for only a decade, yet
the usage of amate dates at least as far back
as the Aztec period. Fray Bernardo Sahagún
(1946) devotes a volume of his *Historia General
de las Cosas de Nueva España* to the use of bark
paper before the Conquest. It was employed
not only in the production of codices but also
for rites and ceremonies. The extensive use of
amate paper during this period is illustrated
by the fact that the Aztecs collected 480,000
sheets yearly in the form of tribute from their
subjects (Von Hagen 1954).

European paper and parchment were sub-
stituted for sheets of bark at the time of the
Conquest, but the use of amate for magical
and ritual purposes has continued in some of
the more remote areas, particularly among the
Otomí of Puebla (Toor 1947, Reger 1970, Bat-
tist 1967). The Otomí of San Pablito, Puebla,
employ the amate bark for magical purposes:
for the curing of illness and for casting spells
and inflicting illness. The *curandera* or *bruja*
(witch doctor) cuts the amate bark into figures
(*muñecos*) in a rectangular configuration with
extended arms, which symbolizes the individ-
ual to whom the witchcraft is being directed.

The lighter, almost white, bark is used for "curing" images, whereas the dark-brown bark paper is reserved for black magic.

The techniques by which the bark is obtained and treated closely resemble the methods described by the early Spanish chroniclers (Von Hagen 1954). The men strip the bark of the amate in the spring, before the rains, when the moon is *tierna* (young). The women soak the fibers in streams until the sap is removed, and then boil them in a mixture of ash of lime (*nixtamal*) for several hours. This process loosens the fibers so that the desired colors can be separated into piles, in order to give the bark paper a uniform coloration. Finally, the fibers are placed upon a wooden board and beaten with a stone pounder (called *muinto* by the Otomí) until they are felted together, forming a smooth surface. According to Von Hagen, the Otomí still prefer using the ancient muintos, when they can find them.

Accounts of how the amate paper of San Pablito became known to Xalitla, as well as of the origins of its use for painting, are so variable as to preclude any certainty. One version of the origin of the bark-paper painting is that Señor Max, a Mexico City entrepreneur, knew of the Puebla bark paper, conceived of marketing the paintings as a profitable enterprise, and commissioned some Xalitleños to do the paintings. Another painter claimed that his brother, who had worked as a silversmith in Taxco, was the originator of the amate painting. In Taxco, a number of people claim that bark painting was brought to Xalitla by the late Chato Castillo, a well-known artist-designer who experimented extensively with various new media, particularly metals. Other villagers told me that the innovation was initiated by the Xalitla vendors who sold their pottery-producing neighbors' wares in the cities. Because of the difficulty in transporting the fragile and bulky pots, these middlemen originated the idea of transposing the pottery designs onto a material that would be easier to transport.

Still another version is that the idea of painting on the amate originated at the Museum of Popular Arts in Mexico City. According to Dr. Rubín de la Borbolla, director of the museum, Peggy Golde, an American anthropologist who was studying ceramic designs in this area, had the ceramic artisans record their drawings on note paper, which she showed to Dr. de la Borbolla. For some time, Rubín de la Borbolla had been buying the anthropomorphic images in bark paper. After seeing Dr. Golde's illustrations on paper, he suggested to the San Pablito vendors that they take plain sheets of bark paper to the ceramic producers in order that they might experiment with this medium. When I got in touch with Golde to verify this account, however, she disclaimed any involvement whatsoever.

The catalyst may have been an outsider, but it is remarkable that the villagers of Xalitla, without any kind of a ceramic or painting tradition of their own, demonstrated such a willingness and ability to pursue (perhaps to discover) this innovation. As has already been noted, the Xalitleños had depended almost exclusively upon other villagers for their household pottery. In 1959 a few individuals began to copy the pottery designs onto the amate paper and by 1961 had so mastered the bor-

rowed fauna and flora painting style that they had found an excellent market for their work (see figure 48).

The Marketing of Amate Bark Paintings

The prices the paintings commanded during this initial stage were remarkably high, in contrast to those of more recent years. Soon after they first began the bark paintings, the artists were able to sell their medium-sized (12" x 9") paintings for approximately 50 pesos (U.S. $4).

After the initial experimentation within traditional Indian designs, a nucleus of the original artists began to develop a style of pictorial art with figures and landscape somewhat along the lines of the Hispanic tradition of Mexican painting. Following a format and style representing what they felt a painting ought to be, the artists depicted scenes and activities of their own local society: farmers at work in the fields, wedding ceremonies, fiestas, religious processions. The portrayal of these themes was still within the stylistic framework of the ceramic painting, but these paintings required additional creativity and ingeniuty and might be viewed as the beginnings of new channels of the artists' own creative expression. The transition from the exclusive portrayal of animal figures to the incorporation of human figures was marked by the juxtaposition of animal limbs on human figures. The arms and hands of women, for example, often had the appearance of birds' wings, with the fingers resembling feathers.

The profits obtained from the sale of these paintings made it a lucrative endeavor; an average number of from eight to ten hours was spent on a large painting, which could be sold for from 100 to 150 pesos. This was a remarkable price when compared to a *jornalero's* (hired laborer) salary of 10 pesos or less for a day's work. Artists were selling everything they could produce, most of which was commissioned by entrepreneurs who consistently demanded greater quantities; the development of artistic expression, however, was shortlived and did not have the opportunity to evolve.

As the demand for the paintings continued, the original artists claim that not they but other individuals, and those who worked with pottery, began to produce a more "simple" style of painting that used stylized animals and flowers, similar to those used on the ceramics. Because of the relative simplicity in the designs and the familiarity with these pottery styles, the time required for these paintings was about one third of that for the "scenic" paintings. One of the artists pointed out that much less painting skill and creative thought were required. Within a very short time after the "flora and fauna" designs were revived (figure 47), there was a marked increase in the number of individuals producing these paintings.

The cities of Taxco and Cuernavaca provided a substantial market, yet the primary outlet for the paintings at this time was the Bazaar Sábado in Mexico City—an exclusive center for the sale of highly sophisticated and stylized crafts that caters to foreign tourists and the wealthier residents of the city. Outside the gates of the bazaar, the painters received

25 pesos for a medium-sized painting, one that would take approximately three or four hours of work. The investment in materials was 60 centavos (four and a half cents) for the bark paper and less than three pesos for a one-ounce jar of paint. The good prices brought increasing numbers of painters and even larger quantities of paintings to the bazaar. The urban craftsmen at the bazaar became concerned about the competition of the growing "Indian" market outside the building and attempted to confine the Indians' selling area to a park across the street. It was not long before a *tianguis*, a regular outdoor Indian marketplace, was established in the plaza across the street.

Initially, most of the vendors were from Xalitla, primarily because of its easy access to metropolitan areas and their knowledge of Spanish. One painter, Gregorio Martínez, pointed out that prior to the influx of artists from other villages, the Xalitla artists had been able to maintain a relatively high price structure. But as other painters arrived who were satisfied to receive lower prices for their work, Xalitla artists were forced to compete by lowering their prices also. In the artists' attempts to meet the unrelenting demands of wholesalers for greater quantities of paintings and lower prices, both the price structure and the quality of the paintings were sacrificed.

By 1965, the price of the paintings had fallen to 15 pesos; at the same time, the price of the bark paper had begun to increase. In addition, the quality of the painting deteriorated, as also did the painters' pride in their work. Prior to this trend, the painters claim they had taken more care in the drawing of the lines and

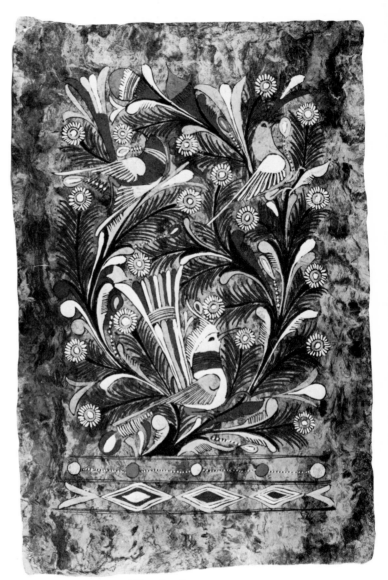

47. Evolved "Fauna and Flora" style *amate* painting; note baseline or incipient border and polychrome complex style (46 cm. x 64 cm.).

in the arrangement of the figures. Although even in the later process of mass production it is true that no two paintings were exactly alike, Gregorio Martínez emphasized that the painters had little time to give their work much thought. Earlier they had sought harmony and originality in the forms and arrangements; now they were content to copy the same format again and again.

In 1966, the rapid destruction and threatened extermination of the amate trees in the region from which the bark was obtained prompted the government to prohibit the further use of bark paper. This legislation had drastic consequences; the artists were compelled to use *cartulina* (a heavy grade of off-white paper), a medium that had little appeal to the customers.

During this period, ceramic work assumed a more significant role in the realm of Mexican Indian crafts, and the craftsmen in Xalitla also began to manufacture ceramics. As ceramic production increased in Xalitla, the forms and the styles began to diverge from the traditonal ones; they became more elaborate and new ones were created (see figure 46).

A New Stimulus

With the staging of the Olympics in Mexico in 1968, the government took a greater interest and a more active role in promoting the indigenous arts and crafts. Both the Huichol and the northern Guerrero arts received special attention because of their somewhat psychedelic quality, which was in harmony with the artistic theme of the Olympics. At this time the artists began to conform to the format of

Western painting, with full border and signature, placing the fauna and flora elements in a somewhat scenic style (see plate 4). The government also permitted the reinstatement of the manufacture of bark paper, provided that 10 trees would be planted for each one chopped down.

The impact of these two circumstances had a dramatic effect upon the art of bark painting and on the communities concerned as well. After the initial impetus in sales, both the quality and the prices of the paintings hit a bottom low. The wholesalers—Americans and Mexicans who supplied or owned large retail outlets—began making trips directly to the villages, placing orders for hundreds and even thousands of paintings. The result was a drop in the average price of the paintings to seven pesos (56 cents). The deterioration in the artwork became evident in (1) the sloppiness in the painting and the designs, (2) the watering down of the colors, and (3) the use of thinner and cruder bark paper.

Perhaps the most unfortunate feature of these developments is that the process has proved almost irreversible. Since the Olympics boom, the prices of the paintings have continued to plummet—to the point where medium-sized ones are now sold for two and three pesos. At this rate, the profit for the painter is almost negligible, if it exists at all.

As a consequence of these conditions, hundreds of individuals in each of the four villages are involved in producing the paintings. In order to fill the demands during peak seasons or for large wholesale orders, the labor of the entire family is utilized. The cost of this labor is not estimated in the cost of production

or in the prices of the paintings. Common practice is that the painters (usually the men) outline the figures in black, and the women and children fill in the colors (see figure 48). It is usually the painters themselves who take the paintings to the cities and tourist centers for sale.

The most intensive period of painting is during the months of October through April, months in which the fields require little attention.

The sale of crafts was initially a means by which the farmers supplemented their income from the crops; it has now become the major source of income. The additional money received from the paintings helped the farmers subsist during the long periods between the harvesting seasons, but the most significant

48. A mother and son work on filling in the colors after the father has outlined the Fauna and Flora design on *amate*.

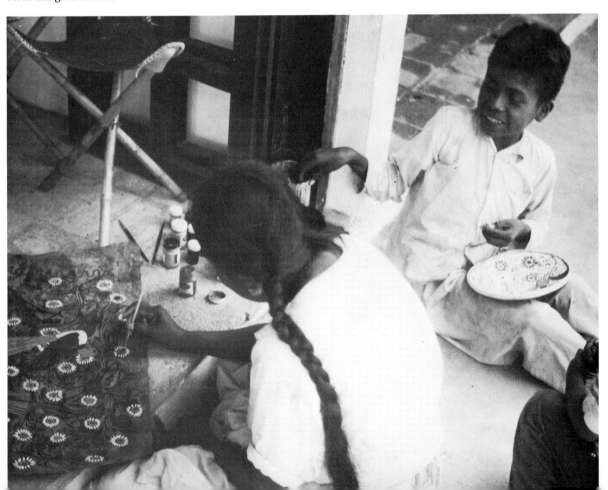

effect of the greater abundance of cash has been to increase the dependence upon monetary transactions of the artists' communities. This has proven to be another irreversible process; now that the people have become consumers of manufactured and industrial products, the necessity to purchase these goods has compelled them to continue the sale of their wares, even though the meager profits do not compensate for their time and expenses.

Since the time of the Olympics, lands and crops have been neglected and some of the painters have either sold or rented out their lands, which has placed even greater pressure upon the sale of paintings.

Innovations

The painters became aware that the reinstatement of former price structures would become less probable each year, and many began to seek new directions in their arts. In 1970, several artists revived and developed the "scenic" style of painting to show typical scenes of rural life (figure 49), breaking completely away from the ceramic-derived fauna and flora style. Although the prices obtained for these are one-half the former price, the artists point out that there are fewer individuals who can master this style, and, thus, competition is not so intense as it is in the sale of the "flora and fauna" styles. In addition, (several) artists began to improve the quality of design and painting of the "flora and fauna" styles, hoping to impress this distinction upon the buyers in anticipation that they would pay more money for better paintings. Some of

these artists, however, have expressed their lack of faith in the buyers' tastes, maintaining that the primary concern of the tourists and wholesalers is to buy the cheapest item they can get, regardless of the time and effort put into it. Nonetheless, some of these better paintings are being produced and sold, which is an indication that there is a market, though limited, for better-quality paintings. An artist from San Agustín Huapa pointed out that in this respect the Xalitla painters have an advantage in being able to speak Spanish, since selling better paintings at higher prices necessitates bringing attention to the quality of the work and a good deal of bargaining.

Another means by which the painters have sought to expand the market has been through experimentation with different sizes and shapes of bark. In the past few years, the introduction of long rectangular shapes and the small postcard-size paintings has increased the volume of sales. Variation in color schemes has had a similar effect. Besides the bright phosphorescent colors that were accentuated during the Olympics, the painters have begun to sell paintings in which only two colors are employed, such as black and white. They have also discovered a market for the black outlines without the color application.

Many of the painters agree that further artistic innovations will be crucial to the continuation of their arts and crafts industry. For example, Gregorio Martínez feels that the use of a different medium (such as the high-fired ceramic ware manufactured in Cuernavaca and Mexico City) will be the only way he can continue his trade. He pointed out that it would be less likely for the painting on fine-

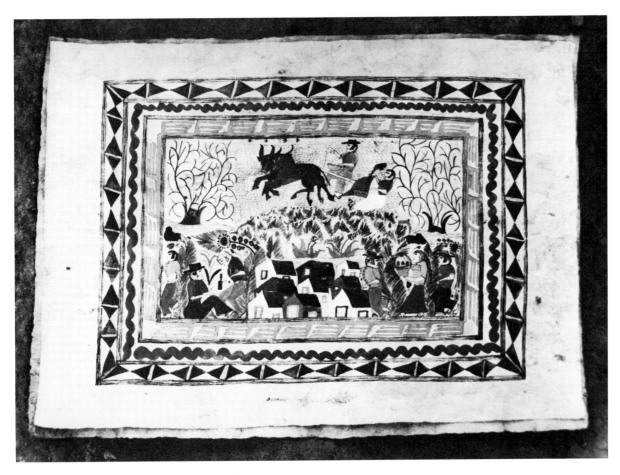

49. Developed scenic *amate* painting, by Pablo
Nicolas of Xalitla.

grade ceramic to suffer the same ill effects of
massive competition as in the bark painting (1)
because of the other painters' lack of knowl-
edge regarding the technique and use of spe-
cial materials (which he had acquired in Mex-
ico City), (2) because of the greater financial
investment in materials it would require, and
(3) because the higher value of this ceramic
work would function as a control on quality
and thus on prices. Martínez had planned to
go into business with an American who had
taken him to the United States to do his

painting at shows, but after he had completed some of the plates the American wanted to pay him only one peso per plate. Enraged, he returned to Xalitla and worked to save money from the sale of paintings in order to purchase the specialized ceramic materials himself. In Mexico City, he was a victim of the fate sometimes experienced by rural craftsmen in the larger cities. He was robbed of 1,500 pesos by two men who posed as policemen.

In 1972, the Banco de Fomento Cooperativo (BANFOCO), a government agency concerned with the promotion and development of rural industries, organized an art competition among the amate painters of the area. The state representative, Macrina Rabadán, also organized an exhibit of the award-winning paintings in Iguala, and later in Acapulco. The organizers of the competition requested the painters to submit creative and imaginative portrayals of pictorial scenes, and guaranteed the winners a continued purchase of their paintings. The BANFOCO's innovative attempt to restore the waning vitality and creativity of bark painting has provided a welcome new stimulus to the Xalitla. The paintings of seven award winners (six of whom were Xalitleños) are sold to the BANFOCO for 50 pesos (U.S. $4) or more. The paintings that I viewed in 1973 exhibited a marked development of creativity and skill in the execution of the drawings.

Gregorio Martínez, who was awarded the first prize, has done a great deal of experimentation with vivid colors and perspective, and has brought more fictional and imagined scenes into his paintings. Pedro Díaz has ex-celled in the intricate black-line drawings of ritual dances traditional to the area, in which the eyes of the dancers are occasionally depicted as stylized flowers and the lines of the head ornaments flow into the shapes of strange animals. The younger Pascasio Ortiz' paintings tend toward the portrayal of subjects in varying states of emotion: young men involved in duels with ferocious monster-beasts, while others depict a more serene setting. These "fantástico" paintings often contain frightening subjects reminiscent of former Aztec settings and beliefs (figure 50).

Furthermore, the styles of the individual painters have undergone marked differentiation, to the degree that the paintings of the different artists are readily apparent to the outside observer.

The establishment of a minimum price by BANFOCO has also provided an impetus for the artists to execute their paintings well, for they know that their additional investment in work and time will be adequately rewarded. It also provides them with the option of refusing to sell their paintings to outside clients who offer less than 50 pesos, and has actually encouraged them to ask for more. In this respect, this small group of artists has been rescued from the bottomless pit into which the prices of the flora and fauna paintings have descended, and continue to descend.

On the other hand, these painters have reported that BANFOCO is only willing to purchase about two-thirds of the paintings that they can paint and need to sell per week. The difficulty in finding other markets for these paintings has prompted Gregorio Mar-

tínez to renew his search for new applications of the designs. His proposal to BANFO-CO for the purchase of a kiln to carry out the transposing of his designs onto a finer class of high-glaze ceramic was again discarded, mainly because of his misgivings about assuming the responsibility of coordinating financial cooperation of at least 12 other painters to obtain the kiln.

During a recent visit to Xalitla, Martínez expressed to me his strong interest in learning the Batik process in order to develop some of his ideas for textiles and tablecloths. He requested that I send him an instruction manual from the United States upon my return. When I pointed out that to my knowledge they have been published only in English, he asked that I also include an English primer so that he could

50. "Fantastico" style of scenic painting, showing Aztec warriors chasing mythical beasts, by Pascasio Ortiz of Xalitla, 1972 (46 cm. x 64 cm.).

translate it, and that a knowledge of English would be particularly advantageous in securing markets among Americans.

CONCLUSION

The plight of the Xalitla bark-paper painters and the conditions surrounding the development of their craft are not exclusive to this particular craft.

The pressure of the market toward mass production and lower prices has been accompanied by a highly individualistic response from the painters. What had emerged as the beginning of a new and progressive artistic tradition soon gave way to an entrepreneurial approach to production. As entrepreneurs, the painters increasingly competed with their peers in economic terms rather than along artistic lines.

Thus, artistic identity is essentially relinquished and the incentives to innovate stem from economic rather than artistic considerations. In this respect, the individual nature of the artist's identity is, at one level, easily translated into an individualistic approach to production—a transition that provides a situation that is conducive to a highly competitive type of production and an increasingly greater dependence upon the market and its dictates.

In response to the predicament of market saturation and dwindling prices, the government, through the incentives of the BANFOCO competitions, sought to reestablish artistic and innovative motivations among the painters. Although this project has been successful in providing a new innovative impetus for some of the painters, the underlying dynamics basically remain the same. By providing a small portion of the painters with a guaranteed price structure, the incentives to continue innovating are sustained. But the likelihood that the scenic and fantástico paintings will experience the same fate as the flora and fauna still remains.

In spite of the overwhelming economic pressures, it is still possible to see the artistic forces at work in the trends described. After the artists become adept at each major innovation, they elaborate the elements in the direction of greater complexity to the point of near baroqueness, leading to the evolution of personal styles within each of the major genres. Thus, the fauna and flora became more complex and intertwined; the paintings of rural scenes became more full of activities, to the exaggeration of the artists' personal orientation; the introduction of the Aztec motifs has been followed by the glorification of the fantastic and the grotesque.

South America, like Mexico and Central America, has experienced the rise of great civilizations, conquest, wars of national liberation, and the recent florescence of popular and tourist arts. Traditional Indian wares are still much in demand for everyday use, but are increasingly sold for nonpractical ends. Threatened by competition from industrial products, by a population explosion, and by relative poverty, old forms have been adapted for sale and new forms are quick to appear in rural and, especially, urban markets (Dockstader 1967).

LATHRAP recounts the results of his archeological and ethnological research among the Shipibo-Conibo at the headwaters of the Amazon basin east of the Andes in Peru. These Indians of the rain forest have recently adapted their traditional ceramics for the market, drawing upon archaic and neighboring traditions and even coming up with entirely new forms for urban Peruvians. Consequently, they have relaxed their strict standards of design and painting, reducing the complexity of the decoration and mixing pottery types. Simultaneously, industrial containers are replacing their functional ceramics in household use, and the production of pottery itself is being neglected in favor of beadwork and other more lucrative souvenir items.

The spread of tourism to hinterland areas has stimulated the production of pseudotraditional arts, often replacing quality with volume. Local, governmental, and entrepreneurial efforts, along with the Peace Corps, have aided the development and distribution of these salable arts, while others die an unmarked death in the *jungas* and on the *altiplano*.

BOYER recalls that gourd embellishment is a traditional Peruvian art, going back to pre-Inca times. The gourd-carvers of Cochas Chico and Cochas Grande of the central Andes decorate gourds for the local and international markets. Using gourds grown in the montaña and in Northern Peru, they practice incising and pyro-engraving, as well as reembellishing

the acid-decorated gourds from the North Coast. Though the gourds have long been made for local and urban functional purposes, the Peace Corps and recent tourist demand have encouraged the making of non-functional ware and concomitant innovations. The makers, however, still cater mainly to the local and domestic markets, continuing to adhere to the highest standards when well paid for it.

In the Andean area particularly, the high arts of previous civilizations have been subject to destruction, restoration, imitation, and export, and now are being preserved and promoted as national symbols by recent governments. For the tourist and for national "ethnic" purposes, there have been revivals of both ancient technology and design motifs. Among the former are pottery molds, lacquerwork, and featherwork. Faking and smuggling, too, are part of this attractive trade.

Contemporary textiles, pottery, and utensils are often a synthesis of Indian and early Spanish forms (Gayton). They are found in local and regional markets where they form important functional indicators of ethnicity, and are traded over large areas by such Indian entrepreneurs as the Otavalans. These ethnic arts have been integrated into Peruvian, Bolivian, and Ecuadorean cultures and are, for all intents and purposes, traditional; when sold to tourists they are taken as such. In Brazil, where there is more of a cultural gulf between people of Euro-African background and the indigenous peoples, the latter are turning out souvenir crafts while their culture and lands are fast slipping away from them. But the pluralism of Brazilian society is a stimulant to many other popular and practical arts (Andrade, 1952). Argentina and Chile, however, add very little to contemporary Fourth World arts. Few aboriginal peoples of this area have maintained any degree of autonomy, except for those on the fringes of contact in the vast Amazon and Orinoco basins, and now, even these are fast being overrun. Farther north, the peoples of Colombia and Panama (until recently a part of Colombia) are more fortunate.

SALVADOR concentrates on the clothing arts of the women of the San Blas islands on the Atlantic coast of Panama. As the Cuna have maintained some independence from Panama, their textile arts are not a trickle down from some outside culture; thus, we have a case of art paralleling cultural history. Though the Cuna may eventually sell their *mola* blouses, they make them primarily for themselves, following their own individual and collective fads and technical standards. Upon the introduction of cloth, needles, scissors, and thread earlier in this century the Cuna began to develop molas based on designs they used on their basketry and in their body painting. Today, they generally adhere to the finest standards of workmanship, in spite of a few tourist items influenced by outside tastes. Molas are therefore a reintegrated modern, but culturally embedded, art form. The success and the cultural integrity of the art form is testified to by the efforts of tourist entrepreneurs, airlines, and the central government—all of whom have tried to make Cuna molas one of the prime features of Panamanian "ethnicity," a fact of which the Cuna themselves are not unaware.

9. The Clothing Arts of the Cuna of San Blas, Panama

Mari Lyn Salvador

Molas, as they are known outside the San Blas Islands of Panama, are the appliquéd front or back panels of a blouse that is part of the traditional dress worn by Cuna women. The art of mola making has developed within the last hundred years, combining the creative utilization of new materials and processes (cloth, scissors, needles) with the traditional art form of body painting. A very important part of Cuna culture, the mola has ramifications throughout the cultural context.

The Cuna are one of three distinct Indian groups living in Panama. The others are the Guaymi, who live in the mountains in central and western Panama, and the Choco, who live along the rivers in the Darien jungle extending into Colombia. The Cuna language, previously thought to have been Chibchan, is now considered to be the only representative of a group otherwise extinct (Kramer 1970:11). Most Cuna now live in the Archipelago of San Blas, a chain of islands off the Atlantic coast from San Blas Point to the Gulf of Uraba, about 170 miles. Some live on the adjacent mainland, most of them along the Bayano River. Most of the population, which in 1960 was 21,000 (Holloman 1969a:84), live on about 40 of the 375 islands. On many of the uninhabited islands, the Cuna grow coconuts that are used for food and in trade.

Although planes run daily between San Blas and Panama City, boats are the major form of interisland transportation. The *ulu,*[1] a canoe-shaped boat carved from a single log, is the most common type of boat; it carries sails, but is generally paddled or driven by an outboard motor. Ulus are used mainly for fishing,

Mari Lyn Salvador received training in art, folklore, and anthropology at California State University at San Francisco, and the University of California, Berkeley, where she was awarded her Ph.D. for her dissertation on the ethno-aesthetics of the Cuna of Panama. Starting with two years in the Peace Corps in Panama in 1966-1968, she and Vernon have pursued anthropological and photographic research among the Cuna and among the folk artists of Mexico. For over a decade they have also done folklore and anthropological research amongst Portuguese-Americans in California and have recently been awarded a Fulbright research grant to do similar research in the Azores while Mari Lyn takes a year off from her duties as Assistant Director of the Center for Folk Arts and Contemporary Crafts in San Francisco.

[1]The spelling of Cuna words is mainly taken from Nils Homer (1952) or Nordenskiöld (1938).

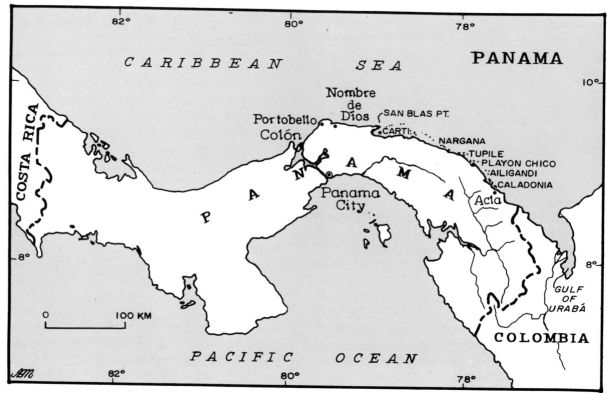

Map 4.

and for transportation to the coconut islands for farming and to the mainland rivers for water. Larger, motor-driven boats carry passengers and cargo between the islands and to and from Colon, a Panamanian port town (see map 4). *Canoas*, large cargo boats with both sails and engines, come from Cartagena, Colombia, to trade cloth, hammocks, sugar, coffee, flour, and household goods for coconuts. This trade with Colombia is technically illegal, but the Panamanian authorities have not supplied an equivalent means of trade for the Cuna, who by now depend on these canoas for manufactured goods as well as for income from the sale of coconuts. Small stores on the islands keep a supply of these goods and accept coconuts (value eight U.S. cents) as payment for them. Coconuts have long been the basic unit of exchange, and admission to a movie is still two coconuts.

Men gather nightly in the congress hall on each island to discuss island problems, make decisions on pressing matters, assign work groups, and visit. Oratory skills are very important and highly developed. Traditional or chanting congresses are held for men and women about once a month on each island. Special men who know the chants and myths, the history and origins of traditions, and the rules for behavior come to sing. Aspects of social organization—such as certain duties, customs, and puberty celebrations—are traced to *Ibeorgum*, a culture hero, who was sent by God to teach the Cuna how to live. The history and traditions are passed down orally in these congresses since the Cuna language is unwritten. Picture writing, however, is sometimes used as a mnemonic device.

The social organization is based on the matrilocal extended family. The man moves in with his wife's family upon marriage; hence, the more daughters a family has, the larger the family will be. Within the family group, the oldest working male is final authority; all the men collectively are responsible for providing the food.

There are some concrete houses, but most houses are made of cane lashed onto a pole frame with a thatched roof. The cane, wood, and thatch have to be brought from the mainland and the work is done cooperatively by groups assigned at congress meetings. The sleeping house is one room, with hammocks strung from the poles. Although the women no longer spin, some do weave beautiful hammocks on looms similar to those described in 1699 by Wafer (1933), a buccaneer ship's doctor who lived in the area from 1680–1688. Blue, white, and brown cordage is bought from the Colombian canoes.

Women cook on log fires in a separate house. *Tule masi*, a soup made from grated coconut, plantains, and fish, is served with salt, lime, and sometimes fried fish and rice. Corn is ground and made into a thick drink or fermented with sugar cane into a drink resembling beer, which is drunk at the *inna*, girls' puberty celebrations. Cocoa beans are also ground and mixed with sugar for a sweet drink. Mangos, oranges, and pineapples grow on the mainland. Food is carried and stored in a variety of beautiful baskets, which are woven by the men.

Some men go to Panama City, Colon, or the Canal Zone to work, often for several years; when they return, they have to pay a tax to the community for the local jobs they have missed. Pay from work in the city, money for coconuts sold rather than traded, and money from selling molas are the main sources of cash. This is spent on boat motors, concrete-block houses, travel to Panama City and Colon, schooling, jewelry, and cloth for molas. The women's jewelry and fine molas are conspicuous signs of a family's wealth.

History

The earliest known contact in the San Blas area was with the Cueva Indians, who were subsequently displaced by the Cuna (Kramer 1970). The Cuna are not an isolated group, having had extensive contact with outsiders for over 400 years. There has been considerable ship traffic in the area since the early sixteenth century—Bastides, Columbus, and

Balboa all visited the area. The first American bishopric was founded in 1510 at Santa Maria and then moved to Panama City in 1521. Balboa founded Aylatihuala (Acla) and by 1512 there were 200 Spanish frigates trading between Nombre de Dios and Cartagena. By 1548, many slaves had escaped and were living in the interior along the Bayano River and the coast near Colon.

Between 1675 and 1725, the Cuna had their greatest contact with pirates, with whom they joined forces for a time in fighting their common enemy, the Spanish. Both the English and the French were aided by the Indians; and the Scots, under William Patterson, founded a short-lived trading colony in 1699. From 1690 to 1757, French Calvinist Huguenots colonized Concepcion, some of them marrying Cuna women (Stout, 1947). This brought Protestantism to the Cuna, who had earlier encountered some Catholic influences. In the seventeenth and eighteenth centuries, Cuna men began shipping on board vessels as cabin boys and crew, sailing around the world.

In the eighteenth century, the Cuna sporadically attacked Spanish towns. A peace treaty was finally signed in 1741, but there were other rebellions until New Spain granted the unconquered Cuna independence in 1831. Although the Cuna knew of the San Blas Islands, it was not until around 1850 that they began to live on them. Several factors stimulated this migration: unfriendly relations with blacks and with the Spanish in the interior and along the Pacific Coast; the Cuna desire to get away from the insects, vampire bats, etc. of the jungle; and the increasing coastal trade in coconuts and tortoise shell.

In the early 1900s, the Panamanian Government, in cooperation with a progressive group of Cuna men, pursued a policy of forced assimilation. This included the introduction of Panamanian schools and police to San Blas and a ban on traditional dress and ceremonies. The Cuna rebelled in 1925, killing several policemen and reversing the above trends. In the negotiated settlement that followed, Panama recognized Cuna autonomy in the San Blas region.[2] Today there are still Panamanian schools, but some have Cuna teachers, the police are all Cuna, and traditional dress for women continues to flourish.

CUNA CLOTHING

The Development of Traditional Dress

Cuna dress is an example of a unique style developed after contact with outsiders and the arrival of new materials—cotton cloth, scissors, needles, etc. (see figures 51, 52, and 53). The Seminole (Sturtevant 1967) and Navaho (Kluckhohn and Leighton 1962:86–87) dress are examples of similar phenomena. Elements of outsiders' dress style have been combined with traditional ones in a creative way to produce a dress style that is unique—neither like the native styles at the time of contact, nor like those of present-day neighbors. The Cuna are eclectic; they are not set against outside influences and, in fact, use many "modern" things, but strong traditions govern their se-

[2]For a detailed discussion of this period, see Hollomon 1969a.

lections. For instance, they place a very strong value upon racial purity, which they conserve **by not marrying outsiders.**

Cuna clothing has long figured in outsiders' accounts as a remarkable aspect of Cuna life, but is is only recently that the mola—reverse appliqué panel—as we know it has developed and come to be the major feature of the Cuna **women's dress (figure 51).**

Some Cuna women wear modern dresses, but most wear a traditional outfit, unique to San Blas. This has some elements that can be traced back several hundred years, and others that have developed as the result of contact. As the Cuna have found things they like and can use, they have integrated them; thus, the origin of their costume cannot be credited to any single outside source.

The importance of gold jewelry was described by the early chroniclers. Wafer in 1699 (1933:85) described the men as wearing half-moon-shaped plates hanging from their noses **and the women as wearing gold nose rings.** He noted that chiefs wore large and elaborate earrings. Women still wear a gold nose ring, large gold earrings, and plates that hang from their necks to their waists (see figure 52), but men no longer wear the gold jewelry. Wafer went on to describe

Chains of Teeth, Shells, Beads or the like, hanging from the Neck down upon the Breast and to the pit of the Stomach . . . whatever Bugles [beads] or other such Toys they get, they find a place for them among their Chains . . . She is a poor Woman who has not fifteen or twenty pounds weight upon her . . . Women, besides these Chains, have sometimes Bracelets about their Arms of a small quantity of the same ma-

terials [beads] twisted several times about. Both Men and Women, when painted, and set out with all these fineries make no ordinary figure (1933 [1699]:87–89).

Women still use many strings of trade beads, seeds, shell, and coins as necklaces. The women wear bands of imported Czechoslovakian trade beads called *wini* (see figures 52 and 53) wrapped around their arms and legs, the wide bands on their arms being in solid colors and those on their legs bearing fancy geometric

51. Traditional dance group from Ailigandi in everyday dress. The pipe-playing leader is an albino man, and the women are playing flutes and rattles. Note the uniformity of hair style, nose rings, beads and clothing, and the pattern variations within the uniform.

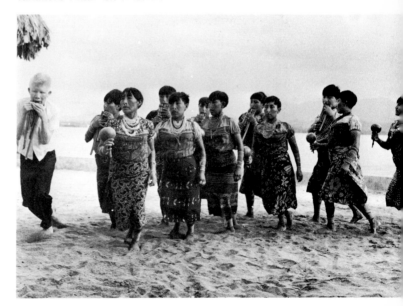

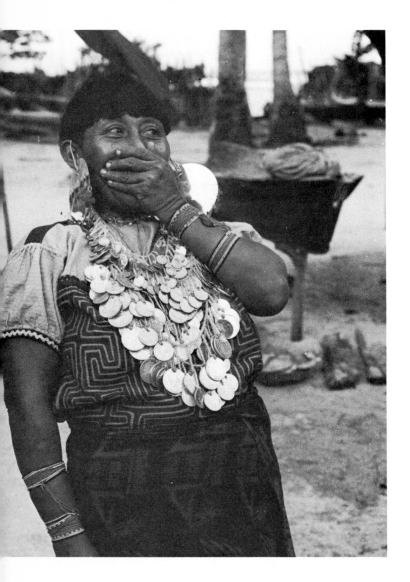

52. Marina from Tigre, wearing a three-layer geometric mola and traditional jewelry. Note construction of the blouse, the *wini* and the wraparound skirt.

patterns. These are usually orange and yellow, or red and pink, with blue or green borders. Wini are made by winding on a single strand of beads to make a preplanned pattern.

It is generally felt that the mola idea and designs developed from the transfer of aboriginal body-painting onto clothing, first to the *picha* underskirt (see figure 54a) and later, as Cuna women covered up more, onto the blouses themselves. Wafer described women in cloth skirts, beads, and nose rings, and gave a vivid account of body-painting:

> They make Figures of Birds, Beasts, Men, Trees, or the like, up and down every part of the Body, more especially the Face: But the Figures are not extraordinary like what they represent and are of differing Dimensions, as their Fancies lead them.
> The Women are the Painters, and take a great delight in it. The Colours they like and use most are Red, Yellow and Blue, very bright and lovely (1933:82).

Similarly, the women now make the molas, using designs of birds, beasts, and men, and other figures. Also, they still like the same basic color combinations: red, yellow (or orange), and dark blue or black. *Sabdur (Genipa Americana)*, a natural blue-black dye is painted as a line on the nose and all over the body of the young girls during their *inna*, a puberty celebration for girls.

There are similarities between designs of body painting and some mola designs, especially two-color geometric molas (see figure 54b). These two-color designs are also similar to the patterns on Cuna basketry and *wini*, as well as those painted in *pichas*.

Skirt and Headscarf

Women in cloth skirts reaching to the knees or ankles were described by Wafer, and Stout (*op cit.*) mentions that skirts were made of cloth obtained in trade with other groups who had contact with the Spaniards. Women now wear a plain picha underskirt and a wrap-around **skirt (*saburet*) made of printed fabric** (see figures 51 and 53).

Stout also says that the headscarf (figure 53), an essential part of the outfit, may have been indigenous but more likely is of Spanish origin. Fabric for the scarf and the skirt are imported from England and are used without modification.

THE MOLA

The term *mola* means blouse in the Cuna language, but is now also used for the appliqué panels themselves. When I mention mola, I refer to the panels, mola work to the appliqué process; I use mola blouse for the entire garment. For export purposes, the blouses are often taken apart and the panels themselves sold completely detached from any utilitarian garment.

The origin of the mola is uncertain. It is presumed that this decorated panel came into its present form after the introduction of manufactured cloth, metal sewing needles, and scissors, just before the turn of this century.

In 1868, Cuna women were wearing "short sleeved chemises extending to the knees"

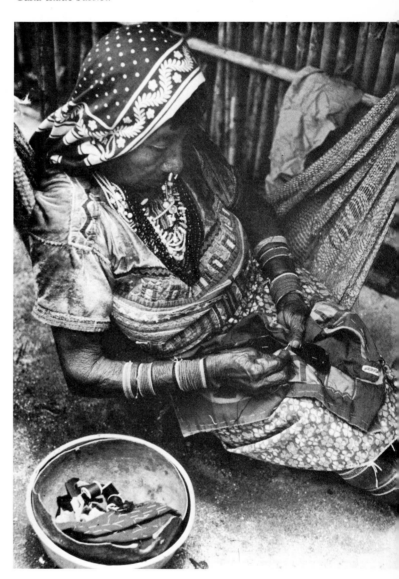

53. Old woman making a mola, wearing a *muswe* headscarf, with her sewing materials in a Cuna-made basket.

(quoted in Stout 1947:67). Later, the blouses worn were reported as dark blue with a red border at the hem and were worn over the picha underskirt, which was painted with geometric designs (see figure 54a). By 1900, as more bright-colored cloth became available, women began to make simple molas, the decoration was cut out of the top layer and sewn to the layer below, a type of decoration that is an indigenous development. Soon the mola work covered the bottom half of the blouse. When printed-blue trade cloth was introduced the women used it as a wrap-around skirt over the picha underskirt, which was no longer painted (Stout 1947:67). The blouse was then made shorter and the mola portion was increased until now only a small yoke and the sleeves are made of plain cloth. The painting on the picha has been discontinued.

The structure of the outfit is quite rigid (see figure 51): the skirt and scarf are rectangular cuts of cloth, and the blouse has two mola panels with a yoke at the top and puffed sleeves. Even the color choices are restricted. The scarf is always red and yellow; the skirt is usually dark blue with green or yellow. Patterns are numerous and choices are made with care. The mola offers the most freedom of artistic expression and women take full advantage of it to express themselves. Generally, traditional women wear the whole outfit, and women who have changed to modern dress rarely wear any of it.

Although the mola is less than 100 years old, it plays an important role in the culture, being both a source of family pride and an expressive outlet for the women. Its reputed origins have been incorporated into traditional chants and Cuna history.

Aesthetics and Variation

There is considerable variation in the quality of molas. Some women always make beautiful molas; others make fancy ones for special occasions, an inna for example, but are not so careful with every day molas; and there are some women who just aren't very good at it. Occasionally, a woman who doesn't sew very well will get a mola from a friend when she needs to be dressed up.

The Cuna believe in a general concept of talent or intelligence, kurgin, which is distributed in varying degrees to all people, and accounts for one's skills in life. Kurgin is intelligence, natural aptitude, ability, or talent. Mu, the ancient grandmother from mythology, gives kurgin of different kinds to the fetus when it is formed. One can have kurgin for any skill—hunting, learning a foreign language, eloquence, or making beautiful molas. It can be improved with medicines. "In order to get a beautiful singing voice one places gramaphone needles, whistles and gold and silver bells, in water and then drinks the water" (Nordenskiöld 1938:395). Plants having leaves with beautiful designs that look like geometrical figures are soaked in water that is used to bathe the eyes, thereby improving the kurgin to make beautiful baskets and cut beautiful molas (ibid.:414).

Mola making is an important part of the women's lives. They talk to one another about their work; keen judgments are made, and a highly refined system of criteria has been developed. The sewing must be carefully done with matched thread, no stitches showing, and no raw edges. Lines have to be even, thin, and equally spaced. Large areas should not be left unfilled. Women experiment with color using

saturated hues. Contrast is important, shades of the same color are not used on top of one another, and colors within a close range are considered to be the same.

Women always look at the molas that I buy and are quick to criticize if they don't like them, explaining in great detail what is wrong. On the other hand, they often copy the ones they like.

Sometimes all the women in a girl's family and also her close friends make the "same" mola for her inna. It is not uncommon for several women to copy the same picture or even the same mola, but the results are always different. Certain themes, if they interest enough women, become fads. For instance, if many women on one island make cat or Biblical molas, or experiment with a certain color combination or particular style, the style might spread from island to island. Sometimes the fad lasts for several months, and when it is over, it's over. Most young women wouldn't wear a mola that is out of style.

Types of Molas

There are several different types of molas. Two-color molas, those with only two layers, are called *mugan* (see figure 54b), "grandmother" or old-fashioned molas. This was the first type of mola made and the designs were probably similar to those painted on the picha (figure 54a); this type is more popular on some islands than on others. They generally have geometric designs, although some have stylized birds, fish, or flowers (see figure 54c). Women who make mugan molas also make other types.

Molas with only two layers of cloth, but in three colors, are called *obogalet*. This is a prestigious type of mola that is quite difficult to design. The designs of each layer are integrated with the base making an overall outline (see figure 54d).

There are also three-color geometric molas with three full layers of cloth without other colors introduced as filler. This is the type seen most often in photographs from the 1930s and 1940s, but they are still popular (see figure 52). The most popular type of mola now is multicolored, usually with at least three full layers of cloth in different colors plus several other colors in the filler areas. They often have a central figure with subordinate designs around it and the remaining space filled by a number of techniques.

Mola Design and Technique

Decisions on design, overall color, and the placement of colors are made before the first cut. The overall layers are basted together with small patches of colors preplaced in between. Sometimes the main design is sketched on the top layer and it is all cut at once. About one-sixteenth of an inch along the cut is folded under and sewn with hidden stitches to the second layer, leaving a finished edge. If the mola is to be more than two colors, the same process is repeated. The top layer, most often red, is outlined by the second layer, usually orange, yellow, or green, which is then sewn onto a black background. Sometimes the red and black are reversed, but they are always a full layer, not half red and half black, for example.

If there is to be variation in the outline colors, the procedure is slightly more com-

54a. A rare contemporary version of a painted
picha underskirt (142 cm. x 60 cm.).

For details or color variations on the top layer, areas are sometimes built up in a regular appliqué process.

Good design requires that large areas of one color are not left and that all space be filled. There are several methods of showing the colors in the layer below. Most of these involve cutting through the first layer to expose colors in the second layer.

Some molas have an overall integrated design that covers the entire mola with geometric or stylized patterns, eliminating distinctions between figure and background. If there is a central figure on a mola, but the subordinate space is filled with connected geometric pat-

54b. A *mugan* or grandmother mola, with two-color geometric design; this type of design is most closely related to those of the *picha*, basketry and body painting (*mola*, 40 cm. x 33 cm.).

plicated. Most often there are two outline colors, one around the central figures and another along the background. Subordinate figures may be outlined in different colors and the space between figures is usually filled with several colors distributed across the surface. Most of these have been placed before cutting.

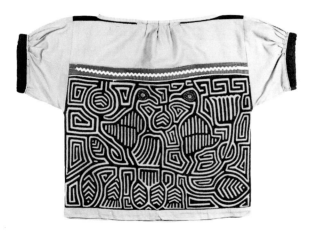

54c. A *mugan* mola with stylized birds; the geometric fill is *bisu-bisu*: note the rickrack on the trim. (*mola*, 48 cm. x 33 cm.).

Letters are common, sometimes being used to identify the subjects and sometimes merely as decoration. Since most Cuna women do not write, they use letters the way they look best, which may be upside down and backwards (see plate 6). Rick-rack, mainly used for trim around the sleeves and between the mola and yoke, can also be used as decoration on the mola. A very fancy old style of outline, "*dientes*," (see figure 55c) or teeth, which looks like rick-rack but is made by hand, has become popular again. Many women now do this type of handwork, which is considered to be more beautiful and certainly entails much more work.

Red is the predominant color and is usually

terns, the fill is called *bisu-bisu* (see figure 54c).

The most popular fill-in technique is called *tas-tas* (see figure 55a). Short parallel slits are made in the top layer, which is then stitched to small patches of different colors that have been placed between the first and second layers. This gives an overall horizontal or vertical linear pattern to the mola. A similar method is to cut little circles rather than lines, a technique especially good for small areas (see figure 55b). A slightly harder and more prestigious method is to cut triangles out of the top layer, remove the layers in between, stitch the top layer to the bottom, and then fill the center of the triangle with a different color (see plate 6b).

Embroidery is sometimes used as surface decoration for detail on clothing or faces and to show letters or feathers (see figure 55c).

54d. An *obogalet* mola under construction, with two different colors in the top layer; note the two interlocking top layers are basted down but not yet tucked under. (38 cm. x 29 cm.).

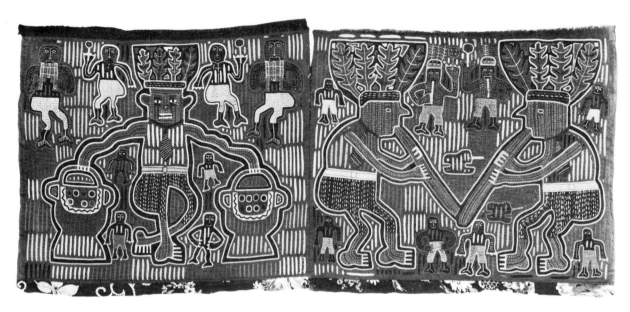

55a. Front and back panels from an *inna* mola blouse. The vertical slit fill is *tas-tas*. Note the use of embroidery for detail and the recurrent use of four and eight elements in the designs. (103 cm. x 40 cm.).

the top layer. Black, mainly used as the base that outlines the whole design, may be exchanged with the red. Yellow or orange, and green, are generally used for the second layer or the outline, but blue, purple, and pink are also used. Any color may be used as a filler. The Cuna like intense rather than pastel or muted colors. White is rarely used, except for eyes, toenails, teeth, and hats, or as the base layer for two-color molas. Contrast is very important, as we have mentioned, and colors within the same range, blue and green for example, are not used together because they are considered to be the same.

The women constantly experiment with color. There has recently been an experimental fad, for example, in which complementary colors, red and green, and close colors, red and blue and red and purple, were used together in complicated op-art like geometric designs. The red and blue are especially effective at confusing the eye. Many women have also experimented with black and white, and although for a time these molas were very popular with tourists, the fad didn't last long. When it had ended, a black-and-white mola was difficult to find.

Solid-color fabric for the mola, prints for

the top and sleeves, and the special fabric for scarf and skirt are all sold in small stores on the islands. Scraps of the prints are used for filler colors on the mola or as the base layer. Polka dots make effective eyes. Most material comes to San Blas on the Colombian canoes, though some Panamanian fabric does come from Colon.

The front and back panels of the mola are not necessarily the same, but they generally have related subjects and are always basically the same colors (see plate 6). They are attached to the top part of the blouse and then the sides are sewn together. The fabric from the sleeves and yoke presents another choice. Printed fabric is very often used; if a solid color is used,

it is usually the base color or one that will contrast with the colors in the mola. The yoke and sleeves, slightly gathered strips of contrasting material, are bound in order to finish raw edges. These, and the borders between the mola and yoke are often trimmed with handwork or rick-rack. Sometimes, sewing machines are used to sew the blouses together and to put on the rick-rack.

The Cuna reaction to the rumor that the Peace Corps had brought sewing machines to San Blas and taught the women how to use them to make molas illustrates the basic self-confidence of the Cuna. At first they thought it was funny, because they had had sewing machines long before they had Peace Corps

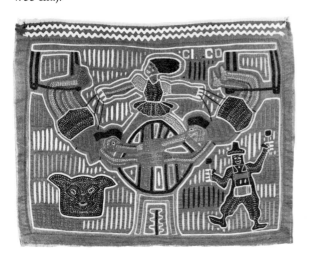

55b. Circus mola; note the realistic treatment of the legs actually going over the trapezes. (51 cm. x 38 cm.).

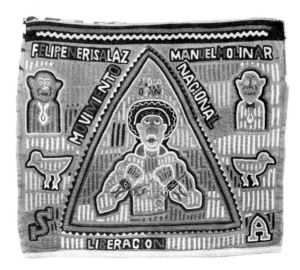

55c. Political mola, with fine embroidery for facial detail. Note the decorative and informational use of letters; the trim on the triangle is *dientes*. (48 cm. x 40 cm.).

volunteers. As they discussed the rumor, however, they became furious at the idea that anyone would think that if someone told them to make a mola on a sewing machine and they did not want to, that they would do it anyhow. A clarifying letter was sent to the *New York Times*, one source of the rumor. Although some women have for many years sewn their molas with a machine, only certain designs with lots of straight long lines can be done that way. Also, because the Cuna believe that stitches should be completely hidden, machine stitching breaks with a Cuna criterion of quality and is therefore highly criticized.

Content and Inspiration

The subject matter of the pictorial molas may be taken from the local environment —e.g., scenes from daily life, including the missions—or from pictures. All these subjects, of course, are often discussed by the women as they work. Subjects may also be things from the outside that are seen briefly but are not there all the time, or even things that have been described but never seen (see plate 6).

Birds, fish, turtles, and cats, and other subjects from the local environment are very popular motifs (see plate 6d). Cuna social activities are also inspiration for molas. The inna, or girls' puberty celebration, is also a popular motif. The mola in figure 58a shows various elements of the ceremony in great detail: some men are playing flutes and rattles and two men are smoking large cigars with the lit end in their mouths; braziers are shown from both the front and top in order to reveal

the cocoa beans burning inside. All the men have on traditional hats with feathers in the tops and, in addition, all the important men have on neckties—a sign of their status. Design elements in combinations of four and eight—important ritual numbers for the Cuna —appear repeatedly in this mola. Traditional medicine also provides subject matter: two molas illustrating an unsuccessful curing ceremony and subsequent funeral are shown in *Molas: Art of the Cuna Indians* (Mueller 1973:11, figures 6,7). Keller (1969:76) shows a mola depicting the interior of the congress hall: the *sailas* (elected leaders) are lying in hammocks in the center of the hall, while other men sit in bleachers around the walls. One man has a child in his lap, and even the sailas' assistants' chairs are shown in their proper places.

Religious Themes

The present-day Cuna have been subject to missionization in recent decades but the majority of them still hold aboriginal beliefs, following a kind of syncretistic religion drawn from many sources. They are as eclectic with religious ideas as they are with other aspects of life, including material culture. They believe in a distant creative God and an "original mother." After death, the soul journeys to an earthlike paradise, encountering past deeds along the way. Although some types of sickness are within the jurisdiction of Western doctors, many are still treated by traditional medicine. A large number of maladies are thought to be due to the theft of the soul, *purba*,

by evil spirits. When someone is afflicted by such a malady, a diviner, *nele*, attempts to find the soul by communicating in a dream with the soul of carved wooden figures, *nuchu*, which have been animated by chanting and sent to the underworld. The diviner then prescribes the proper combination of chants and medicine to the medicine man, *inatuledi*, who makes the medicine by immersing certain special herbs, bark, stones, and animal bones in water and then bathes the sick person with the medicine to cure him. This medicine can also be used as a preventative or to increase certain natural abilities. Although there were earlier missionary efforts, intensive missionary work with the Cuna was not undertaken until this century. Father Leonardo Gasso, a Catholic missionary, came to Nargana in 1907 to set up a school, and Anna Coope, a Baptist missionary, came in 1913. There are now Catholic, Baptist, and Mormon missions on several islands. Some Cuna men have become Baptist ministers and returned to San Blas.

In the 1960s there was a fad of "Dios" or missionary molas, interpretations of Bible stories, including those of Noah, Adam and Eve, and the Crucifixion. Keeler and Mueller both show several good examples. There are several Crucifixion molas that seem to be from the same original picture, always with the cross as the central element, the nameplate at the top and figures kneeling or standing below. Christ's feet are actually crossed and the nails are small pieces of material sewn on top. Some show people at the bottom and others have angels collecting Christ's blood in little pots (see Keeler 1969:38, and also plate 6a).

Now that the fad for Dios molas is over, few women wear them. This does not mean that there was any change in religious beliefs, only that the style was no longer popular.

Political Themes

Each island has three *sailas*, or elected leaders, who make decisions on a consensus basis after extensive discussion. Many of them receive small salaries from the government of Panama and are officially recognized as the local political authorities. Each year there is one great congress for all the islands, where matters affecting the Cuna as a group are discussed. Since the Cuna stress equality, any leadership positions can be attained by any Cuna man through ability and hard work.

Although San Blas is an autonomous region, the Cuna vote in Panamanian national elections. Politicians come with flags and posters, and the women make molas with the symbols of their political party. The symbol of the Partido National Republicana (Republican Party) is a deer with antlers within a round circle; molas show the deer as a central element with the flags and people around the edges. One mola had a portrait of the current candidate, which the women say looks just like him, but they put his name on anyway. The "Movimiento Nacional Liberacion" mola (see figure 55c), which is taken from a poster, shows a worker breaking the chains that enslaved him; the main figure is depicted quite realistically—his muscles are bulging, his hands are strong, his eyes are cast upward, and the chains are circles of fabric really linked

together, with the last one broken. All the details from the poster are realistic, but the subordinate figures are quite stylized. The men have on ties and the candidates' names are on the top. The outline around the triangle is an example of *dientes* and the vertical lines are *tas-tas*.

Recreational Themes

Boxing is popular with both men and women and, like anything that interests the Cuna, it has become a subject for molas (see plate 6b). Again, the central figures are realistic, and perspective is given full consideration. The stance of the upright figure captures the feeling of a boxer in action; his forearm is shown actually on top, with the other arm, a separate piece of cloth, placed behind it. The legs of the other man are behind his arm and the standing man's leg. When a person is unconscious, his purba is said to leave the body and may be stolen by evil spirits. The other side of the mola shows both men upright and boxing. The mola's designer has put the boxers inside the ring and has shown the ropes behind them. The floor is raised. Spectators and bells around the sides are stylized. The small circular cutout fill is shown on the bodies and the triangles have been built up from the base.

As many women have been to the circus in Panama City or Colon, circus themes also appear on molas. In the mola shown in figure 55b, the woman has combined the trapeze flyers and the lady who rides horseback. Embroidery is used for detail on the bodies and clothing. It is difficult to say which designs were copied from pictures and which were made following the observation of real events.

Recent External Influences

Molas, with the exception of "tourista molas," are made to wear and are usually sold only after a woman is tired of them. Most women do not sell their new molas. For years men have sold molas in Panama City and Colon as a favor to the women in their families, a handy system where current style is important and old molas have to be got rid of. Recently, the women who live on islands where there are tourists sell their own molas and there are also buyers who come to San Blas to purchase hundreds of molas at a time. Nevertheless, relatively few women make molas especially for sale.

A few women do make what the Cuna themselves call "tourista molas," which are the same shape and size as the regular panels for a blouse but are made quickly at the expense of the accepted quality criteria. Women who make them are often criticized and the problem of "tourista molas" has been discussed at the Cuna congress.

Plate 6d is an example of a good "tourista mola." It was made for sale with no intention of being used in a mola blouse and as such is well made. Nevertheless, the women did criticize it, explaining that the lines were irregular, the areas were left unfilled, that spacing was too wide, and that the stitches were too large, unevenly spaced, and made with the wrong colors of thread. Further, to them the colors are all wrong: "The colors are ugly, . . . too pale" were the comments made most

often about this mola.[3] Moreover, they felt that chartreuse is not good as the underlayer for the central figures, and is especially bad next to the yellow, and that the outline around the birds is not effective and does not stand out; they considered the olive green to be an ugly color.

Besides creating the demand for "tourista molas," outsiders have affected mola making through special orders. Women have been copying designs from pictures for so long that orders for a particular theme present little difficulty. People also order mola panels in different sizes and shapes for framing. The largest one I saw was about three feet by ten feet. Several women worked on it and although it won first prize in a National Crafts Contest it was considered to be *problema tumadi* (a big problem) and they would not make another one. Orders are also received for small areas of mola work, a bird or fish for example, on a large unworked piece of cloth.

Members of the *Cooperativo de Mola de San Blas* also make molas especially for sale, but in this case the quality is maintained, probably in part because the women take pride in their work for the Coop and in part because of its strict quality-control board, which is made up of the very best mola makers.

In 1963, Peace Corps volunteers started a sewing school at Nargana where women who no longer wear traditional dress could learn to make clothing for themselves. Dresses with molas cut up and sewn on as pockets or belts had been sold in Panama City for several years, but in the Nargana classes women began to make dresses with the molas designed for certain areas of the dresses. Some of the first mola work was done by women who lived nearby because those from Nargana didn't make molas. The dresses sold well and in 1966 the Coop started. There are now 300 members on eight islands who market their products through retail stores in Panama City.

Scarves, pillows, toys, and many other things are made, and designing for new and unusual shapes has caused little difficulty. Some pastels are used and also new materials such as silk. None of the objects introduced through the Coop are used by the women themselves and mola work still has only one use—for clothing. The pastel colors, the new color combinations used in items for the Coop, and many of the new materials have not been incorporated into traditional molas, but the Coop symbol has become a design motif. The most significant effect of the Coop has been that women who formerly did not make molas are now making them and incorporating them in their modern dress.[4]

CONCLUSIONS

The mola making process is developing in the direction of increased complexity. Quality criteria are based on the skillful manipulation of the technical process, balanced design, and

[3]These comments were generated in 1974 during an experiment in which women were asked to critique and rank order a standard set of molas (see Salvador 1975).

[4]For further discussion of the cooperative, see Keeler (1969) and Hollomon (1969a).

the use of proper colors. Molas vary in quality; not all molas made for sale are poorly made, nor are all those for personal use well done.

Many Cuna women who wear contemporary Panamanian-style dresses cut and sew beautiful molas, even though they do not wear them. Thus, though Cuna ethnicity is closely tied to the standard Cuna women's dress form, there is no imperative for every individual to wear the outfit. Molas are a functional art, recently developed but fully integrated into the Cuna culture. They also qualify as a "commercial fine art" (see Introduction), except for a few heavily criticized souvenir molas.

10. Gourd Decoration in Highland Peru

Ruth McDonald Boyer

Gourd embellishment is a traditional art of Peru, one that reflects the changing tastes and accomplishments of Indian artisans over a time span of at least three thousand years. The focus of this presentation will be the contemporary work of skilled gourd-carvers and pyroengravers living in two adjacent villages in the Central Andes, namely, Cochas Chico and Cochas Grande.[1] (See map 5.)

These villages are located approximately eight or nine miles north and east of Huancayo, the capital of the Department of Junín. To reach them, the bus from Huancayo wends its way upward over the foothills, through oc-casional groves of eucalyptus trees, and eventually attains an altitude of some 13,000 feet above sea level. The bus stops before a small shop, which offers certain household items, soda pop, and bread. This is the outskirts of Chocas Chico, and visitors and residents thenceforth must make their way on foot.

Within the boundaries of the two villages, each with a separate plaza, dwell some 150 families. Their rectangular, one-story homes of adobe brick with red tile roofs are within walking distance of each other, but each is built on its individually owned farming land.

Agriculture provides the basic source of subsistence for people in the Cochas area, just as it does for those living in the Valley of the Río Mantaro below, and just as it did for centuries among the ancient inhabitants of the entire Central Andes. The principal crops in the Huancayo region are maize, various kinds of beans and potatoes, *ullucos* and *mashuas* (raised for their tubers and eaten as substitutes for potatoes), and barley and wheat. Although dry farming is the major occupation of Cochas' residents, the ownership of cattle lends

Ruth McDonald Boyer was awarded her Ph.D. in anthropology from the University of California, Berkeley. In addition to her position as Associate Research Anthropologist at the Lowie Museum, she has taught at the University of California, Berkeley, and at the California College of Arts and Crafts in Oakland. She has done research among the Apache Indians as well as in Peru, and is known for her publications on textiles and material culture. She is coauthor (with William Bascom) of *Narrow Band Weaving in Nigeria* (in press).

[1] The fieldwork was carried out by the author in the summer of 1966. It was partially financed by a Faculty Research Grant through the Department of Design, University of California, Berkeley.

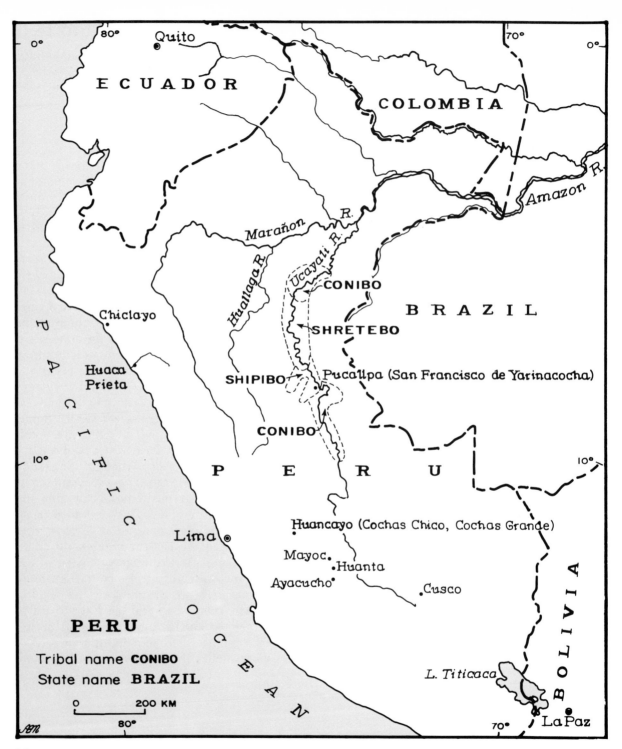

Map 5.

special prestige and is an indication of monetary wealth. Such animals tend to be guarded much of the time within the confines of the walled courtyards that serve as entries to the houses. In addition to farming and the herding of livestock, skilled artisans in almost every family engage either in weaving or gourd carving as a part-time activity.

The native language is *Quechua*, the speech imposed by the Incas early in the fifteenth century as a means of consolidating, and of communicating with, the diverse peoples they conquered. In addition, most of these particular villagers speak at least rudimentary Spanish. Those who frequently participate in the Sunday market activities in Huancayo tend to become proficient bilinguists.

Historically, Cochas Chico and Cochas Grande are relatively new as village entities. Immediately prior to the turn of this century, the property on which they stand comprised the hacienda of a gentleman of Chinese ancestry. The Indians who tilled the soil were given the privilege of building their houses on his land, but he demanded an outrageous proportion of the crops they produced. For the Peruvians, the meager reward was not commensurate with the hard toil and long hours involved, and general unrest began to seethe among them. This dissent finally broke forth in rebellion when the Chinese estate was sold to another foreigner, this time a North American. With the passive compliance of the Peruvian government, the Indians forced the new owner to leave, freeing his considerable acreage. Various families from Huancayo came to join their friends and relatives who had been active in the revolt. Thus the rolling

hills with their fertile fields were populated and planted by independent Peruvian Indians.

Historical Orientation

There is insufficient evidence to reconstruct a complete sequential continuum of representative motifs for the gourds decorated in different time periods and locations throughout Peru. In part, this is because these fruits tend to decay or to be eaten by insects, and, in part, because they are readily available and thus have often been used as everyday household vessels and containers, subject to breakage and casual discard.

Nonetheless, information to date indicates considerable antiquity for gourd embellishment. It also suggests that such decoration was in conformity with art styles of specific culture periods, art styles found in other media and reflecting the world views of their makers. A few explanatory examples follow.

The earliest important archeological discoveries occurred when Dr. Junius B. Bird excavated the site of Huaca Prieta, on the northern coast of Peru in the Chicama River Valley, and found more than 10,000 gourd objects and fragments in a refuse deposit. Of this vast number, only 13 showed surface decoration, but the techniques used in that decoration have continued to be utilized by gourd artisans up to the present. For instance, some of the fragments showed a simple scratching on the epidermis before the fruit was completely dry; two bore incised fine-line hatching; and five displayed pyroengraving or burning of the surface to create color and depth of design.

More significant, however, were two small

carved gourds found in a shallow burial at the same site, gourds whose age by means of Carbon-14 dating has been estimated as approximately 1950 B.C. Fortunately, these two specimens were in a sufficiently good state of preservation to warrant the hardening and reconstruction of their fragments. The motifs that emerged were complex in design, indicating skillful planning and execution (Bird 1963). In fact, their very sophistication has prompted an interesting suggestion with regard to the origin of the Huaca Prieta art style. It has been noted that the faces appearing on these two gourds are similar to those excised on southern Ecuadorian pottery and stone figurines of about the same date (Lanning 1967:66).

To continue with another example of significant pre-Columbian evidence, a number of well-preserved gourds have been excavated from Paracas culture sites. These were used and decorated at about the time of Christ by a religious people living in small settlements on the south coast of Peru. Their concern with supernatural beings is manifest in a rich pantheon of animal, bird, fish, and fantastic mythological creatures, illustrated pictorially on textiles and ceramics as well as on incised and pyroengraved gourds.

Progressing once again through time to the period of Inca ascendancy and domination, from about 1440 to 1532, we find that although there are but few actual specimens to examine, and certainly nothing like a complete record of design configurations, there are literary sources that refer to brilliantly painted gourds that are said to have served as substitutes for pottery vessels. What we do find for the Inca

period in relative abundance are cups known as *keros* (*queros, qiros, qerus*). Those made of wood were used by fairly affluent people well into the eighteenth century. Some of these beakers, frequently of tumbler shape, were carved; others were painted or lacquered, or even elaborately incised with lead. Scenes and motifs of local interest depicted on the *keros* were lively in execution, and were often arranged in parallel zones or registers (Rowe 1961). This was also the arrangement of designs on many of the gourds throughout the period of Spanish colonialism, in the days of the Republic, and in contemporary times, and the presence of topical themes has continued to be a characteristic of gourd decoration.

Gourds dating from the colonial period are available in greater number than are those of Inca days. Perhaps because of this relative profusion, their decoration displays a wider variety of subject matter. Various degrees of skill are apparent in the embellishment; some appear to have been the work of amateurs, others of master craftsmen. Almost all show some evidence of European influence. The artisans combined native Peruvian themes and scenery with foreign innovations. Members of the Inca nobility were arranged side by side with Spaniards, or at least people attired in Spanish clothing. Llamas and alpacas were set in intertwined foliage strangely reminiscent of Moorish arabesques; lions and bears were framed in roundels comparable to the medallions seen in Near Eastern arts. Increasingly, backgrounds consisting simply of the undecorated epidermal surface were obliterated by intricate carvings. The edges of lids, instead of being cut in sharp zig-zags, were modeled in

the Quechua term for calabash, *mati*, is evident. Within this general classification, many different terms are used for specific shapes of the fruits, or for certain kinds of receptacles cut from the gourds. These terms differ according to the geographical area. For instance, in Ayacucho, the Spanish word *azucarero*, or sugar bowl, is used for small, round gourds with fitted lids; this would be called a *poto* in Ica. As a further example, a bottle-shaped gourd called a *poto* in Huancayo, might be known as a *porongo* or *limeta* along the coast (Jiménez Borja 1948:46–53). These are only a few of many possible illustrations of sometimes confusing terminology.

Creating the Designs

In postcolonial times, at least, two main styles of gourd decoration are recognized: one is referred to currently as the Huancayo style, the other as the Ayacucho style. In general, but not always, each is made in the region of the city named. A few Huancayo-style gourds have been made by artisans from Ayacucho, Huanta, and Mayoc; Cochas carvers know and use both techniques.

In the Huancayo style, which is the one more popular among the engravers of Cochas Chico and Cochas Grande, full advantage is taken of the natural golden color of the epidermis of the gourd. The background areas are hollowed out with a burin or engraving tool (*burillado*) so that the pictorial themes appear in yellow- and brown-toned low relief on a white setting. The steps in the process are outlined below.

1. The design is sketched on the gourd in pencil. Some of the more accomplished carvers omit this stage, particularly if the theme is one they use frequently.

2. The pencil lines are then traced with a fine burin, creating a narrow white incised outline that remains visible throughout the remaining steps.

3. To add depth and variation of hue, certain areas are then pyroengraved. To accomplish this, the engraver holds the red-hot tip of a piece of *quinal* wood against the epidermis until the burning attains the desired, color, ranging from tan through various brown tones to black. Artisans complain that the smoke spiralling from the scorched skin bothers their eyes, for they must constantly lean over the gourd, blowing on the coal to keep it burning (see plate 7a). Quinual is a hard wood obtained from a tree (*Polylepis incana*) that grows locally in the highlands, although not in such profusion as it did in the past (Dissenhoff 1967:13).

4. After pyroengraving is completed, and following the outline previously made, the carver chisels away the background areas, using various widths of burins, or perhaps a knife. The natural color that emerges is a creamy white, but if a whiter pictorial ground is desired, it may be rubbed with calcium carbonate.

5. If a lid is desired on any gourd, a knife is used to cut through to the hollow center. Today this is usually done in a simple zig-zag edge, one that has been outlined by a pattern involving the golden hue of the fruit, plus the pyroengraving.

57. Ayacucho style gourd *azucarero*, with scenes of town life (11.5 cm. diameter).

6. Finally, the seeds are removed. The most carefully executed *mates* are then sanded on the lid edges and on the inside of the gourd with commercial sandpaper.

The Ayacucho-style gourd is characterized by a black background rather than the white of the Huancayo style, and is created by the following steps.

1. Motifs are sketched in pencil if the worker feels it necessary.

2. A burin is used to make an outline of the design.

3. The background is carved out with a burin or knife.

4. In order to color the ground black, the artisan rubs the mate with a mixture of fat and the ashes of *ichu* (or *ischu*), an Andean grass that grows profusely in the highlands. Occasionally, barley grass or stubble is substituted for the *ichu*, but the latter is deemed equally satisfactory and is available to everyone. Pig lard serves as the usual fatty substance. The mixture is melted to a liquid state and is then rubbed over the surface of the gourd with a small rag, the black seeping into those areas of the mate that have been cut away—that is, the background areas. Certain innovators have used shoe polish for this coloring, but this practice has not met with general approval.

5. The gourd is then washed. The cream-gold color of the outermost skin wipes clean; black adheres only to the exposed portions of the more porous layer under the shell.

6. If desired, additional engraving may be done on the outer surface, thus creating lines or spaces of white contrast.

7. If the shape so warrants, lids are cut, seeds are removed, and the inside of the gourd is sanded.

Aniline dyes, available at hardware and drugstores in Huancayo, are sometimes used to stain certain portions of both Huancayo- and Ayacucho-style designs (figure 57).

There is a third type or style of gourd engraving, seemingly without special designation, in which the artisan uses aniline dye to cover the entire surface of the mate. The fruit is first dipped into a dye bath of red, purple, or green, or any desired hue, and then, when the

gourd is sufficiently dry, it is incised with a fine burin, or wider spaces are cut out. Tree gourds from the selva are often treated in this way.

The carvers of gourds in Cochas Chico and Cochas Grande are proficient in all three of the styles described.

One other effect should be mentioned. As noted previously, the Cochas artisans prefer to buy gourds grown on the north coast of Peru, where such cultivation of gourds is common, and import them to Huancayo. In the Department of Lambayeque, where such cultivation of gourds is common, an entirely different style of mate decoration is done. The motifs are painted on with acid, silver nitrate, and sulphuric acid to create curving floral designs, geometric patterns, and occasionally slogans or mottos. Sometimes the gourds that are shipped to Huancayo bear such decoration. So, if no unembellished fruits are available, the people of Cochas must buy acid-burned gourds, which are slightly more expensive than those they would have preferred. When this happens, the Cochas artisans sometimes utilize the patterning of the "North," incorporating the motifs in their own style of design, and sometimes ignore the acid-made decoration, hoping it will not interfere too much with their own creations (figure 58). Most of the designs from northern regions such as Lambayeque appear on the rims of cut vessels, but occasionally, on the more expensive mates, the entire surface will be covered.

Subject Matter of the Gourds

The themes pictured on the Cochas mates reflect today's village and domestic life. Per-haps the most usual motif is that of llamas or alpacas moving one after the other through one or more zones or registers. There are also many family scenes, some of which depict individuals quarreling. Another kind of violence may appear in the depiction of bullfights on the village roads or on the plaza. Various agricultural activities are also depicted, as are the processes of spinning and weaving and ceremonies such as weddings and funerals. On the better quality gourds, there are tab-

58. Gourd by Vertibo Medina of Cochas Grande with scene of musician and man carrying banner of 28th July and two men branding calf; note incising and pyro-engraving over the original, lighter, acid-engraving around the rim (23 cm. diameter).

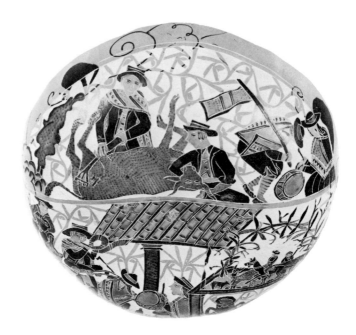

leaux of people shown in times of celebration, such as a neighborhood *chicha* party, when quantities of this fermented brew are consumed. Other significant occasions depicted include such events as the blessing and attachment of a roof ornament when the construction of a house is completed, and the Santiago Ceremony in July, based on an ancient fertility rite and indicated on the gourd by a "Santiago horn," made of several cows' horns fitted into one another and spiralling in bizarre fashion into the air. In all such festive scenes, there are musicians bearing typical Andean instruments: harps, the *saxo*, flutes, violins, and *tinyas* (small drums). Native dress on dancers and on chicha drinkers is graphically portrayed.

Two of the many gala occasions that appear frequently on the mates will be described here: the *jalapato* and the *cortamonte*.

The jalapato ("pull-duck") takes place between the end of June and the Fiesta of Santiago, immediately prior to the Peruvian Day of Independence, July 28, and involves a game of violent death for the bird that provides the sport. For the jalapato, a wooden scaffold must be set up consisting of two tall vertical poles with a crossbar, from the center of which a live duck is suspended by its legs, head down. Men on horseback take turns riding under the bird, trying to choke it to death as they pass; the one who succeeds is the winner. This contest sounds similar to the *cóndor-rachi* ("pulling of the condor," or "tearing the condor to pieces") that occurs in the Callejón de Huaylas region, north of Huancayo. Here, during February, some 15 birds are killed. Again, horsemen, with festively

painted faces, strike the suspended condor with their fists as they ride beneath it. Finally, one rider grasps the bird by the throat, and bites out its tongue. Then the condor is lowered, to be torn apart by the audience. Feathers are much desired and are used for magical purposes (McGahan 1971:707). Insofar as I could ascertain without seeing the game, the jalapato is somewhat less gruesome than the condor-pull, but both seem related in terms of sequences of events, and perhaps psychologically as well. The cóndor-rachi was not seen on any of the decorated gourds, and depictions of the watered-down duck version were more frequent about a decade ago than they are now.

The cortamonte may occur during the carnival period just before the harvest in March, or during the Santiago celebration, or as part of other important festivities. In this ceremony, a tree is felled and carried by the men of the village to their plaza, where it is wedged into a hole in the earth and decorated with gifts. There is music and the people dance and drink chicha. Each couple dances toward the tree in turn; when they reach the tree, the man takes up an axe and slashes at the trunk. The one whose efforts succeed in toppling the tree is awarded the honor of paying for the next fiesta. All participants in the merriment share the scattered gifts.

In addition to the traditional panoramas in gourd depictions, there are many original and personal delineations. An historical event, an individual incident, or even a fantasy may provide suitable subject matter. I have seen several gourds in which an airplane is shown crashing into a church or into village homes. A

carver who goes frequently into the selva may show animals and people on a meandering path, passing through the various kinds of foliage one encounters on such a trip—flora varying from desert cacti to large-leaved tropical plants. One of the recognized *maestros* of gourd engraving had jobs with industrial plants in his earlier years, and some of his works set forth various of the operations he has seen and been associated with (figure 59).

ECONOMICS AND THE SUNDAY MARKET

Besides giving the artisan the satisfaction of making something attractive, gourd carving pays better than many of the other crafts in the Huancayo area. A manta of the Cochas style, which takes approximately one week to weave, brings the weaver from about five to eight United States dollars when it is sold. To engrave a large gourd of highest quality takes about the same period of time to make, but it sells for twice as much as the manta.

Three qualities of mate decoration are recognized. The poorest quality consists of relatively small gourds, usually from three to five inches across, in which the design is roughly cut out. There tends to be little if any pyroengraving, although some are aniline-dipped and then incised. Designs are usually repetitive and simple, perhaps consisting of row on row of poorly outlined llamas. This crude-quality mate is generally turned over to a mayorista. He may attempt to sell them in Huancayo, but more often he will

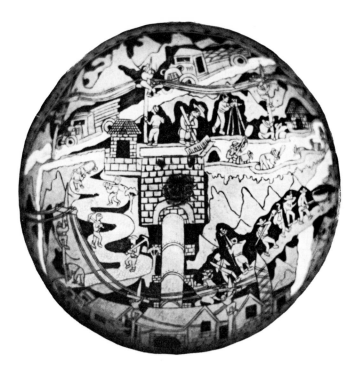

59. Contemporary Ayacucho style gourd, showing operations of electric plant.

ship them to craft shops in cities such as Lima, where tourists find them pleasing and inexpensive mementos.

The middle-quality engraved gourd is more carefully executed. It tends to be somewhat larger than the poorer-quality pieces, but still would take a skilled artisan only a day or two to complete. Although some of these mates pass through the hands of a middleman and are exported from Huancayo, many appear in the stalls of the individual families when they

take their work to the local Sunday market. The prices such gourds bring are dependent on several factors: size of the gourd, the time it took the artisan to decorate it, and the quality and extent of the embellishment. Estimates of price vary from three to ten dollars. These are the mates sought by most tourists and mestizos, who later display them as art objects in their homes. They are too expensive for the village Peruvians who, needing gourds for utility purposes, find either the undecorated fruits or those designed on the north coast quite satisfactory. Even better and more durable are plastic or enamel vessels, both of which are available at the market. The middle-quality gourd is sometimes exported to shops in the United States.

The finest-quality gourd is indeed expensive, but it is also a work of art. These are usually made to order for a specific buyer. They take from five to six, or even more days, to complete. In 1966, an undecorated fruit from the north coast, one ranging from 10 to 14 inches in diameter, would cost the artisan about three dollars. After being carefully designed and incised, with appropriate coloring added, such a gourd would bring from 15 to 20 dollars if sold directly by the craftsman. If handled by a mayorista, another five dollars might be added, but the artist would receive no more. Artisans seem to take genuine pleasure in displaying such works at the Huancayo Sunday fair.

The Sunday market in Huancayo is a colorful affair. The main street is closed to automobile traffic, and stalls of merchandise are set up on both sides and down the middle of the thoroughfare. Booths selling specific wares are to be found in the same location each week.

For instance, the gourd-carvers set up their stands in a row down the central aisle, beginning at the corner nearest the big Catholic Church, and moving south toward the hotel. Even among themselves, there is a respected alignment of each of the families and mayoristas.

All the gourds are placed on tables or on the ground in front of one or two family members. The mayoristas show middle- and poor-quality gourds plus undecorated and acid-embellished mates from the north coast. They and the carvers are ready to begin bartering with any interested customer. Only the finest-quality large gourds seem to have a set price.

In general, this Sunday market, or fair, as it is sometimes called, offers an opportunity for village friends to meet, gossip, and make the necessary purchases for the coming week. One might expect genial conviviality among the *materos*, the gourd-carvers, who sit side by side, but such is not the situation. Members of adjacent families do not speak to each other; if a neighbor asks, they claim not to know even the initial asking prices for their pieces, let alone the purchase prices. This is a striking indication of the rampant rivalry existing in the Cochas villages. The hostility is said to be the result of one family's "stealing" the designs of another, particularly designs that have proved highly marketable.

INNOVATIONS AND EVALUATIONS

In 1966, considerable interest was evidenced in the art of gourd incising, not just in

the vicinity of Huancayo, but in Lima among those interested in furthering the national folk arts.

In Cochas, enthusiasm for the art was being furthered by the efforts of a Peace Corps couple, the Zagars, who were living in the schoolhouse on the old plaza of Cochas Chico. Both these young people were artists in their own right, and they recognized and encouraged individual expression on the part of the materos. In 1967, they arranged for a showing of the best work of the villages in a gallery in Lima. The exhibit was received there with considerable enthusiasm.

But even before the coming of these Peace Corps workers, efforts had been made to preserve the best of Peruvian crafts. For instance, one of the masters of the gourd-carving art of Cochas had been employed for some five years as a teacher in the *Centro Artesenal* in Huancayo under the sponsorship of the *Instituto Nacional de Formación de Instructores*. This maestro instructed anyone who desired to learn the various techniques at his command. At the time of my fieldwork, he had some 14 students, all from the Cochas villages. He himself received a salary far exceeding what he would have earned from carving mates, and his new position offered him considerable prestige. Unfortunately, he had almost completely stopped his own esthetic endeavors, leaving such work to his wife and sons.

One innovative design that the Zagars were directly responsible for is worth mentioning. This new concept involved using long-necked gourds with bulbous bodies as sculptural objects. The Zagars had shown certain of the Cochas families illustrations of ancient Peruvian ceramics, and the villagers had been

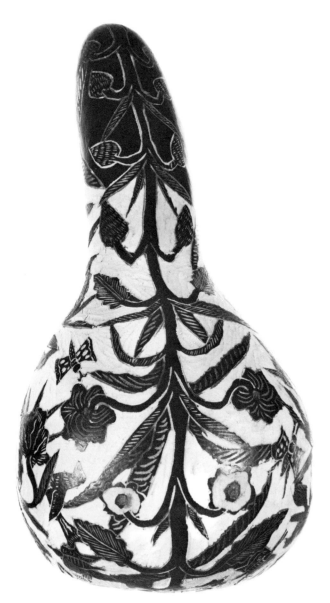

60. Innovative "bouquet of flowers" design gourd, with analine dyes, by Juan and Bonifacio Gracia, of Huancayo, Peru (23.5 cm. high).

struck by some of the bird and animal forms. They transferred the idea to the mates, which were duly incised and pyroengraved to represent the new images, complete with plumage, fur, or scales. The neck of the gourd was used as the beak of a bird or as the snout of an animal. The same kind of gourd was sometimes fashioned into a bouquet of flowers (although this form had not been among the photographed archaeological objects), with the neck of the mate serving as the stem area for the blossoms (figure 60). Representations of fish were more frequently made on long oval-shaped gourds than on the long-necked type.

In conclusion, then, as we have seen, the gourd-carvers of Cochas Grande and Cochas Chico are receiving continued encouragement in their practice of quality craftsmanship. This approval comes not only from tourists who buy the work, but also from staff members of the *Museo de la Cultura Peruana* in Lima, from connoisseurs of the art, and from collectors of native crafts.

This attitude differs from that of such people in the past who regarded contemporary gourd engraving as "sloppy," "careless," "crude," and "decadent," and compared it negatively with colonial gourd engraving, which was esteemed for its internal complexities and the integration of European and Peruvian themes and designs. Most of the mates made during the colonial period and in the early days of the Republic were made in the Ayacucho style and were created in or near that colonial center. As a result, many of the themes have urban backgrounds.

Although the Cochas villagers recognize the sales potential of their current work, they themselves prefer simpler designs. Their favorite gourds are those bearing only a simple motif or series of motifs around the rim of the cut fruit. This is the way the Big Four first worked, but this is not what the tourists and rich Peruvians buy, and so this style has been abandoned.

The future of mate engraving is difficult to predict. Suffice it to say that in 1970 the sculptural birds, animals, and fish were being marketed in the United States in shops known for their "contemporary good taste"; prices were commensurate with those seen earlier in Lima.

The art itself is a viable one. The materos, as always, are sensitive to the tastes of buyers. They recognize that the sculptural forms, often in humorous vein, have particular appeal to North Americans. Provided the quality of workmanship remains high and individuals express their own tastes and experiences, gourd engraving may provide a better income for artisans of the Peruvian Highlands than they have enjoyed in the past.

11. Shipibo Tourist Art

Donald W. Lathrap

It is well to make clear at the beginning that my observations concerning the effects of tourism and commercial collecting on the ceramic art of the Shipibo-Conibo are by no means systematic or intensive. In 1956, I began what has turned out to be a long-term research program[1] on the culture, history, and ethnography of the Central Ucayali Basin within the tropical forests of eastern Peru (Lathrap 1970). I returned in 1962 with my wife and daughter, and again in 1964 with William L. Allen and Thomas P. Myers. Only during 1967–1968 did

I devote more attention to contemporary ceramic production, particularly to items made for domestic use.[2]

THE PEOPLE

The Shipibo-Conibo are a populous and rather widely dispersed ethnic unit inhabiting the tropical forest zone of eastern Peru. Most of their cultural inventory is typical of the way

Donald W. Lathrap received his Ph.D. in anthropology from Harvard University and is now Professor of Anthropology at the University of Illinois, Urbana. For nearly two decades, assisted by his wife, Joan, also an anthropologist, he has undertaken archeological and ethnological research among the Indians who live on the Amazon Basin side of the Andes in Eastern Peru. He is well known for his book, *The Upper Amazon* (1970), and for numerous other publications.

[1]The research discussed was accomplished with support from the Fulbright-Hayes Commission under a Center, Faculty Research Fellowship. The paper has benefited greatly from the critical comments of my wife, Joan W. Lathrap, though I assume full responsibility for any residual errors or oversimplifications. I also want to thank Nelson H. H. Graburn, the organizer of this symposium, for his continuing encouragement.

[2]A detailed account of the research follows: During 1956, I documented what has proved to be the longest ceramic sequence known for any region in Peru (Lathrap 1962; 1971). In 1962, I commenced a program of site survey spreading out gradually from the Shipibo village of San Francisco de Yarinacocha. In 1964, William L. Allen and Thomas P. Myers worked with me in expanding the geographical range of our archaeological sequence, while my wife, Joan W. Lathrap, was studying various aspects of Shipibo culture. During an 8-month field session in 1967-1968 I devoted my attention to ceramic production among the modern Shipibo-Conibo, focusing on pottery made for use in households rather than on pottery made for sale. My intention was to investigate the relationship between stylistic variation and such factors as residence patterns and kinship. The ceramic production of the extant Shipibo-Conibo

of life that has been designated "Tropical Forest culture." They subsist by root-crop agriculture with a very heavy dependence on the fish and aquatic reptiles available in the major rivers. Traditionally, the staple crop was manioc, but in postcontact times various kinds of banana have come to replace manioc as the single most significant source of calories. Agriculture is implemented by the slash-and-burn system.

The Shipibo and Conibo speak mutually intelligible dialects within the Panoan linguistic stock. The Panoan linguistic stock includes a large number of speech communities scattered in a huge arc extending from the south shore of the central Amazon westward to the foothills of the Peruvian Andes and then southeast into the lowlands of eastern Bolivia (see map 5, in chapter 10). The ethnic groups adjacent to the Shipibo-Conibo to the east include the Amahuaca, Remo, and Capanahua. All speak languages within the Panoan family, as do the Cashibo, the major ethnic group to the west.

Archaeological and linguistic evidence sug-

gests that all these Panoan-speaking communities of eastern Peru dispersed from a common ancestry within the last twelve hundred years or so; and yet there is a marked difference between the level of cultural complexity maintained by the riverine Panoan groups, whose settlements are entirely oriented to the flood plain of the Ucayali River and its major tributaries, and the Panoan groups, who exploited the broad expanses of forest lying between the major rivers. The Shipibo, the Conibo, and the Shretebo, who have now been almost completely assimilated into the other two ethnic units, have a far more complex cultural inventory than that of their backwoods Panoan-speaking neighbors, who live well away from the major rivers. This difference is nowhere more noticeable than when one compares the technologically advanced and artistically elaborate pottery of the Shipibo-Conibo with the carelessly formed and largely undecorated pottery of the backwoods Panoan groups, such as the Cashibo or Amahuaca.

It is suspected that in pre-Columbian times

is one of the few nonindustrial ceramic complexes of sufficient decorative complexity to permit the testing of the claims about such relationships that have been made by Deetz (1965) and Longacre (1964; for a critique of such thinking, see also Allen and Richardson 1971). In the course of this study, I made a complete ceramic census for every household in several Shipibo-Conibo villages and a full census for several households in each of a number of other villages. These data were paralleled by complete information on residence patterns and genealogy collected for all inhabitants of each village studied, and by statements from each artist as to her mentor in the art of making and decorating pottery. The ceramic census included complete measurements of all the ceramic vessels in the households and a recording of decoration by both photographs and drawings. During the first half of the project, I deliberately excluded from

my sample all pottery not in use by the Indians themselves. Only during the last three months did it occur to me that a detailed recording of pottery being produced for sale might be of some interest as a kind of control.

Curiously, at the same time I was doing my study, a German anthropology student was analyzing the published literature on the pottery of the Shipibo-Conibo and on the museum collections available in Europe. Even more curious is the fact that this student, Rüdiger Vossen, in preparing his Ph.D. dissertation (1969), had as one of his purposes the evaluation of the kinds of hypotheses presented by Deetz and Longacre. The reader wishing a particularly complete bibliography on the ceramic industry of the Shipibo-Conibo should refer to Vossen's publication.

Plate 1. Huichol yarn painting depicting a
shaman and his healing stick (*muvieri*) diagnosing
an illness, while the patient and his wife hold
candles; wool yarn in beeswax on plywood, by
Juan Rios Martinez, 1972 (60 cm. x 60 cm.).

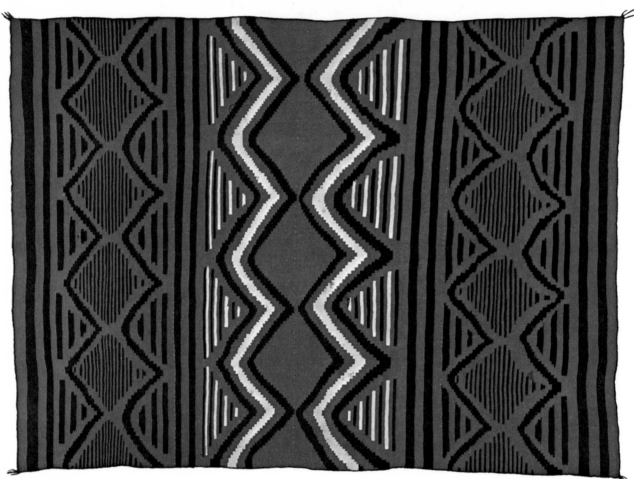

Plate 2. Classic Period Navajo blanket (ca. 1860).
Bayeta red; indigo blue and natural white
handspun wool (164 cm. x 121 cm.).

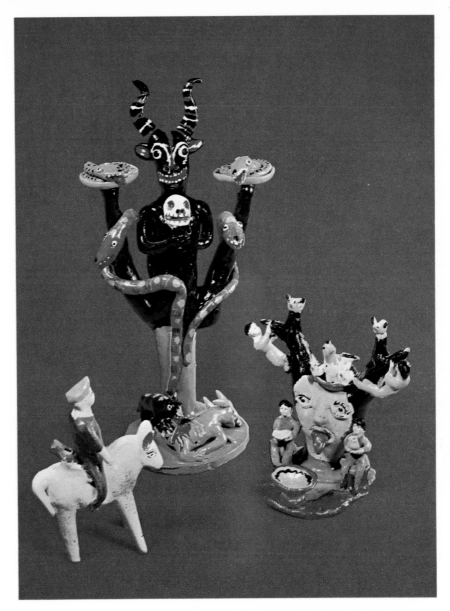

Plate 3. Ocumicho pottery figures: Left: *Jinete* horseman whistle, artist unknown, 1974; Center: Devil with snakes, by Maria Guadalupe Alvarez Sanchez, 1973; Right: Talking oak tree, by Delphina Serrano Jiminez, 1974 (10 cm.).

Plate 4. "Psychedelic" polychrome represents an early transition from the fauna-and-flora to the scenic style; note full border and artist's signature; by Pedro de Jesus of Xalitla, 1969 (48 cm. x 70 cm.).

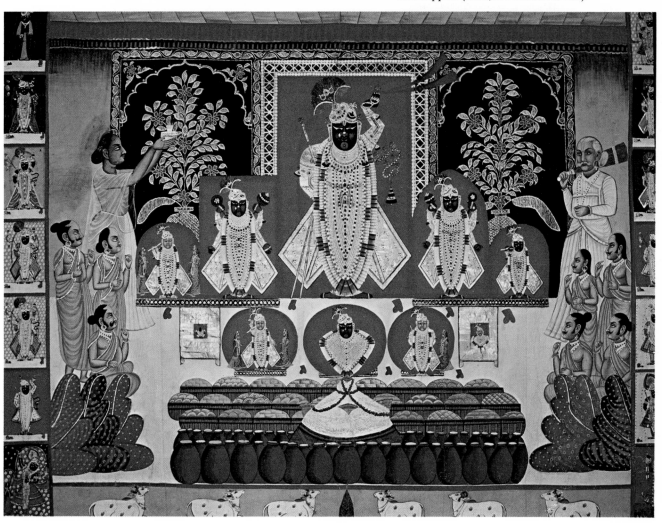

Plate 5. A Nathdwara *pichwai* cloth painting of temple scene, showing *Sri Nathji* surrounded by worshippers (cloth, 253 cm. x 216 cm.).

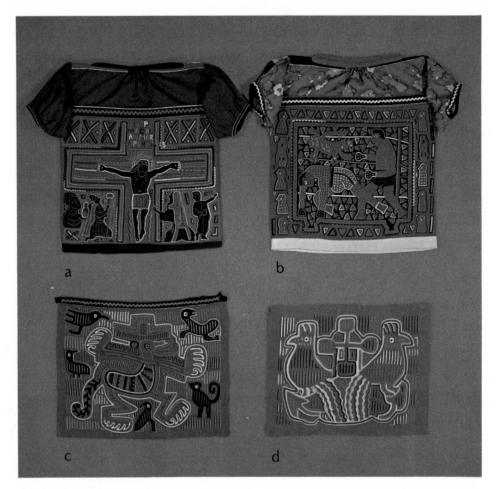

Plate 6a. Crucifixion or *dios* mola, with Cuna writing, made by a member of the Baptist Church (mola, 43 cm. x 36 cm.).

Plate 6b. Boxing mola, with prestigious triangular type of fill, made by a teenager.

Plate 6c. Ancient Panamanian Pre-columbian design, copied from the design on a commercial imported dinner plate, itself copied from an archeological report of the original find (46 cm. x 36 cm.).

Plate 6d. A "tourista" mola: note the difference between its colors and those preferred color selections on the other three molas (43 cm. x 35 cm.).

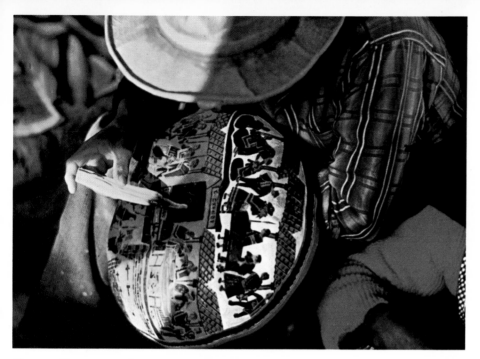

Plate 7a. The process of
pyro-engraving; Eugenio Medina at work, Cochas
Chico, Peru.

Plate 7b. Two new Iwam shields, of increased
size and more contrasting color and design
elements, in Tauri village (ca. 190 cm.).

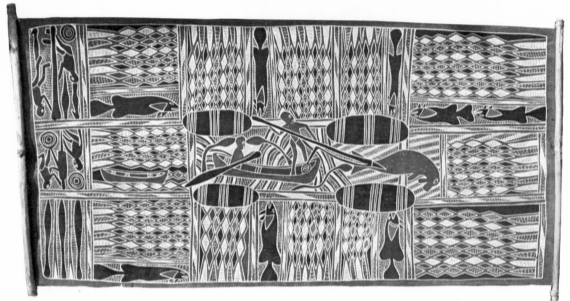

Plate 8a. A large bark of a hunting scene
(130 cm. x 60 cm.).

Plate 8b. Smaller, souvenir type bark painting
(65 cm. x 33 cm.).

Plate 8c. A pair of three-
dimensional crafts made at
Yirrkala.

the social organization of the Shipibo-Conibo was appropriate to the large stable communities indicated both by the archaeological record and by the accounts of the earliest explorers, who speak of towns with populations in the one and two thousand range. It is difficult to reconstruct what the details of this social organization might have been, since during the seventeenth and eighteenth centuries the Shipibo-Conibo went through several periods of intensive missionization, and during the early part of the twentieth century the surviving Shipibo-Conibo were almost entirely parcelled out to the various *patróns* involved in the rubber boom. Nuclear families were about the only units that survived during this final period of disruption. Starting in the third decade of this century, Shipibo-Conibo communities of moderate size and stability have grown up around various schools and mission stations. Given the disruptive factors that have operated on Shipibo-Conibo culture during the last four centuries the elaboration of the traditional aspects of material culture and art is remarkable. During the last three decades, the Shipibo-Conibo have been going through a period of rapid population growth. For around 1940, the best population estimates are about 2,500 for both groups; the best estimates of current population are around 12,500.

The reader wishing a more general picture of Shipibo-Conibo culture and its relationship to that of other Tropical Forest agriculturalists of the Amazon Basin should refer to the summary article by Steward and Metraux (1948) and to my book, *The Upper Amazon* (1970).

THE CONTEMPORARY ARTS

If one turns one's attention to the effects of tourism and commercial collecting on the Shipibo-Conibo, at least four distinct trends can be observed: (1) the appearance of elaborate, nontraditional vessel shapes, (2) the blurring of traditional standards of vessel shape and vessel size, (3) the reduction in the complexity of painted designs, and (4) the substitution of other "folk art" for pottery in those locations where tourism is most active. These processes are cumulative in their effect and seem to have commenced their disruption of traditional standards in the order in which I have enumerated them. Each of these trends will be considered in turn.

Almost all of the ceramic vessels in everyday use in traditional Shipibo-Conibo households are readily classifiable within a system of functionally meaningful categories: *quënti* (cooking), *chomo* (storage container for liquid), *quënpo* (cup), *quëncha* (food bowl). The first three of these form categories are subdivided into three functionally meaningful size categories, while three functionally meaningful variants of quëncha are distinguished on the basis of further variation in shape and surface finish. This set of ceramic concepts, though not totally exhaustive of traditional Shipibo-Conibo ceramic production, covers well over 90 per cent of the sample I recorded. Contacts with non-Indian groups have led to the production of "exotic" forms outside the traditional native categories, and have altered the frequency in which traditional categories are manufactured.

61. A rather crude example of a *hunichomo* made by Casimira de Augustin of the Shipibo village of San Francisco de Yarinacocha. This specimen, made and collected in 1956, shows the conventions of applique limbs and applique facial features which relate the Shipibo-Conibo *hunichomo* to the burial urns of the Caimito archaeological complex, to the Napo complex of eastern Ecuador, and to the Pacoval variant of the Marajoara complex at the mouth of the Amazon.

The Appearance of Nontraditional Forms

As early as 1948 or 1949, Sr. Raul de los Ríos of Pucallpa, a professional collector, started purchasing large collections of Shipibo-Conibo crafts for sale to various museums and collectors in Europe and America. He also brought several Shipibo to Lima so that they could make pottery and engage in other craft activities as part of a craft fair. During the first decade of these activities, he purchased much of his material from Casimira Rengifo de Augustín, an exceptionally able potter and artist who was later to become my *comadre*. By 1950, Casimira was producing quantities of anthropomorphic vessels of a form previously unknown to the Shipibo of San Francisco de Yarinacocha and to the Shipibo-Conibo communities farther downstream along the Ucayali (figure 61). The basic shape of these vessels, *hunichomo*, has some relationship with the traditional Shipibo-Conibo form of water jar, *chomo*, but the modelled face and the appliqué limbs have no antecedents in traditional Shipibo-Conibo ceramic production. Once Casimira started producing the hunichomo on a large scale and selling it in quantity, the form was picked up by a number of other potters at San Francisco de Yarinacocha and in many other villages. Evidently its high marketability was a strong prod to its rapid diffusion.

Though I have questioned Casimira on several occasions on the source of this shape category, I have yet to get from her a completely convincing account of this innovation. Her most frequent explanation is that she just made the form up, that it was pure inspiration

on her part. Her husband and her brother, in discussing the same matter, stress that immediately before she came up with this new form she had had intensive contact with some Conibo potters on the Upper Ucayali and that she probably got the idea from them.

Regardless of the details, there is strong circumstantial evidence that the appearance of the huníchomo represents the revival of archaeological material rather than the uninfluenced inspiration of a single potter. The case of the huníchomo is thus somewhat similar to Nampeyo's revival of ancient Hopi design (Fewkes 1919:218; Nequatewa 1942:40–42), but in this instance the Shipibo-Conibo potters appear to have drawn on archaeological material outside their own ceramic tradition.

It is now possible to trace the development of modern Shipibo-Conibo ceramics out of the Cumancaya Tradition with considerable certainty and in some detail (Lathrap 1970:136–145). On the one hand, for the last twelve hundred years there is no evidence of anthropomorphic vessels in the Central Ucayali branch of the Cumancaya Tradition. On the other hand, the Caimito components that were intrusive into the Central Ucayali during the fifteenth century and ancestral to the modern, Tupí-speaking Cocama (Lathrap 1970:145–159) were characterized by anthropomorphic burial urns showing most of the characteristics of the modern Shipibo huníchomo (Lathrap 1970:fig. 34). This style of burial urn is also common on the Río Napo (Meggers 1966, plate 72; Evans and Meggers 1968, plates 53, 55–65) and can be traced back

to still earlier examples on the Island of Marajó at the mouth of the Amazon (Meggers and Evans 1957, plate 78a; Nordenskiöld 1930, plate 18; Palmatary 1950, plates 27, 30a, 34).

In their painted decoration, Casimira's huníchomos are typical, indeed excellent, examples of Shipibo art. Hence, this initial phase of commercial collecting seems to have resulted mainly in the presence of a vessel shape of dubious pedigree in a number of museum collections of Shipibo-Conibo pottery.

As the population of Pucallpa has grown, there has been an increasing demand for Indian pottery for use in the Peruvian households. The chomo functions admirably as a water cooler in any house lacking refrigeration and has been widely adapted to this function by the middle- and lower-class urban population of Pucallpa, greatly increasing the production of this one traditional form category at the expense of other traditional form categories.

Probably starting slightly later than the demand for the chomo has been that for Shipibo vessels for use as flower pots. Initially, various traditional form categories were put to this function in a makeshift way, but by 1964 a well-standardized form category, the *florero*, made up a significant segment of all Shipibo ceramic production in San Francisco de Yarinacocha. The painted decoration of the florero is traditional in nature, usually in the white-on-red style; the designs may be well executed but are usually of a scale relatively more gross than would be used on a vessel made for home consumption. The form of the florero, with its squat, globular body, widely

flaring fluted rim, and perforated bottom, has no antecedents in the traditional style and would appear to be a rational response to the functional demands of another society.

The Relaxing of Standards

The Shipibo-Conibo have definite standards as to the proper shape and size for vessels serving particular, and highly specific, functions. Thus, the drinking vessel, quënpo, is characterized by a sharply defined form with a markedly insloping rim, a body with strongly convex shoulder, and a sharply inflected basal section. This form occurs in three distinct size categories, each serving a different function. The small size, *quënpo vacu*, has a mouth in the 11–13 centimeter range. It comes in conjunction with a miniaturized liquid container, *chomo vacu*, the two functioning together as a canteen, with the quënpo vacu serving both as lid and drinking cup. A man going out for a day's work in his fields or on a prolonged fishing trip will take his daily ration of banana gruel in this canteen.

The regular size, quënpo, will be used on most social occasions when one person offers a beverage, either alcoholic or nonalcoholic, to another person. Its mouth diameter is under extremely tight cultural control, rarely straying outside the 16 to 18 centimeter range. The king size, *quënpo ani*, with a mouth diameter centering on 24 centimeters, serves as a communal drinking vessel for certain major fiestas. In addition to its large size, the quënpo ani may, in some instances, have a rattle built into its bottom.

When making pottery for their own use, the Shipibo-Conibo adhere to these size standards rigidly, but they feel no compulsion to observe them when making pottery for sale. On one occasion, while carrying out my ceramic census in a house at San Francisco de Yarinacocha, I noticed a quënpo with a particularly fine painted design. It was much the worse for wear, having served its alloted span as a cup until its increasing shabbiness led to its use as a paint palette, and finally as a storage container for ash temper, a sequence of usage typical for Shipibo pottery. I commissioned the potter who had made it to make me another that would duplicate its features. The specimen she finally produced was intermediate in size between the standard quënpo and the quënpo vacu and was painted with far less care than the example of her art I had originally admired.

Though hard, Shipibo pottery is extremely brittle, so the tourist is faced with a difficult problem in transporting examples of this attractive ware back to civilization. Since a small pot can be securely packed with far less difficulty than a large one, the tourist is far more likely to buy a miniaturized specimen. Consequently, pottery made for sale to tourists is progressively shrinking from the normal standards.

Reduction in Complexity of Design

Those potters who are producing large quantities of vessels to sell to tourists, or more frequently to the curio dealers in Pucallpa who then sell them to tourists, are typically making pottery that is technologically up to the best Shipibo-Conibo standards. The ware is thin,

62. The design from a *quënpo ani* by the famous Conibo artist, Wasëmëa, shortly before her death. The specimen was made in the downstream Conibo village of Painaco ca. 1957, and was preserved as an heirloom by Wasëmëa's adopted daughter until 1967, when it was collected. The design and the specimen were greatly admired by the Shipibo artists of San Francisco de Yarinacocha, who spent a good deal of time going through my notebook of Painaco designs. The design is in black and red (stipple) on a white slip and covers the whole exterior of the vessel. Some distortion was inevitable in transferring the design from a hemispherical surface to a plane surface. (Max. diam. 29 cm.).

evenly shaped, and very well fired. Their products may show eccentricities in form, such as extreme carinations or a noncircular horizontal cross section, but they are most likely to diverge from pottery made for domestic consumption in having markedly simplified designs.

In evaluating traditional artistic production, the Shipibo artist, who is almost invariably female, places a high value on complex design. The works of Wasëmëa, the most respected Shipibo-Conibo artist of the century, are characterized by the complexity of the heavy painted lines, which in Shipibo-Conibo art are always organized symmetrically, and by the intricacy of the fine-line painting that fills the spaces between the heavy lines in a nonsymmetrical organization (figure 62). A design will be admired both for the amount of fine-line painting it contains and for the care and control with which this line drawing, or incision through slip, was executed.

In pottery produced for sale, the framework of broad lines making up the basic design tends to be more widely spaced, and the fine-line fill much less intricate. In examples

made for use by the Peruvian neighbors of the Shipibo-Conibo, this process of simplification may not be extreme (figure 63), but in examples intended for the tourist market the number of brush strokes per unit-area of pot surface will be reduced to a half or a third of what is normal in the traditional style. In many instances, the fine-line painting, which is the most time-consuming part of the decoration, will be completely eliminated (figure 64). There is also a tendency in pottery made for commercial purposes to show large panels of contrasting color, making a design that is visually effective at a considerable distance (figure 65). The intricacies of traditional Shipibo-Conibo pottery are best appreciated at close range. The bold and simplified designs on specimens intended for the tourist are best viewed from a distance, and, whether or not the Indian artist so intended them, such pots serve well as elements in modern schemes of interior decoration.

These tendencies toward design simplification and bold layouts reach their maximum expression in the pottery produced for sale by the isolated Shipibo on the upper Río Pisqui and upper Río Aguatía. The traditional design layouts of the culturally divergent group of Shipibo are far more massive than is the norm for the rest of the Shipibo-Conibo. When simplified to speed up production these designs become sufficiently blatant to delight the

63. A newly made *chomo* from the Conibo village of Caimito, on Imariacocha. The specimen was recorded in late September, 1967. The artist, Florinda, had entered into an agreement with a traveling vendor from Pucallpa to exchange this water jar and three or four similar vessels for a set of aluminum cooking pots. The *chomo* was probably sold in one of the Pucallpa markets to a middle or lower class resident of that town for use as a water cooler. This is an excellent example of Conibo art but the design is noticeably less intricate than those Florinda had applied to vessels designed for her own use. (28 cm. high and 35 cm. in diameter.).

64. A standard-sized *quënpo* from the Conibo village of Caimito recorded in late September, 1967. The shape conformation is excellent, but the design is unusual in that the artist, Bidi Rama, has completely omitted the fine-line work. (10 cm. high, max. diam. 22.5 cm.).

taste of the average tourist and to convince such a tourist that he is indeed purchasing the art of a genuine "primitive" (figure 66).

The Substitution of Other Folk Art for Pottery

Tourism is rapidly increasing in the jungle around Pucallpa, Peru. In 1956, I had only two outside visitors during my four-month stay at San Francisco. In 1967, few days went by without a large group of tourists descending on the village. The effect of such intensive tourism is the suppression rather than the promotion of ceramic production.

On the basis of my ceramic census of San Francisco de Yarinacocha, it is clear that those households that have and produce the most pottery and those that manufacture the most pottery for sale are the most isolated and the least often visited by tourists. The Peruvian entrepreneur who transports most of the

tourists to the village in his boat has a variety of extremely exploitative financial arrangements with three or four families in the village. He works very hard to make sure that the tourists purchase their souvenirs within the households of these deeply indebted families. The women of these families simply cannot produce enough pottery to keep up with the steady stream of tourists, so they have turned to stringing a mixture of glass trade beads and the various hard seeds that have traditionally served as beads. Only by these simple, rapid, and mechanically repetitive procedures can they produce enough tourist "art."

SUMMARY

The initial effect of commercial demand on Shipibo-Conibo ceramic art was to favor the

65. The shoulder panel design from an eccentric *chomo vacu* made for the tourist trade. The bold design is executed in black and red (hatched band) on a white slip, which contrasts with four panels of unslipped, tan clay (stipple). The example was made in mid-October 1967 by the Shipibo artist, Juana Plasa de Sinaci, a granddaughter in the large, extended family of hyperactive potters living in Nuevo Distino. Nuevo Destino is a small Shipibo town located an hour's walk back in the jungle from San Francisco de Yarinacocha, and thus completely sheltered from tourist visitation. This starkly simple design is in sharpest contrast to the paintings which Juana executes on the pottery made for her own household. (16 cm. high, max. diam. 23.5 cm.).

66. The work area of a member of the Aguatia Shipibo community now producing quantities of pottery for sale to tourists at the Aguatia bridge. During early December 1967 she was visiting relatives in the isolated Shipibo community of Nueva Eden on the upper Rio Pisqui and had temporarily set up her "studio" there. The *chomo* in the foreground has been painted but not fired. Its bold design is a simplification of the massive painting style characteristic of the Shipibo on the Pisqui and upper Aguatia. Note also the slipped but as yet unpainted pitchers in the background.

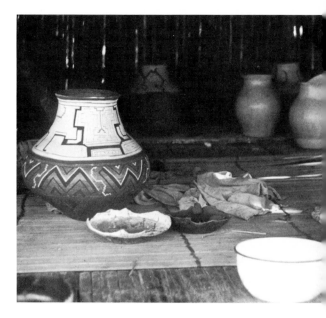

introduction and spread of exotic and unusual forms that would catch the eye of the professional buyer or collector for museums; there was no decline in the elaboration with which the pottery was decorated. Vossen's recent survey of all of the collections of Shipibo-Conibo pottery in European museums (1969) shows that the strategy of the potter was indeed effective, since such deviant forms make up a large percentage of the pottery that has found its way into museums. Such collections are thus largely unsuitable as a basis for studying native ceramic categories. An increased demand led to the relaxing of certain standards relevant to the culture of the Shipibo but not to the culture of the buyer. As demand has increased by a factor of 10 or 20, owing to the influx of tourists, and as a larger number of Shipibo-Conibo families have come to rely on the sale of tourist art as a major part of their income, there has been a tendency to speed up production by reducing the complexity of the painted designs. In those households where tourism is most strongly felt, pottery has been abandoned in favor of more efficient means of producing tourist goods, mainly the purely mechanical procedure of bead stringing. Min-iature weapons (bow and arrow sets and *macanas*, sword-clubs) that are carved by the men and decorated by the women form another expanding domain of tourist art.

All these observations seem to me to be expectable and indeed commonplace in terms of what we know about the effects of Western economy as it penetrates other parts of the world. They appear as little more than a pathetic footnote to Sapir's views (1924) on genuine and spurious culture. More remarkable, and to me more interesting, are the large number of Shipibo-Conibo women who are still producing pottery that is fully within the traditional canon and is of the highest quality, as evaluated by their own standards. For those who were willing to bargain for slightly used pieces or to wait around a Shipibo village and try to buy new pots as they come from the kiln, 1967, or even 1970, were vintage years for collecting Shipibo-Conibo art. None of this production is intended for sale, though it may be intended to serve as gifts on festive occasions. It would take another and far longer paper to analyze why such pottery making has persisted.

Though the art traditions of Asia may be richer and more numerous than any of the other continents, the majority of the arts do not fall within the province of this book, which is restricted to small-scale societies. These high arts, which are expressive of the literate strata of the historical civilizations of Asia, have not been stationary in time, but have spread their influences, which often lie in layers in countries far from their origins. India is the source of the Hindu, Mogul, and Dravidian traditions; the Chinese have carried their influence throughout South and East Asia; the Indonesian and Malaysian aristocracies have partaken of both Hindu and Islamic, as well as Chinese, traditions (Holt 1967; Bodrogi 1972). Japanese, Korean, Thai, and Khmer civilizations all have their great traditions, but these have remained confined to smaller areas. Bordering areas have developed their own arts, often as derivatives of the central civilizations, such as in Taiwan, Tibet, Afghanistan, Nepal, Viet Nam, and the Philippines, each with its own historical art establishments.

MADURO describes the history of one of the more isolated local developments within the Hindu great tradition. The Brahmin painters of Nathdwara, Rajasthan, serve a Hindu pilgrimage center and also provide secular and ritual arts. Theirs is a complementary articulation of the local and high arts, from huge cloth *pichwai* temple paintings (plate 5) to miniatures and commercial calendar paintings. The painter caste has risen in status through the centuries and has clung to strong aesthetic and religious traditions. Now, however, it finds itself up against technological competition and creeping secularism, leading to more compromise and eventual abandonment of their calling.

The main traditions of Asia are surrounded by innumerable separate folk and local traditions, which sometimes bear a "trickle down" relationship to the upper **strata. These traditions are the remains of** previously independent cultures that have been swallowed up by trends such as

Sanskritization in India and Sinicization in East Asia. These more truly Fourth World peoples include the "Tribals" in India, the Chin in Burma, the Miao of Burma, Thailand, and China, the Karen and Montagnards of Southeast Asia, the Siberian aborigines, the Ainu of Japan, and, of course, the many "pagan" peoples of Borneo and Indonesia (Adams 1973; Wagner 1959). The local traditions of these peoples are much in danger from decreasing local interest in both sacred and secular arts and from nationalist forces, especially the newer media of printing and radio. Some of these arts are being preserved and modified by commercialism or by elevation to national status, such as the Thai "use" of Karen arts or the Soviet Union's promotion of Siberian Eskimo souvenirs.

Low describes the commercial arts of the Ainu of Japan, who, like the American Indians, had been subject to a government policy of assimilation. Apart from a few utilitarian and ritual forms, their art forms—such as the black bear and silver salmon—have been instigated by outside demand, conforming to American and Japanese stereotypes of Ainu life. The Ainu have also adapted their sacred *inau* stick and their design elements for the decoration of small practical souvenirs, while the Japanese are increasingly using Ainu motifs as part of their national "ethnicity." The Ainu, along with Japanese coworkers, have adapted for sale some Japanese crafts such as wooden boxes and polished stones.

The special issue of *Craft Horizons* on Asia (1975) has an extensive bibliography, and sensible discussions of problems concerning the lowering of quality, the mass-production catering to foreign tastes, and the continued support of practitioners of threatened art forms.

12. Contemporary Ainu Wood and Stone Carving

Setha M. Low

The Ainu of Hokkaido, Japan—the inhabitants of ancient *Ezo* or *Yezo*—are an aboriginal people whose prehistoric and racial origins remain a disputed topic of anthropology. Ainu place names (Hitchcock 1891) and the remains of shell heaps and kitchen middens from Hokkaido to Kyushu (Milne 1882) are proposed as indicators that the Ainu once occupied all of Japan. A recent analysis of the data by Kodama (1970), however, suggests a more limited settlement area: (1) historical studies of Japanese documents indicate that the Ainu have lived in Hokkaido since the sixth century A.D.; (2) archaeological excavations of a pit of the Final Jomon Period[1] (2000–3000 years B.P.) at Higashi-Kushiro, Hokkaido, have discov-

ered evidence of Ainu culture, a charred *inau*, or ritual fetish, made of a willow stick with attached curled shavings (see figure 67) (Kodama 1969); and (3) anthropometric investigation of skeletal remains found in southern Hokkaido led to the identification of a well-preserved skull of the Middle Jomon Period that showed Ainu characteristics.

The combined evidence of the shared Jomon culture periods and the serological and dental data suggests that the Ainu are probably a genetic isolate of the Honshū Japanese population.[2]

It is fair to say, however, that the participation of the Ainu was relatively insignificant in the ethnic formation of the Japanese people. If the Ainu

Setha M. Low received her graduate training in anthropology at the University of California, Berkeley, and is now Assistant Professor of Anthropology in the Department of Landscape Architecture and Regional Planning at the University of Pennsylvania. In addition to her study of arts and crafts in Japan, she has undertaken research in urban anthropology in the San Francisco Bay Area and in San Jose, Costa Rica.

[1]The Jomon culture is an early phase of Japanese prehistory named after the cord markings commonly imprinted on the outer surface of the pottery. Stratigraphically it is a layer of black alluvial soil 30–100 centimeters in depth overlaying the loam layer of the soil of the upper Pleistocene preceramic period. Jomon culture was divided into five periods. In the third

phase, the distinctive northeastern, central and southwestern culture sub-areas emerge; in the fifth and final phase the local subareal distinctions reappear (Yamata 1962; Watanabe 1966b).

[2]Current theories of physical-type classification and genetic affiliation are diverse: the Mongoloid theory, supported by the plasma-protein similarity (Omoto and Harada 1969) and the dental affinity (Hanihara 1966) of the Ainu to the Japanese; the Caucasoid theory, based on anthropometric, somatoscopic, craniological, and cerebrum studies enumerating Ainu characteristics that appear closer to Europeoid (Kodama 1970); and the Australo-Oceanic theory, which hypothesizes a common Ainu-Polynesian ancestry influenced by Mongoloid admixture and genetic drift (Levin 1963).

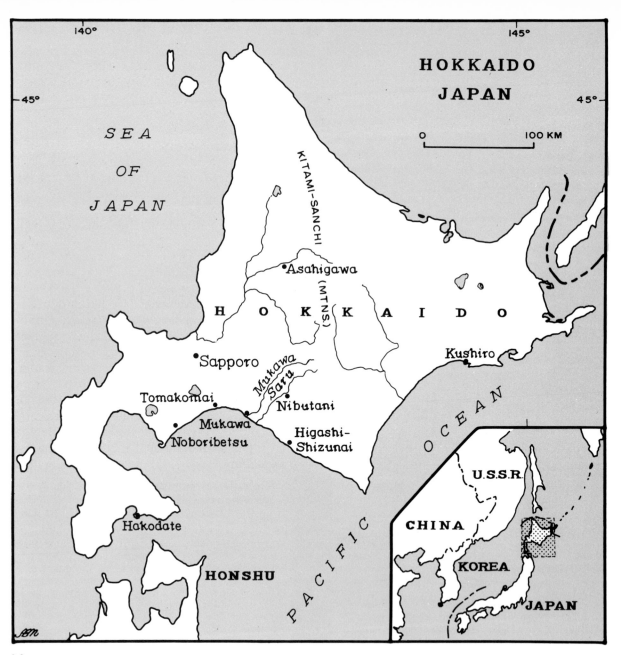

Map 6.

were the bearers of at least a part of the Jomon culture in eastern Japan, they must have been driven to the north by the Wa people with whom the Yayoi and Tomb cultures spread from the southwest to northeast. Even if racial mixture occurred between the two, the Ainu have remained until the twentieth century a distinctive ethnic unit with their own racial, linguistic and cultural characters (Ishida 1962:6.6).

The first Ainu census was taken in 1804–1807 to estimate available labor for a fishing industry and to establish direct control by the Matsumae clan. Between 1822 and 1854, there was a marked decrease in Ainu numbers: acute infectious disease, forced clinical abortion of Japanese-impregnated Ainu women, malnutrition, and lowered disease resistance are cited as suspected causes of the 25 per cent population reduction (Kodama 1970; Watanabe 1973). In 1960, approximately 17,000 Ainu resided on Hokkaido (Hilger 1971), and although this figure reflects more than 95 per cent Ainu of mixed blood (Kodama 1970), the total population has remained stable since 1854.

Hokkaido, an island of about 77,900 square kilometers, is composed of volcanic and metamorphic rock with tracts of alluvium in the river valleys and along the coasts. It is divided along the north-south axis by the Kitami mountain range, from which the principal

rivers have their source. Sites for Ainu dwellings were traditionally chosen near fresh water, fishing, and hunting grounds, and therefore usually situated near the edge of a river terrace (Watanabe 1973: vii). Scattered Ainu settlements are still found along the Mukawa and Saru river valleys, where agricultural conditions are favorable, and at the tourist villages of Noboribetsu, Shiraoi, and Asahigawa.

The climate on Hokkaido is severe, with snowfall from October through May and mean annual temperatures ranging from 5.2°C. to 8.5°C. Watanabe (1973:1) describes the island as well wooded: "The southwestern part is rich in latifoliate trees represented by beech, while the northeastern part abounds in coniferous forests, the representative species being firs, *Abies sachalinensis* and *Picea jezoensis*." Chestnut, maple, and linden trees are found, as well as the less-abundant willow, from which the *inau* are carved (Hitchcock 1891:430). Wild vegetables such as hog peanuts (*Falcata japonica*), marsh marigolds (*Caltha palustris*), *turep* (a kind of lily, *Cardiocrinum glehnii*), *pukusa* (a species of wild garlic, *Allium victorialis*), and seeds from several varieties of grasses supplemented the Ainu preagricultural diet (Hilger 1971:35). The major food resources were salmon and herring, eaten fresh in the spring and dried for winter;

	Years						
	1807	1822	1854	1887	1917	1940	1960
Ainu population of Hokkaido or Ezo Island	21,697	21,768	16,136	16,962	18,480	16,170	17,000

Note: Census data 1807–1940 from Kodama 1970:34–38; 1960 from Izumi 1968, as reported by Hilger 1971:XII.

deer, bear, and various marine animals were hunted for meat and skins (Kindaichi 1941:31). Rice, wheat, barley, and rye, introduced by the Japanese, have replaced millet as a staple cereal.

Japanese-Ainu Relations

The history of the Ainu records the gradual colonization of Hokkaido and subsequent assimilation by the Japanese. The oldest document on the Ainu describes an expedition to Hokkaido by Hirafu Abenoomi (658–660 A.D.), who returned to present Emperor Saimei with two live brown bears and 70 sheets of furs (Kodama 1970:1–2). Until the fifteenth century, contact was limited to trade with the Russians, Chinese, and Japanese. In 1456, the Matsumae clan, subordinate to the Tokugawa Shogunate, occupied the southwestern tip of Hokkaido and incorporated the Ainu into a system of restricted trade and feudal tribute. The exclusive control of the Matsumae resulted in the unequal trade of Japanese rice, sake, tobacco, and lacquered storage boxes for Ainu salmon, dried sea cucumber, deerskins, and hawk feathers. Japanese immigration and the exploitation of gold-mining and trade rights led to the 1669 and 1789 Ainu uprisings. The assumption of direct control by the Tokugawa Shogunate in 1799 ended Ainu independence, and Ainu trading stations became military outposts to protect Japanese interests from expanding Russian mercantile activities (Levin and Potapov 1956:762). Local administrative organization regulated trade and defense but did not interfere with internal affairs (Takakura 1960).

In 1869, the Meiji Restoration established a colonial government in Hokkaido that accelerated the colonization process. The Ainu were registered by census and their territory was declared government property. To promote farming and cattle raising, laws were enacted giving land to Ainu and Japanese settlers and forbidding traditional Ainu hunting and fishing practices. In 1883, each Ainu household was granted a parcel of land, given agricultural implements and seed, and provided with technical instruction by Japanese specialists. "The introduction of agriculture thus encouraged by the Japanese Government resulted in considerable displacement in the traditional territorial groupings of the Ainu which had been correlated to fishing, hunting, and collecting tracts, rather than to any terrain suitable for farming. The land allotment program caused the splitting and mixing of Ainu settlement groups and other serious disturbances for the traditional organization" (Watanabe 1966a:105).

Although it was said that "after a century of contact with the Japanese they have learned no arts, adopted no improvements" (Hitchcock 1891:443), the Ainu by 1900 had clearly undergone considerable acculturation. They were no longer subsistence hunter-gatherers; agricultural plots had become an important source of supplementary foods; and iron-tipped arrows, guns, and other Japanese trade items provided a new basis for hunting and fishing. Social scientists and travelers, drawn by their interest in the *Iomande*, the annual bear-sacrifice ritual, recorded Ainu culture from 1870 through 1930. These accounts contain general information about this transition-

al period that may be compared to modern Ainu observations (Bickmore 1968; Hitchcock 1891; Landor 1893; Hallowell 1926; Munro 1963).

The Ainu settlement—the *kotan*, or village —consisted of from one to ten homesteads arranged according to cosmological principles (Watanabe 1973:9). Each homestead included a dwelling (*chisei*) and associated structures for storage and food processing. The *chisei* was a rectangular, wood-framed, single room with a thatched, gabled roof. In the center of the room was the sunken hearth around which all family activity took place. In the southwest corner were stored fishnets, spears, bows and arrows; in the northeast were carved bowls, knives, receptacles, weaving equipment, and the treasures of the family: lacquered sake cups, Japanese swords, and round lacquered cases (Hitchcock 1891; Hilger 1971:147).

The nuclear family was the basic social unit; residence was virilocal. Sociopolitical groups consisted of the families of one or several *kotan* who recognized a common headman, collective ownership of salmon spawning grounds, group participation in ritual, and cooperation in house building (Watanabe 1973:11). Division of labor by sex was manifest in both substantive and ritual domains. Men hunted deer and bear and also fished, principally for salmon. Women collected firewood and roots of grasses, drew water, and cultivated gardens of *muk* (a native potato, *Codonopsis lanceolate*) and other vegetables (Takakura 1960:16; Hilger 1971:35). Men carved wood, decorated their weapons and ceremonial objects with representational figures, and made *inau*; while women wove *attush* (a cloth of elm and linden

67. A Hokkaido *inau*, "sacred stick," traditionally made for ritual purposes and recently for gifts and occasional sale (26 cm. high).

bark), mats, carrying lines, and purses (Lundin 1965:15). Both men and women dressed in animal skins for winter and *attush* clothing for summer, and wore earrings, bracelets, and necklaces. Formal attire was colorful and was decorated with geometrical designs distinct for each *kotan*. Tattooing of the lips at puberty was considered a mark of feminine beauty and essential for obtaining a husband. Men cut short or shaved their frontal hair but allowed their beards to grow.

Ainu religion was animistic and shamanistic; its rituals were usually petitions for favors. All spiritual beings, called *kamui*, were seen as beneficial essences within fire, water, plains, mountains, trees, seas, and animals. *Inau* (see figure 67) found inside entrances to houses, in the family hearth, or outside altars and wherever supernatural powers were invoked, were prayed to as intermediaries to the *kamui*. Patrilineal family markings were carved on the *inau* used for *kamui* offerings. The male head of the household conducted family rituals for the ancestors, and Ainu women were said to possess curing, prophetic, and witchcraft powers (Kindaichi 1941:67; Watanabe 1973:105).

The present life conditions of the Ainu reflect their participation in the dominant Japanese culture. "These aboriginal inhabitants of Japan, whose culture, language, religion and economy once set them off as distinctly different from the Japanese, are now virtually indistinguishable from the majority among whom they live," proposes Watanabe (1973:vii). Simeon states that, from the point of view of the observer, "the present-day Ainu are simply Japanese living and working alongside their Japanese neighbors" (1974:78), and in a sense this is true. Ainu live in traditional Japanese-style wooden houses, but more often in the cement-block houses with corrugated iron or asbestos shingle roofs that are popular in Hokkaido. Their occupations include commercial farming and fishing, forestry, construction, and transportation. Diet consists of Japanese-introduced cultivated foods; meat is obtained at local markets. The previously segregated educational system no longer distinguishes the Ainu from the Japanese.

Nevertheless, class distinctions exist between the Ainu and their Japanese neighbors. Cultural organizations, such as the *Yay Yukara Ainu*, *Minzokugakukai*, and *Hokkaido Utari Kyokai*, reinforce sociopsychological distinctions. Ohnuki-Tierney, in her reply to Simeon, suggests that: "... we now look at an ethnic group as a social group whose members identify themselves as belonging to it, rather than defining it in terms of diacritical cultural traits, institutions, and overt behavioral patterns. There is no question that the Ainu constitute a social group distinct from that of the Japanese. At the present, the Ainu, both young and old, are reasserting their cultural identity" (1975:287).

CONTEMPORARY AINU ARTS AND CRAFTS

Ainu carved bears, polished stones, woven bags, and designs have recently appeared as part of a growing tourist industry in Japan.

The bears are widely distributed and may be found at gift and import counters throughout Japan and the United States. In Hokkaido modern *chisei* have been constructed near original Ainu villages where Ainu, dressed in traditional clothing, now sell their products and entertain visitors with ceremonial dances and songs. Part of the attraction for tourists is to watch the "expert Ainu" carving bears or polishing semiprecious stones (Hilger 1971:40).

Carved bears and polished stones, never part of the repetoire of traditional arts and crafts, began to be made when the Ainu turned to the use of available resources and skills to satisfy visitor demands for souvenir items. A parallel case is cited by Gunther (1968:91): "While the Haida used argillite for charms and amulets, it was never an important material in their culture until the early nineteenth century when they found that European visitors liked carvings made of it, and a 'tourist' art began which is still carried on today." (c.f. chapter 2). Certain Ainu products may also be described as "airport art" (Graburn 1967b), emphasizing the commercial nature of Ainu industry, distribution networks, and marketing patterns; or as an art of acculturation (Graburn 1969b) —that is, an art made by artists who make nontraditional use of materials and techniques, and are receptive to innovation and buyer preference.

If an art is defined as that which the producers judge to be aesthetically or ritually significant, then a distinction should be made between the carved and polished objects and the ceremonially important *inau*. When traditional form and mode of production is re-tained and the object is not ritually significant, it may be called a craft. The weaving of *attush* purses and carrying bags and the embroidering of geometrical designs are therefore crafts, even though now made for tourists rather than for domestic use. This classification scheme of art, tourist art, and craft provides a conceptual framework for the study of underlying sociopsychological and economic processes.

Nibutani

Nibutani, originally the site of several Ainu kotan, was chosen as a sample population for an investigation[3] of Ainu carvers. Seventy-six households, or 67.9 per cent of the inhabitants, are Ainu (Peng, Ricketts, and Imamura 1970:16,20). The settlement is located in the hills overlooking the Saru River. Land is scarce, though some rice and garden produce are cultivated, and only a few wealthy Ainu have as much as several hectares. According to Peng, Ricketts, and Imamura:

> A few years ago, several Ainu in Niputani began to produce items for the tourist trade. A Livelihood Center (*Seikatsu-kan*) was built and this group of Ainu began to prosper. Today, economic power is concentrated in the hands of one family, descendants of the original inhabitants, which controls through marriage not only the

[3]I am grateful to Professor Toshio Oba of Hokkaido University and Professor Tatsuji Umehara of Sapporo University, who advised me in my choice of field site; to Professor Hiroshi Watanabe of the University of Tokyo, who introduced me to the university faculties; to Ms. Hinako Adachi, my interpreter and guide; to Mr. and Mrs. Yoichi Kaizawa, my hosts at the Munro House; and to Professor Nelson Graburn of the University of California, Berkeley, and to that university itself, which provided partial funding and the leave of absence necessary to undertake this investigation.

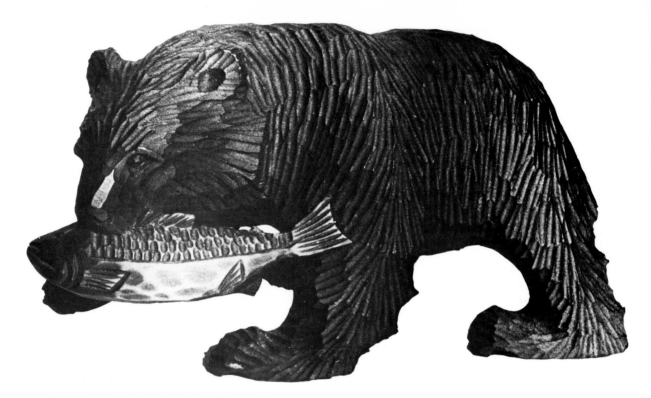

68. Black bear with salmon, made of *shina* wood;
this example was considered "good" because of
its attention to such details as the silver salmon
color and the fine, even finish (ca. 27 cm. long).

Seikatsu-kan, but the only retail store and one of
the two restaurants in Niputani. They also con-
trol the distribution of Ainu arts and crafts in the
area, which includes the group of women
weavers who depend on them for a living. Of the
ten Ainu who run the *Seikatsu-kan*, seven are
related to this family and exercise full control
over its operation. The outlook of this group as a
whole is conservative since their livelihoods de-
pend upon their Ainu heritage (1970:126).

Basic data on carving, production, and
marketing were collected by means of an
open-ended interview schedule and were veri-
fied by direct observation and by discussions
with carvers and stone-workers. Photographs
were taken to illustrate the stages of bear-
figure production, and resource and tool use,
and to record the contemporary lifestyle and
setting. Although the focus of the data collec-

tion was on bear carving, other arts and crafts were considered.

Art and Craft Products

Carvers in Nibutani produce both tourist and traditional art. The most frequently carved tourist items are black-stained bears, salmon, bear and salmon compositions (figure 68), and replicas of Ainu men and women. Dark-stained bowls and trays and other small souvenir items—keychains, jewelry, and cigarette boxes resembling Japanese lacquered cases (figure 69)—are also made and can be purchased at roadside stands. Blond, carved wood bowls with geometrical designs, and shaved *inau* represent traditional objects that continue to be made more for personal use, museum display, or gifts than for sale.

Nibutani men also work with semiprecious stone, which they cut and polish to make decorative sculptures for foreign and domestic trade. Traditional crafts are pursued by a few Nibutani women: purses, carrying bags, and cigarette pouches are woven and sold with other tourist art.

Products are of uneven quality, with differing degrees of finish and detail. Softwood products are frequently stained with vegetable dyes, but hardwood pieces are carefully sanded without added color or texture. Stone sculpture may be highly polished with smoothed edges or left as partially roughed-out rock. Some *inau* have several rows of finely shaved curls radiating from the stem, others have bunches of eight to ten curls inserted into an incision on the stem. Weaving varies by the strength of the fiber used, type of decoration, color, and size. Much of the quality variation depends upon artist skill and preference. According to Hilger, "Each carver has a distinctive style and one can detect similarities in design and workmanship in their finished pieces" (1971:84).

69. Wooden cigarette box modeled after the Japanese lacquered storage chests found in many Ainu homes; note the carved Ainu motif on the lid (ca. 13 cm. high).

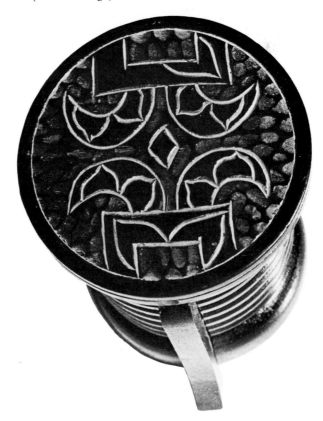

70. Nibutani carver with "typical Ainu" bears in three stages of production.

Origins

The carving of bears and other replicas began during the post-World War II occupation of Japan. United States' servicemen stationed on Hokkaido were said to have asked rural Ainu to carve them bears and salmon as souvenirs. American tourists have since visited villages and selectively bought souvenir items, stimulating further production according to buyer preferences. In Nibutani, carving was institutionalized with the establishment of a Livelihood Center. Another origin story is recounted: "Known for their carved bears and hunters, the Ainu began this craft early in the 20th century, after the visit of an Austrian traveler" (Craft Horizons 1975:63).

Wood carving is, however, a traditional skill. Ainu men had long carved all household utensils and hunting and fishing equipment. Old carvings, though, did not represent humans or animals, "lest they become receptacles for evil spirits" (Hilger 1971:84). Contemporary carvers do not share the old beliefs: they have replaced their wooden utensils with plastic ones, and now carve for a tourist market and commercial reward. Stone sculpture was said to have begun in a similar manner. Some 15 years ago tourists had shown interest in colorful stones the Ainu had collected and polished; stone sculpture presently is another available souvenir.

Resources, Tools, and Workshops

Three kinds of wood are generally used for carving: *shina* (probably linden, *Tilia japonica*), a softwood brought from the hills bordering the Saru River; *culume*, a local hardwood; and willow (*Salix* sp.), used only for *inau*. The inner bark of the shina tree and elm (*Ulmus laciniata*) is soaked, dried and pulled into threadlike strands for weaving (Hilger 1971:78). The soft stone used for sculpture is *aotola*, a volcanic rock found at Hakodate.

Carving tools include a variety of knives, small saws, wood files, and gouges. A power saw is used to trim wood blocks into shapes from which the bears are carved and bowls gouged and sanded (figure 70). Templates are used to trace the profiles of Ainu men and

women onto wood plaques. *Inau* are made from a green willow stick by shaving curls with a knife tipped with a small block of wood (Hilger 1971:91), held in one hand and drawn toward the carver much as a drawknife is used.

Most tourist items are produced at the Livelihood Center in Nibutani by the group of Ainu and Japanese men who work year round in the modern and well-equipped workshop. Some individual carvers have smaller workshops in their homes, and though their selection of tools is not as great as at the center, the entire family participates to produce high-quality and finely detailed bears. There is also a stone workshop in the center of Nibutani, near the Livelihood Center, where men work on different stages of rock polishing and on painting the fitted wooden stands (figure 71). Their shelves are lined with sculpture of a variety of sizes, shapes, and colors.

Aesthetic Considerations

According to Ainu informants, a carved bear can be "bad" or "good." Only a few men are said to make good bears, whereas bad bears are made by many. A good one is supposed to look realistic, and is usually made by a man who has specialized in carving bears. A bad bear is crude, and "looks like a doll."

The carvers follow the demands of their buyers perhaps more than their own aesthetic judgments. Initially, many animals native to Hokkaido were carved, particularly reindeer, bears, and salmon. But reindeer and other animals were not purchased, so only bear and salmon continue to be produced. Bears were

formerly left without stain, but since the black bears were considered more typical and purchased more often by tourists, eventually only stained bears were produced.

Japanese informants intimated that they thought that most of the Ainu products were ugly or meaningless. The only item chosen as an acceptable gift was the small round cigarette box, itself a miniature of the traditional Japanese lacquered case (see figure 69). Ainu tourist art was excluded from the exhibitions at the Japanese Folk Art Museum in Osaka.

71. Polished *aotora* (Tiger eye) rock, mounted on a wood stand (18 cm. high).

72. Ainu "couple dolls," the most souvenir-like
Ainu product (8 cm. high).

Notwithstanding, some elements of Ainu design, particularly the quadrifoil, are incorporated into Japanese commercial designs. Furthermore, the Ainu bear and salmon sculptures are now prominently displayed in many Japanese homes.

Marketing

Pricing is directly related to the amount of time taken to complete an item and the quantity of material used. A man may produce one 18-inch carved bear in one day, and be able to sell it for as much as three lesser-quality bears 8 to 12 inches in length produced in the same time. Usually, price rather than subject is the major selection factor, though some items are inexpensive and still have limited popularity. Ainu "dolls"—crude square-cut wooden figurines about two to three inches tall—are simple to make and require little time, but they do not sell well (figure 72). The polished stone sculptures are produced at the same rate as bears, but as the sculptures are not often purchased they are made only part of the year. The traditional culume-wood bowls, which require a highly skilled carver considerable time to make, are difficult to sell because of the high price and the lack of tourist recognition. Consequently, they are not often made. The culume work is now by contract and has a selective market. The shina-wood bowls, quickly made, are inexpensive and sell easily.

Although prices are relatively standardized for carved bears and other objects made from shina, the Ainu would bargain when selling them. Efforts to buy the more sacred or traditional objects, however, produced an entirely different response. A *culume* bowl about 17 inches across was priced at ¥5,000 ($14.00), and no bargaining was permitted. *Inau* were rarely offered for sale, but when they were, pricing was irregular or nonexistent. Upon inquiry, the Ainu replied that they had not thought of them as salable objects, but that they could be presented as gifts.

Tourists, store agents, and wholesale buyers come to Nibutani. Though wholesale buyers and store agents purchase in large quantities and tourists buy individual pieces, investigation suggested that prices are roughly the same for all purchasers. Commercial mark-up on the products follows regular

merchandising patterns: the price is increased at each transaction by the amount of the original sale cost. Thus, a bear bought in Nibutani for $1.00 sold in Sapporo for $2.00, at the Hokkaido airport for $3.00, and in Tokyo for $4.00. For cheaper items, such as miniature bears or key chains, the initial cost may be more than doubled from Nibutani to Sapporo, but increments thereafter are proportionately less.

73. Two examples of women's crafts, a woven matchbox cover and book marker (20 cm. long). The women only make a small proportion of the Ainu commercial crafts but traditionally had a wide variety of skills; note the use of the traditional Ainu motif on these utilitarian objects.

Carving as an Occupation

Many Ainu men cannot obtain steady employment because of a lack of educational and technical skills. Elementary school is attended but not necessarily completed. Only 4 per cent of Hokkaido's Ainu received a higher education, and though this figure has increased, it remains far below the norm for the Japanese community (Peng, Ricketts, and Imamura 1970:81). These factors are reflected in the occupational distribution for Nibutani: 28.3 per cent involved in farming, 8.6 per cent in forestry, 27.9 per cent in construction and manufacture, 19.1 per cent unemployed, and 16.1 per cent in other areas (Peng, Ricketts, and Imamura 1970:63, from Bureau of Statistics, Tokyo). The high rate of unemployment influences young Ainu to seek jobs in the urban areas or to find alternative ways to supplement their incomes in the villages.

Approximately 10 per cent of the men of Nibutani spend more than half of their time as carvers. The entire family often participates: the women make mats, purses (figure 73), and some shina bowls, and the children help to clean, polish, or finish edges. More young men

than old carve bears, though the skill is not exclusive to any group. Men may learn carving from their fathers or through apprenticeship. *Inau* carving, however, is specialized, being done only by older men, and is a disappearing skill of little commercial interest. Only one Ainu man in Nibutani was known to derive his entire income from carving. Most men carve to supplement income derived from farming, truck driving, and other local occupations.

Carving is not a high-status occupation, as it requires no special training or educational attainment. Nonetheless, the carver who participates in external trade relationships does achieve some measure of political control and status. "Tourist chiefs" were chosen by representatives of travel bureaus and local government officials to develop tourist areas and to organize and direct Ainu activities within them. With increased tourism and tourist revenues, these Ainu representative mediators (Löffler 1971) will strengthen their roles in determining Ainu development and in Ainu power relationships.

DISCUSSION AND CONCLUSIONS

The history of the Ainu reflects their colonization and exploitation by the Japanese. A series of policies were imposed to maximize profit from trade while extending political and social control. Monopolization of trade networks forced dependence on Japanese barter goods, decreasing Ainu self-sufficiency. Expanded Japanese controls usurped Ainu hunting and fishing rights and ended eco-

nomic security based on traditional resources. Income and prestige were transferred to jobs introduced by the Japanese in areas of industry, farming, and transportation. In response to ensuing occupational marginality and economic insecurity, the Ainu have capitalized on carving skills and resources to provide economic alternatives.

Tourist art is of increasing importance to the welfare of the Ainu. Souvenir demand initiated wood and stone carving and introduced a new economic potential based on the production of "typical" Ainu items. Tourist-related activity has created new sources of employment, economic networks, and sociopolitical roles within the Ainu community. Tourism, however, is based upon the ability of the Ainu to satisfy buyer preferences, thus promoting but another kind of economic dependency even as it increases the range of available economic choices.

The black, carved bear is an example of a successful production adaptation to market demand. The shina wood is easily available at low cost. Labor costs are low, as carving constitutes only a part-time activity during winter and occupational slack seasons. Further, shina wood is easily worked, so that many bears may be completed in a short amount of time. These three production factors interact with the essential plasticity of the objects carved —that is, there is no traditional pattern that dictates what a bear must look like or how it must be finished. Thus, the product can be quickly adapted to changing buyer preference.

The exclusively "Ainu" tourist art, the economic value is "being" an Ainu, and concomitant social organizational change redefine

and reaffirm fading ethnic identity. According to one Nibutani Ainu, by selling Ainu crafts, he was "able to reinforce his Ainu background which would otherwise be lost to him" (Peng, Ricketts and Imamura 1970:126).

A study of the arts and crafts of the Ainu ethnic minority reveals certain patterns of acculturation, economic relationship, and affirmation of group identity that can exist within a dominant society. Description of the art-production process contributes to a knowledge of the techniques, materials, and aesthetic considerations involved in the carving of Ainu bears and other replicas. Marketing and pricing practices, as well as the socioeconomic position of the carvers, are examined to determine the impact of tourist art on economic and status structures. Further, such work on the arts of minority peoples may provide insight into the problems of cultural adaptation in complex societies.

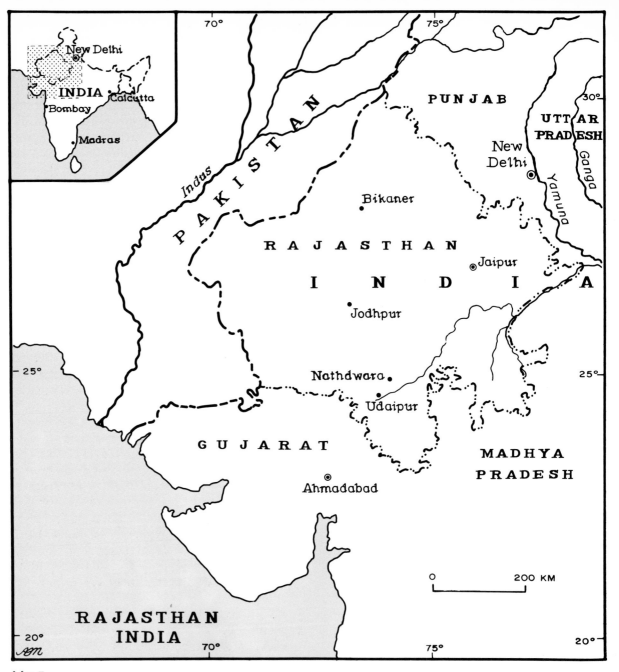

Map 7.

13. The Brahmin Painters of Nathdwara, Rajasthan

Renaldo Maduro

Nathdwara is a small pilgrimage town in Udaipur District, Rajasthan, western India,[1] where there is a community of more than 165 folk painters, the only one of its kind and size in India. At two thousand feet above sea level in the Aravalli hills on a few square miles of rugged semiarid terrain, the domestic dwellings in Nathdwara huddle together under a baking sun. From the center of town, the famous and sacred Shri Nathji temple, narrow alleys twist off in all directions, turning back upon themselves to form a labyrinth of shadowed pavements.

The town is situated 32 miles north of Udaipur, the conservative capital of an area known historically as Mewar. Before Indian independence became a political reality in 1947, Nathdwara was an integral part of the Princely State of Mewar. What is now the unified state of Rajasthan was then a network of 18 "native states," 16 of which were Rajput under treaty with the Imperial British Government. The Maharana, "His Highness," is still regarded highly by all strata of Mewari society. Mewari people are well known throughout India for their love of political freedom, their social isolation, their high self-esteem, their own poetic language, their spirit of defiant independence, and for the pertinacity with which they have for centuries cherished and protected these values in word and deed.

Nathdwara is oasislike, culturally, economically, socially, politically, and geographically. Outside the town proper, the worst and

Renaldo Maduro was awarded his Ph.D. in anthropology from the University of California, Berkeley. With a background in psychological anthropology, clinical psychology, and the fine arts, he is now Research Psychologist in the Program in Medical Anthropology at the Langley-Porter Institute, University of California Medical Center, San Francisco. He also has a part-time private practice and is receiving advanced psychoanalytical training at the C. G. Jung Institute, San Francisco. Among his published papers is "Artistic Creativity and Aging in India" (1974); he is also author of the monograph, *Artistic Creativity in a Brahmin Painter Community.*

[1]The field work upon which this article is based was carried out in Nathdwara during an 18-month period in 1968–1970. Research was made possible by a generous grant from the Foreign Area Fellowship Program under the auspices of the Joint Committee of the Social Science Research Council and the American Council of Learned Societies. Partial support was also provided by Public Health Grant No. HD00238.

most inhospitable hilly tracts are inhabited by autochthonous Bhil tribesmen, who are only slightly acculturated to the Hindu culture found in the more orthodox villages and towns such as Nathdwara. Tribal customs contrast sharply with orthodox Hinduism, and therefore Bhils are viewed with a disdain reserved for untouchable groups. The geographical isolation of Nathdwara, surrounded as it is by scrubby wasteland, aboriginal Bhils, and other peasant "little traditions," makes it truly impressive as a center for the Hindu Great Tradition.

The social composition of Nathdwara is peculiar, inasmuch as priestly Brahmins are particularly numerous, which is undoubtedly due to their hereditary attachments to the Shri Nathji temple complex. Other castes include a small number of Rajputs (ideally, warriors and landlords), a good number of Mahajans (Jains) or Banias (merchants, traders), and Shudra servant castes, which include such occupations as potter, oil presser, artisan, barber, etc. There are also nearly a thousand Muslims, who reside in town as weavers, cloth dyers, and shopkeepers. Other non-Hindu residents include a Christian nurse from Kerala and a few Sikhs from Punjab. There are no Parsis, Buddhists, or Jews. As one might expect from the large number of Brahmins and the pressure of the cult institution, the picture is one of extreme Hindu orthodoxy and social conservatism. A large number of Bhils from outside regions have emigrated to Nathdwara. Although they comprise about 16 per cent of the total population, which in 1961 was 13,890 (Census of India 1961), their influence on local affairs is negligible.

The name Nathdwara means gateway (*dwara*) to the Lord (*nath*). A cult institution devoted to the divine childhood of Lord Krishna, in the form of Shri Nathji, was established at Nathdwara in 1671, when the sacred idol was moved in haste from Mathura to Rajasthan in order to prevent its certain destruction at the hands of the Muslim Emperor Aurenzeb. Since that time, Nathdwara has been the headquarters of the chief deity of the *Pushtimarga* sect (The Way of Divine Grace), a group founded by Shri Vallabhacharya (1479–1533) in the sixteenth century.

Nathdwara features the celebrated image of Shri Nathji, a seven-year-old child form (*bala swarup*) of Krishna, a principal incarnation (*avatar*) of Vishnu. The idol is fervently believed to be not a statue hewn from stone but a living playful divine child, who is fed, bathed, clothed, let out to play, and made to give his public appearance (*darshana*) eight times each day. This numinous phenomenon draws many thousands of Vallabhachari pilgrims a year, and the flow increases.

The teachings of the prophet Vallabhacharya are based more-or-less exclusively on the *Bhagwata Purana* scriptures, drawing largely from its tenth book, which expounds at length on the way to spiritual salvation (*moksha*) through earthly physical love. Unlike other Hindu sects, Pushtimarga does not stress asceticism, fasting, or mortification of the body. Vallabha's doctrine is positive: it preaches the gospel of life and more life, especially as experienced in young adulthood, which is the second of four major stages of the Hindu life cycle and is known as *Grihasthashrama*, the householder stage. Indeed, one is

enjoined to appreciate the material and sensual comforts of the world while he can.

Today, the Shri Nathji cult is as active and alive as ever. Official membership is claimed to be more than 15 million, but more likely the figure rests somewhere between 8 and 10 million.

As in centuries past, traditional Hindu painters are found painting within the confines of a sacred temple complex. The divine child is the raison d'être of Nathdwara, as it is for the folk painters. Since they paint in or near the temple for visiting pilgrims, who purchase and carry away their devotional paintings, or paint for sect members living all over India, their livelihood also depends very much on Shri Nathji. Moreover, when painting sect-related subjects, the painters feel that they participate in a divinely inspired ritual.

THE COMMUNITY OF ARTISTS

For 165 Nathdwara artists, painting is a full-time home-based cottage industry. Art is the occupational heritage of the whole joint family; each member, regardless of his age, has his own particular duties to perform. The folk painter comes to accept his ascribed status as simply his natural and rightful place in the universe, his *dharma*.

In Nathdwara, there are two different painter subcastes (*jatis*), both claiming to be nonviolent vegetarian Vaishnavas and Brahmins: the Jangira Brahmins and the Adi Gaur Brahmins. The smaller Jangira group lives together on the outskirts of town in a section called Artists' Quarters; the Adi Gaurs live closer to the sacred temple of Shri Nathji in the center of the bazar, inhabiting a narrow overcrowded lane called Painters' Alley.

There are more Adi Gaurs than Jangira Brahmins. Population statistics recorded in 1970 show that Adi Gaur painters working full time outnumber the Jangiras almost three to one. Only 40 Jangiras (37 men, 3 women) compete with 115 Adi Gaurs (73 men, 42 women). Moreover, Jangira women clearly do not participate in the artistic profession to the extent that Adi Gaur women do. Both castes agree that one becomes proficient enough to be considered a full-time painter by the age of 15.

How the painters came to constitute a community within a community is something about which they know very little themselves. Each painter caste asserts that it arrived three hundred years ago (in 1671) with the Shri Nathji idol itself. Temple authorities, however, deny this claim and assert that painters followed later. But each caste is convinced that it arrived first, and even within castes, individual clans vie with each other for honor and supremacy on this score. What scanty historical evidence there is suggests that once Nathdwara was established, painters from many parts of India migrated to the site in hopes of royal and religious patronage and attracted by the temple itself. Painters are known to have arrived from Jaipur, Udaipur, Bundi, Kotah, and Kishangargh. Several of these places were also centers of Pushtimarga, although they emphasized different aspects of Vallabha's philosophy.

74. A partly finished miniature painting of a Rajasthani historical scene, by Narotam Narayan of Nathdwara. (Thin cardboard, 18 cm. x 13 cm.).

mention only a few genres here. The most important and ubiquitous kind of painting is the Shri Nathji portrait. Virtually every painter, creative or noncreative, at times paints a straightforward standing Shri Nathji idol. This is the painting that children first learn to work on and that tourists buy as souvenirs; it is the common denominator for all painters. (See plate 5).

Other prestigious genres include: (1) miniature paintings (figure 74), (2) *pichwai* paintings on cloth, and (3) calendar art. Painters consider these three genres important because to work in them implies technical competence, versatility, and creative imagination. Miniatures sell well and at high prices to Western tourists outside Nathdwara, but each one can take more than a month to complete. Pichwais, which are hung behind Pushtimarga idols at Nathdwara and elsewhere, are the special contribution of Nathdwara to Indian art history. They depict Shri Nathji and the life history of Lord Krishna and consequently are almost always used ritually. By far the greatest avenue for creativity and for the expression of rich fantasy life is the calendar genre (figure 75). These paintings are filled with mythological symbolic content that is often expressionistic in the best sense of the term. The paintings of this often garish genre clearly function as compensatory devices, or as escape mechanisms, for in the popular art there is much gore, bloodshed, grotesque violence, and sex.

Other genres include landscapes, portraits, wall paintings (figure 76), skin decorations, drama costumes, jewelry designs, and animal/people scenes. For fuller details, the reader should refer to Maduro (1976).

Painters in Nathdwara have a large repertoire of styles and subject matter. They recognize at least 17 different kinds of paintings being done today; for each of these, the art-buying public and the contextual use are quite distinct. Although most paintings are in some way associated with or used by the Pushti-marga sect, some are purely secular in nature.

Certain genres of painting are more important than others both to painters and to the life of the pilgrim center, and I shall attempt to

ground-stone water-based pigments for all the genres. Until recently, the artists would collect the stones from the surrounding countryside and grind them laboriously to powder (figure 77), but increasingly these paints are being abandoned in favor of store-bought powders.

The types of brushes used depend on the

75a. Oleograph reproduction of calendar painting by Moham Sharma of Nathdwara, showing Lord Vishvakarma, the patron saint of artists. (Paper, 48 cm. x 23 cm.).

Materials

Although the many genres embrace surfaces as large as walls and as small as cameo-like miniatures on ivory, and although materials range from whitewashed walls, cloth, wood, and ivory, to human skin, the artists are all familiar with paper. The vast majority use

75b. Oleograph reproduction of calendar painting by B. G. Sharma of Nathdwara, showing Lord Krishna as a boy. (Paper, 14 cm. x 9 cm.).

76. Two men painting the wall of a roadside shrine; wall painting is a less prestigious genre but there is still considerable employment for painters provided by the communities and by individuals for ritual occasions such as weddings.

requirements of the particular painting. For instance, the finest miniatures require squirrel-hair brushes, whereas large backgrounds are best done with coarser horsehair. Painters spend hours trying to trap squirrels in the early mornings of the hottest season. Once obtained, the hair is combined with quill, bamboo stick, and string to make a homemade brush, which will last for perhaps six months. Brushes, like stone pigments, are made at home less frequently now than previously.

Although in the past there has been a good deal of interest in Indian art history (e.g., Coomaraswamy 1934; Rowland 1956; Zimmer 1946, 1955), the study of the worth and position of the traditional artist himself, as a creative individual, has been sadly neglected. With few exceptions, students of India have never contextualized the artists' social role or probed his motivations. Here I will attempt to deal with one all-important aspect of the traditional Indian painter's social identity, his place in the caste hierarchy—that is, his changing social status. We shall see how, in such a culturally diversified society as India, contact with foreign British rule helped to modify status relationships between artist and patron, as well as within whole painter castes and other sections of the orthodox Hindu social structure. First, however, I shall point up the great symbolic significance of the god Vishvakarma—the mythological ancestor from whom Nathdwara painters claim to have descended and received their status.

Lord Vishvakarma: Archetypal Creative Power

Artists all over India, today as in the past, claim descent from, and identification with,

Lord Vishvakarma, the primordial creator and supreme patron of all arts, crafts, and creativity. Vishvakarma, who is mentioned as early as in the last book of the *Rig Veda* and later in the *Brahmanas* (Hastings 1960:XII:606b), is synonymous with Brahma, the highest god of the Hindu Trinity. But the public worship of Brahma as Vishvakarma declined early and there are no longer any major Brahma cults, such as there are for Vishnu and Shiva. Vishvakarma, however, is still very much alive to artists and is at once the Great Architect of the Universe, the Spirit of Creative Process, and the symbol of total, centered consciousness. As a divine source of artistic inspiration, he is said to appear in artists' dreams and waking fantasies (see figure 75a).

Lord Vishvakarma, as an active force, is often depicted in red, this color symbolizing creative power, passion, and activity: "He has four heads in reference to the four quarters of his *yajna* or sacrifice, is full of *Kamana*, or desire and creation: 'I shall be many'," (Shukla 1957:184). The Lord's assertion "I shall be many" is of great psychic significance, implying oneness and unity, and yet diversity, duality, and artistic variation at the same time. Vishvakarma, the synthesis of opposites—of good and evil, of male and female (i.e., with his consort, the goddess Saraswati)—both in myth and in the minds of the artists, is an important living symbol with roots in the creative unconscious mind. The more creative artists identify with and try to live out personally the myth of Vishvakarma; in this they are encouraged and strengthened by the weight of Indian mythological tradition.

According to Hindu Great Tradition, all arts and crafts are of divine origin. Consequently,

the artist's work is indeed sacred ritual, other-worldly, magical, and even divine. While creating, the artist's role is sacerdotal, and he partakes of the eternal cosmic creative urge.

The best artists of India are often priests

77. Old man grinding green stone pigment for *pichwai* or miniatures.

and their works are seen as sacred mystery. During the ritual of artistic creation, painters say they feel the living presence of the god; the artist experiences himself in his work as if he were an instrument of divine communication between the archetypal forces at work in him and the needs and values of his collectivity. The artist accepts the mythical paradigm in which the ancestor god first taught him how to paint and create. This acceptance lends certainty, continuity, and psychological coherence to everyday life and work by explaining the origins of what already is known to exist. Man does now what the gods did originally.

As origin myths are validations of every creative situation, the versions of the nature and life of Vishvakarma and his divine female counterpart (*Shakti*) explain and support the feelings and social positions of artists in history and in the present. In one myth, for example, he is supposed to have had an incestuous affair with his daughter, the goddess Saraswati, also said to possess creative power of active imagination and invention. The myth is used to explain the decline of Vishvakarma's general popularity (Kramrisch 1959). In another more widely known myth, Vishvakarma is said to have begotten five sons from five faces: Manu a blacksmith, Maya a carpenter, Twashtar a brass-caster, Shilpi a mason-architect, and Vishvagna a goldsmith. Each son gave rise to a major artistic lineage and theoretically any artist can trace his mythological descent to one of these. Although artists can wax poetic about Vishvakarma, there are not many who can recall off-hand the particular son from whom they are descended.

THE PLACE OF THE ARTIST IN TRADITIONAL INDIA

The "Anonymous" Artist

Research into the topic of the place of the artist in traditional India presents some difficulties because (1) the artists were and are thought to be anonymous, and (2) there is inconsistency in the sacred texts that deal with the artist.

Unlike the modern artist in the East or West, who, according to Coomaraswamy (1934:37), is decadent and condemned to an exhibition of his "own irregularity and imperfection . . . which makes a virtue of vanity and is complacently described as self-expression," the Indian artist until recent times has generally been considered anonymous and unacknowledged, because the names of earlier artists often have not been recorded. The painter, for example, almost never identified himself for posterity; it has often been assumed, therefore, in the absence of evidence to the contrary, that he receded into the background once he had created.

One might argue from a philosophical point of view, as Coomaraswamy and others do, that the Indian artist was never expected or required by his patrons to express change, the transient, or his own individuality. In expressing the transpersonal, the artist was encouraged by the spiritual climate of his society to obliterate his personal whim and vision by successfully merging, through a self-identification, with the eternal theme, image, and emotional state he sought to create. After all, is not a man's present life nothing but a mere

ripple in a vast timeless ocean of rebirths and insignificant events? According to the Hindu world view, which expounds a universe of cyclical time and cosmic causation, could it be other than pretentious, dangerous, and foolish to fancy oneself and one's artistic activities as unique? In light of these philosophical premises, it is argued that the artist did not bother to sign or engrave his own name.

Indeed, the painters of Nathdwara (in 1970) listed humility, self-effacement, and lack of self-assertion or arrogant pride among the most important ideal personality attributes of the creative artist—a complete contradiction of the modern international-style tradition to which Coomaraswamy refers. Yet some of these same individuals are able to realize a creative self-image and to experience the creative process, and are often singled out and rewarded for their originality. Though the artist must not flaunt his achievements in behavior that would seem to "raise him above others," his creativity does raise his status within the painter community above that of "just an artisan-laborer." In the past too, some patrons, including the Maharanas of Mewar, encouraged technical excellence, individuality, and artistic freedom within the framework of the Rajasthani style.

As we dig deeper into historical records and traditions, we find that indeed it is now often possible to discover exactly who were the artists and artisans responsible for the creation of Gothic cathedrals, African tribal sculptures, and Indian works of art. It is no longer tenable to assume that the creation of these valued objects was totally "anonymous" in former times, or that the best and most creative artists were not well known, highly respected, and rewarded individually for their difference.

Vocational Categories

Social-status ambiguity is compounded by the ambiguity of words and concepts. For example, the Sanskrit *shilpa* refers to all arts and crafts. In several of the sacred Hindu texts, 64 "practical arts and crafts" (*bahya kala*) are discussed and include everything from dance and music to medicine and architecture. Moreover, the *kalas* as avocations (callings) must be properly distinguished from the shilpas as vocations (caste occupations); kalas are personal accomplishments, whereas to acquire a shilpa one must be long apprenticed to a guru. Architecture and paintings are kalas that also qualify as shilpas. Even then, we are unable to assign any precise psychological meaning to the word shilpa, which might be translated as "art, craft, skillful labor, artistic vocation, magical ritual, and creative imaginative work."

The shilpa practitioner, or *shilpin*, included everyone from creative artist to tradesmen. Since frequently an artist was skilled in many of the kalas at one time, the designation shilpin was comprehensive and simpler to employ, although as an omnibus category it creates confusion with regard to understanding the differences in social and ritual status among the various kinds of artists. Today, the word shilpin is rarely used; instead, circumlocutions are employed to indicate that an artist is creative—one who makes new and original things (*mauliktā banāne wāllā*), one who works from his powers of imagination (*kalpnā shakti wāllā* or *kalpnāshil*), one who recreates

symbolic forms thrown out from a vast unconscious reservoir of creative power invested in primordial images (*māya rūpa sē banāne wāllā*), and so on.

Caste Status and Employment

Although contemporary folk artists working in India are generally considered by other Hindus to be low caste, there was little concern with the caste status of artists in the early historical texts, since the whole system was not yet as rigidly defined as in more recent times. Although caste *varnas* (ranking within the four major hierarchical divisions of Hindu society) are rarely mentioned, we do learn of Brahmins (the highest varna) who "lived by handicrafts" (Kramrisch 1959:18; Sharma 1958:90).

The four major social settings in which, until recent times, artists have worked were: (1) the village, (2) from village to village and among tribal peoples, (3) the town or city, and (4) the courts of the emperor, king, high priest, or maharajah. In the village, the folk artist was an organic part of the symbiotic *jajman-kamin* (reciprocal services) system, and was paid by fellow villagers in kind. In some village situations, the artist worked almost exclusively in the service of tribals who lived nearby; he was often itinerant and traveled widely to wherever his services were needed. Many itinerant artists exist in India today, stopping to work in small towns and villages; they generally function as important communication links between widely dispersed settlements.

In the towns and cities, artists formed powerful guilds (*shreni* or *shilpisamgha*) with hereditary membership and officers (*mahajans*) who regulated competition and enforced work habits. Fixed prices and high standards were maintained by this closed-shop system. As the guilds were to a certain extent charitable institutions, no poor artist was allowed to starve. Thus, they provided the individual with a great sense of personal and occupational security.

In the feudal relationship of a servant to a religious or political leader, the artist became part of the royal household or court, temporarily, by commission, or more-or-less permanently. In this particular patron-client relationship, artists often attained high status and were economically very well endowed. They were given land and in later years paid in cash. Upon return from the court, these "royal artists" enjoyed lasting high prestige in their own communities.

The Historical Record

Though artists today are usually deemed Shudra (the lowest of the four caste varnas) by fellow Hindus, even if they emulate those of high ritual status, the art of painting was originally highly esteemed as "a source of pleasure" fit for kings. We know that Mahendravarman, the celebrated Pallava king of the seventh century A.D., was himself an accomplished sculptor, poet, musician, architect, and painter, who delighted in calling himself "a tiger among painters" (*chitrakarapuli*). That kings themselves were artists may have raised the status of the whole profession in the eyes of society.

The early *Shilpa Shastras* unequivocally cite painting, both religious and secular, as the finest of the fine arts, but painters appear as members of no one exclusive caste group. Yet by the third century A.D., the *Vishnusmriti* clearly assigns all artistic occupations to servant-caste Shudras. For a number of unexplained reasons, artists sank to a low status and only began to rise again in the nineteenth century.

One mythological version of the fall of artists from status and divine grace tells of Vishvakarma, who was of Brahmin descent himself. Vishvakarma married a Shudra woman who had nine sons. Three sons—an architect, a painter, and a goldsmith—became unholy and incompetent to offer sacrifice. Today, these same three castes are generally considered to be the "most clean" of the Shudras, reflecting their involvement with ritual contexts, temples, and the purest substance of all—gold. All three castes in some way manipulate gold, a very precious and highly symbolic substance, which for most Hindus is charged with magical and religious connotations. They regard gold as the most sacred of all sacred objects. Gold is the purest of the pure and can therefore purify; it is symbolic of the precious life substance, semen itself (cf. Spratt 1966). In the Gupta period (320–500 A.D.), these three groups led the Shudra castes in general in acquiring increased political and religious freedom and economic well-being.

As the guilds grew more powerful, economic rewards grew, so that even the kings had to respect "the customs of the guilds." Kings and maharajas could, however, require artists to work for them at least one day per month. This custom was remembered with feeling and related to me by the painter Hira Lal in 1969.

> The artist must be free to work according to his own tastes so that he can develop his art. Nowadays, if an artist works all day according to his heart and his own imagination, nobody will buy his work and he will not be able to eat. He will starve. The first thing is one's stomach. In the old days, the Maharana used to call for us. We went to Udaipur to paint, sometimes for a whole month. Sometimes it was necessary for them to carry away painters by force! But once we got there we received food and clothing. We had few worries. We were given the freedom to paint what we pleased and at our own speeds. The Maharana simply insisted on good work, and he didn't care if it took a painter all day to paint only one flower. Nowadays, the government should act like that to us. It should provide us with such freedom, like the old days. But they don't understand that the artist's mind is different from other people's, and that he works according to his moods.

Except for this one service obligation, the artists and their guilds were quite independent. When the guild acted, the king often had to accept its decisions (Majumdar 1922:62). The head officers of the guilds were actively involved with politics and government at district levels (Sharma 1958:278). All these activities came to be associated with Shudras.

The rise of the Shudra castes—socially, economically, politically—at about the time of the Gupta period, is related to the beginning of the fall of the artist's ritual status, which previously had often been high. There had always

been Shudra artists, but in this period the artist-Brahmin idea was eclipsed, and thereafter artists and craftsmen of all types seem to have become stereotyped as only nonprivileged Shudras. They were treated accordingly in social and ritual contexts, although they themselves retained the notions of artist-priest, art as sacred ritual, and the divine origin of the arts. It is not until the nineteenth and twentieth centuries that we see a well-organized return to the old idea of artists as Brahmins. This occurs partly in connection with British rule and the increased possibilities for Sanskritization of the Shudra lifestyle.

The Social Mobility of Folk Painters

The four main orders (varnas) of Hindu society that are fixed and pan-Indian are:
1. Brahmins—priests and teachers (ideally).
2. Kshatriyas—rulers, warriors, and landholders.
3. Vaishyas—merchants, traders, peddlers.
4. Shudras—laborers, artisans, servants.
Below these come the pariah groups, the untouchables, who are depersonalized and conceptualized as nonhuman. Within each of the four varnas there are literally thousands of endogamous and ranked castes, *jatis*. This unit of social participation may also be seen as a marriage network, a social field in which there can be ritual interaction, with all the attributes of a regional subculture. The jati is ideally occupation-specific.

The work of Srinivas (1952, 1962, 1966), and others, shows that some mobility has always occurred within this traditional ideal structure. Individuals are seldom socially mobile, but whole corporate jatis can make positional changes within the varna structure, often by the process of Sanskritization.

This common occurrence is a widespread cultural process in which a lower caste (jati) emulates the status and associated behavior of another, usually higher, or more dominant caste. A lower Shudra jati, for example, may adopt Rajput Kshatriya rites and customs en masse. Their whole way of life will be changed by adopting not only rituals, but institutions and values related to more orthodox Hinduism. The two Brahmin painter jatis of Nathdwara, as well as other Pahari painter jatis who live to the north in the Kangra Valley, have done exactly that.

Goswamy (1966) found that the consulting of records (*bahis*) kept by *pandits* at centers of pilgrimage was an especially profitable way to get at the social and economic history of Pahari folk painters. These registers are like our "visitors books," except that they also record self-assigned caste and other vital statistics. Goswamy writes:

> It was fascinating for me to see how the painters of three hundred years ago were content with simply describing themselves as *Tarkhans* or *Tarkhan Chitreras* [carpenter-painters], and their descendants of fifty years ago sought to raise themselves in status by giving themselves out as *Rajput Chitreras*. The painters and carpenters and blacksmiths of the hills today, of course, when we fondly believe that the consciousness of caste is on the decline, describe themselves of *Dhiman Brahmins*, because a conference of theirs in the Kangra District a few years ago so decided (1966:180).

The Nathdwara painters loathe being called chitrera, with its connotations of Shudra status and of the painting of house walls in rural areas. They prefer the more Sanskritized word, *chitrakar*, for themselves. Yet in signed paintings of only fifty or sixty years ago, they wrote "Chitrera so-and-so," and the high-sounding chitrakar has only appeared very recently. The vagueness of exact caste designations, the flexibility of the system, and the many mythological claims to high-status origins have allowed this mobility for painters and many other jatis. Nathdwara townsmen cite painter jatis working for Shri Nathji as exceptions and attribute the success of their mobility efforts to their working with gold.

British rule improved the possibilities for group social mobility, economic improvement, and the acquisition of political power. More important, when census enumeration began in 1867, castes saw an opportunity to raise their status by reporting themselves at higher varna levels. This practice became very widespread with the census of 1901, when not only varna claims were enumerated, but jatis were also ranked according to "native public opinion at the present day" (Census of India 1901:130). After 1901, groups began to organize to press their claims. In *Caste and Class in India*, Ghurye (1957:169) writes, "Various ambitious castes quickly perceived the chances of raising their status. They invited conferences of their members, and formed councils to take steps to see that their status was recorded in the way they thought honorable to them." Both the Jangira and the Adi Gaur painter castes in Nathdwara were just such "ambitious" groups, and their efforts have met with a measure of success.

THE STRUGGLE OF THE ARTS IN MODERN INDIA

In contemporary India, in spite of the success of the drive for high status, the artists of Nathdwara are economically more hard pressed than ever, a situation that is even more true of painters in other areas. Without sustained support, their ability to paint what they consider appropriate and their very occupational identity are threatened by a number of factors.

The Decline of Patronage

In addition to the impetus for social mobility provided under the British by census classifications and other opportunities, other major significant changes in the behavior and work habits of the Nathdwara painters have also occurred because of Westernization. The term "Westernization" is used here in its widest sense and refers to both European and American influences, although the most far-reaching and lasting changes have resulted from British rule in particular.

The acceleration of modernization in India, especially since Independence in 1947, brought with it the final breakdown of the traditional relationship between patron and artist. When the British were in power, they

never took over the role of the sensitive "royal" patron, for an essential feature of that relationship had always been at least a partial sharing of well-known cultural symbols and aesthetic values by artists and traditional patrons. During British rule, there were still some petty princes and local maharajas who continued to support, and take an active patronizing interest in, the artist and his craft. But after the turn of the century, these ties gradually weakened and faded. The Maharana of Udaipur is one of the few patrons to have remained well into the twentieth century; the High Priest-Maharaja at Nathdwara abandoned this role earlier.

As long as there were maharajas to act as patrons, painters and artists of all kinds gathered to receive the temporary support they needed to keep working, but even before the end of British rule this means of support began to dry up, and today there is virtually no kind of extensive "royal" patronage. Although the Government of India has extended aid and encouragement to other cottage industries, the more than two hundred painters living in Udaipur District of Rajasthan say they have gotten none of it. As a community of folk painters, they may disintegrate if not supported financially and spiritually in some major way. Perhaps the development of tourism will turn out to be a boon.

Technological Competition

In the absence of the all-important patron, what has happened to these painters in the last one hundred fifty years? First, when the British brought the printing press to India, they revolutionized education and communication by introducing the machine-printed word. Together with photography, it perhaps sounded the death knell for traditional painting in India. Now that rural Indians could purchase cheap reproductions and oleographs, especially those of popular Hindu gods and goddesses, they no longer supported traditional folk painters. On the contrary, among the illiterate masses, and even among the middle classes there is a certain amount of social prestige attached to having a machine-printed image, as though it were nearly the same as owning a book. Moreover, it is easy to pick and choose from among many popular prints made available in one place at one time. Customers can then avoid the bother of consulting first-hand with a painter, and having to haggle over prices and sizes. Finally, machine prints are cheaper and, since they are "new," attract great interest.

The lack of official support, the absence of a discriminating Indian audience, and an increased secularization of religious values throughout India have forced the Indian painter to see himself in a new light. He must increasingly ask himself what he can *get* out of painting, in contrast to what he might *give* to his art. He must see himself and his paintings as commodities, and his artistic activity as commerce. The modernization of folk painting has destroyed a basic joy—leisure time —and the deep and personal bond that once existed between artist and patron—whether the patron were another villager or a king. All over Rajasthan, the disillusioned painter complains that "I can no longer paint with my own heart."

Commercialization

In place of the patron, we find the Indian and foreign tourist looking for curios and only rarely for traditional concepts of beauty; because of this there has been an overall drop in the quality of paintings being made for the outside market. In place of the royal patron, we find the out-of-town businessman, the *bania*, who encourages haste and a sterile efficiency while playing one painter off against another. These banias can often be quite unscrupulous, misrepresenting the paintings to tourists by saying they are old or that copies are originals. At urban tourist centers like Bombay or Delhi, they extract exhorbitant sums for inferior work painted just yesterday. The bania who pays a Nathdwara painter 100 rupees for a miniature painting will charge anywhere from 700 to 2,000 rupees for it in the cities.

Gone is the ideal of guild responsibility —and with it cooperation among painters, security, and the lack of cutthroat competition. Many of the painters are deeply in debt to the banias. For example, in order to finance a wedding and to build a small extra room on his house, the artist Bhim Das borrowed a large sum of money from an "art dealer" who comes to visit him from time to time. In return for lending the money, interest free, the dealer has the right to lay first claim to everything the painter produces and in this way keeps a firm grip on him. It is a new kind of jajmani relationship, which has emerged in response to expanding tourist markets in India and abroad; unlike the older village relationship, which in many ways was mutually beneficial for both parties, the painter is now trapped.

Money has replaced payment in land or other goods and services.

The new form of patronage and the distant markets have created a situation in which painters must strive to produce a completely standardized product for mass tourist consumption if they hope to survive. This has often meant a reduction in the size of paintings. The *Bhilwara Parh*, for instance, a Rajasthani painting on cloth that is used even today in the countryside by itinerant minstrels to tell a story from village to village, is customarily from 30 to 50 feet long by 5 feet wide. For at least the past eight years the Parh has been getting smaller and smaller. For the Delhi and Bombay markets, it has been hacked up conveniently into smaller "suitcase size" pieces.

The commercial spirit has now come to infect every aspect of the painter's life. Because of the increased competition among individuals, painters of the same caste work alone surreptitiously and fear each other. There is very little exchange of ideas, artistic fantasies, or technical information.

The demands of the market for efficiency, haste, and a product salable to tourists have put an end to individuality and creativity in the painting of all but a few courageous painters devoted to working within the old Mewari styles. Artistic sterility, conventionalism, and frozen styles characterize the new wave of folk paintings from Rajasthan. Worst of all, the painters have lost much of their self-respect, without which creativity is impossible. The indigenous art-buying public no longer values highly many of the old artistic traditions, and therefore the painting arts no

78. The painter Ram Lal works on a sacred pichwai while his young son watches and learns.

ist's concern for these things? Instead of gathering and then grinding stones from the hillsides, painters use commercial chemical powders that often produce a very garish effect. Instead of the meticulous care that once produced such high quality and the original vitality that expressed the joie de vivre and the Rajasthani folk spirit, quantity has become, perforce, the goal.

Content and Change

One may say, however, that very few Western motifs have actually been painted, and although machine-made materials and tools (paints, paper, brushes, etc.) are being used to a greater extent, sacred motifs remain relatively unaffected. Artists appear to make an important distinction between the sacred and the profane when it comes to subjects and motifs in their paintings. Two attitudes are unwittingly expressed.

(1) The style and motifs of their traditional school, which they cherish still, are not abandoned. Instead, they have chosen to paint certain kinds of paintings from their own traditional repertoire, which, from experience, they know tourists will find most appealing and therefore buy. Thus, painter Ram Lal paints miniatures or copies of miniatures 90 per cent of his working time. In what time remains, he sketches what he likes most and works on *pichwai* (figure 78) paintings for very special commissions. In this way, he feels he has struck a compromise with the financial realities of the new age. Other painters paint miniatures with erotic overtones or of the sec-

longer express the painter's pride and sense of social unity.

Old techniques and materials are also thrown over in the interests of saving time and making money. The folk artist has lost the precious leisure time he once had to be both a better craftsman and a more creative artist in his style. Who now will take the trouble to prepare the pigments in the ancient way when rewards are inversely proportionate to the art-

ular Moghul School, since they know Western tourists prefer these. By rearranging their own artistic priorities in this way, the painters maximize their monetary gains, and the noncreative painters, at least, rationalize that they have lost nothing in the process. Painters still work within their Rajasthani styles, however, and only a few of the younger painters have suggested that they might begin to paint the crucifixion or other subjects that have no deep meaning for them.

(2) When it comes to accepting change, an important distinction between secular and religious motifs is also made. Arts with a secular reference, such as landscape paintings and border designs, have been introduced or changed more readily to meet the new demands for cheap, mass-produced art. Animal designs, pleasant decorative motifs, or folktale paintings that are not strictly sacred are changing in style and content more quickly than paintings associated with the Hindu Great Tradition or with the Shri Nathji sacred temple complex in Nathdwara.

Although there are still pilgrims coming to Nathdwara every year who buy enough paintings to keep all the painters alive, their position is weakening. The changes mentioned above are fast overtaking them. In light of the economic hardship and the sociopolitical strains that the making of the new nation state have placed on the lives of all Indians, it is amazing that so few of the painters have actually left their caste occupations. Those who have left are nearly all in related artistic occupations requiring more education: several have become art teachers; others have enrolled in art classes at the college level; one expainter is now selling betel nut (a *pān walla*), and a few others have become bus drivers or calendar printers.

CONCLUSIONS AND CONSIDERATIONS

Until now, Nathdwara paintings have remained functional, inasmuch as they are used in ritual contexts and still reflect and maintain a cultural identity. Vaishnava followers of the cult of Shri Nathji make up a discrete and identifiable ethnic group within a larger pluralistic setting. Thus, the paintings have always fostered interethnic communication, and will continue to do so in India for as long as major Hindu sects can attract a significant number of adherents. But since the painters cannot continue to survive on this market alone, we may expect to witness an increase in the importance of commercial souvenir art items and of the tourist market outside India for which they are generally made. This foreign audience is characteristically quite ignorant of Hinduism, and therefore is little equipped to understand or appreciate the context and content of exotic Indian folk paintings. This being the case, it is impossible to predict how and to what extent the paintings can and will foster cross-cultural understanding.

The Hindu God of Creativity, Lord Vishvakarma, has said: "I shall be Many." Within the amazing diversity and cultural pluralism that characterize our contemporary societies, we shall have to consider the god's words seri-

ously and search for underlying symbolic unities. Perhaps we will pass from this stage, in which exotic ethnic arts are simple curiosities and status symbols, to the exciting possibilities of a more serious time in which more people actually study the cultures from which the arts derive. Art can play a vital role in this cross-cultural adventure. To the extent that we can begin to look for symbolic universals and psychological similarities, as well as formal stylistic and cultural differences, the ethnic arts will serve as psychocultural indicators of a more unified world culture. The age in which the myriad visual arts of all mankind could remain quite isolated and uninfluenced by the styles and mannerisms of each other has clearly passed away. Instead, we may look forward to a time when many artistic currents feed into one large stream of world culture.

PART V/OCEANIA

Oceania, as considered here, includes the continent of Australia and the island peoples of Polynesia, Melanesia, and Micronesia (see map 8). Polynesia covers the largest area, from Hawaii to New Zealand. Most Polynesians are island, seagoing peoples, with ranked societies and rich arts reflecting the rituals and nuances of ceremonial life. These arts include woodcarving on houses and boats and carved wood sculptures, brilliant textiles, including featherwork, and elaborate body-decoration, such as tattooing and skin-sculpture (Barrow 1972).

MEAD's chapter on the contemporary arts of the Maori exemplifies the range of Polynesian arts, including the demise of some, such as the elaborate face and body tattooing, and the technical changes in others, such as the introduction of European tools and industrial paints for the carved ceremonial houses. Some Maori arts have become commercialized without the loss of standards, whereas others, such as greenstone *Tiki* figures, have fallen prey to mass production and may no longer be made in New Zealand at all. See also Barrow (1969) and Mataira (1968) for further information on Maori arts.

Melanesia, perhaps even more famous for its arts than Polynesia, includes the peoples of New Guinea and the surrounding islands, such as the Trobriand Islands (Wilson and Menzies 1967), New Britain (Dark 1974), the Solomon Islands (Mead 1973), and New Ireland (Lewis 1969). These peoples, though less stratified than the cultures of Polynesia, were famous for their woodcarving arts and elaborate costume and body decoration. They have been in contact with European society for over one hundred years, and have been subject to missionization, "blackbirding," and massive colonization; hence, many of the traditional arts have been destroyed. The most famous art area, the Sepik River, was made known to the art world through the great collections by German traders and colonists at the turn of the twentieth century (Gardi 1960; Forge 1973). Now a prime tourist area, most of

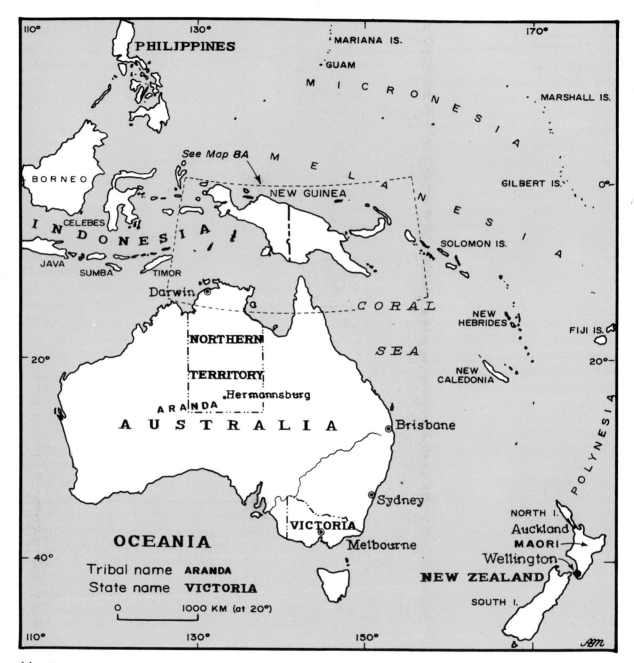

Map 8.

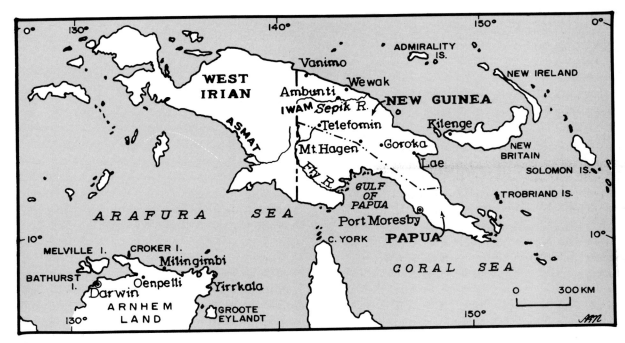

Map 8a.

the art forms are copies, mere shadows of their former selves (see figure 5) (Stewart 1972; May 1974; Carpenter 1972).

ABRAMSON describes the processes of change in the shield style of the Iwam of the Upper Sepik and May River area of highland New Guinea. He shows how acculturation and the perceived forces of the market have loosened the rules of style that the artists have to follow, leading not only to a breakdown and a divergence from the strict local styles, but also to new forms of creativity and experimentation. The previous Australian administration and the newly independent governments of Papua-New Guinea continue to promote the arts, encouraging great displays of costume that are less and less traditional, such as the annual agricultural fair at Mount Hagen (Strathern 1971). Further east, on the fringes of Melanesia, *tapa* cloth, made from the beaten bark of the paper mulberry tree, reaches its height in Tonga and Fiji, though it is known from New Guinea to Hawaii (Kooijman 1972). In Fiji, traditional *tapa* is still made and commercial *tapa* of very

high quality can still be found, though smaller souvenir pieces, sold at Suleva airport may be second grade.

Micronesia, the least-populous area, consists of very small islands with relatively scarce resources, and produced little in the way of recognized arts, save for models of material crafts. These have continued as a tourist industry and new forms of woodcarving have arisen in response to visitors' demands.

Australian aboriginal arts were focused on their extensive ritual and body decoration, for their material property was meager (Berndt 1964).

WILLIAMS shows us how the bark paintings of Arnhem Land, originally derived from body painting or from casual didactic diagrams, were developed with white encouragement for commercial purposes. The bark paintings are still used for teaching the young the traditions of the tribe, even when made for eventual sale. The traditional rules, however, have broken to allow women to do bark paintings too, though usually they are restricted to painting souvenir small barks and are not allowed to illustrate "important stories" (see also Kupka 1965; Allen, in press; Elkin 1950).

The religious arts of central Australia (Munn, in Forge 1973) have not been quite so developed for commercial purposes, though recently their motifs have been incorporated into much of Australia's "national" arts (Black 1964), just as Maori art has been incorporated into New Zealand national arts. In this central area arose the Hermansburg School of water-color painting, after an Aranda man, Albert Namatjira, learned from a visiting white artist how to paint scenes in water colors (Batty 1963) (see figure 2).

Throughout Oceania, the local, Fourth World arts are assuming greater importance. Australia and New Zealand are using the arts of their aboriginal peoples as unique national symbols, while the newly independent Third World nations of the Pacific, such as Papua-New Guinea, are creating national art styles out of the most illustrious of their indigenous arts (see Graburn 1976b). Dying arts are being revived (Schneebaum 1975; Beier and Kiki 1971) and new assimilated and popular arts are proliferating (Lauen 1975).

Oceania has long held a special place in the minds of Europeans (Smith 1960) as a kind of paradise, and its art traditions have been well reported (Buhler 1962; Firth 1936; Guiart 1963; Linton and Wingert 1946; and Schmitz 1971). For contemporary developments, consult Mead's Exploring the Art of Oceania (1978) and the Pacific Art Newsletter.

14. Style Change in an Upper Sepik Contact Situation

J. A. Abramson

The Sepik River, with an approximate length of seven hundred miles, is the largest river in New Guinea.[1] Originating in the mountainous spine comprising the central highlands of the island, the Sepik flows down through mountain rain forest and onto a vast floodplain before emptying on the northeast coast into the Pacific Ocean. At various points in its meandering course, the river plain is broken by lower mountain groups and by huge swamps interspersed with thick lowland jungle. Thus, the Sepik area may be thought of as involving at least three distinct ecological situations with respect to human population, coastal and delta lands, riverine/swamp environments, and inland and foothill locales.

Jerry Abramson was awarded his Ph.D. in art history from the Institute of Fine Arts of New York University, and has taught art history and anthropology at York University in Toronto. He has done extensive research in New Guinea and has published works on a number of indigenous arts.

[1]Portions of this article appeared as "The Third Iwam Style," in *Artforum*, November 1970, and I thank them for permission to reprint. Much of the fieldwork upon which this article is based was done under a grant from the Wenner-Gren Foundation for Anthropological Research in 1969–70, and I wish to acknowledge this with gratitude.

The Sepik region is situated almost wholly within the Mandated Australian Territory of New Guinea and is divided into two large administrative districts: the East Sepik District, with government headquarters at Wewak on the coast west of the Sepik mouth, and the Western Sepik District, with its administrative center at Vanimo on the north coast adjacent to the boundary line of Irian Barat.

From 1884 to 1914, the present Territory of New Guinea was under German control as part of Kaiser Wilhelmsland. The Sepik River was first discovered by Finsch, who sailed inland in 1885. Dallman followed Finsch in 1886; in the same year, von Schleinitz steamed upriver 200 miles and finally reached the area around Ambunti, at the upper end of the Middle Sepik. In 1887, Schrader penetrated 380 miles upriver, and in 1910, Leonard Schultze and a Dutch-German boundary expedition followed the river 600 miles into its mountainous headwaters region. In 1912–13, the Sepik area was the subject of an intensive scientific reconnaisance expedition under the direction of Dr. W. Behrmann, but the upper

reaches of the river were not exposed to any great degree of contact with Europeans until the years following 1945 (Souter 1963; Schuster 1970).

Although climatically and topographically a rather inhospitable area for Europeans, the Sepik region has occupied the attention of anthropologists and collectors since the years of its early penetration, principally because of the richness of the traditional arts created by its peoples. In stylistic and technical sophistication and in actual amount of production, the two Sepik districts stand second only to the Congo Basin as centers of primitive art. The repertoire of the region is not limited to woodcarving, but also includes carving in stone, bone, and shell, superlative painting on bark sheets and wood surfaces, a large variety of weaving techniques, striking architecture, and several types of distinctive ceramics. Because of its abundance and variety, Sepik art is extensively represented in the ethnographic collections of the museums of the world. Until recently, however, this profusion of objects has tended to cloud, by an abundance of riches, any overall phylogenetic understanding of the styles of the area. The problem is made even more difficult by the fact that these styles are changing—growing, dying, being born, moving from place to place—owing both to factors inherent in the traditional culture of the area and to the rapidly increasing amount of contact with Europeans and their culture.

Although the Sepik region is geographically the basin for one river and its system of tributaries and is divided politically into two districts, it is usually thought of as comprising four somewhat distinct cultural areas: the coastal and Lower Sepik, the Middle Sepik, the Upper Sepik, and the Sepik Fringe or peripheral Sepik. This fourfold division has some degree of congruence with the apparent style groups of the region. It also coincides to a degree with the languages spoken by the inhabitants: the Sepik coast is characterized by a mixture of Austronesian (Malayo-Polynesian) and non-Austronesian languages; the Lower and Middle Sepik by non-Austronesian or Papuan languages, mostly belonging to the *ndu*-family and to the "Sepik Hill" language family; and the Upper Sepik by non-Austronesian or Papuan languages of the so-called Upper Sepik Stock, with some *Ok*-family non-Austronesian groups in the headwaters area (Laycock 1965; Dye, Townsend, and Townsend 1968; Capell 1969, map 1 and pp. 140–142).

Generally, the inhabitants of the Sepik region are village-dwellers, organized in exogamous, usually totemic, patrilineal clans. Intertribal warfare was frequent in the region, with headhunting and cannibalism common features. Myth centered around ancestors and nature spirits; ritual involved initiation into cults under the aegis of the ancestors and other spirits, and apotropaic/increase ceremonies were held in which the ancestors and other spirits were petitioned and propitiated.

The banks and tributaries of the Upper Sepik are shared by a number of more-or-less related cultures, among them the linguistically defined group known as Iwam.[2] Anthropologists usually divide the Iwam, on the basis of

[2]The author wishes to express gratitude to D. Newton, of the Museum of Primitive Art, New York, New York, for information concerning traditional Iwam culture that he was kind enough to communicate.

certain cultural differences, into two sub-groups, those inhabiting the lower reaches of the May River (an Upper Sepik tributary), and those living along the banks of the Sepik itself, mostly down-river from the May-Sepik confluence.

A state-of-war condition was endemic to all the Iwam, both among their own separate villages and between the Iwam and the culturally distinct peoples adjacent to them. All the Iwam were headhunters and ritual cannibals. It should be noted that ritual cannibalism, as distinct from nutritional cannibalism, involved the ingestion of various parts of enemy bodies either for the purpose of attaining spiritual immunity from the vengeful ghosts of the deceased, or for the transference to the eater of certain spiritual or physical powers once possessed by the deceased, or both. In some areas of New Guinea, the souls or spirits of enemies who had been killed in battle were adopted into the tribe as "honorary" ancestral spirits—thus placating the wandering souls and giving them a home—and the bodies, or parts of them, were eaten. Iwam cannibalism, however, usually was practiced only on the bodies of non-Iwam victims. Trophy heads were painted and hung in the doorways of the "Haus Tambarans," or spirit houses, serving both to advertise the prowess of the group and to ensure nonentry into the house by the uninitiated and by women. The intra-Iwam conflicts usually had their roots in disagreements over women, whereas those involving the Iwam with outsiders generally arose from disputes over land or fishing areas and the recurring ritual need for new trophy heads. Among the Iwam, if a man wished to marry, he must first qualify himself as a man by taking the head of an enemy (Schuster 1970:14). In other areas of the Sepik, it was common to find similar requirements for boys about to be initiated, for the consecration of a new spirit house, and the like.

SEPIK ARTS

There appear to be at least three major groups of art styles in the Sepik: a purely non-Austronesian or Papuan type in the Upper Sepik and Sepik Fringe areas, a Papuan-Austronesian mixture in the Middle and Lower Sepik, and some elements of a more-or-less pure Austronesian type in various locations on the Sepik coast (Abramson and Holst 1972; Newton 1966, 200–215).

The factor that is most distinctive about primitive art is the almost total functionalism of the object. This is especially true of Sepik River art. The art-for-art's-sake motive was a rarity here. The artist functioned as an adjunct shaman or priest, reifying the myths and principles of the native religion. The objects themselves served either as personifications of primordial ancestors and mythical beings, or as occasional or permanent dwelling places for ancestral spirits, totemic animal or plant spirits, or even the "spiritual force" of living men. The stylistic and iconographic variations permitted the artist were small, since such variations, by confusing the viewers, could hinder the ritual functioning of the object.

Style was also influenced by function in another way in the Sepik; objects such as war shields, bowls, lime containers, and canoes, which were not completely ritual in usage,

carried decorations derived from ritual art and adapted to the type of surface to which they were applied. The function of decoration here also was often magico-religious rather than purely decorative; for example, the faces on shields could be the ancestral spirits who went ahead of the war party, searched out the enemy, and sapped his strength, and they may have protected the shield-bearer from both magical and physical attacks. Decoration on such items as lime containers (used to hold powdered lime, which, together with a pepper leaf, was chewed with betel nut), though done for aesthetic purposes, almost invariably used standard iconography adapted to the physical character of the object and functioned also to indicate ownership in a personal, clan, and village sense.

The artist himself was usually a part-time craftsman rather than a full-time carver, and, except for periods of festivals, initiations, and warfare, supported himself and his family in the same manner as other men of the group supported theirs, by gardening, hunting, and fishing. There were, of course, exceptions; there were a few groups in the Sepik who specialized in certain types of crafts (such as the Chambri Lake tribes of the Middle Sepik, who were noted ceramicists), and there were certainly a few artists who experimented occasionally. Artistic or technical excellence was usually rewarded by social recognition, however, rather than by financial support (which was always available to those who carved, as the carvings were as necessary as food and shelter). So, in a sense, one might have typified Sepik art as basically iconic (personifying, rather than representing, the spirits), acting to

extend man's social and conceptual sphere beyond this world into the universe of the Tambaran or spirits. A huge female figure giving birth personified the first ancestress, and the child, her descendants (the tribe, living and dead). Or again, a male figure surmounted by a bird often personified the tribe, in the form of its spiritual and physical power in war. Thus, the motif or image stood for (or "was") the tribe and its culture, acting to extend both entities backward and forward in time, and functioning on several levels: as ritual or apotropaic iconography, as a group solidarity and identity symbol, as objectification of cultural values and cultural experience, and doubtlessly also as pure form and color. Such multi-leveled dynamics, of course, is not restricted to Sepik art, any more than is art-as-icon. In their present-day American context, as encountered by Americans in a museum or gallery, a Warhol Campbell's soup can or a 1950 Chevrolet fender á la Rosenquist work in a very similar fashion.

Traditional Sepik Arts

The traditional Iwam warrior armed himself with a variety of weapons: bone daggers (made both from cassowary femurs and from the leg bones of human enemies), bows and arrows, spears, and various types of axes and clubs. In addition, a shield was often carried; shields were elaborately carved with tools of marsupial tooth or cassowary bone. The traditional Iwam shields seem to have been manufactured in two models, a broad thick shield used by men advancing in file or in groups, and a narrow shield used by a single

man, usually armed with a bow. Shield manufacture involved five separate processes or stages: first, the fashioning of the wood plank from a log; second, the charring of the surface of the plank to make it smoother and to provide a dark background; third, the application of a "cartoon" or sketch of the design in white clay paint on the dark charred surface; fourth, the carving-out of all areas covered with the white pigment, resulting in a relief design on a flat surface; and fifth, the painting of the sunken areas with various bright earth and vegetable pigments and the darkening with soot of the raised areas. The greatest artistic status was accorded to the painter of the shields rather than to the carvers, but both the painting and carving of shields was traditionally a hereditary specialty occupation, taught to a boy who had reached adulthood by his father or uncle and passed down in certain families (Schuster 1970:10–12). The motifs used seem to have had a definite but extremely complex connection with the family or clan affiliations of the owner of the shield, and possibly, also, to some degree with those of the carver and painter.

The Iwam traditional shield style (figures 79, 80, and 81) was distinctive, both formally and functionally. Immediately apparent as a basic formal orientation is a rigid bilateral symmetry, which is to be found not only on shields, but also on canoe prows, decorated arrows and gourds, carved cassowary bone daggers, and bark paintings. The Iwam arrangement involves a distribution of a limited motif vocabulary along either side of a midline running the length of the shield. A secondary organizing principle is a habitual division of

79. Iwam traditional shield from Tane village, 1955 (147 cm. long).

80. Traditional May River Iwam shields, 1959
(left 203 cm. long; right 191 cm. long).

the shield horizontally into working areas or registers. The motif vocabulary is seen to be relatively large when many decorated objects are considered together as a tribal *oeuvre*, but it tends to be restricted to three or four elements on each individual village. The teardrop or lobe-shaped motifs, usually filled with "teeth," may represent opossum tails or bird wings, or may, when combined with circular designs, represent the fruit and leaves of a type of ginger plant (*ibid.*: 12). The circles themselves, which are common and usually contain "teeth" or rays or star designs, are generally interpreted as eye or sun symbols. The "teeth" elements themselves, called *yohu muio*, apparently are representations of crocodile teeth or serrations on banana or ginger leaves, depending on the clan (or mental set) of the carver, owner, or informant. Vertical running scrolls or S-curves are often interpreted as opossum tails or pythons, and the horizontal bands of chevrons, called *tagu*, can be either water or the backbone of a turtle.

These elements combine in various ways, and persist in an unbroken line from the traditional pieces, through the degenerate later pieces, and into the contemporary "synthesis" examples to be discussed here. If Iwam traditional shields are examined, a minor stylistic divergence between May River Iwam and Sepik River Iwam becomes apparent. Shields from the latter Iwam area (figure 81) usually tend to have patterns organized in a system of large Xs, the limbs of which are formed from the lobed, tooth-filled elements mentioned above. Patterns of shields from the May River Iwam (figure 80) seem to use double vertical lines of connected S-curves, or some permu-

tation of them, rather than the Xs within registers, or vertical rows of toothed lobes and circles, which effectively divide the shield surface into horizontal registers (e.g., in Schuster 1970:plate 16). This stylistic divergence between May and Sepik Iwam is minor perhaps, because the Sepik Iwam represent a rather recent expansion of the Iwam from the May River area.

The shield in plate 7b, a new piece from a Sepik River Iwam village, shows both the conservatism of motifs and the Sepik substyle mentioned above. In the bottom third of the composition, a standard and traditional motif or motif combination is presented twice, apparently for decorative purposes. This part of the shield decoration seems to be an extremely stylized combination of snakes and crocodiles, with the free circles being crocodile eyes, the serrations crocodile teeth, and the lobe shapes with eyes pythons.

Since a running scroll may be a python's or an opossum's tail at only one level of iconography, this sometimes can be completely misleading. A curious but consistent phenomenon in New Guinea art, especially in that of the Sepik River, involves the multiple interpretations of the same motif or visual configuration by people of the same tribe or village, or even by members of the same family. Often, when the anthropologist questions six different people from the same village about the meaning of one motif, he receives six different answers: "It is a crocodile (a snake, the river, a fruit vine, a bird, etc.)." Such diversity, of course, can indicate unperceptive questioning on the part of the investigator, but often this apparent lack of consistency is a sign of a

81. Traditional Sepik River Iwam shield from Inick village (ca. 160 cm.).

multileveled iconography. The investigator may find, after more fieldwork, that all the apparently disparate interpretations have a "common denominator"; they are all members of an image-meaning system revolving around one central idea, perhaps war, fertility, or some ritual. In addition, he may find that such factors relating to the social identity of the native informant as age, sex, sodality membership, kinship-group affiliations, occupational specialty, and the like will act to structure which of the disparate but related "meanings" the informant will assign to any particular motif. In other words, the informant's knowledge of the spectrum of interpretations involved with one motif-meaning complex will be necessarily incomplete and specialized. To further confuse the outsider, the image-meaning systems of a style will often deliberately involve both types or levels of meanings. There will be images designed to present one obvious meaning and these will be interpreted with great consistency by everyone; at the same time, and often in the same composition or object, there will be images or motifs that are interpreted with very little consistency. These latter can be the personal idiosyncratic devices of the designer (pure decoration); or they can be elements of a meaning complex with a generally recognized and single referent, as discussed above; or they can be iconographical configurations, the meaning of which, in a specific sense, is known to one group of people and in a general way to another group of people. (An excellent example of this is the crest poles of the Northwest Coast Amerindians, the com-

plete iconography of which often is known only to the carver, his patron, and perhaps a few members of the patron's family, although the generalized meanings of the crest pole —the wealth, status, and broad kinship affiliations of the owner—are obvious to the community at large.) Images subject to inconsistent interpretation also may be incidental survivals of an older motif complex that is no longer in general use, the iconography of which has become unclear or confused to the majority of the present population. In addition, similar confusions may arise from the investigator's attempts to ascertain the meaning of apparent motifs that in reality are only part of the actual motif, or, conversely, that are several motifs erroneously thought of as one by the investigator.

Contemporary Sepik Arts

The new Iwam shields represent a fascinating mixture of consistency with, and radical departures from, the old traditional styles. Their manufacture is no longer a specialty occupation; they are now being made by almost every male member of many of the villages. As constant inter- and intragroup warfare has been suppressed for the most part in this area, the shields are no longer strictly functional objects. Also, as the old ritual practices have begun to decline, the content now apparently lacks any deliberate ritual or mythological references. One would suspect, although it is extremely difficult to verify, that the "multileveled imagery" discussed above has also gone by the board. The traditional carving of

shields in two sizes seems to have been dispensed with, owing to the change in function of the shields from objects used in warfare to objects for commerce. In fact, many of the new shields are almost outlandishly huge, up to thirteen feet tall and two and one-half feet wide. Although the motifs or motif elements themselves are still derived for the most part from traditional sources or models, the relationship traditionally existing between the person(s) owning and fashioning the shield and the designs themselves has broken down. Thus, a change in design emphasis is apparent: where once utilization of design elements was conditioned by facts of kinship-group affiliation and, probably, by the ritual or mythological connotations of the design elements, now aesthetic considerations (always present to some degree) oriented around the desire to sell the object seem to be paramount. The artist attempts to achieve the most interesting and "striking" effect he can. As the shields are either sold to the rare European visitor to the Iwam area or are transported by canoe down-river to Ambunti, the farthest up-river European settlement, the artist is now faced with rather limited prospects for the sale of his product. When a visitor arrives at one of the Iwam villages, he has no sooner disembarked from his canoe than every household in the village has lined up its shields for display and sale. Several hundred shields per village may thus be displayed in some of the larger Sepik River villages, confronting the artist with a dilemma similar to that of the detergent manufacturer in our society; he must make his product stand out from the multitude. This is

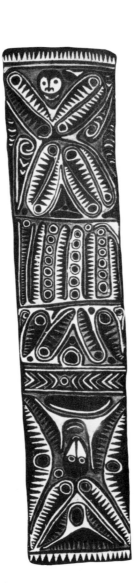
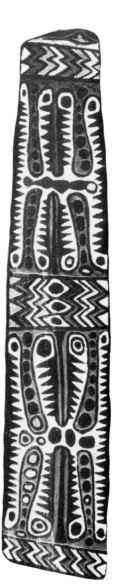

82. Newer Iwam shield, from Tauri village, 1969 (ca. 170 cm.).

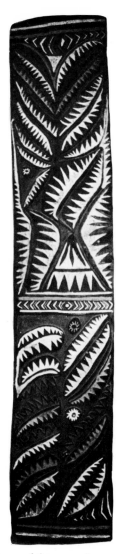

83. A tour de force of the newer Iwam shield style; made in Waniap village by Wogumash, a man from Biaga; note the abandonment of bilateral symmetry and a great variety of design motifs (190 cm.).

perhaps the major factor influencing the experimentation and increasing freedom and ingenuity of design to be seen in these shields today.

Most of the more obvious formal changes in the Iwam shields under discussion here probably result from this new necessity for visual impact. Especially notable, besides the general increase in size of the object, are the following (see plate 7b, and figures 82 and 83): a *horror vacuii* tendency; a heightened attention to value contrast, usually manifested by greater use of black against white and dark red instead of the old predominant use of orange and light-red grounds; a certain "hardening" and standardization of the various motifs or design elements; a willingness (as exemplified by the *tour de force* in figure 83) to dispense with such organizing traits as bilateral symmetry; and a use of a greater number of motifs. Some of the hardening of design elements has resulted from the changeover from tools of stone, tooth, and shell to those of steel, but some is attributable to the greatly increased number of carvers and, consequently, of shields produced. ("Hardening" here refers to the reduction of the traditional rhythms of linear curves to sharp, unbalanced, and nonorganized angles.)

It must be noted also that this standardization of elements is somewhat balanced by an increased freedom of composition and a willingness to expand the motif vocabulary, new motifs being introduced both as a result of personal experimentation by the artists and because of the increased mobility of the tribe as a whole. Some Iwam tribes are becoming familiar with some of the other styles of the

Sepik Basin and, in addition, are now beginning to be exposed to an ever-increasing number of European goods and images, which also play a part in increasing the elements in the Iwam motif repertoire.

Degeneration of Traditional Sepik Art

It must be admitted that the traditional forms of Sepik art are for the most part dead or dying today. The curio shops in Port Moresby and Lae, the two capitals of Papua and New Guinea respectively, are filled with degenerate, slapdash junk. "Artifact from New Guinea" has begun to be the equivalent of "genuine Navajo blanket."

These artifacts exhibit elements of traditional form and iconography, but they seem to lack something. They appear to be sloppily done and the fine flowing line and rhythmic curves have been replaced by a summary, almost soulless execution. The intricate curvilinear designs and surface motifs, once carved into the wood with extreme delicacy, are now carelessly daubed on in gaudy trade-store paint. Rather than being "primitive art," the objects are quick impressions of what art once was in this area.

Despite the degeneration of traditional art forms, *art* in the Sepik is not dying by any means. If one considers that the old traditional art forms represent "valid" art because of the function of the pieces and the stylistic coherence that is the result of their purposeful conception and manufacture, and if one labels the modern curios as junk, because they offer only a flat, summary impression of the old traditional style and craftsmanship, then the latter may be seen as a transitional phase, because a third phase is becoming apparent. This is a phenomenon that is seen also in African and in American primitive art. First, the traditional style dies, along with the old non-European culture; then a more-or-less sizable outpouring of degenerate slovenly pieces occurs; and finally, a stylistic (in conjunction with a cultural) synthesis is achieved. The last phase is marked by a resurgence of technical skill and a distinctive sort of "content."

This "synthetic" style represents a qualitative aesthetic departure from the styles antecedent to it. If one examines a collection of old traditional pieces, a definite range of technical skill and breadth of imagination can be seen. Some are "good" in terms of pure craftsmanship and the handling of formal elements, and some are not so good. But they all have an air about them; they seem "authentic" or distinct in some way. This is perhaps because their manufacture and conception were structured by a style conception directly linked with magic, ritual, and myth. Such structuring tends to impose a purity of style and conception on the objects that transcends craftsmanship. Perhaps one could say, searching for the most apt expression of nuance and not attempting empirical or ontological precision, that such objects are all manifestations of the same archetype or mental configuration. This nebulous unity, of course, is what is lacking in the degenerate material. Many so-called "tourist pieces" are actually extremely well done in terms of pure craftsmanship, but something vital is missing in every one.

The third phase mentioned above shares

with the transitional phase an orientation toward sale, thus differing from the traditional phase, which was oriented toward culturally internal functions. These three phases (here admittedly an oversimplification) have been noted in such disparate arts as Indian pottery and weaving of the American Southwest, in Yoruba wood carving, and in Eskimo ivory work. They are also now to be found in Sepik art, and eventually should be characteristic of the other art-producing areas of Melanesia. In actual time and effort expended, art was a central activity in the Sepik, and production traditions of this kind apparently do not die as easily as do style and ritual traditions.

INNOVATION AND DISPERSION

The three-stage description of Iwam style proposed in this paper is, of course, a heuristic device; in reality, the situation is much more complex, and indeed, in general form may be qualitatively different. Where the most obvious untested assumptions lie is in the reification of the first, or "traditional" stage. I do not actually know how conservative or static the traditional Iwam style was, because I have no significant time depth in my sampling of Iwam art objects. Neither do I know much about the "normal" rate of change or innovation in pre-European-contact Iwam styles. Moreover, this sort of investigation may be forever beyond the capabilities of outside observers. (Here an element reminiscent of Heisenberg's Uncertainty Principle comes into play, where the act of measuring or observing distorts the quantity measured. Obviously, the rate of innovation in pre-European-contact styles cannot be measured if we have to contact them to do it.) In certain other cultural contexts, we might expect to gain some insight from archeological investigations. But the probably recent localization of the Iwam in their present territory and the lack in their material culture of decorated objects that might be expected to last over long periods in the Sepik climate make the success of such archeological endeavors doubtful. In addition, we are not even sure whether the "traditional" Iwam style was a clan style, a tribal style, a style restricted to a certain segment of Iwam culture generally, or perhaps a style involving the Iwam and some other neighboring cultures also. The Iwam style today, transformed by the effects of European contact, extends beyond the Iwam themselves and has become a basic part of a general "Upper Sepik River style," which includes not only Iwam elements, but also features of the traditional styles of the April River, the Leonhard Schultz River, the Freida River, and the Wogumas River.[3]

Innovation and "creativity" in so-called traditional Iwam cultures were functional to the amount and nature of the variables impinging on the creative moment and process. There are certain factors common to most cultures, primitive or not, the operations of which tend to affect innovation in art styles as well as in other aspects of culture. We must be

[3]See figure 83, this paper, from Biaga village at the mouth of the Wogumush River. The style is obviously derived primarily from Iwam motifs and organization, but the piece was not an Iwam.

objects purchased from Aborigines primarily in trade goods, mainly tobacco, cloth, rice, tea, "Golden Syrup," and metal knives and axes. In addition, Chaseling used stick tobacco as a kind of currency: each stick of tobacco was valued at four cents (a half stick at two cents). A "bank" was established in a locked shed; empty tins, on which the depositors' names were written, were used as repositories, and tobacco was deposited and withdrawn on a depositor's order. Chaseling said that tobacco "currency" was sometimes shaved, just as, before milling, the edges of silver coins were.

The marketing of arts did not expand significantly from this beginning until the mid-1950s, probably owing to factors connected with World War II and its aftermath. Although a wartime military installation near Yirrkala created a limited market, coastal transport was undependable. Rupert Kentish, missionary at Yirrkala for 15 months in 1943–1944, stated that it was extremely difficult to transport goods along the north coast during the war, partly as a result of frequent Japanese air attacks. The mission staff, always small, was further reduced, and Kentish recalled that the "mechanics of running the station" (providing medical service, supervising gardening and building activities, maintaining liaison between the military establishment of more than a thousand men and the Aboriginal community, and teaching school) kept him fully occupied. Even without direct encouragement, however, Aborigines continued to produce arts that they asked Kentish to buy. Kentish reported the following objects made for sale during the time he was at Yirrkala: wooden pipes with intricately carved stems

(inspired by the pipes of the Macassans), carvings of birds and animals, hafted stone axes and spears, carved and painted wooden spears, throwing sticks, fighting sticks, and *didjeridoos* (drone pipes used to provide accompaniment for ritual chants), "message sticks," bundles of fire sticks, string, rope, and rarely, bark paintings. Women made round mats (a form taught them by the wives of Fijian missionaries), net bags, and baskets that were modifications of woven pandanus dilly bags.

The Aborigines were paid from two to five shillings (approximately 32 to 90 cents) for each of these objects; the criteria Kentish employed in valuing them were the amount of work that had been expended in their manufacture and the "workmanship" apparent in the finished product. Kentish said that he had discouraged the sale of important ritual objects, as well as the presence of white spectators at ritual performances. He felt that the profanation resulting from such commercialization would not be limited to the objects and the ritual, but would denigrate as well the concept of sacredness itself, and as a consequence, he believed, would make it difficult to convince Aborigines of the sacredness of Christian belief and ritual.

Kentish sent art and artifacts by any available ship into Darwin, where they were sold, if they arrived in salable condition, by mission personnel, and the money returned to the artists. Kentish managed the banking of money received from arts, as well as money from other sources, in the following way: deposits, withdrawals, and advances were entered in a ledger; withdrawals might be in the form of

goods purchased at the mission store or in cash. The chief source of cash during World War II was not art production, however, but wages paid for employment at the military installation nearby. At the suggestion of the Aboriginal leaders, a number of young men took jobs at the installation in turn, while the older men remained on the mission station, supervising work and maintaining order. Cash wages received from the military were regularly distributed among the families of those working. Aborigines had little opportunity to spend this money, but toward the end of his tenure at Yirrkala, Kentish was able to purchase goods desired by the Aborigines that were in oversupply at the Red Cross Canteen on the military base; these goods he then sold at cost in the mission store.

I obtained little information regarding the marketing of arts in Yirrkala from 1944 to 1950. During this period, a series of Fijian ministers were superintendents at Yirrkala; subsequently they returned to Fiji and I have not attempted to contact them.

To summarize, the chief market for Yirrkala arts from the mid-1930s until after World War II consisted of anthropologists, museums, art galleries, and wartime visitors. Some art was sold in Darwin through the auspices of the mission or of private individuals, or through shops. Payment to Aboriginal artists was for the most part in the form of trade goods, but beginning about 1943 some payments were made in cash.

In 1950, Douglas Tuffin began his 13-year tenure at Yirrkala. He was a lay missionary and in the mid-fifties was assigned the responsibility of buying arts at Yirrkala. Tuffin described the objects then being produced for marketing as few in number and poor in quality: message sticks, pipes, human figures roughly shaped from flat pieces of wood, all quite plain and ochred without fixative so the color rubbed off. In addition, there were serviette rings woven by men and round mats woven by women. The men were painting on bark, but not generally presenting the barks for sale. When accepted and paid for (usually in trade goods), these objects were forwarded to Darwin for sale; if sold there, the profits were returned to the artist in cash.

Shortly after the Reverend Gordon Symons assumed the superintendency of the mission at Yirrkala in 1954, he began to encourage both bark painting and woodcarving as means for Aborigines to express pride in their cultural heritage and as a possible source of income. Subsequently, Symons requested Tuffin to assume the responsibility of buying and selling art at Yirrkala.

Tuffin introduced innovations both in form and techniques that he judged would make the arts more salable and fetch higher prices. Among them were barks in shapes other than rectangular, finely drawn paintings on "miniature" barks, the canoe models, and the technique of incising fine parallel lines on ochre-washed surfaces (now typical of models of canoes, Macassan-type pipes, didjeridoos, small birds, fishes, amphibians, and human figures). Tuffin described two men as the most apt students in carving canoes; one remained a principal producer of the canoe model until his death in 1969. Tuffin recalled that when he

complained of the difficulty in keeping bark paintings flat and straight (in order to prevent damage and to facilitate shipping), Aboriginal artists devised the split-stick binding on the narrow ends of barks that has become identified with bark paintings from Yirrkala.

From 1954 on, artists were regularly paid in cash for their art. Tuffin set a probable retail price, and artists were paid two-thirds of this figure. If the object were sold at retail through a mission agency at a price higher than the one set by Tuffin, the additional amount was returned to the artist. Most of the Aborigines whose present source of income is derived mainly from the sale of bark paintings and carvings dated the beginning of their occupation as full or part-time artists from the time they began to sell their work to Tuffin. By the mid-1950s, the mission had assumed the function of art dealer as a means of improving the economic base of the Aboriginal community, and the sale of arts had come to be viewed as a major source of cash income to Aborigines.

Missionaries at Yirrkala who have succeeded to the responsibility of buying and selling arts have varied in their interest and skill at this occupation, but until 1969 it had to be undertaken by each of them in addition to other full-time staff duties. Nevertheless, the mission has come to regard the production of arts as an economic activity important to the Aboriginal community.

In 1964, when Keith Thiele assumed the role of buyer for the mission-staff, he found that production consistently exceeded demand and that sometimes cash on hand was insufficient to make immediate full payment to Aborigines for their art. He canvassed other members of the mission staff for names of business firms (not necessarily art dealers) throughout Australia who might be potential buyers of Aboriginal art, and he circularized approximately two hundred of those suggested. In addition, he temporarily restricted production of bark paintings. Drawing up a list of artists whose work he considered of excellent quality, chiefly older men, some of whose work was already in demand,[4] he said he would buy only the work of those artists, because their work was of high quality, was known, and, therefore was most salable. He explained to the artists whose work he would not buy the reasons for the restriction. Thiele received responses from approximately fifty of the firms circularized, and from that time until 1966, when he left Yirrkala, orders consistently exceeded production and he was able to remove the restriction on the number of artists whose work he would buy.

In 1964, Thiele had small labels printed that attested to the provenance and authenticity of the art, and artists began the practice of fastening these labels to their work.

In 1962, as a result of a decision made at a District Committee Meeting held at Elcho Island, the Methodist missions throughout the Arnhem Land District reduced their markup from $33\frac{1}{3}$ per cent to 25 per cent. Individual artists' receipts were thus increased to 75 per

[4]The list included two women, one of whom was a daughter of Mawalan. Mawalan, encouraged by Tuffin, taught his daughters how to paint around 1955, thus making them the first women to practice art previously restricted to men.

cent of retail price. Working with only a 25 per cent margin, the mission continues to buy, store, prepare for shipment, absorb losses resulting from damage, and conduct all other business requisite to this enterprise.

The following sales figures, provided me in 1970 by the Reverend Gordon J. Symons, then Chairman, North Australia District, Methodist Church of Australasia, give some indication of the increase in the sale of arts from Yirrkala. They are gross sales amounts, 66⅔ percent of which was paid to artists until 1964, 75 per cent after 1964:

Year Ending June		Gross Sales	
1954	£ 130	U.S. $	291
1958	£ 1114		2,495
1968	A$ 12,000		13,440
1969	16,500		18,480
1970	22,217		24,883

The increasing demand for Aboriginal art that began in 1964 has continued to be principally the result of orders from business firms catering to tourists in Australian capital cities. These orders are preponderantly for inexpensive objects, mostly small carvings and suitcase-size bark paintings. Generally, when an order for a large number of small carvings or barks has been received at Yirrkala and passed on to the producers (now mostly women, about ten to fifteen of whom regularly produce such objects for sale), the order has been quickly overfilled. Until very recently, this has necessitated some form of explicit directive from the mission buyer to cease production.

The demand for large bark paintings and for large carvings of all types has continued to

consist almost exclusively of commissions to individual artists and production has not been consistently adequate to supply this demand. The chief purchaser of these large commissioned objects, J. A. Davidson, is a collector of primitive art who maintains a gallery containing Aboriginal and South Pacific art in his residence in Melbourne. Davidson said that in 1962 the Director of Social Welfare, Northern Territory Administration, queried him regarding the possibility of his selling bark paintings from Arnhem Land in Melbourne. Davidson agreed to try. Since then Davidson has traveled annually to Arnhem Land to purchase Aboriginal art, has arranged exhibitions of Aboriginal art, and has given lectures on that subject in Melbourne and large country towns in Victoria. He reported that he " 'educated' a number of people to appreciate the artistic qualities of the bark paintings and to have some understanding of the designs" (1971, personal communication). During his visits to Yirrkala, Davidson meets with artists and gives his commissions directly to them, although most of his purchases are made through local mission buyers. Until 1968, Davidson returned all profits from his sales to the artists at Yirrkala upon the occasion of his annual visits, with the exception of a limited amount donated to Aborigines and Aboriginal causes in Victoria, a sum of $600 used for the purchase of tools for the postprimary school at Yirrkala, and (in 1969) a contribution, which he suggested and which was approved by the Yirrkala artists, toward the cost of the Yirrkala Aborigines' land-rights litigation. He said that since 1968 he has retained a small part of the profits as a contingency fund. Davidson's

methods of commissioning and purchasing are very popular with the artists at Yirrkala, and they look forward to his annual visits and the "bonus" they will receive from him. I observed that for several months before his arrival in June 1970 artists talked about Davidson's impending visit and their desire to complete work on barks and carvings specifically for him. They appeared to spend an appreciable amount of time, at an accelerated rate of production, trying to fulfill his commissions of the preceding year. Davidson reported, however, that only one artist had completed his commissions by the time of his visit in 1970.

Several missionaries and former missionaries felt that the anthropologists, linguists, and art collectors who had visited Yirrkala had been important in the development of marketing by providing stimulus both to quality (by praising good work to the artists) and to production (by purchasing). Others specifically named as significant in the growth of marketing were some of the first mining engineers to spend considerable time on the Gove Peninsula (in the 1950s), who not only purchased art for themselves, but also increased the scope, as well as the volume, of the demand by sending it to distant places. Davidson's exhibitions and lectures were also cited as significant factors in increasing demand.

Aesthetic and Commercial Values

Criteria used for determining the prices paid to artists were consistently listed, but not always in the same order, by missionaries who have been staff buyers at Yirrkala. They are as follows:

1. With respect to the quality of the object itself and the artist's workmanship: Is the bark or the carving without cracks or other flaws? Are the pigments good? Are they smoothly and evenly applied? Are the lines in the drawing uniform and even?

2. Does the bark painting "have a story?"

3. Will the painting or carving be aesthetically or decoratively pleasing to a white buyer?

4. What is the size of the bark or carving (and implicitly the amount of time or work that was expended in its production)?

Aboriginal artists have interpreted these criteria as indicating that, in general, whites want large bark paintings that tell "important stories"; these are often referred to as "sacred paintings." The interpretations of demand and value by the staff buyers and the artists are complementary, since it is only feasible to depict a major segment of a mythological saga, with the necessary actors, appurtenances, and appropriate geographic representations, on a large bark. In addition, buyers who commission large bark paintings are usually knowledgeable regarding the "stories" that individual artists, through their clan relationships, have the right to paint, and they request specific content on the basis of this knowledge. Painting to specific request accords well with Aboriginal values of appropriateness and reciprocity in the ritual sphere. Staff buyers at the mission have generally not specified content. Moreover, with respect to paintings not commissioned, the artists tend to believe that the amount they are paid for barks depends almost exclusively on size; when questioned,

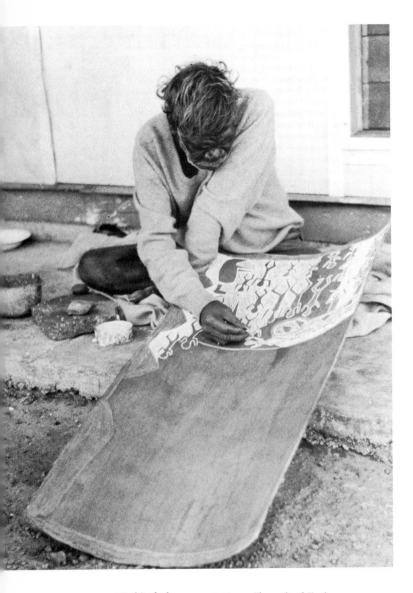

85. Yirrkala man painting a "large bark" of an "important story" commissioned by a dealer in aboriginal arts.

the artists calculated their past and anticipated income on the basis of bark size.

In addition to the category of large bark paintings (figure 85) that depict "important stories," Aborigines of medium- to large-sized paintings as "hunting scenes." "Hunting scene" has evolved as an appropriate English label for subject matter that has no restriction on its use by artists and distinguishes it from "sacred paintings," whose production is restricted. Hunting scenes contain at least one, and sometimes several, natural representations—human figures, animals, birds, trees. The arrangement of the figures may represent some aspect of hunting, gathering, or food preparation, and it is this that is translated to describe a "hunting scene." No painting, however, is contrived by an artist outside the framework of mythology and the conventional modes of its visual representation; no line is without symbolic meaning.

No Aboriginal term denotes art in the sense of *ars gratia artis,* and therefore no indigenous aesthetic canons apply specifically to such a category of art. Just as the role "artist" developed from white buyers' demands for the works of specific artists, "art" is what is sold and Aborigines' judgments of "art" are based on their interpretations of buyers' criteria.

Artists who have responded to their perception of the market for their paintings by producing large-scale representations of mythological sagas—whether "important stories" or "hunting scenes"—believe that paintings containing innovations in technique or media will be rejected. Those who have traveled to Australian capital cities and visited art galleries say that they have been advised

not to deviate from traditional techniques and media in their paintings. Some innovations, in fact, have depreciated the financial return to the innovators. Among these innovations were the addition of green to the traditional palette, realistic portrayal of facial features, and the printed name of the artist worked into the painting. The addition of signatures was an innovation suggested by a white collector in the late 1950s, enthusiastically adopted by a few artists, and reluctantly abandoned by at least one. Innovations unacceptable to white buyers have been overtly discouraged by staff buyers. In fact, however, certain features that white buyers recognize as innovation (and some that they do not) have come to be considered desirable.

Since the mid-1950s, some of the most successful artists at Yirrkala have visited cities where their works are sold in shops and displayed in galleries. These artists have persistently requested an increase in the amount of money they are paid by the mission buyer. They do not complain of the 25 per cent that the mission retains to cover its costs as art dealer and shipper—they feel that this is reasonable—but they do complain almost universally that they do not receive enough money for their work. One artist interviewed said that he received "good money" from selling his carvings, but that it was not adequate to meet his and his family's needs; this man was employed by the mission as an agricultural worker and received a regular wage from that employment. Artists frequently added that they receive less money now than when they first began to sell their work. Permanent sales records kept at the mission be-

ginning in 1965 were made available for my study; they indicate that the price paid to artists for large barks declined slightly during the period 1965–1969, but that for other categories it increased. During the last two months of this study (September-October 1970), the price paid to artists for all categories of art increased significantly. This increase appeared to be the result of several factors: recently decreased production (a smaller number of regularly producing artists and more irregular production), an increasing backlog of unfilled orders from shops and galleries in the capital cities, an increased local demand at the mission shop by employees of the nearby mining venture, and the direct sale by artists to these local purchasers.

Functions of Commercial Art: Traditional and Contemporary

Some artists have tended to carve exclusively, others to paint barks exclusively, and still others to produce both forms of art for sale. Since the introduction of marketing, some have tended to produce art regularly for sale, others less regularly. In 1964, between twenty and twenty-five artists at Yirrkala were regularly producing either bark paintings or carvings, or both, for sale, and ten less regularly. Four of these artists died between 1964 and 1970. In 1970, between ten and fifteen were regularly producing and selling art to the mission buyer, and another ten less regularly. Women began carving and painting barks for sale regularly in the early 1960s (figure 86); since that time five have continued more or less consistently to produce bark paintings for

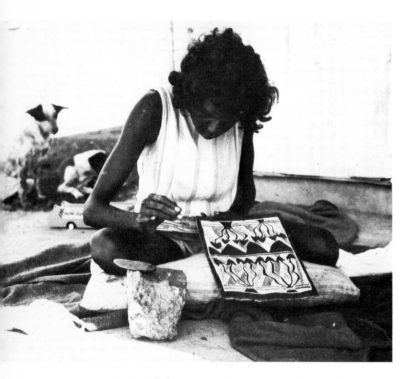

86. Yirrkala woman painting a small decorated bark that might qualify as "souvenir art."

All 10 of the bark painters interviewed gave the same two reasons for painting barks. The reason most gave first was to keep (or not to lose) the sacred stories and thus the laws given by the creator beings and hero ancestors that are recorded in these stories. As noted above, these stories not only record the charter of rights to land, but also prescribe the ritual means of regularly validating these rights. In relation to these lands, they also specify categories of rights to certain natural resources, including highly valued foods, and the means of obtaining and preparing these foods. Men frequently said that they kept completed bark paintings several days before selling them so that they could show them to their sons who were growing up and explain to them the stories and the meanings symbolized in the paintings.

Although the specific form and composition of bark paintings were innovations of the late 1930s, the subject matter itself has remained traditional. Thus, bark paintings now serve as an additional means of insuring that the stories and the knowledge that is embedded in them will be transmitted to future generations.

All the artists interviewed responded, in answer to direct questioning, that they would continue to paint barks even if they had full-time jobs at good wages; however, examination of sales records between 1965 and 1970 revealed that all those who have been employed since 1965 (either by the mission or by one of the firms associated with the mining venture) and who receive a regular wage, are no longer regularly producing bark paintings for sale.

The second reason for painting given by all

sale, and an additional six carve small figures and sell them regularly.

As of October 1970, three of these men selling art both regularly and less regularly were carvers exclusively, five produced both carvings and paintings, and the remainder produced paintings exclusively. Eleven of the artists then selling art regularly were interviewed; seven painted barks exclusively, one carved exclusively, and three produced both bark paintings and carvings.

those whose income was derived exclusively from bark painting was to earn enough money to provide food and clothing for themselves, their wives, and their children, although they said the money earned from selling bark paintings was not enough to provide adequately for these needs. The income from this source of artists selling regularly to the mission buyer during 1970 was A$20 to A$30 per week.

Art as a commercial enterprise at Yirrkala has some of the characteristics of a "cottage industry" or a "family business."[5] With the exception of the few women who paint small barks and who do all phases of the work themselves, older men in an extended family are always responsible for what is called in English "drawing" the picture. They take the bark after it has been prepared and outline the content of the finished bark (usually with yellow ochre). If paintings by members of a family have been reproduced in books or if photographs of them are in the possession of the family (both desired, especially the latter), then these are sometimes used as models, particularly if they are works of men who have gained repute as bark painters. Preceding the layout, there may be some discussion with other kinsmen regarding the figures to be shown, how they will be depicted in terms of posture or action, what symbols are necessary to the representation of the story, and how they are to be placed. Comments also may be volunteered by others present during the course of the drawing. More or less completely laid out, the barks may be turned over to other members of the family to complete. Some families appear to have a fairly formalized division of labor in the production of bark paintings, one or two men regularly drawing the pictures and one or two women completing the paintings. A member of the family, if sitting for some time with an artist, may pick up a brush and assist, either alone on a bark that is in the process of being painted, or on the same bark that the artist is working on.[6]

Beginning in the late 1950s, artists have been employed to teach children bark painting and carving in the school on the mission station. Thus, since that time the first experience in painting for both girls and boys has probably been at school when they are approximately from eight to ten years old. Young men about twenty years old can paint bodies, and do; but as of October 1970, no one this young was painting barks for sale.

DISCUSSION AND CONCLUSIONS

In discussing the relation between the commercial production of art and the process of acculturation, Graburn (1969b:13) has

[5]Art production as a family enterprise tends to be oriented toward the acquisition of sufficient cash to purchase hard goods—most notably, motor vehicles. This cash is accumulated by depositing it in the branch of the Commonwealth Savings Bank at Yirrkala. Artists working individually tend to spend most of their income on subsistence goods, although they may make contributions to a clan savings account for the purchase of a clan-owned vehicle, the most common target of group-oriented cash accumulation.

[6]Tuffin first noted more than one man working on a single bark about 1960; he associated this with the first demands for very large barks—as large as 3 by 25 feet.

proposed the use of four categories to provide a typology indicating the range of response to white contact in the production of art by non-Western peoples. The four categories are (1) functional (fine) arts: the principal symbols and functions are unchanged, but techniques and materials may be changed; (2) commercial (fine) arts: traditional technique, content, and aesthetic criteria are unchanged, but production is for commercial purposes; (3) souvenir arts: in which "the aesthetic impulse is subjugated to the profit motive by the limitations of time and in which the tastes of the buyers override those of the producers"; and (4) assimilated (fine) arts: the traditional art forms of the group dominant in the process of acculturation are used. The bark paintings and carvings currently being produced for sale at Yirrkala may be viewed as falling within the first three of these four categories, with minor qualifications.

1. *Functional (fine) art:* Large bark paintings of "important stories." (plate 8a) Even though innovative elements are commonly utilized in their production (steel axes and knives and sandpaper used in obtaining and preparing the sheets of bark, pipeclay mixed with water in a tin can, the commercially manufactured brushes sometimes used, and the specially prepared flattened sheets of bark themselves all constitute innovations[7]), bark paintings in this category represent fine art, following Graburn's definition. These bark paintings are valued by the artists and by other members of the artists' society. Since, in the terms set out

[7]Sheets of masonite have occasionally been used as a surface for painting. Paintings on masonite are not valued by buyers as highly as those on bark, and artists have been discouraged by staff buyers from using masonite.

above, they are innovations, they cannot be said precisely to fulfill a "traditional function." They are utilized, however, to reinforce and to enhance an important aspect of traditional culture and the values it expresses. In this sense, they constitute a contemporary art that performs a traditional function, and in providing cash income they serve a contemporary function as well. The media—the bark, the pigments—and the techniques of artistic execution are traditional. Used in the instruction of young men in important aspects of Aboriginal culture, these paintings appear to have become an adjunct to traditional means of instructing youths toward the goal of responsible adulthood as traditionally defined. A certain militancy is implied in the determination to succeed in this goal, despite the Australian government's official policy of assimilating Aborigines into white Australian society. The "important stories" depicted in bark paintings are referred to as statements of law, and aboriginal leaders at Yirrkala, in relating the stories, often concluded, "This law will stand for future generations!"

2. *Commercial (fine) art:* Large- and medium-sized barks depicting "hunting scenes"; some barks and carvings by frankly innovative artists; some larger, well-done carvings of animals and birds of more than minor totemic significance; some painted and incised didjeridoos. (plate 8c.)

Paintings in this category are produced in the same manner as those in the category "functional (fine) art." Size, content (functionally interdependent factors), and artists' secular interpretations of the stories they illustrate place them in the category "commer-

92. An ancestor figure whose facial tattoo has been carved and subsequently over-painted with black and white. His name is painted on his neck. This figure is in the house called *Te Whai-A-Te-Motu*, at Ruatahuna. The house was first built in 1888 and then refurbished in 1932. It is still used as a meeting house by the local people.

ufacture and no concert group can afford such an outlay. The obvious solution is to buy some heavy machine-made material and use the techniques and equipment available to any housewife to make the material into concert cloaks. Such cloaks are acceptable as entertainment costume but are considered inappropriate to drape over coffins or to use as ceremonial costumes for important persons.

There are many tasks associated with the decoration of a meetinghouse that do not require the constant attention of an expert. Local people are called upon to help paint the rafter patterns or to complete the stitches on decorative reed panels. The tasks are largely mechanical, as the patterns and color schemes have already been planned by experts.

In some meetinghouses, especially in the Maataatua canoe area (Ruatahuna, Waimana, Rautoki, Te Whaiti, Murupara, and toward the coast of Whakatane) some of the painted panels include examples of representative art—paintings of bird-snaring scenes, portraits, and depictions of the ancestral canoes and of different modes of transport.[12] Such

[12]Examples can be seen in the houses called Te-Whai-a-te-motu, Te Ngaawari, Tami-ki-Hikurangi, Kuramihirangi, and Ruaihona.

paintings, done with commercial house paints, were usually the work of some local artist whose "training" for art was, in the main, limited to art and craft lessons in the local primary school. Techniques of painting with water-color and tempera paints were taught at

93. In the late nineteenth century Maori artists incorporated naturalistic paintings into their meeting houses. Here is a hunting scene painted on the rafters of the house *Te Whai-A-Te-Motu*. The hunter is waiting for the birds to alight after which he will use a spear or a snare to capture the prey.

a most elementary level but were apparently sufficient to enable a talented folk artist to commemmorate some local event in oil-based paints for future generations to admire.

The purpose of the folk artist accorded with the generally held idea that a meetinghouse is a kind of museum and history book of the local tribe (see figures 92, 93, 94). Such paintings were thus conceived as forming an integral part of the decorative and commemorative scheme and were not regarded as quaint anomalies, as Pakeha viewers tend to view them.

Also coming within the category of folk arts are baskets and mats. Native baskets are necessary for carrying potatoes and other agricultural produce and are better than any mass-produced container for collecting shellfish from the sea. Women often use native kits rather than purses and handbags when they go to town or to large meetings. Baskets are made by folk craftswomen when they are required. Most superior baskets are made by women who are regarded as experts in the craft; there are several such experts in every tribal area. It is a matter of pride to go out with a superior basket made by a known expert.

The examples of folk art discussed above are usually produced by amateur artisans and usually require no payment for services other than food while the artisans work. There is nothing to stop a talented and ambitious person, however, from improving his skills to the point where his work is admired and desired by others. Then objects may be exchanged, work commissioned, and productions ultimately sold openly. By this time, the folk

artisan has upgraded himself to the position of a specialist and expert.

Recently, a heavy demand for native kits has come from the European sector of the population, complicating the cultural position of this artifact and its production. The native basket has become a New Zealand basket, highly valued by university students not only for the utilitarian task of carrying books but also as a mark of national identity. The producers are presented now with many more opportunities to commercialize the craft. Moreover, because of European and tourist interest, the craft has found new respectability and basket-makers are on demand to give demonstrations and to instruct European women. Basket making is thus quickly becoming a "craft" activity of the same order as pottery making among Pakeha craftsmen.

COMMERCIAL ARTS AND CRAFTS

As described by Graburn, commercial arts are those which "satisfy their creators and the other members of the artist's society, but which must also appeal to the buyers of 'primitive arts' around the world" (1969c:3). Thus the objects produced must have artistic and ethnographic value in order to attract the attention of overseas art buyers, some national value in order to attract the support of buyers from the dominant society, and some traditional value to attract native patronage. All the artifacts I have classed as traditionally based would meet these requirements, but it is doubtful whether Graburn would include

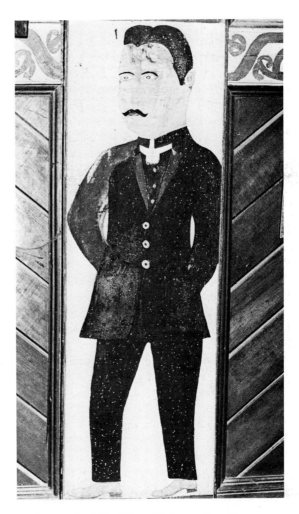

94. A portrait of Timi Kara (Sir James Carroll) a prominent Maori politician of the late nineteenth century, painted by Rehu Kereama of Ruatoki. There are two portraits of Sir James Carroll in the house called *Kuramihirangi* at Ruatoki, first opened in 1916. The Tuuhoe people of Ruatoki are reminded, even today, that this man played a part in the rape of Tuuhoe lands.

them under the heading commercial arts, by which he means traditionally based objects made especially for the primitive art market.

The situation in New Zealand differs somewhat from that of the Asmat area, where many art objects are made expressly to sell or that on the Polynesian island of Mangaia, where for several decades ceremonial adzes have been manufactured to sell to museum buyers. The Maori greenstone *tiki* or neck pendant would have qualified earlier as an example of commercial art, but at present the greenstone trade is firmly in the hands of Europeans. Groube (1967) pointed out that soon after contact with the Pakeha, Maori producers converted greenstone adze blades into tiki that collectors bought enthusiastically. Later, Germany became the center of production of greenstone objects, but now, by law, greenstone must be worked locally. All the master carvers in New Zealand are potential producers of commercial art. Some have carved pieces especially for museum collections and a few, no doubt, have sold examples of their work. One carver on the East Coast specialized in decorating gourds, which he made to sell.

The best examples of modern carving made expressly to sell to discriminating buyers are produced at Rotorua by students of the Institute of Maori Arts and Crafts, which was established by the government in 1936.[13] The Institute trains Maori youths in the techniques

of woodcarving, and much of their work is sold to the public by the Institute. In addition, the Institute undertakes, for a fee, the task of providing the carved slabs necessary for a meeting house.

There are several carvers at Rotorua who produce individual wood carvings of a high standard of workmenship to sell to interested buyers. The carvers adhere to their own standard of quality and demand a high fee for their art work. Objects produced by students of the Maori Arts and Crafts Institute are also of a high standard and must be approved by the master carver before being offered for sale. These objects come under the category of commercial art rather than tourist or airport art.

TOURIST ART

Included in the category of tourist art are the mass-produced objects that fill the shelves of gift shops in the towns, cities, shipping terminals, and airports. Such objects are produced by both Maori and Pakeha producers, but the bulk of the material is made by Pakeha "primitive artists." Wood carvings are small, generally sparsely decorated, and crudely carved. To a trained eye, the objects are obviously out of character compared with the genuine artifacts—that is, they do not look like Maori carving. Nevertheless, tourists buy them as mementos of their visit because they are cheap and easy to carry. There is considerable activity in tourist art directly linked with the increasing tourist trade of the country. Maori producers have no control

[13]Established under the Act entitled Rotorua Maori Arts and Crafts Institute Act 1963. Among other things, the institute was empowered to "engage in the business of creating, buying, or selling articles having a special significance in respect to Maori arts or crafts or relating to Maori life or culture."

over production and a very few have distributional control. As mentioned already, control is largely in the hands of Pakeha producers and entrepreneurs. The modern tourist thus has provided a powerful economic incentive that encourages many Pakeha craftsmen to turn to Maori art.

ASSIMILATED FINE ARTS

Assimilated fine arts are works done in the Western tradition by Maori artists. The artists meet the criterion of being "formally or informally trained by practising artists or even in art schools," as set forth by Graburn (1969c:5). Moreover, to a greater or lesser estent they try to maintain an "ethnic" identity. This is especially true of Fred Graham, Para Matchitt, and Arnold Wilson.[14] It is difficult to perceive any signs of "ethnic" identity in the works of Ralph Hotere and Selwyn Muru, whose paintings are marked by idiosyncratic distinctions rather than by cultural ones; that is to say, the artists are completely assimilated into the Western tradition of art. Any indications of Maori social heritage in their work appear to be consciously contrived and do not just happen unconsciously.

The significant point to consider, however, is that Maori artists have chosen to compete openly with Pakeha artists in the galleries of the dominant society. Their entry has been smooth, welcomed, and largely successful.

[14]Cf. Katarina Mataira's article (1968), in which she discusses and gives photographic examples of the work of Maori artists.

Their success parallels the success of other Maori individuals who have entered into the activities and vocations of the dominant society and bears witness to the national desire for racial equality in all spheres of New Zealand activity.

CONCLUSIONS

Maori art and craft is no longer the sole preserve of Maori artists and craftsmen, nor does such work meet only the needs of Maori people. The New Zealand population as a whole is gradually taking over more and more of the cultural heritage of the Maori in its quest to construct a distinctive national image. It is no surprise, then, to find Pakeha beauty queens donning Maori costume when they go overseas, or university students carrying their books in Maori baskets, or government officials wearing Maori cloaks. The application of Maori rock art to postage stamps, ash trays, and linen tea towels, and of rafter patterns to ceramics and interior decorations is now a common phenomenon. Everywhere, New Zealanders seem to be "Maori-fying" the artifacts they produce. The cultural climate in New Zealand at present is such that Maori art and craft objects are appreciated positively, not only for their aesthetic value but also for other reasons. Obviously, such objects can serve as distinctive cultural markers to distinguish the New Zealander from, say, the Australian: or, on a more pragmatic level, New Zealand objects can be distinguished from Australian objects in a gift shop.

A result of the prevailing attitude of good will is that a greater number of Pakeha New Zealanders are learning about Maori arts and crafts and, furthermore, are learning how to produce them. Production for the tourist trade is already dominated by Pakeha craftsmen, whose motivation is largely economic and has little to do with aesthetics and social value. Nevertheless, there are several Pakeha artists producing what has been classified here as commercial art, in particular, high-quality woodcarving and decorated gourds. Pakeha artists are thus able to find aesthetic satisfaction in Maori art and to build reputations on its production.

Maori artists and craftsmen are still able to build reputations by producing art work for Maori consumption only. For example, meetinghouses are still being constructed today. Into these structures goes the best work that Maori artists are capable of. Their work is seen by hundreds of people over a very long period of time, as long as a hundred years. Meetinghouses require superior floor mats, and the work of the women who produce them is also on show, but for a shorter period, about twenty years at the most. Since a very high value is placed upon such work by the Maori public, the artists tend to be well known among Maori people, although they may be completely unknown in the dominant society.

Some Maori artists, however, both men and women, have not confined their artistic activities to the Maori sphere, but are producing work in the Western tradition for the general consumption of the greater society. Reputations are built in open competition against Pakeha artists. Maori artists producing what has been termed here as assimilated art tend to be well known in the great society but virtually unknown in Maori society.

In short, there is no such thing as Maori art that is exclusive to Maori artists and there is no such art as Pakeha art that is exclusive to Pakeha artists. In fact, the terms Maori and Pakeha no longer indicate a clear dichotomy. Some individuals from Maori and Pakeha communities are crossing cultural boundaries in order to reach the kind of art they want to produce. Such mobility is possible largely because the dominant culture now sees cultural, aesthetic, national, and economic value in Maori art. This change of attitude is compatible with the national policy of racial equality, which is generally regarded as a euphemism for assimilation. Mixture, whether it be social, genetic, cultural, or aesthetic, is expected though not always approved.

The Maori population has valued its own art because it has wanted to maintain its cultural identity; the language and the arts have always been regarded as necessary to preserve Maoritanga. At the present time, the language is still spoken, the arts and crafts are still produced, and Maoritanga survives. Many modern Maori people believe in the principal of racial equality, but unless they can maintain a degree of separatism, Maori culture as such is doomed. As present developments in the arts indicate, it will become New Zealand culture, most of it gift-wrapped for the tourists.

PART VI/AFRICA

The African continent is home of some of the most powerful and vigorous art traditions of the world. Though long collected as curios by the colonizers, the appreciation of African arts for their aesthetic qualities did not come until the end of the nineteenth century. The enthusiasm then generated by avant-garde European artists has now passed on to avid collectors and millions of museum goers. It is West and Central African arts that are most striking to Europeans: the woodcarvings, masks, and other ceremonial paraphernalia that were often symbolic of tribal stratification (Fraser and Cole 1972). Though masks are displayed statically in exhibit halls of the Western world, it is probable that the costuming, mime, dance, and music that accompany their aboriginal uses have inspired awe and admiration that is part of what the Western world sees in African arts (Thompson 1974).

Bascom outlines the long history of African arts and European influences and identifies the processes that have accelerated pace of change in the twentieth century. Colonialism brought a demand for souvenirs along with the destruction, and collection, of many traditional African arts. More recently, tourism has accentuated the trend of collecting souvenirs and has brought with it new rules imposed by needs of instant recognition and portability. Initially, African arts were deemed to be of little value, or perhaps evil, by the Christian and Islamic powers. This in turn led to the abandonment of indigenous systems of apprenticeship and training, so that the newer arts are often produced in new organizations.

Christian and Islamic missionaries, along with their converts, caused the destruction of many African arts, among which was the making of graven or pagan idols. These art objects were often seen as symbols of tribal resistance to colonial or central government authorities and thus were sought out for banning or burning.

Biebuyck describes in some detail the original place of *bwami* carving in Lega society, and

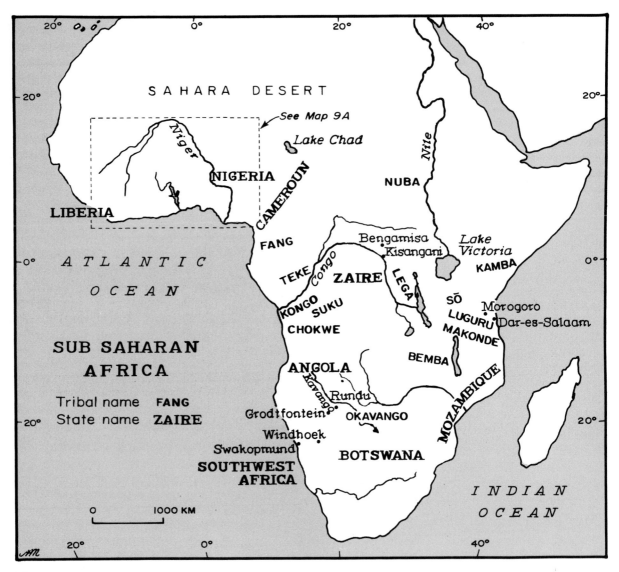

Map 9.

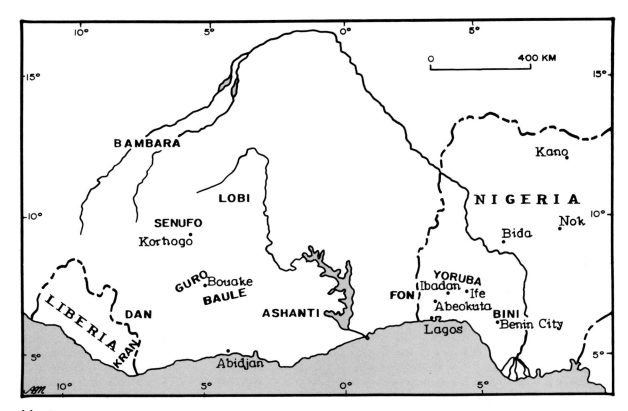

Map 9a.

documents the forces and consequences that led to its demise. When ivory hunting was banned, the sculptors turned to wood. Old sculptures were sometimes disposed of or sold to avoid detection by punitive colonial powers who were trying to outlaw *bwami*. Other ways to avoid detection were to substitute natural phenomena such as bones, or even non-Lega

artifacts such as European medicine bottles, for the *bwami* sculptures.

But Christian, Islamic, and European influences were not always detrimental. Many new synthetic traditions have arisen (Bravmann 1974). New lifestyles have en-

couraged new art traditions (Beier 1960, 1968) for African appreciation and use. Other art forms have been developed for tourists out of old traditions or even *de novo* as in the case of the Makonde of Tanzania (Stout 1966).

BEN-AMOS deals with another, more typical transformation of the traditional arts. After the *oba* and his court were overthrown by the British powers in Nigeria, the court art traditions faltered but never really died out. Modern Benin carvers usually work for the commercial market, though there is still some demand for traditional ritual purposes. The Bini now carve more naturalistic, eminently "African" objects, or even make practical crafts for their foreign buyers. Like other Africans in the tourist trade, they usually carve in ebony, a dark wood deemed more valuable by Europeans. For this new style, they have their own new standards, of which they are very proud, even if their art products may be down-graded by the antique-conscious market.

SANDELOWSKY describes a thoroughly colonial situation still obtaining in Southwest Africa. There, many of the artists are Chokwe immigrants from Angola and Zaïre. Most of the woodcarvers produce souvenir arts to the taste of local and South African visitors and sol-diers, modifying some of their traditional forms such as stools and drums or making copies of European items, such as angels, guns, spoons, and knives. In addition, they make some woodcrafts for themselves and are reluctant to sell them to any European who prefers "authentic" African carving.

But Africa, unlike North and South America, consists mainly of newly independent Third World nations. In these, some tribal traditions are perpetuated, or even elaborated, to become national arts, creating new national ethnicities (Kent 1973), sometimes to the detriment of the arts and symbols of competing tribal groups. Aboriginal arts and crafts may never have died out, or may be encouraged by being left with some degree of freedom within the pluralistic new nations (Fagg 1971; Gardi 1969; Newman 1974). The educated elites, after decades of willingly or unwillingly following the traditions of their colonizers, are now free to patronize their own new "ethnic" arts or *arts populaires* (Szombati-Fabian and **Fabian 1976). Africa itself has spawned new** training grounds for artists in old and new genres (Brown 1966). In spite of the pervasive feeling that old art forms are dying or merely being copied for sale (Crowley 1970), the arts still express the living power and vitality of the African people themselves.

17. Changing African Art

William Bascom

Changes in African art, like other changes in African culture, unquestionably predate European contact by many centuries. Not only are there tentatively dated changes in Benin and Ife sculpture (Fagg and List 1963: 32–38; Willett 1967;129–165), but there has also been the demise of Nok and Sao sculpture in terra cotta and of rock painting in South Africa and the Sahara (Willett 1971:43–77). Even if bronze and brass casting by the *cire perdue* technique was originally introduced from North Africa or the Middle East, as has been suggested, it has been completely diversified stylistically since its introduction from Liberia

William Bascom is Director of the Lowie Museum of Anthropology and Professor of Anthropology at the University of California, Berkeley. He was awarded his Ph.D. in anthropology from Northwestern University and is well known for four decades of research and publications on the culture, art, and folklore of the peoples of West Africa, especially the Yoruba. In addition, he has done research on Afro-American cultures of the Carribean and of North and South America and among the Micronesians of Ponape. He is perhaps best known for the *Handbook of West African Art* (with P. Gebauer, 1953), *Continuity and Change in African Cultures* (edited with M. Herskovits, 1959) and his monumental *Ifa Divination* (1969c), as well as for his *Yoruba of Southwestern Nigeria* (1969b) and his *African Art in Cultural Perspective* (1973).

to Cameroun, testifying to the fact of change in centuries past. Because there are marked stylistic differences between woodcarvings and brass casting in a number of groups, including the Ashanti, Fon, and Yoruba (Bascom 1969a:107–109), it seems unsafe to assume that this stylistic diversity in brass casting is simply the result of the adaptation of a new medium and new technique to previously established local stylistic standards. Moreover, the great diversity in the so-called tribal styles of African woodcarving (Fagg and Plass 1964:6–7; Bascom 1967:2) also argues convincingly for changes over many centuries.

Since the fifteenth century, when the Portuguese first explored the western coast of Africa, African artists have adapted glass beads, mirrors, paints and dyes, aluminum, brass and brass tacks, silk thread, cotton cloth, paper, and other European materials to their own purposes. Africans have also been quick to reflect the changing scene by depicting guns, pith helmets, bicycles, wrist watches, tobacco pipes, match boxes, tea kettles, and gin bottles in traditional genres (figure 95). In

95. Yoruba Gelede mask surmounted by a European motorcyclist (the District Officer) wearing a pith helmet. From Meko, Nigeria (60 cm. high).

Badagry in 1942, two Egungun masks were collected, one of an Englishman with a moustache and an exaggerated Caucasoid nose and the other of an African harlot. I never saw these two masks used in the traditional ceremony for which they were carved, but I was told that the performance was comic burlesque, with the Englishman in lively pursuit of the prostitute. This portrayal of European characters (Lips 1937), plus other newly introduced cultural elements, was not a new phenomenon, however. It dates back to the early days of contact, as documented by the representation of Portuguese soldiers and officials in the Benin bronzes (Forman and Dark 1960: Pls. 44–45; Fagg and List 1963: Pls. 41–42; Trowell 1954:34).

The colonial and precolonial periods saw the establishment of Christian missions, which contributed directly to the decline of African sculpture and, in some areas, to its disappearance. Large quantities of "heathen" sculptures were destroyed at the hands of or at the instigation of Christian missionaries. Woodcarvers and brass-casters lost their customers through conversion. And in the mission schools, which dominated education in Africa, students were taught to look down on their artistic heritage as evidence of the backwardness of their forefathers. "The African has been told so long and so often that his art is childish, ignorant, ugly, and grotesque, that he cannot be blamed for misjudging his own inheritance and thinking less highly of it than he ought to think" (Sadler 1935:9).

In some areas, African art has suffered equally, and over a much longer period, as the

result of the spread of Islam, which takes the First Commandment literally and prohibits all representations of humans and animals. Nor can all the blame be placed on outsiders. African arts have also suffered severely at the hands of nativistic and syncretistic cults of local origin. Shrines and religious carvings were destroyed by the followers of William Wade Harris in the Ivory Coast in 1914 and of Simon Kibangu in Zaire in the early 1920s, and more recently by members of the Atinga cult, which swept across Ghana and Dahomey, reaching western Nigeria in 1950, and of the Massa cult among the Senufo in the 1950s.

Prior to World War II, it was customary to proclaim the demise of African art, as the result of European contact. If it were not already dead, at least great sculptures were a thing of the past. In their early book on African sculpture, Guillaume and Munro said of the period immediately after 1907:

The small supply of genuine and important objects was soon exhausted; others came but slowly from remote tropical villages. For the art had long been dead in Africa, and only the ancestral heirlooms, centuries old and sacred, were to be desired. But enterprising manufacturers, there and in Europe, began counterfeiting them, and reaped a harvest from directors of provincial museums (1926:2).

Elsewhere [than Benin, with its "hybrid" art] the coming of the white man has meant the passing of the negro artist; behind him remains only an occasional uninspired craftsman dully imitating the art of his ancestors, chipping wood or ivory into a stiff, characterless image for the foreign trade. The art-producing negro, then, was the negro untouched by foreign influence (ibid:13).

Sir Michael Sadler saw the decay as due to the decline of traditional African religions, with which much African sculpture is intimately associated.

'The indigenous art of Africa is above all things stamped with the associations of religion.' In this fact lay its power. But the same fact explains its decay and is the presage of its doom. The tribal religions of West Africa cannot permanently survive the disintegrating acids of science or the impact of European and American teaching and example. In its traditional forms the genius of West Africa has expressed itself in many masterpieces, not to speak of the high level of its customary skill. But the axe has been laid at the root of the tree Thus the conditions which fostered the older art are passing away, and will not return. With them is passing the art which was sustained by the ancient tradition of ritual and worship The shadows are falling fast on what is best in West African art (1935:7, 8).

Nevertheless, Sadler strongly opposed the suggestion that programs to revive African sculpture be undertaken by the colonial government.

The arts of West Africa, the plastic arts, are by immemorial tradition bound up with forms of religious belief which should not receive renewed and emphatic recognition from Government, and with habits of mind which are so inimical to scientific observation and reasoning that (whatever be the kernel of truth which lies at the heart of them) they have forfeited all claim to support from progressive minds in a modern community. So long as the plastic arts are entangled with superstition, and so long as the allurement of those superstitions retains any measure of power, it would be against the public

interest to reinforce their obsolescent authority by an artistic propaganda, which, through the schools, might imprint on the minds of children a wrong conception of the validity of the claims of those superstitions upon their capacity for belief, and tempt them to the renewal of ritual habits from which their elders are shaking themselves free (1935:10).

Following World War II, the emphasis shifted to the regrettable effects of the tourist market; but the message was the same: great pieces of African art are no longer produced, and recent pieces are of no artistic value.

It is always interesting to speculate how great the influence of a foreign invader can be on the art of any country, and we have enough evidence from our own day to come to certain definite conclusions. In our own day, in Africa at least, the foreigner will have a very considerable influence through his choice and patronage. He will as a tourist (and in the old days the sailor and merchant adventurer must have played the same role), buy up everything which takes his fancy, and a market is then created in which the native craftsman will attempt to work to satisfy his patron's taste. As the patron will almost certainly have no understanding of the psychological approach to the art of a people other than his own, and will seldom have the artistic sensibility to appreciate formal values which are different from his own artistic tradition, such patronage will unfortunately often have a corrupting effect on local art forms. Work will be admired which most nearly approaches the criteria of the invader's own artistic idiom, or alternatively which is considered crude and quaint. If the demand is great, mass production will set in, and within a very short time the work will have lost all artistic value. We can see this happening all over Africa, especially in centers where air travel brings a large flow of passing tourists for night stops Local art is affected by the foreigner in three ways: it may be affected by the introduction of fresh techniques and materials; its form of expression may be altered by the adoption of new idioms or the turning out of new types of applied art; or, most fundamental of all, its whole content of ideas may be changed (Trowell 1954:32–33).

The carvings which were produced after this cultural conquest reflect such changes. They no longer have the homogenity [sic] of style and workmanship which characterized the old work. European art-teaching and European artifacts caused a demand for naturalistic work; a tourist trade created a chaos of mechanical or meretricious ornaments. There are still talented African carvers, but the great tradition of African carving now lies in the past (Segy 1958:32).

The negro artist has found new patrons, to whose taste he is bound to conform. Where formerly it was the secret societies, priests and kings who assured his existence, today his customers are largely to be found amongst town-dwellers and missionaries, White settlers and tourists. In the hope of rapid and easy gain, the negro complies with their wishes. Thus there have arisen in the larger towns busy artisan workshops, producing *en masse* furniture, implements, ivory carvings and brass castings for the souvenir market If tourists want masks and sculptures, then they shall have them, as many as they wish! But what is produced is of most questionable value: works without any cultural roots or artistic content; elegant, perhaps, and ingenious, but at the same time plain, mannered, and empty (Leuzinger 1960:209).

Officials, merchants and especially ethnologists have still been able to discover ancient

pieces during the last few years. However, their limited number and their relatively high price, indicates that the African source is practically dried up This art has degenerated and veritable studios have been opened to meet the demand of tourists. All that was good in African sculpture has disappeared in these examples conceived solely for sale But the sculptures in which European influence is apparent are generally ugly and all sense of rhythm has disappeared. These are figures in European costume, painted in chemical colours and provided with a helmet, walking stick or a gun; the white wood is waxed or engraved with a red-hot iron. Contemporary works are far from having the same value as the older ones which were made at leisure, without any consideration for monetary profit (Paulme 1962:149–150).

Figures and masks rooted purely in tribal traditions, inspired by a spiritual ethos, and made by real artists have become rare The market is flooded with masks and figures made exclusively for Western (bad) taste and with fakes manufactured in Europe The negro sculptor who has succumbed to fashion has either become a kind of skilled worker at the conveyorbelt or is to a greater or lesser extent producing fakes. He will make figures and masks on demand; if necessary, those of other tribes. He is by nature a deft, able craftsman but his art is blunted by the increased demand and his products bear witness to this (Sannes 1970:19–20).

Paulme's comments are in a chapter that follows an earlier one by Segy (1952:134–154) on "The Collector's Point of View," including his sections on "Rarity of Antique Pieces" and "How to Recognize a Genuine Old Carving." Paulme's curious conception of the African carver or caster as totally unconcerned with

economic rewards, suggesting the European painter in his attic, need not concern us here. What is relevant is the continued repetition of the dictum that great African art belongs to the remote past. Recent African art has no merit because it has been contaminated through European contact.

We will return to this point later, but the absence of guns and pith helmets is no measure of sculptural quality. Bicycles have been depicted in Yoruba carvings since the 1890s (Fagg and List 1963:pl.93), and European paints have been used on them for at least a century (Willett 1971:87). There is also direct evidence of European contact in the mirrors on Kongo charm figures and in the Portuguese characters and costumes in Benin bronzes. In fact, because they are in wood, we must assume that most of the masterpieces of African sculpture have been produced during the period of contact.

Nevertheless, it is obvious that African art is changing rapidly under the pressures of acculturation. Although changes have been going on for centuries, the pace of change seems to have heightened dramatically during the past century, following the partition of Africa and the establishment of colonial rule. African religions, which supported much of African art, have been undermined by proselytism and Western education. Royal patronage of the arts has decreased drastically with the political developments of the colonial and postcolonial periods. Weaving, pottery, basketry, metalworking, and even woodcarving have had to compete with the flood of plastics and other factory-made goods imported from abroad. Africans have found new occupations in edu-

cation, commerce, and government, and they have been moving to the large urban centers by the millions. They have been taught to despise, or at least disparage, the baskets, calabashes, and clay pots of their forefathers, and the masks and figures that have brought world renown to African art. Meanwhile, because of the demand of Europeans for their work, African artists have been producing for new patrons on an ever-increasing scale.

Although it is not possible to treat the results of these changes in any historical sequence because, even if they could be established, the critical dates differed from one part of the continent to another, many of the changes in African art can be partially documented. Over the past 35 years, I have observed some of these changes. It is my hope that even an incomplete listing will invite more detailed investigations by others.

At least it should be worthwhile to see whether it is possible to be more specific about the nature of the changes that have resulted from the "corrupting" effects of the tastes of the African artists' new patrons. Can we say only that the results are plain, mannered, empty; stiff, characterless; crude, quaint; deficient in homogeneity and workmanship; ugly and lacking all sense of rhythm? And how do the results relate to tourist tastes and approach the criteria of the new patrons' own artistic idiom?

TOURIST ART

One very obvious change has been the great expansion of "tourist art," particularly since World War II. As royal patronage declined and as African artists lost their customers through conversion to the newly introduced or newly developed religions, they began producing for Europeans.

Prior to World War II, most expatriates were attached to the colonial governments, commerce, mining, and the missions, and there was no real tourism in West Africa. What is now known as tourist art was sold as souvenirs by African traders who went from door to door, displaying their wares for sale at European homes, government rest houses, or local markets. Today, with improved accommodations for tourists and increasing travel to Africa, they also sell at hotels and airports. The trade in what has now been called "airport art" has grown to considerable proportions.

> In the center of Abidjan, capital of the Ivory Coast republic, is the "marché des antiquités." A dozen Sengalese traders are each offering hundreds of masks and figures and metalwork. Their displays are of quite a heterogeneous nature. Most of the objects are imitations of traditional sculptures. The Senufo and Baule send the bulk of these objects, whilst other carving tribes, like the Guro and Guere, are as yet scarcely represented. Some of this "merchandise" is probably even manufactured in Abidjan. If one looks behind the boutiques of the dealers, one can see their sons busily blackening brand new objects in the bark-and-mud process. (Himmelheber 1967a:192; photo, Goldwater 1964:119; and Crowley 1970:45.)

There are many who disdain tourist art and deplore its rapid growth. Certainly it is not of comparable cultural significance or aesthetic quality to traditional African art, although its aesthetic quality varies considerably. As one

who is interested in both continuity and change in African cultures, I have long maintained that it represents an important opportunity for studying changing art styles (Bascom and Gebauer 1953:40–43). As I have pointed out, some of the best known American Indian artists produced for the tourist market (Bascom 1969a:116–117). Regardless of any aesthetic considerations, it is a cultural phenomenon worthy of study, is of considerable economic importance to those who make it and sell it, and is even of some importance to the national economies (Himmelheber 1967a:196; Keller 1967:28–31; Crowley 1970:48).

William Fagg, a staunch critic of African tourist art, has devoted extensive study and a book to Afro-Portuguese ivories, which were carved for the Portuguese, probably in the sixteenth century (Fagg and Forman n.d.). African tourist art is not, as is sometimes thought, a product of the twentieth century. Although we may never be able to date its beginnings precisely, it obviously goes back to the early days of European contact.

Innovations

One result of producing for Europeans has been a shift from objects for African religious, state, and secular uses to those that were useful from the point of view of the new customers. There had been three broad categories of traditional African sculpture: (1) religious objects, which were the most numerous; (2) court objects, which supported and glorified the status of chiefs and kings; and (3) a variety of secular items, ranging from weavers' pulleys to decorated spoons and combs (Bascom 1967:6). From the early European point of view, all these were but curios, and, as the Afro-Portuguese ivory hunting horns, saltcellars, forks, and spoons demonstrate, African artists soon began producing things that had practical uses for Europeans.

If one took the time, one could probably find instances of the continued emphasis on the practical in many parts of the continent. I will cite only two examples. By 1938, as recorded in the June issue of the magazine *Nigeria*, the metal-workers of Kano and Bida in northern Nigeria were producing brass and silver trays, ash trays, finger bowls, and flower bowls. Secondly, in the same issue of *Nigeria* there was a call for the rehabilitation of the great brass-casting industry of Benin, noting that during the previous few years it had "received so little encouragement that most of the craftsmen have taken to other occupations." Apparently, sometime within the next four years it was revivified under the sponsorship of Nigeria's Forestry Department, which had also established a small shop in Lagos for the sale of Bini brasses and a variety of Nigerian crafts of a practical nature, including table mats, purses, and scrub brushes.

Following what I have called the postwar "rediscovery of African art," when traditional genres were more widely appreciated by visitors to Africa, there have been other attempts by outsiders to revive or sustain traditional arts, some of which might not have been to Sir Michael Sadler's liking. Woodcarving in the grasslands style was revived by a Peace Corps group in the Cameroun, as illustrated by a stool purchased in 1968 at an import house in San Francisco (figure 96) I do not know how long this revival lasted. Another Peace Corps

96. Cameroun stool produced for export, 1968
(48 cm. high).

group encouraged the adaptation of Yoruba tie-dyeing to sport shirts and other garments for expatriates. Moreover, they were able to induce Yoruba women to use imported dyes of various colors. Yoruba weavers have long been using thread dyed locally with European dyes; in 1937–1938, I tried to persuade a tie-dyer in Ife to use them, but she conservatively refused to use anything but the traditional indigo. This Peace Corps venture has been highly successful, and has been repeated elsewhere in West Africa.

A Ghanaian artist was commissioned to carve the elaborate State Chair of Ghana for Kwame Nkrumah; and in 1956, one of Father Kevin Carroll's carvers, Lamidi Fakeye, was given contracts to carve thrones, chairs, and doors for the House of Assembly and the House of Chiefs in Ibadan. Starting in 1947, Father Carroll began employing Yoruba artists to produce pieces for use by the Catholic Church. Of all the changes in African art, this is the best documented, particularly concerning the work of three Yoruba woodcarvers, although weavers, leatherworkers, and bead-workers were also employed (Carroll 1967). A similar project, on a smaller scale and employing Baule carvers, was undertaken before 1962 at the Benedictine monastery at Bouake in the Ivory Coast, and there may be comparable instances elsewhere.

Employing the skills of African artists for the purposes of church and state represents a continuation of two traditional functions of African art, although the church and state have changed. Again, this is nothing new. We do not know the circumstances under which they were produced, but a number of crucifixes were cast in brass on the lower Congo River for the Portuguese, probably in the sixteenth century (Segy 1952, fig. 6).

New creations are currently being produced at the Mbari Mbayo center at Oshogbo, Nigeria, where artists are working with beads glued on wood, and in cement, tin sheet, brass, paint, and pen and ink. An excellent review of this and other art centers in Africa has been published by Beier (1968).

Other new genres of African art have been developed in response to the suggestion and encouragement of Europeans, as in the case of the naturalistic human and animal carvings and salad-servers of the Kamba (Elkan 1958) and their imitations as far south as Zambia (Keller 1967:49). One Zambian carver who departed from this style produced grotesque figures with protruding stomachs and breasts, bullet heads, and protruding eyes, after having been given a picture by a curio dealer of Suku figures to copy (Keller 1967:51).

Rattray (1927:274) noted that the Ashanti began to carve more naturalistic figures, including groups of drummers, when he commissioned them to do so for the British Empire Exhibition at Wembley in 1924. They produced nearly a hundred figures, "and vied with each other in making every detail of the figures and their dress as accurate as possible."[1] Such figures were still being produced in the 1940s by art teachers at the Achimota school.

[1] I wish to correct the statement by Crowley (1970:47) that *mmoatia* and *asasobonsam* spirits were "never previously represented in Ashanti sculpture." I acquired a carving of the former, with its feet turned backward, and several of the latter during World War II, and while I was in Ghana at that time a brass or bronze *asasabonsam* was excavated in the course of gold-mining operations. Rattray (1927:27, Fig. 19) illustrates carvings of both, and separates these from his carvings for Wembley.

Similarly, Labouret (1931:188, 1. 16:4–6) recorded that he instructed a Lobi carver to copy a Baule mask and that subsequently he and his pupils produced them for export. Since the Lobi have no specialists in carving, according to Labouret, the works of this group of unnamed carvers are easy to identify. Even though he describes them as *"maladroitement exécutées et du valeur artistisque nulle,"* an example is included by Kjersmeier (1935–1938, I:28, pl. 37). During World War II, I purchased two of these masks in Ghana. Later, in a Paris shop, I found a Lobi figure that was obviously made and used for ritual purposes and that came from the same small school of Lobi carvers (Robbins 1966:No. 37). Recently, in a Berkeley garage sale, Mrs. Bascom found a Lobi "shoulder baton" from the same school, almost identical to the one illustrated by Leiris and Delange (1968:380). Opinions of the merit of the works of these carvers obviously differ, as they do about that of Lobi arts in general (Paulme, 1962:67). Labouret's artists, however, carved for traditional customers as well as for the tourist market, as many other African carvers must have done (Himmelheber 1967a:194).

The ebony-carvers of Benin are discussed by Paula Ben-Amos in Chapter 18 below. By 1938, at least two of these, H. I. Erhabor and Igbolovia Ida, were established in Lagos, far from their traditional market, producing decorated furniture and other carvings. By 1942, there were several houses of Bini carvers in Lagos fashioning ebony bookends and letter-openers—both obviously practical and of European origin—in addition to male and female busts of ebony, and mahogany plaques and tables. Neither ebony nor mahogany were traditionally used for carving, but both were more highly prized by Europeans and brought higher prices than work in commoner woods. The ebony that was used was attractively marked with brown streaks, but these were carefully concealed with commercial black shoe polish.

During World War II, the American Army PX's contracted with these Bini carvers for large quantities of ebony pieces to sell to troops at American bases in West and North Africa. Assistants and apprentices did the initial roughing out, and, if they had time, the master carvers added the finishing touches. With large orders to be filled and firm delivery dates to be met, the results were not difficult to anticipate; the quality of the workmanship deteriorated and thousands of crudely carved ebony busts and book ends were presumably brought home by American servicemen.

Workmanship

Such shoddy workmanship is often a result of carving for the tourist market, where the emphasis is on volume. It is to be seen, for example, in many of the Senufo carvings produced on a large scale at Korhogo (Goldwater 1964: pls. 178–182), and in many recent Yoruba carvings from Abeokuta. Tourist art has been increasingly mass produced and sometimes approaches what Sannes described as "conveyor-belt" production, although this apparently does not always result in shoddiness. "The non-traditional so-called 'Kamba carvings from Kenya,' as often made by Makonde and Luguru in huge production-line

factories in Dar es Salaam and Morogoro, Tanzania, are as alike as if produced in a mold. Yet each piece is completely handcrafted—one man does the blocking-out, and another the head, another ears and feet, another the finishing, and still another adds the ivory, leather, or wire adornments" (Crowley 1970:47).

Tourist art is usually produced in advance, whereas most traditional African sculpture was individually commissioned by the ultimate owner. If tourist art is commissioned, it is in quantity and by a middleman, whether he be an African trader, PX officer, exporter, or the owner of a local curio shop. The artist's ultimate customers are not merely strangers; they are foreigners, not even members of his own ethnic group. The tourist market is highly impersonal, and since most tourist art is sold through middlemen, an artist may never even see his customer. As long as the sale is made, the artist need have no concern for the customer's opinion of his workmanship, because it cannot affect his reputation. A tourist may search for well-carved pieces but have to settle for shoddy ones, perhaps persuading himself that they are typical of the local workmanship. Not all tourist art is of poor quality, to be sure, but we can be certain that shoddy work does sell, because it is still being produced.

Tourist Tastes

Whether they are good or bad, tourist tastes have an effect on the work of African artists; indeed, it would seem that some artists aim at their lowest common denominator. It may not be necessary for the artists' actual survival, but if Europeans do not buy their work, they may not be able to continue as artists. The results are evident in the works themselves. Beatrice Sandelowsky has recorded a revealing statement by an African carver about the very empirical manner in which "We try to find out what people want to buy and then we make it" (chapter 20 below). Trowell, Leuzinger, Sannes, and others have concluded that the results are inevitable. But what are the results of tourist patronage, and how do these results relate to tourist tastes? Europeans' preference for valuable over common woods, and their desire for things that they can put to some use have already been noted. In addition, I believe that three stylistic trends are evident that reflect tourist tastes (Bascom 1967:9).

The first of these is a trend toward naturalism. Bonnie Keller believes that the Zambian animal carvings developed from the animal figures on wooden pot lids. Although she does not attempt an answer, she adds, "The problem for an expert in primitive art, however, is to account for the change in style of carving from the impressionistic type of animals which decorate wooden pots to the ultra-realistic type of animal carvings now popular" (Keller 1967:49). Other examples of this naturalistic trend are to be found in the Kamba human and animal carvings and in the Ashanti figures commissioned by Rattray.

This obvious concession to nineteenth-century European taste has meant the complete abandonment of stylization, the primary characteristic of most traditional African sculpture (Bascom 1967:1, 9). It was the de-

parture from the realistic portrayal of nature in African carvings that first appealed to the artists of Europe, who were seeking to escape from stereotyped standards of naturalism of the Academy of France. These artists, however, were far ahead of the public; four decades later Fagg (1951:3) could say, "There can be no doubt that the very great majority of Europeans judge works of art in the first place by whether they are lifelike." Thus, it is not surprising that the first African sculptures to be appreciated by the public were in the relatively naturalistic styles of Benin, Baule, and Fang, or that many European and American tourists still prefer naturalistic pieces. It was only as Western canons of art were liberalized, particularly after the acceptance of German expressionism, that more forceful African art styles became accepted.

The second trend, in a quite different direction, is toward the grotesque. Despite their obvious creativity, the new Makonde carvings represent one example (see figure 6), and the Zambian carver who copied Suku figures from a curio dealer's photograph provides another. Grotesque tourist carvings are not meant to inspire awe, as in traditional masks and figures, but to please tourist tastes. These may reflect both European preconceptions about the savagery or strength of African sculpture as well as the influence of German expressionism on European artistic tastes. Some Europeans today find Baule carvings so "sweet" as to border on banality.

A third trend in tourist art is gigantism. It has been traditional for artists to charge more for larger pieces, just as they did for those that were more complex, more carefully finished, or more creative. The greater his economic return, the more time and thought an artist was willing to devote to his task. Size is also a factor determining the price that collectors pay for African art. Smaller pieces such as loom pulleys, combs, and even small figurines are not "major" works of art and a dealer may stress the point that a mask has "scale" as well as that it has "good age." Some of the items made for the tourist market are so large that they would be difficult to use for their traditional purposes. For example, Yoruba carvers at Abeokuta have been reproducing the bells or tappers used in Ifa divination, which are normally from eight to sixteen inches long and about an inch in diameter, in versions that are three feet long and three inches in diameter (figure 97).

Fakes and Antiquities

A final new development in African art is faking. This is variously defined, but in my view it involves the misrepresentation of the age or authenticity of objects for sale; and, although it is quite different, it is not always easily distinguishable from the sale of reproductions of traditional genres. The question, as I see it, is how art objects are offered for sale. Copies of Benin and Ife heads have been bought in Lagos and elsewhere in the hope, at least, that they might be real antiquities. Fortunately, most recent Bini brass castings are so crudely produced that there should have been little trouble in avoiding this mistake. It is more difficult to detect wooden sculptures that have been artificially aged, it is said, by burying them in termite hills (Bascom 1967:9; Crowley 1970:48).

With a better knowledge of African cultures

97. New and old Ifa divination bells. Left (88 cm.), from Abeokuta, Nigeria. Center and right (29 cm. and 28 cm.) from Igana, Nigeria, 1938. (Collection: Lowie Museum of Anthropology.)

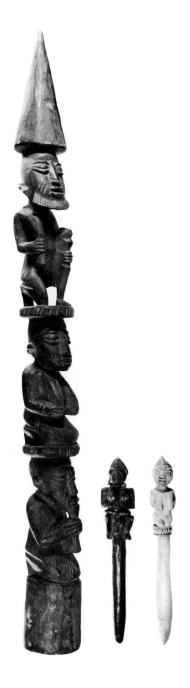

and the fashion of collecting African art, the demand for traditional pieces also grew in Europe and America. So the African carvers and their middlemen faced the temptation of making new pieces into old ones—and they succumbed to it. Since about the mid-1950s there has been the faking of art in Africa, in the true sense and on a large scale. Apparently fewer carvers than traders give the carvings an old appearance. I have not yet personally had the opportunity to observe the methods employed, but it is not difficult to understand that they would hide them. Moisture, sand abrasion, and insect damage alter the surface in the desired manner. Afterward, one often sees them buried in mud (Himmelheber 1967b:21–23).

A beginning has been made in penetrating the mask of anonymity that conceals the identity of African artists, but the admittedly great sculptures of the past remain the work of unknown carvers and casters. Therefore, the faking of African art cannot be explained by a desire to reproduce the expensive works of famous artists. It can be explained only by the continued repetition of the dictum that great African art belongs to the past. Recent pieces have no value, monetary or otherwise, and new creations do not merit study, or even consideration. Antiquity has become one of the most important determinants of the market value of African art. There are other considerations, of course, such as sculptural qua-

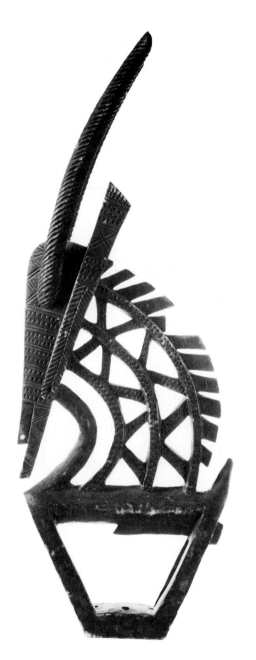

lity, stylistic fidelity, the preferences of individual collectors, rarity, size, the value of the media (e.g., bronze, ivory, ebony), perfect "mint condition," heavy weathering, and patination. Both of these last two factors are indications of age. What may be called a "cult of antiquity" has developed that is largely responsible both for faking and for the passage of antiquities legislation in many African countries.

Anthropologists and art historians have contributed by disparaging individual pieces as not "authentic" if they have not been used. A piece may have been carved many years ago, but if it was never used, perhaps because the customer who commissioned it died unexpectedly, it is not "authentic," just as an object lacks power in the eyes of the African believer if it has not been sanctified by herbs or sacrifices. But even if the ingredients of power have been removed—from a Teke charm figure for example—it remains "authentic" because it has been ritually used. The result is the faking of patination and other evidence of use. Some contemporary carvers have learned that certain masks should have holes by which they could be fastened to a costume, and that Bambara antelope headpieces bring higher prices if they are attached to basketry caps.

Replicas of traditional carvings, commissioned from recognized artists and made in conformity with traditional stylistic

98. Bambara headpiece (*tyiwara*) 1965 (70 cm. high).

99. Dahomean applique cloth, depicting an elephant hunt, 1965. (115 cm. x 165 cm.).

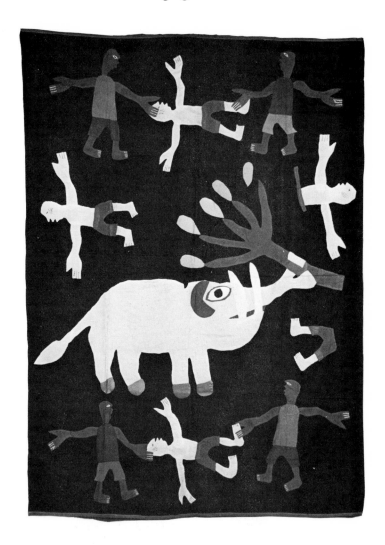

standards, are of little monetary value compared to those that may have been damaged by use (Schwab 1947: Fig. 72b; Bascom 1967: Nos. 108–110; Bascom 1969a: pl. 73; Bascom 1969b:105). For the study of African art, however, stylistic fidelity is certainly more important than use, the work of a known artist of repute is more important than that of an anonymous one of comparable ability, and in many cases the date of a carving is more important than its age.

Redeeming Features

Despite these often regrettable developments, tourist art does have redeeming features. Some genres are being produced that are fairly faithful to traditional styles, like the Cameroun carvings sponsored by the Peace Corps (see figure 96), Dahomean appliquéd cloths (figure 99), and some of the Bambara antelope headpieces, which have long been favorites with European and American connoisseurs and were being produced in quantity for the tourist market in 1965 (figure 98).

There have also been creative innovations, which are important for an understanding of change. The Yoruba thorn carvings, first created by J. D. Akeredolu, depart from tradition in that they are carved with a pocket knife, in a new medium, on a miniature scale, and with remarkable realism (Bascom and Gebauer 1953). They have proved so popular with European visitors to Nigeria that in 1965 scores of school boys were carving thorn figures, using thorns of different colors to give them even greater realism.

Another example of innovation for the

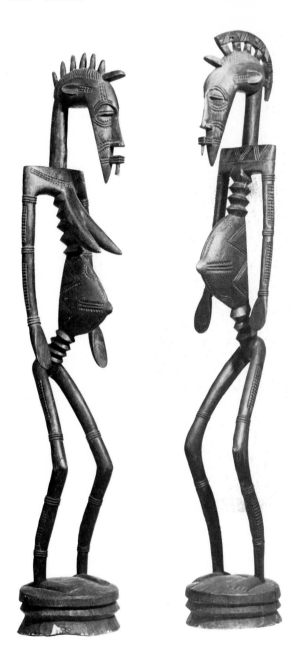

tourist market is afforded by the so-called "caricatures" of the late Thomas Ona. He carved small figures of missionaries, polo players, district officers, and Yoruba kings, coloring them with imported inks (Bascom 1957a, 1957b). Although they exaggerated the physical differences between Europeans and Africans, they were not intended as satires. Not unlike the Benin bronzes, they were representations of the contemporary scene that he had observed in his lifetime.

The new style of Makonde carving, which has become popular amongst some segments of the European market, has flourished in Tanzania in recent years; although I do not personally fancy it, it clearly displays creative imagination. Senufo carvers have also been especially creative, as evidenced by a striking new form of male and female figures that appeared on the market at Abidjan between 1963 and 1965 (figure 100). As Himmelheber says:

The bulk of these modern Senufo sculptures is hurriedly made, for experience shows that they are paid by numbers, not by quality. However, a few carvers, real artists, seem to see an opportunity in this nouveau art. Working for an unknown customer of a foreign race frees them from the obligation of holding to the traditional tribal style and to fixed peculiarities of specific types of masks or figures. So we find carvings, usually statues of bigger size, which show new, personal styles, although still recognizably Senufo. It seems that the artist then

100. Senufo male and female figurines, 1965 (112 cm. high).

works for a number of years in this his new style, for one encounters dozens of his figures in the coastal cities, until one year they suddenly disappear. Most of these new personal styles are weaker than the traditional Senufo style, but some show real artistic ingenuity. Then, though rarely, one encounters a single outstanding work of art, as one I recently saw on the Abidjan *marché des antiquités,* which might well have been a Barlach. Senufo art thus proves that we should not condemn this wholesale new "Airport Art" (1967a:196).

Not all African artists have become involved in the tourist market. In some areas they have continued to produce only for their traditional customers and patrons; but even here there has often been a decline in quality. Because of the introduction of schooling and the attraction of higher incomes in other occupations, many African artists have found it increasingly difficult to find capable apprentices to carry on their work (Bascom 1967:8).

Undoubtedly there are individual artists whose work lost its inspiration or became less skillful as a result of working for Europeans or producing for the tourist market (Fagg 1955–1956:52). But it would be an oversimplification to blame the decline of African art on the commercialism of tourist art. It is also an oversimplification to reject all tourist art as lacking aesthetic merit. Some of the effects of producing for European customers date back to the early period of Portuguese domination and relate to the Benin bronzes, the first African sculpture to win European recognition as art and among those most highly prized in the world market today.

SUMMARY

In summary, we can safely assume that African arts have been changing since long before the Portuguese explored the coast of Africa and that many masterpieces were produced in the centuries since their arrival. We can be certain that from the initial period of European contact African artists were quick to depict the changing scene and to adapt new media to their purposes. African arts have markedly declined, and in some areas have disappeared, partly as the result of the influence of Christianity, Islam, and local nativistic religious cults. All three have led to the actual destruction of religious sculpture, to the loss of the artists' customers through conversion, and to the acceptance of the idea that these sculptures were a shameful heritage of heathen barbarism. Royal patronage of the arts has decreased as a result of shifts in political power, and social and economic changes have also had their effects.

African tourist art, which goes back to the period of Portuguese domination, has developed on a large scale since World War II. It has resulted in the use of new media, an emphasis on the practical (from the tourists' point of view), shoddiness, faking, naturalism, grotesqueness, and gigantism. It has also led, however, to the revival or continuation of some arts that are faithful to traditional styles and genres. In addition, new genres have been created, both in response to expatriate stimulation and through the creativity of individual African artists working for new African patrons.

18. "A la Recherche du Temps Perdu": On Being an Ebony-Carver in Benin

Paula Ben-Amos

The kingdom of Benin has been an important political and artistic center since at least the twelfth or thirteenth century. In the fifteenth and sixteenth centuries, Benin enjoyed a period of great military expansion, owing in part to its role as one of the centers of early West African trade with the European world. The kingdom's fortunes declined somewhat in the seventeenth and eighteenth centuries and it fell to the British in 1897.[1]

At its height, the Benin kingdom stretched over a large area, encompassing much of midwestern Nigeria and even reaching the borders of Dahomey. Presently, the Bini people are concentrated in and around Benin City, the capital of the Mid-West State. Benin City was also the traditional administrative and religious center of the empire. Its importance stemmed from the fact that it was the home of the divine king (Oba) and a large court-oriented population of nobility, retainers, ritual specialists, and craftsmen, all dedicated to serving the king.[2]

Traditionally, there were two formal organizations of carvers in Benin City: the patrilineal carvers' guild (Igbesanmwan) and the royal pages (Omada). These two groups differed considerably in their approach to sculpture. Igbesanmwan was a guild much like those of medieval Europe. The members lived in a special ward of the city next to the quarters of the smiths and woodworkers. Theoretically, the guild was a closed corpora-

Paula Girschick Ben-Amos received her Ph.D. in anthropology from Indiana University, and is currently Associate Professor at the Tyler School of Art, Temple University, Philadelphia. She has carried out research in Nigeria in the past decade and is well known for her papers on the arts, especially her "Pidgin Languages and Tourist Arts" (1973) and her "Professionals and Amateurs in Benin Court Carving" (1975). She is, in addition, editor of the series *Working Papers in Traditional Arts*.

[1]This paper is based on research carried out in Benin City in 1966 under a grant from the Foreign Area Fellowship Program and again in 1975. I would like to thank Rebecca Agheyisi, Robinson Ahanon, Elizabeth Akenzua, and Solomon Amadasu for their help at various stages of the project.

[2]The material in this section is drawn from several sources: Bradbury (1959; 1964; 1967), Connah (1967), and Egharevba (1960).

tion with a monopoly on carving; the punishment for anyone caught carving outside the guild was death.

In spite of the fact that members of Igbesanmwan owned and worked farms, carving was considered their prime occupation and raison d'être. Igbesanmwan members felt that knowledge of their craft was "in their blood" and that all their work was inspired by their patron deity, Ugbe n'Owewe. The deity appeared in their dreams and gave them ideas for their carving, guiding them at every step. The various carvings made by the guild were used mainly for religious, commemorative, and decorative purposes; that is, they served to establish communication with the supernatural, to commemorate important personages and events, and to decorate shrines, houses, and ceremonial attire. They functioned, however, within a context of social prestige in which the types of objects and materials used were strictly regulated in accordance with the status system.

The carvers saw themselves essentially as "servants of the king," sharing this status with the other craft guilds, with whom they were also linked through ties of intermarriage and economic cooperation. All craftsmen were considered *iwero*, that is, possessed of special skills that set them apart from the population at large and gave them a sense of prestige within the community.

The other source of carving—the Omada —was an association of pages living in the palace. The Omada were young men who were given by their families to the king to be his servants and retainers. Their official duty was to accompany the Oba on his public appearances carrying the *ada*, a ceremonial sword. During the day they performed menial tasks around the palace and, in their spare time, they practiced carving and wrestling. The objects produced by the Omada—bas-relief-carved coconuts, stools, and plaques— were considered strictly decorative and were given by them to the nobility in order to curry favor. No religious aura surrounded their work, as it did with the guild, and, in fact, the entire process of carving was seen as a way of keeping the idle hands of the young occupied. Upon release from service to the king, these young men might never carve again.

Although differing in approach, both the Omada and the Igbesanmwan felt that their position in society derived from their role as "servants of the Oba," not from the act of carving *per se*. Both also basked in the glory of producing prestigeful objects for the elite, whether or not these objects had any intrinsic religious meaning.

In 1897, the traditional way of life was disrupted by the British invasion and the Oba was sent into exile. There followed a period of instability, and then, in 1914, the British allowed the son of the exiled king to assume the throne and reestablish the less politically threatening aspects of Bini culture. With the encouragement and financial assistance of the British, who were interested in preserving the arts, the new Oba set up an Arts and Crafts School in the courtyard of his palace. The first pupils he chose were the Omada, whom he apparently felt would benefit from this opportunity to enter the new economic situation.

Later, members of the guild were added, but they never played a significant role in the school.

The Arts and Crafts School was not financially able to support all the Omada and other youths who became interested in making a living from carving, so in the 1920s some of them migrated to Lagos, the capital of Nigeria, to search for better economic conditions. The earliest carvers there formed a "union" and began training Bini apprentices. The industry flourished during World War II because of the influx of British and American soldiers. After the war, and particularly in the late 1950s, the midwestern part of Nigeria began to develop economically and carvers started returning to Benin City, where they set up workshops similar to the one in Lagos.

The experience in Lagos was crucial for the development of modern carving. Like other new towns in West Africa, Lagos was a "locus of innovation" (Lloyd 1967:110), with a maximum of exposure to novel ideas. In Lagos, the young men were far from the supervision of the Oba, who had chosen the subject matter and guided the work of the carvers in his palace and school (Cordwell 1952:177). Their patrons were now from different ethnic groups, expressing varied tastes. The resulting situation enabled and encouraged carvers to utilize new materials and tools, both of which had been restricted, and to create artistic forms appealing to their new and growing clientele. Similarly, in the absence of royal or British financial support, the carvers were forced to enter economic relationships more characteristic of a marketplace than a patronage system.

In short, a totally new profession was created: the tourist artist.[3] Yet the ideological component of this new role—the concept of what it means to be a carver—did not change so readily, and the tourist artist was haunted by the image of the Oba's servant.

ON BEING AN EBONY-CARVER

Most of the carvers today work mainly with ebony; in fact, the use of ebony is the distinguishing mark of modern carving. It is quite likely that the ex-Omada in Lagos were the first to use this wood, which was later introduced into Benin City. Ebony had not been used traditionally for carving purposes in Benin, although the trees grew in abundance in that area. Woods such as iroko (*Chlorophora excelsa*) and kola nut (*Sterculia acuminata*)[4] were strictly distributed according to status principles and were imbued with symbolic meaning within Bini culture. In contrast, there were no such restrictions on who could use ebony and what could be carved with it. By using ebony, the carver placed himself outside the traditional framework and was thus free to create forms as the demand arose.

Carvers use two kinds of ebony: *Diospyros crassiflora* and *Diospyros atropupurea* (Cordwell 1952:348). The former comes from the Benin area; its Edo name is *abokpo*, but most carvers

[3]A more detailed discussion of these historical developments, with documentation from governmental files in Benin City, can be found in Ben-Amos (1971:93–126).

[4]Botanical nomenclature is taken from Munro (1967:77–81).

call it simply *erhan n'ekhui*, black wood. The other type comes from the Western Region, mainly the Abeokuta area, and is called "Lagos" or "king" ebony.[5] Ebony is a very hard wood and is difficult to carve, but because of its sales value most carvers prefer to use it. Other woods are carved as well, such as African mahogany (*Khaya ivorensis*), walnut (*Lovoa klaineana*), and even the traditionally restricted iroko.

Carvers do not cut their own lumber, but they can purchase a variety of woods from the Benin City Forestry Department, which also auctions off ivory when an elephant has been killed. It was the Benin City Forestry Department that originally encouraged the use of ebony by local carvers, and it still supplies materials to the Arts and Crafts School. Most ebony carvers, however, prefer to buy from contractors who specialize in that particular wood. As a matter of fact, wood contracting is a new occupation that has developed in direct response to the growth of the ebony-carving industry. In the early days of the industry, carvers had to fetch their own wood, but in the early 1950s, local entrepreneurs entered the field and by 1966 they had formed a contractors' association. Although they work individually, the members meet regularly to discuss their business and fix prices.

Utilizing the services of a contractor has freed the carver so he can devote himself exclusively to his work. At the same time, it has introduced him into a whole network of economic relationships, tying him not only to the contractor, but also, indirectly, to lumbermen and lorry-renters. Since the carver is now dependent upon them, his fortunes can fluctuate with theirs.

In this system, the carver finds himself in a weak economic position. Availability of wood varies considerably. During the rainy season, when sections of the bush are flooded, the contractors have difficulty obtaining wood; the limited supplies then brought to Benin naturally are much more expensive. Occasionally, no wood at all is available, creating periods of underemployment in which carvers can neither meet commissions nor produce objects for open sale. The craftsman is also dependent on the contractor in the timing of his purchases; he cannot buy wood when and if he needs it, but must purchase whatever he can afford when the supply is at hand.

The modern carver also has a new source of supply for his tools. Traditional tools, particularly the various types of chisels (*agben*), are still purchased from the blacksmiths (*Igun Ematon*); however, many of the other old tools, such as the scraper (*akhien*), drill (*oha*), smoothing leaves (*ebe ameme*), and adze (*agha*), have been replaced by their modern equivalents, which are bought in various small shops along Lagos Road. Even more important, a vast new repertoire of tools has been added to the carvers' kit. The newly enthroned Oba may have been the first to introduce modern equipment; according to Cordwell (1952:404), he urged the palace carvers to use a mallet when making panels. In Lagos, carvers, evidently influenced by Westerners, began to use the saw and vise, and shoe polish (Cordwell

[5]According to Cordwell (1952:348), the Bini name for Lagos ebony is *owegbo*.

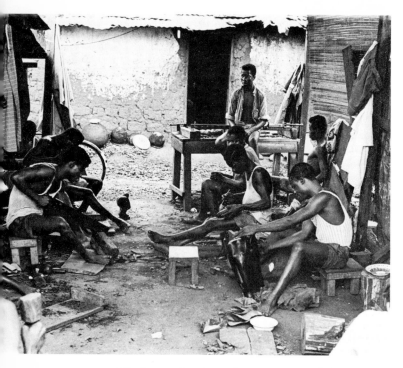

101. Apprentices in an ebony carving workshop using modern equipment, left to right: mallet, saw, vise, sandpaper, and shoe polish.

1952:407). When Cordwell was in Benin in 1949–1950, she found the following situation:

> The tools of the carvers today, be they those of the palace, the traditional specialists, the men of the Arts and Crafts School, the Lagos Bini carvers, or the young men working entirely in modern forms, are basically the adzes of varying sizes, knives, gouges, the chisel, and in the case of all but some of the traditional carvers, the mallet. The traditional [Igbesanmwan] carvers

use the adze and knife more than the chisel, while the opposite is true of the carvers who are palace-trained [ex-Omada], for there the emphasis is on the chisel. The reason for this is that the chisel is necessary for bas-relief work and for ebony carving in the round, for the chisel is the one available tool which can not only bite into the hard brittle wood, but prevent it from splintering (1952:406).

Since then, carvers have added axes, rasp files, rulers, sharpening stones, design hammers, sandpaper of various grades, and a vast array of chisels and gouges (figure 101). Today, to start out in the profession with at least the bare minimum of equipment (which carvers would consider to include a saw, vise, rasp file, ruler, drill, sharpening stone, sandpaper, shoe polish, chalk, two or three kinds of gouges, and at least eight types of chisels) would cost at least £15 and might run as high as £40. It must be pointed out that in carving, in contrast to other crafts, the introduction of all these new tools has not materially changed the work process. The new tools are mainly variants on the traditional ones, extending the range of the carvers' skill. Thus they may have affected the workmanship, but they have not made carving itself any more efficient.

The exact composition of each carver's kit varies tremendously depending on his specialty, financial ability, degree of expertise (beginners tend to know less of the fine distinctions between tools), and degree of acquaintance with the range of Western tools available (one carver claimed to receive catalogues from America and even spoke longingly of the machines Kenyan tourist artists

use). Most carvers have a "mixed kit" of both traditional and modern tools, and feel that each type is suitable for different aspects of carving. A glance at figure 101 reveals that in most cases modern tools have augmented and even supplanted traditional ones. The sole exception is the indigenous chisel (*agben-oro*) used for "decorating" the object. It is employed primarily when the carver sets out to do especially good work, as exemplified by this statement by Richard Amu: "If I do my work in a hurry then I will use a vin gouge and a mallet to make the lines and it will take an hour. But if I want to do it well, I will take a small chisel in my hand and it will take a whole day to make it neat and good." The preservation of the indigenous chisel as the tool for creating the most intricate patterns is not only technologically sound (Cordwell suggests that the chisel is the most appropriate tool for carving ebony), but it is also consistent with an aesthetic that stresses the importance of details and the value of traditional designs.

Bini generally consider the main function of carvings to be the verification and maintenance of tradition. This is best expressed by the frequently heard statement: "Carvings are the olden days' photographs." By this, Bini mean that carvings, like photos, were records of important events. The primary duty of the sculptor is to capture an image of social, historical, and ritual importance. The carver can accomplish this only by being faithful to his intended subject and, therefore, carvers place their highest critical value on accuracy of representation.

This basic conception of the nature of sculpture underlies the work of the Igeb-sanmwan guild and of the ebony-carvers. The fact that traditional carvings were highly stylized and modern ebony ones are naturalistic does not negate the notion that both types of carvers believe they are producing representational sculpture. It is the way in which they depict reality that differs. The traditional carvers are working within a religious framework, properly using Bini conventions to represent ancestors and kings. The ebony-carvers lack any religious sanction and, instead, are influenced by commercial values, which undoubtedly have played an important role in the development of the naturalistic style. Their way of carving essentially reflects the taste of European customers.

The ebony-carver is concerned with the response to his work. This concern obviously has a commercial base, since he must attract customers or go out of business. He feels that people buy carvings nowadays for "decoration and because of the history behind it," and so his work must appeal to them on those grounds. Yet there is another side to the question. Since he sees himself basically as a commemorator, in his work he must prove his knowledge of the past and his ability to carve things as they are. The confrontation with the customer is thus a test of his skill as a carver. One carver, James Abudu, told me, "When I start to make something, I remember that I will get questions. I must be prepared to convince people. It must really resemble what I am explaining and [they] must agree that the thing is really what I say it is." The importance of accuracy is expressed in the actual practice of carving by the concern for detail; the fold of the eye, the shape of the fingernail, the pattern

Terminology and Tools of the Carving Process

Stage of Work	Terminology		Tools Used	
	Edo	*Pidgin*	*Pre-1897**	*1966***
1. Scraping the bark and hacking out the rough shape	*kee*	"dressing the wood"	adze (*agha*)	axe and saw
2. Marking out the major areas	*fian*	"cutting of" (neck, head, etc.)	chisel (*afian*)	chalk to mark out areas; mallet with European gouge chisel
3. Shaping the main parts	*gben*	"bringing out" (foot, head, etc.)	chisel (*agben obo*)	European gouge chisel, flat chisel, vin gouge, etc., occasionally traditional chisels
4. Putting in the more intricate designs	*te*	"decorating"	chisel (*agben oro*)	same as previous use
5. Finishing and polishing	*rie*	"smoothing"	leaves (*ebeameme*)	sandpaper, shoe polish

*The traditional tools varied in size; thus adzes and the various types of chisels were distinguished as "large" or "small."
**Because of the great variety of tools now used, only the most basic and widespread are cited here.

of the cloth are all formed with great care. Some carvers claim to spend time observing people so as not to make any mistakes.

On another level, details also reveal one's knowledge of the past, particularly ritual knowledge. The traditional carver's guild possessed a series of designs and patterns that its members alone could use and the meaning of which they alone knew. One of their major criteria for a good carving was to "get all the patterns right." Modern ebony-carvers do not have this esoteric knowledge, but through their training as pages, or under ex-pages, they often do know about traditional dress and customs. A typical boast of an ebony-carver is: "I can carve every detail of an Oba's dress and I know the name of every single piece. If there is a contest in all Benin I couldn't get less than third for knowledge of traditional carving." By "traditional carving" he does not mean ancestral altar pieces—which he may know how to make but rarely does. Instead, he is referring to carvings illustrating historical subject matter. It is interesting to note that ebony-carvers actually operate on a dual standard: they distinguish between strictly "commercial" works—that is, European articles (figure 102) like salad bowls or Fulani girls' heads—which are done quickly for sale purposes, and their "traditional" carvings—figures of Obas, chiefs, and warriors—which they value most (figure 103). Their sense of pride as carvers

102. A "commercial" carving: mahogany elephant table made by S. O. I. Osula (ca. 63 cm. tall).

comes from knowing how to make these latter pieces, whether or not they actually sell as well as commercial ones.

As a matter of fact, this dichotomization of objects into "commercial" and "traditional" is not reflected at all in the types of objects made. Carvers produce whatever sells, regardless of their personal preference or sense of pride in knowing traditional patterns. Whenever I asked a carver what kind of object he liked to carve and why, he invariably told me which carving was selling best in his shop.

Carvers traditionally worked only on direct order. Their wood was supplied, as was their food and lodging during the period of production. Today, the commission still is the most desirable and secure method, because the carver usually receives an advance payment for the purchase of wood, and he is assured of a one-to-one relationship between production and sales. In today's market, a carver who can rely totally on commissions has either a very large clientele or a very rich one. Very few, however, have such well-established reputations that they can rely on a regular flow of orders through their known patrons. Most of them, consequently, have also entered into a kind of marketplace system to attract on-the-spot purchases. To do this, a carver must have a workshop in an easily accessible location and must produce a surplus of carvings so that there will be sufficient variety to attract customers. In this way, the ebony-carvers differ from other craftsmen, such as those described by Lloyd (1954:36), who have insufficient capital to build up a stock of goods. Because of the luxury nature of the product, the modern carver must have more funds available to him than his fellow craftsmen—the tailors, carpenters, and mechanics—in order to build up a broad selection of objects that, according to the Western psychology of buying, will draw customers. For the same reason, he usually must set up a showroom. In traditional situations, this was totally unnecessary, first of all, because the potential customers knew the entire cultural repertoire of carved objects, and secondly, because what they were allowed to purchase was carefully regulated by the status

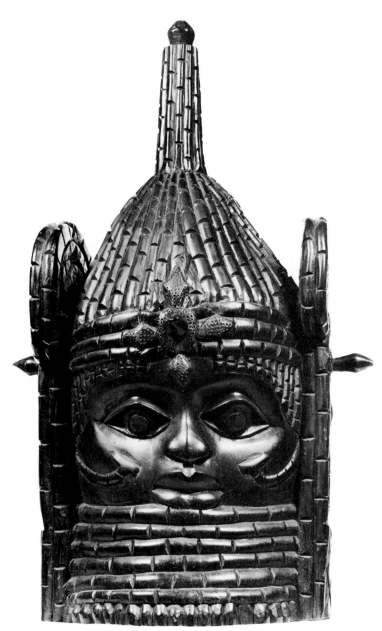

103. A "traditional" ebony head of the Oba, King Ewuare the Great, by Robinson Ihaza, probably 1930s (41 cm. tall).

system. Now each carver has to evolve his own repertoire and to make his own decisions about what will appeal to customers. Smaller workshops are at a disadvantage in this situation, since the larger ones have more capital to invest and thus a greater quantity of objects to display (figure 104).

It is financially difficult for carvers to depend on commissions or to find the capital for producing a surplus. As Lewis points out: "The craftsman cannot afford to hold stocks of materials, or to produce articles for stock. If he works according to customers' orders only, he will as likely as not be subject to much irregular unemployment. Production is most economically organized if there is a middleman between the craftsman and the final consumer, [who] can carry stocks . . . in order to widen the market . . ." (1955:139). Indeed the carving industry has come to rely in large measure on the activities of middlemen.[6] There are a number of local traders who travel around the villages or between workshops, buying carvings to hawk in the main white residential section. Some also come from other regions of Nigeria. But by far the most significant middleman economically is the Hausa

[6]It is interesting to note that no institution of "curio dealers" has developed in Benin, as it has in East Africa for the Makonde and Akamba carvers (Stout 1966:8–11; Elkan 1958:321). The closest equivalent in Benin is the carver who pays a commission to have his wares displayed and sold at the Benin Airport and another who has the same arrangement for the Mogambo Palace Hotel.

trader. The claim made by one craftsman that "without Hausamen most of the carvers would starve" is an exaggeration, but it nevertheless indicates the importance of these middlemen in the sale of ebony carvings.

Hausa trade, as Cohen (1969) has shown, involves an elaborate network of relationships stretching over long distances. Benin is the focal point for the trade in ebony carvings and modern brasswork. There are essentially two systems of Hausa trade operating in Benin

104. Showroom of a large workshop; Benin Carvers Cooperative Society.

City. On the one hand, there are six or seven Hausa who live in Benin City and consider it their "station." Some of them even speak the local language and have personal friendships with carvers. As traders, they specialize in Benin art and are acquainted with most if not all of the carvers in Benin. They act as suppliers for their trading partners in other areas of Nigeria, and even outside the country. There are also a large number of out-of-town Hausa traders who regularly visit Benin to purchase local artwork. They congregate in a small "market" on Laos Street, where apprentices and unsuccessful carvers bring their wares. For filling orders from other parts of Africa, they visit different "specialists," with whom they often have established trade relationships. Many carvers prefer to sell to the outsiders because they pay higher prices.

The Hausa traders buy in large quantities and in return receive a discount price. They tend to buy the "small-small" objects, carvings that are easily transportable, like the ebony crown birds now found throughout West Africa. Occasionally, they commission larger and more expensive objects, for example one carver was working on a lion valued at £75 ordered from Monrovia.

The Hausa not only know all the carvers in the area and are aware of their specialties, but they also have a definite system of ranking their abilities. This system operates as a guideline for purchases; objects that are going to be hawked on the open market are usually purchased from the poorer, less well-established, and often less skilled craftsmen. The traders actually repair and finish carvings they

judge inadequate. Special orders are given to the known and expert carvers, upon whom the Hausa can rely to satisfy the client.

Like their fellow middlemen, the ebony contractors, the Hausa cooperate to insure good trading conditions. Theirs is an informal network, but an effective one. They pass on information to each other about which carvers are more skilled or give better prices, and if one of their number is offended, they join together to boycott the craftsman responsible. The carver, however, is in a somewhat better position vis-á-vis the Hausa than vis-á-vis the contractors, because he has alternative channels for selling his products.

The manner in which a carver sells his work has important social implications. Hawking is of very low status, particularly in comparison to working on commission. Naturally, this evaluation has an economic base, yet it is also related to Bini status conceptions. Since working on commission has a prototype in the traditional patronage system, the carver who can rely on orders alone is, in a sense, basking in the light of traditional glories. Moreover, receiving a commission is a sign of respect and recognition, as expressed by the fact that the recipient remains at home and people come to him. The Bini assign mobility functions to people of low status—the primary task of young people is to go on errands and to carry messages. Conversely, the person of ultimate prestige is the Oba, who supposedly never leaves the palace.

To whom a carver sells is also important and reflects on his status. Although carvers cater to a wide variety of customers—tourists,

senior civil servants, chiefs, resident expatriates, and traders—they evaluate their standing in terms of the polar types: the Hausa versus the Eruopean. Ranking of these groups is based on what Southall (1961:29) and Mitchell (1966:52–53) have called "categorization." Categorical relationships arise in situations where contact is superficial—in the marketplace, on the streets, in bars. "In these situations people sometimes must interact socially with strangers or near-strangers and the pattern this interaction takes often results from 'what kind of person' these strangers are thought to be" (Pendleton 1970:6). Intracategory differentiation is minimized (a Swiss is rarely distinguished from an Italian), and the commonly accepted characteristics of his ethnic group are ascribed to the individual.

The Bini view of the Hausa trader is similar to the western European attitude towards gypsies. The Hausa is an outsider with no established position in the community. He lacks the accepted markers that place a person in social perspective, that is familial identification or specific service to the Oba. Furthermore, he is primarily a wanderer, and persons without roots are considered irresponsible and potentially dangerous. They have no one to "stand for them" (owman n'o mudia n'omwan). The carvers consider the Hausa traders totally untrustworthy and fully expect to be cheated and tricked (an expectation that may have some basis in fact). The Hausa is not even respected as a trader because "he can't account for the things he sells"—that is, he does not produce what he sells and is therefore not responsible for their quality.

But the main reason that the carvers do not like to deal with Hausa as customers is that the trader always demands lower prices than other customers. Although the Hausa buys in quantity (the carver may or may not recognize the economic rationale behind this), the carver considers the lower price a reflection on his professional standing. Only the apprentice with his unfinished work and the carver down on his luck have no choice but to sell their wares to traders. Both have little status in the carving community, and other craftsmen do not wish to be identified with them. Most craftsmen either deny selling to Hausa entirely ("Thank God I haven't time to sell to Hausamen!"), or claim to resort to them only when business is particularly bad ("Hausamen are afraid to buy from me because my prices are too high. . . . But if I don't see any Europeans for a while, I'll sell to Hausamen.").

At the opposite end of the spectrum are the "Europeans" (a term applied to all white men). In spite of their being outsiders, their dominant position places them in a totally different category from the marginal Hausa trader. Europeans are generally believed to be rich and powerful and carvers draw a great deal of satisfaction from being associated with them. Europeans are also desirable as customers because they are considered honest and reliable: "Europeans never cheat you." Most important, the white man gives the carvers respect and recognition for their work, something their own people fail to do. The European buys their carvings (at a high price) and also often asks them questions about the meaning and history of different pieces. Recogni-

tion of their special knowledge and expertise by a powerful person is as close to the traditional relationship with the Oba as modern carvers can come.

CONCLUSIONS

Although they work within a modern system, all ebony-carvers know about traditional carving and many were actually trained as Omada or by ex-Omada. Their concept of carving, then, is strongly traditional and the only model they know for what it means to be a carver is the notion of "Oba's servant." In spite of their efforts to elicit his support, however, the Oba has little interest in acting as patron for the ebony-carvers. When he has need of traditional work for royal shrines he can rely on the few members of Igbesanmwan still carving, and when he wishes modern work to present to visiting dignitaries he turns to the school established by his father.

The ebony-carver has been forced to look for substitutes; he produces his neo-traditional objects, while trying to find a European potential patron. The European, indeed, has the proper qualifications for assuming the role of patron—power, wealth, and specialized knowledge. These characteristics set him apart socially, as expressed in the Bini saying: "You can never rank yourself with a white man" (*Ebo i r-owman n'ih-omwan*). Since the Europeans no longer govern, they do not constitute a corporate group to whom the carvers can relate as did Igbesanmwan to the Oba. Yet, as individuals functioning as the equivalent of chiefs, they can supply the interest, encouragement, and, particularly the financial support the carvers so desire. The secret hope of nearly every carver in Benin City is that some European will "sponsor" him by sending him to "the U.K." for further training; spending time in England is considered the key to instant success. In actual fact, few carvers have succeeded in attaining this type of relationship, and those who have (Felix Idubor and Benson Osawe) are the focus of great admiration and jealousy on the part of other carvers. Thus, the relationship with the white man functions as an ideal for which carvers long, a longing that reflects their lack of a clear-cut role within the emerging social system.

Similarly, the objects created by the carver do not provide him with the sense of prestigeful creativity that traditional carvers felt, as described by a chief:

> In the olden days, suppose I wanted an ivory carved [for me]. I would allow the carver to stay in my *ikun*, my innermost private apartment. There he would carve and I would spend money to entertain him very well. After finishing the carving, I would put it on my ancestor shrine and people would be rushing in to see it. This gives the carver very great respect to be associated with such a work.

Modern ebony carvings are purchased mainly by visiting Europeans to take home as curios, by Hausa traders for export to all parts of West Africa, by officials of the Ministry of Trade and Industry for shipment to trade fairs, and by an occasional Bini civil servant or office worker who wishes to give a gift to a friend (Nigerian or European) departing for overseas or being promoted to a post outside Benin

City. In other words, the bulk of ebony carvings are removed from the physical environment of their place of origin—ebony carving is truly an export art.

Within Benin itself, the attitudes toward these modern carvings vary tremendously, from total disdain to approval for their skill of execution and shininess—both assumed to be due to the introduction of European techniques. No one admires them because they capture Benin history (i.e., because they are "traditional"), as does the carver himself. The fact is, that by using ebony—which is the very symbol of modernity—the carver has made such an appreciation impossible. The ideological dilemma inherent in the new carving is best expressed in this (admittedly biased) comparison by Samson Okungbowa, a member of the guild:

> To make a proper ancestral commemorative head it is necessary to get all the patterns right. Someone who doesn't know how to make it will lose parts of the pattern. Or he may say—a real mouth is not like this and he will try to make it another way. . . . The Igbesanmwan are not interested in realism. They are making a commemorative head for a shrine. The modern carving is exactly like a person and is not made for a shrine. The commemorative head represents a spirit not a human being. Its purpose is to instill fear. *No one was ever afraid of an ebony head.*

19. The Decline of Lega Sculptural Art

Daniel P. Biebuyck

Little attention has been paid to the circumstances under which traditional arts in Africa decline and disappear, the events and conditions that undermine them, and the replacement objects that are eventually accepted with old or new meanings attached to them. This type of analysis is significant not merely because it forms an intrinsic aspect of the study of culture change, particularly of what happens under conditions of stress, but also because it can contribute to an understanding of what art is in a specific human group, what it does, and what it means for the members of that group.

In the artistically very rich Zaïre Republic, many sculptural traditions had vanished before the advent of independence in 1960; other

Daniel P. Biebuyck is H. Rodney Sharp Professor and Chairman of the Department of Anthropology at the University of Delaware, Newark. He was awarded his Ph.D. in anthropology from Ghent University, and has since 1949 carried out fieldwork in the Republic of Zaïre. Among his numerous publications on the arts and cultures of Central Africa, the best known are perhaps his two edited works, *African Agrarian Systems* (1963) and *Tradition and Creativity in Tribal Art* (1969), and his definitive *Lega Culture: Art, Initiation and Moral Philosophy Among a Congo People* (1972).

sculptural arts were on the wane; many artistic traditions in general had declined. In many of these cases, traditional art objects were still used, but no longer produced, except perhaps in small quantities. Sometimes they were of mediocre or at least deteriorated quality, and sometimes they had an entirely new intent. Occasionally, new combinations, forms, and subjects emerged that were meant to be artistic but were questionable as to their quality and purpose. Usually, where the sculptural traditions were on the wane, no new art forms emerged or were introduced to replace or complement the old ones. In a few areas, however, such as the Northeast and the region of Kisangani, where sculptural traditions had never been vigorous, new sculptural forms affirmed themselves, largely outside the established social and ritual contexts. Here and there, mission schools, local academies, and one or another local carvers' corporations (e.g., the ebony-carvers of Buta, the ivory-carvers of Beni and Masisi, the carved-chair-makers of Bengamisa, etc.) produced a large number of new sculptures for the European market. In this general process of decline and re-creation

of art, it is striking that in some ethnic areas certain types of artworks disappeared more rapidly and more completely than did others.

Although the problem has barely been touched upon in the existing literature, there are, from ethnic unit to ethnic unit and from one art-using institution to the other, striking differences in the ways the sculptural arts maintain themselves, survive, or decline. Most ethnic groups have their own autonomous traditions whereby the members of that group supply the necessary artworks for themselves. It is understandable, therefore, that even among neighboring or historically and culturally interconnected groups the processes of artistic change may follow diverging courses. Most ethnic groups have several more-or-less autonomous sculptural traditions, which are linked with different social and ritual contexts, fulfill diverse functions, and respond to different demands. There are obvious differences, then, in the ways these separate traditions grow, change, and perish.

In any given group, one artistic tradition may be much more developed and more strongly represented (in number of objects, degree of integration into the social system, etc.) than another. Masks have always been rare among the Luba; figurines have never been numerous among the Salampasu. Correspondingly, mask traditions among the Luba seem to have faded away much faster and earlier than anthropomorphic carvings of all types. Among the Pende, Yaka, and Cokwe of southwestern Zaïre, where mask and figurine traditions are equally important, the masks are preserved much better than some of the other sculptural forms. Among the Yumbe and other Kongo groups of western Zaïre, tomb sculptures in wood and steatite rapidly lost their significance and were replaced by cement works of similar scope and meaning.

Different local experiences with the colonial administration, with missionaries, with villagers converted to Christianity, with prophetisms or other revivalistic movements, and with new types of political leadership represent powerful factors in shaping differential attitudes toward the traditional works of art. Very importantly, the specific social and ritual contexts within which particular art traditions live and operate also exercise a profound influence on their chances for survival. Some artworks traditionally occur in overt and public manifestations, others are linked with highly closed and esoteric cults or initiations. Some of these contexts are more rapidly doomed than others when rapid change sets in; some are the ready targets of external erosive action; still others manage to survive, with little modification. Some types of initiations, some forms of magical practices, and some aspects of ritual were more rapidly exposed to change and outside corrosive influences than other institutions, such as ancestral cult or dramatic performances linked with youth initiation or chieftainships. In societies of southwestern Zaïre, different types of masks were abundantly used in a great variety of public and private rituals and performances connected with youth initiations. As some of the more esoteric rites tended to decline and disappear, the public, entertaining, dramatic, and choreographic character of the masks would assume new importance, assuring for them a continued need and use.

When we discuss problems of developments in the arts in Africa, we should also

constantly keep in mind that our basic concepts of art—its forms, manifestations, range, quality, and significance—tend to be distorted and misleading for ourselves. This tendency is due in part to the many narrow and evaluative theories we cherish about art, and in part to the selective and uninformed ways in which we have collected the art of foreign ethnic groups. We have emphasized the value of masterpieces and good pieces, conceived in terms of our criteria of age, patination, and style, and of our conceptual framework of aesthetic appreciation. Some of our greatest mistakes were made because we failed to view the total range of artistic creations of a particular people in their geographical and chronological framework and in their total social configuration, particularly in association with many objects that we do not regard as artworks.

The most important questions to be asked are: Among a given people, can a valid distinction be made between art and nonart? If such a distinction is possible, what can art objects do for their users that other types of objects cannot, or can common artifacts or natural objects easily be substituted for the objets d'art? In every group there are many works that are of very uneven quality in craftsmanship. Individual artistry, demand, degree of haste in the making of an object play as great a role as differing regional traditions, time periods, number of carvers, purpose of the object, and vitality of the cultural tradition within which the object is embedded.

Among the Lega of eastern Zaïre, whose art will be discussed here, there existed in the 1950s a fairly large number of carvings that were still actually used within their traditional contexts of initiation and were owned only by the high-ranking members of the *bwami* association. Many hundreds of Lega sculptures were also available in museums and private collections. Although dating is impossible, these various carvings come from different time periods—some are perhaps a century old and more, some are new. Most of the collected specimens were obtained at various periods between 1900 and the present; a few objects were collected in the late nineteenth century. The objects are obviously made by many different carvers, representing all subdivisions and regions of Legaland. They range from what are clearly superb, well-polished, well-patinated, well-finished figurines and masks that illustrate the great artistic skill of their carvers, to badly made, unfinished, and lifeless mediocrities. (Compare figures 105 to 108.) The latter are clearly not always the products of more recent periods of artistic endeavor. They merely represent the total range of carving traditions and reflect the many divergent tendencies among the Lega. In addition to the many obvious factors that shaped the diversity of these objects, there existed also among the Lega an "aesthetic of the ugly," which demanded that specific objects be made in a clumsy and unfinished-looking manner.

TRADITIONAL ART AMONG THE LEGA

In order to understand the factors that led to the breakdown of the art traditions among the

Lega,[1] it is necessary to delineate clearly the social setting within which their art occurs and its ideological foundations. It is indispensable to know what usage the Lega make of this art, what functions it performs, what meanings are attached to it, and in what configurations it operates. Further, the position and role of the artist is an intrinsic part of this discussion.[2]

The Lega make a variety of sculptures in wood, bone, ivory, copal, clay, and stone. All are small—the majority of objects are under 12 inches high. The sculptures include masks, anthropomorphic and zoomorphic figurines, spoons, pegs, dice, hammers, billhooks and other knives, axblades in bone, miniature stools and larger stools. All these objects are made for, used, owned, and interpreted by the members of the *bwami* association. Bwami is a hierarchically structured system of grades and steps, some open to men only and others open to their wives only. Membership at different levels of the association, and accession to different grades, depend on an involved and prolonged system of initiations. Every set of

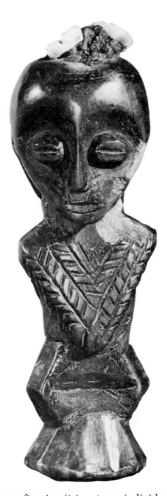

105. Lega ivory figurine (*iginga* type; individual name *kabukenge*); received in 1952 by the author among the Banamunwa clan from Mizegele, a high-ranking *kindi* initiate. The piece is an example of a well-carved, well-used, well-patinated, and well-finished Lega sculpture. The date of manufacture is unknown, but the object is definitely an example of the Lega sculptural tradition before its decline had set in (18 cm. high).

[1]Field research among the Lega was carried out under the auspices of l'Institut pour la Recherche scientifique en Afrique Centrale. My comparative studies on Central African Art are made possible through a grant from the National Endowment for the Humanities (1970–1973). The situation described by this study reflects the period between 1952 and 1959. Unpublished documents that were examined in local archives go back to about 1913. Before that time, there are the data presented by Commander Delhaise (1909), which bear on the period between 1903 and 1906. Some earlier general information is available through the writings of Lieutenant Glorie and Commander Cordella.

[2]For further information on various aspects of Lega art and culture, the reader is referred to the following: Biebuyck, D. 1953a; 1953b; 1953c; 1954a; 1954b; 1966; 1967; 1968; 1969:1–23; 1970:340–352; 1972a:1–19, 75–84; 1972b:7–20; 1973; and Delhaise, 1909.

initiations focuses on the payment of fees, exchange of goods, lavish consumption of foods, and sequences of dances, each of which is based on a song that is always in the form of an aphorism. Here, bwami manifests itself as a *paideia*, a form of systematic training and schooling in patterns of thought and behavior. The songs convey ideas about the moral philosophy, the values, the etiquette, the social relations, the significance of bwami, and so on.

These ideas are vividly underscored, on the one hand, through the dance movements, the mimicry, and the dramatic enactment of situations and events, and, on the other, through the display and manipulation of a vast number of objects. Hundreds of different objects are involved. Many are plain material objects without technological modification, like leaves, scales, claws, teeth, and hides. Other categories of items range from slightly modified material objects (e.g., a polished shell or a pangolin claw adorned with a beaded ring) to temporary or permanent assemblages (e.g., a snakeskin trimmed with porcupine quills or a human figure made of banana strips, twigs, hides, hats). The highest categories of objects comprise the many manufactured insignia, paraphernalia, and initiation objects, ranging from hats and diadems to belts and aprons, from necklaces and bracelets to fiber and feather tuffs, from walking canes and knives to various types of sculptures. Many of these objects, like the sculptures, are made exclusively for the bwami association; others have multiple usages outside bwami. All objects that enter bwami, however, become initiation objects—that is, material devices that are obligatorily used with dances, music, songs, gestures, dramatic performances, and mimicry to illustrate, to concretize, to clarify, to amplify points of teaching and of reflection that are fundamental to the bwami initiations. There are no exceptions: the figurines as well as the masks, the vegetals as well as the animal exuviae, the hats as well as the stools, are *masengo*—that is, heavy things, things that are loaded with, and suggestive of, meaning pertinent to bwami. In the broadest sense, all these objects can be conceived of as mnemonic devices that help perpetuate concepts and ideas.

Certain specific categories of objects and certain individual items acquire additional functions within the bwami context. Some, like hats or belts and all sculptures, are insignia of rank and status. Incumbents of the highest level in the *kindi* grade wear hats that are different from those of men of lower rank. The ownership of ivory and bone sculptures is linked with the kindi grade; ownership of wooden sculptures is connected both with the second highest *yananio* grade and the highest kindi grade. Some individual carvings are associated with particular statuses that are occupied by individual members of the higher grade levels. For example, larger ivory or wooden masks or figurines are held by a kindi member who has most seniority within the ritual community; certain sculptures, like ivory or bone billhook knives, are held by preceptors of kindi grade. All objects that enter the bwami initiations may be viewed as dance paraphernalia, since during the performance the initiates pick up the displayed objects to dance around with them. Specific categories of manufactured objects, such as

aprons made of various hides (sometimes cut into tails and studded with cowries) or bunches of feathers to be worn around the waist, are primarily used as dance paraphernalia. Some objects, most figurines or masks, and other assorted natural and manufactured items, serve as expressions of social cohesion and ritual autonomy within kinship groups or broader ritual communities composed of several kinship units. The number of such single objects or groups of objects is obviously strictly limited within specific social units. None of the Lega sculptures could be conceived of as a fetish used for magical purposes or a cult object used to celebrate or to intercede with ancestors or divinities. Cult practices, in general, are conspicuously absent from the bwami initiation rites. Bwami has many resemblances to Greek mysteries. The initiation itself is a religious act that offers immunity and sanctity to those who undergo it. The objects used by the initiates have an undefinable power anf force. As inherited objects that frequently pass through hands over a number of generations, the sculptures are particularly important in this regard. They symbolize the continuity and quasi-perenniality of their owners and of the association to which they belong. This symbolism is enhanced by the fact that these sculptures are placed temporarily on the tombs of their dead owners under the supervision of the guardian of the tomb, who is himself a high-ranking initiate. These "heavy objects," as the Lega call them, are charged with a force of their own, which is detrimental to those who would usurp their possession and beneficial to their owners and to those who are under their authority. When all other pharmacopoeia fail, Lega men and women drink the dust removed from the statues to reinvigorate themselves.

Objects are used rarely as single items during the initiations. Usually they are used in groups, comprising the same or different categories of items. In several instances, the actual use of the objects in dance movements is preceded by a complex display of them in fixed configurations that include both natural objects and artifacts. The very nature of these configurations gives added specialized meanings to the individual items. Outside the context of initiations, the sculptures, which are generally small, are hidden in shoulderbags or baskets, depending on whether they are individually or collectively owned. Most sculptures of all types are individually owned by the male members of the two highest grades of yananio and kindi; a small number of carvings of specific types is owned individually by the female members of the highest grade (bunyamwa), and male initiates own several carvings of different types, the ownership of which is a sine qua non for membership. Objects characteristic of different grades or grade levels, however, cannot be owned by the same individual. Thus, an initiate moving from the yananio to the kindi grade will transfer his sculptures that are associated with yananio to a kinsman who is achieving that grade, whereas he himself will progressively acquire from other living and dead kinsmen those carvings and other paraphernalia that are distinctive for kindi. Collectively held sculptures and single items or sets of items circulate according to fixed rules; for example, from the most junior incumbent of yananio or kindi to the newest

initiate of that grade, or from the most senior incumbent of that level, when he dies, to the next most senior initiate. The ways and conditions of ownership, the pattern and circumstances of acquisition and transfer of objects are strictly circumscribed. There is, in general, a great flow of objects, conditioned by the death of initiates and by changes in the level, grade, and status they occupy. From one ritual community to another there are many variations in the number of objects, including sculptures, that are owned and used; there are few variations in types of objects and conditions of ownership. There are also local and regional variations in the ways of doing things, but not in the basic principles that underlie acquisition, transfer, ownership, usage, function, and meaning of the sculptures.

During my fieldwork in the early 1950s, few, if any, traditional Lega sculptors were alive or actively making sculptures. In 1951, a colonial administrator had already noted the disappearance of the artists in Lega society. The members of the bwami association itself placed little emphasis on the sculptors. The focus was on the objects and their many usages, functions, and meanings, and on the owners of these objects. Since there was little explicit theory or interpretation around the creative work of carving, it is impossible to make more than a few general statements about the artists themselves. Lega sculptors were relatively few; they tended to work together in certain local centers or ateliers scattered throughout Legaland. Communication among such scattered groups of carvers was encouraged by the widely ramifying system of agnatic, affinal, and cognatic relationships, and

the correlated constant traveling of high initiates throughout Legaland. Artists were mostly, but not necessarily, members of bwami, holding either low or high grades. Social prominence, fame, and reputation, for them, as for all other Lega, were functions of achievement in bwami. As artists and craftsmen, they were not more socially visible or prominent than those vast numbers of Lega who made hats, belts, and many other things of high significance for bwami. The informal mode of training and learning the craft operated within closely knit agnatic descent lines, but sororal nephews (real or classificatory) were also preferred apprentices of their uncles. The artists worked only when commissioned by the members of the highest grades. The demand for art was fairly large because there were many incumbents of the yananio and kindi grades throughout Legaland. This demand, however, was periodic and uneven because of the time span between initiations and because of the strict preservation and inheritance of existing works of art.

To what extent artistic criticism guided the artists among themselves it is difficult to say. The patrons and owners of the art objects do not indulge in artistic criticism, nor do they accept aesthetic evaluations of the sculptures. Like other objects, the sculptures acquire full meaning only after they are consecrated through actual usage in bwami; indeed, the sculptures are finished only through usage, which adds to them the rich patinations, the white or red colors, and certain other ingredients. All objects that are sanctioned through usage in bwami are, by definition, busoga—that is, they have per se the qualities of beauty and

goodness inseparably combined. It is most noteworthy that the living owners of the artworks, in tracing the history of individual pieces, invariably provide the names of successive owners of the object, then invariably wind up with the first owner of the piece, ignoring or simply not knowing its maker.

Sculptures are important in bwami, since they symbolize the highest achievement in initiatory status and knowledge. But the sculptures alone represent only a small fraction of the totality of material items, behavioral patterns, and conceptual activities that make up the system of initiations. The sculptures cannot be isolated or separated from the rest. Moreover, there is ample evidence in the various practices of different ritual communities that the Lega traditionally substitute all kinds of objects for artworks or other items. This is not a function of relative scarcity or unavailability of specific products; it is rooted in the very nature of bwami itself and its modes of proceeding.

Bwami is universal among the Lega and occurs also among several neighboring Lega-related ethnic units, but there is no central agency or organization that enforces conformity. The Lega are divided at different levels, depending on the hierarchical position of the initiation, into a number of ritual communities (largely coinciding with different lineage and territorial groupings) within which initiations are held autonomously. These ritual communities cultivate variations on basic themes; they like to do things somewhat differently from the others, but always with respect for the general principles that are rooted in the bwami tradition. Thus, artworks are more numerous or more diversified in one ritual community, and more restricted in number and diversity in another ritual community. Ideas that are conveyed through artworks in one community are, in another group, expressed through other media. In general, there is an extraordinary capacity for conveying a common symbolism through different objects and actions and for expressing different symbolism through common objects and actions.

In the case, then, of Lega sculpture, we are dealing with a specialized art that is made for a well-defined context and is owned and truly understood only by a limited group of high-ranking initiates. The art is linked with the educational system, the ethics, the social hierarchies and statuses, the system of social solidarity, and also with transcendent mystic principles. In actual social usage, the separation of art and nonart is virtually impossible to make because of the established associations between various kinds of material and manufactured objects and the possible substitution of one type of object by another, at least as far as the conveyance of symbolic meaning is concerned. Lega sculpture is not an art of display and ostentation. It is a hidden art, in the sense that its forms do not readily tell the meanings associated with them.

As was noted above, the sculptures are not only inherited but also change hands during the lifetime of their owners as the latter move up in grade and in level or acquire new statuses and special positions. Although this point is difficult to prove, it seems to me that a saturation of sculptures would easily have been reached in Lega society because old objects were carefully kept and transmitted to

new high initiates, the number of high initiates was limited, and the number of pieces that high initiates could own at any given time was also restricted. Yet there was a continuing, though intermittent, uneven, and somewhat unpredictable, need for new objects. It was customary to leave one or more sculptures on the grave of their deceased owner; these objects eventually decayed or were eaten away by termites and rodents. Objects of all kinds were destroyed through fire or breakage, and wooden sculptures were lost through age and use.

In more recent decades, objects were broken or thrown away in disputes between spouses (particularly when the wife pretended to embrace Christianity), were confiscated in police and other raids against the members of bwami, and were sold to foreigners or exchanged for other goods by their owners. Also, strict limitation on the actual number of high initiates that a lineage or ritual community could have was no longer in force; there are indications that these numbers were steadily increasing in periods preceding the advent of Europeans and also at certain periods during European rule.

There were also subtle rules and meanings governing the number of objects that a single initiate may own. Both yananio and *lutumbo lwa kindi* initiates are restricted, respectively, to one wooden and one ivory (or bone) mask. The achievement of certain levels in yananio and kindi permits possession of one animal figurine in bone or ivory. In some areas, at least, initiates at certain levels of yananio and kindi are allowed the possession of only one small wooden or ivory (or bone) anthropo-morphic figurine. The number of ivory (or bone) figurines that a lutumbo lwa kindi may hold, however, is theoretically unlimited. In practice, I have rarely encountered a kindi having more than about from six to ten anthropomorphic figurines. Some of these figurines might not be his own, but held by him in trust on behalf of a dead kinsman and until a new kindi was initiated.

EXTERNAL INFLUENCES

The Lega settled a few centuries ago in the vast rain forest area where they now reside. They maintain that bwami—"that fruit which came from above"—was already known to them before their eastward migration away from the Lualaba River into their present territory, but as groups scattered and split to undergo different autonomous experiences, some of them lost bwami, or lost high grades in bwami. Ethnohistorical traditions recall the ways and the circumstances under which particular groups managed to get bwami or the kindi grade back. The thought is that bwami and everything pertaining to it are old—as old as the Lega themselves—and that "bwami has no inventor," or, otherwise stated, "bwami has not the one who first saw it"—that is, no individual or group can lay a prior claim to it. Having settled in the rain forest, the Lega found themselves surrounded by various groups of Bantu-speaking peoples, of diverse origins and backgrounds, with whom they were at peace. All around Legaland, properly speaking, there developed subgroups of var-

ious ethnic origins sufficiently acculturated to the Lega to make the transition from the Lega to the surrounding tribal groups an easy and smooth one.

For many decades, bwami brought peace in the land—"There alone is the land prosperous [in good health] where the bwami initiates dance with dried banana leaves." The ethnohistorical traditions point to a long period of growth and to the constant expansion of bwami. By the middle of the nineteenth century, the Lega found themselves on the periphery of important centers for slave- and ivory-raiding set up by the Arabs and their Swahili and other collaborators. The great slave- and ivory-trading routes, such as Nyangwe-Kasongo-Mpala or Baraka-Udjidji, did not cross Legaland. Nonetheless, the Lega, a peace-loving but proud people, had to fight many protective battles and acquired a reputation for fierceness. Some *nyampara*, or representatives of the Arab authority, managed to settle in a couple of areas of Legaland and to stay there through the first decade of King Leopold's Congo Free State. The Lega recall few details of this period explicitly. We know that the nyampara were opposed to the authority of the bwami initiates and their activities. Old Lega initiates frequently complained to me about the loss of priceless ivory masks and figurines during this period of turmoil. We also know that Lega carvings of fine quality arrived at the slave market of Nyangwe,[3] but the channels through which they came are ig-

[3] A few years ago, Mrs. Astrid Gjessing Bentzon of Copenhagen sent me photographs of Lega ivory figurines and spoons that were collected at the market of Nyangwe in 1898 by her uncle, Lieutenant A. Rahbek, then a young officer in the Belgian service.

nored. During the early phases of the colonial period, Legaland remained a vast terra incognita, around which many diverse notions were built by travelers, colonial personnel, missionaries, and others. At various stages, the bwami initiates and their activities and possessions, became the target of severe repression, notwithstanding the sympathetic way in which Commander Delhaise had written about them in *Les Warega* (1909). There are clear indications that from about 1916 on, with a few individual and temporary exceptions, the bwami association and its members were treated with severity and a lack of understanding by administrators, military, missionaries, and mining personnel operating in the area. After much harassment, the association was outlawed in 1933 by the colonial government, then somewhat tolerated again, and finally abolished in 1948 on grounds of immorality, subversiveness, and "threat to tranquility and public order."

Various reasons are at the root of the severe repression of bwami. As the major organizational force in Legaland, it controlled and monopolized many activities, including the boys' circumcision rites, and so could effectively resist the new policy and the new social order whenever they seemed to be contradictory to bwami ideals and customs. As a closed association, many of whose activities and teachings were hidden from the outside world, bwami was easily accused of misconduct, subversiveness, criminal activity, and the like. The members of the association had a quasimonopoly over all ivory, because so many carvings in ivory and whole tusks belonged to the cultural patrimony of bwami. From 1910

on, the Belgian administration introduced stringent regulations with regard to the ownership and disposition of ivory. The rules changed somewhat over the years, but at the initial stages it was virtually illegal for Lega to possess ivory. These negative attitudes toward bwami were further intensified by a total misunderstanding of the purpose and character of the association, and by various prejudices concerning the so-called fetishistic role of the carvings.

Throughout this troublesome period, bwami continued to exist and to exercise its influence, but in a covert and discreet manner. Initiations continued to be held secretly, but with less frequency and regularity. There were periods of relaxation and periods of greater repressive action by the administration. Many hundreds of art objects eventually disappeared from Lega society: some were confiscated during raids or surrendered on the arrest of initiates; others were thrown away or hidden in panic, not to be found again; and other objects were destroyed as evil fetishes by their owners or by the spouses of the owners or by other relatives when they converted to Christianity. Many sculptures were sold by their owners to various Europeans, such as Greek traders living in the area, in order to obtain advantages or to acquire cash. Nevertheless, large numbers of sculptures remained in the hands of their owners. Because of this unusual loss of sculptures, and also because new initiates continued to be recruited, a scarcity of objects occurred, a scarcity that was all the more acute since from year to year there were fewer and fewer artists available to make new sculptures.

A great variety of approaches to this prob-lem were open to the Lega, especially since the Lega held in great respect the tradition of doing things in autonomous and locally relevant ways. The various options that were chosen—never all of them in the same ritual community—can be summarized as follows:

1. *Changes in attitudes toward functional categories based on differences in primary materials.* In Lega tradition, each *lutumbo lwa yananio* has one wooden mask (*lukwakongo*) and each *lutumbo lwa kindi* has one ivory (or elephant bone) mask (*lukungu*). Increasingly, kindi would be permitted to have a well-polished, wooden masquette as an imitation of the ivory masks. This is one example of simple adjustment to the increasing difficulty in securing ivory sculptures.

2. *Changes in patterns of ownership.* As stated under number 1 above, in Lega tradition each lutumbo lwa yananio has a wooden lukwakongo mask as a major symbol of his rank and grade. Faced with the increasing scarcity of these masks, some lineages would prescribe only one such mask for all its members of yananio grade, which would be held in trust by the most junior initiate of the lineage group. Another change in ownership patterns was a shift from collectively held initiation objects to individually kept pieces. The collectively held kindi basket contains, traditionally, a number of natural objects, artifacts, and wooden anthropomorphic figurines. In some communities these figurines were removed from the baskets and kept individually by the "wisest" of kindi—partly as a measure of protection against raiding and partly also to enhance the prestige of these men, who personally owned fewer and fewer carvings.

3. *Replacement of sculptures by other kinds of*

objects. Carvings, artifacts, and natural objects have always been closely interconnected in the bwami initiations. Similar symbolisms can be expressed adequately through a variety of means. In the extremely important and complex *mukumbi* rite, the deeply buried animal of that name (symbolizing the dead body of a high-ranking kindi) can be represented by an animal carving but also by a piece of stuffed hide. Such traditional substitutions and replacements occurred with greater frequency.

4. *Use of European-made objects.* There was never a dense European settlement in Legaland. Outside the administration and trading posts, and the mission stations, the main concentrations of Europeans were found in the few but very important mining centers that had developed in Legaland. Many thousands of Lega worked within and outside Legaland for the European sector; many also were converted to Christianity. Bwami, however, was not readily open to external influences. It is all the more astounding, therefore, that a few Lega communities introduced European-made objects into their initiations, although their number was restricted and their range limited to madonna images, dolls, perfume bottles suggestive of a human body, light bulbs, aluminum, and china dishes. In those few areas where these items were used, they were conceptually equated with figurines (first four sets) or masks (last two sets). It should be explained that some of these objects were specifically used to allude to the many undesired changes that had come with the Europeans. The use of the light bulb is a case in point. The appearance of this object was accompanied with the aphoristic statement: "He who seduces the wife of a great-one, eats an egg with rotten odor." This indicated that with the advent of the whites everything had changed, for the severe sanctions that were traditionally exercised against those who seduced a high-ranking initiated woman were not recognized by the colonial courts. Traditionally, the high-ranking *kanyamwa* woman was married forever to her husband, with whom she had gone through the initiations, but divorces and remarriages of such persons were now tolerated by the established authority.

5. *Use of new types of objects carved by non-Lega artists.* Some Lega communities made a limited use of wooden ebony carvings (such as busts, drummer figures, realistic animal figurines), which they attributed to the Bausa. These sculptures, made by foreign carvers, have their origin and source of inspiration in the works produced by the corporation of sculptors from Buta (northeastern Zaïre). This corporation, which had its origin around 1904, was originally composed by Zande carvers.[4] As the corporation developed, some of its members scattered to settle in other urban centers and in mining or administrative towns, such as Kisangani, Bumba, and Titule. There are three ways in which carvings of this type entered Lega society. Some of the objects were bought from Zande, Mangbetu, and other northeastern Zaïre laborers who came to work in mining centers established within Legaland; others were exchanged with Europeans; and still others were purchased in small local shops. In line with their traditional code of aesthetics, the Lega initiates appreciated the

[4]For a discussion of the activities of these Buta carvers, see: Anon., "Corporation des Ebenistes de Buba," *Brousse*, 3:39–41, (1939).

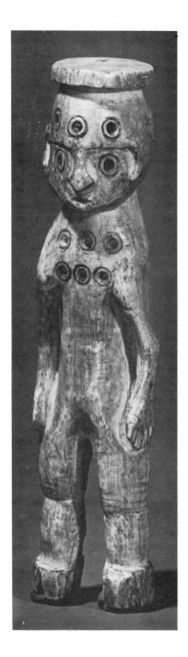

106. Lega ivory figurine received in 1952 by author among the Beigala clan from Kimangamanga, an initiate of *kindi* rank. Although observing the canons of Lega style, the sculpture lacks the patination, gloss, and finish which are so typical of the Lega ivory sculptures. Although the object cannot be dated, there are reasons to believe that it was carved after the decline of Lega sculptural traditions had already set in (17 cm. ghih).

smooth surfaces and the heavy gloss and patination of these pieces. These foreign sculptures were fully integrated into the traditional system of initiatory teachings. Those figurines that represented new subjects (e.g., drummer figures or the representation of an elephant trampling an animal) were interpreted through appropriate traditional aphorisms.

6. *Continuation of a gradually vanishing local carving tradition.* Eroding influences began to work on the bwami activities around the later part of the nineteenth century, as was described above, and by 1916, various types of repressive actions were undertaken against bwami. In particular, the creative tradition of carving was weakened at an early stage. The amount of artworks produced steadily declined from the turn of the century on. The skill and techniques of the artists also degenerated rapidly, probably because of a hiatus in the training and teaching process, which created a gap in cultural transmission between the established carver and his young apprentice. The learning process is one of prolonged, continued contact and cooperation between

carver and apprentice. For more and more young men, it became progressively harder to keep up with this tradition because of the compelling influence of administration, missionaries, and agronomists in matters of education, agricultural activity, and the general use of time. The demand for artworks also became more and more irregular. It must be kept in mind that the occupation of carver was never considered to be prestigious or particularly rewarding.

In the 1950s, the carvings actually possessed by the kindi and yananio initiates showed this decline in artistic skill (figure 106). They ranged widely from what obviously were outstanding, well-patinated carvings to unpolished, unpatinated, or artificially patinated mediocrities. I do not mean to say that earlier Lega carvers had always produced outstanding pieces—early collections in European museums testify to the fact that they did not. But I have seen hundreds of these sculptures and can say that the few sculptors who produced carvings in the later periods, from 1933 to about 1948, had lost most of their artistic skill.

In 1952, when I did my first research among

107. Lega ivory figurines; received by author in 1952 among the Baziri clan from Kikuni, a *kindi* initiate. The piece was carved by a Lega sculptor of the Bakabango clan (southeastern Lega) who came to settle in Kikuni's village sometime between 1940 and 1945. It signifies an almost complete rupture with the Lega style, although the general form (a head on a neck) and size still fit well within the Lega pattern (11 cm. high).

108. Lega ivory figurine; received by author in 1952 from Misenga, an initiate of *kindi* grade. The object was carved by a sculptor of Lega origin who was already cut off from the Lega sculptural tradition, and who, living at a small mining center, was already largely inspired by non-Lega techniques and forms (20 cm. high).

the Lega, the carving tradition was dead. A few younger men of Lega origin living around mining centers did some carving in ivory, but what they produced was poor in quality, narrow in range, and based on European-inspired techniques and motifs (figure 107). These carvers were clearly cut off from the bwami traditions.

In the last decade since independence, many hundreds of clumsily made, artificially patinated ivory carvings—a large number of them poor copies of traditional works—have found their way into Western collections and museums, where I have had the opportunity to see many of them (figure 108). A large number of these carvings are of questionable authenticity and some are outright fakes. A great number of them are poor copies by carvers who are cut off from the tradition, whether they are Lega or not. These carvers are not trained in the traditional techniques; they do not understand the genius of the traditional art; they do not work in the social context to which these works they imitate belong. An authentic new Lega art has not emerged and cannot emerge so long as the carvers are not liberated from traditions that are not their own.

CONCLUDING REMARKS

The Lega carvers created and produced for their bwami association a highly original art, diversified, and beautiful in its forms and unusually rich in its meaning and content. This art was meant to be owned, used, and understood only by those persons who had, through initiation, achieved the summit of wisdom. The social functions and the symbolic meanings of this art were always placed sharply in the foreground by those who owned it. This art was an intrinsic part of a complex initiation system that provided social status and, more importantly, that led individuals to the attainment of the supreme value of goodness and beauty. The art was an intimate part of the system of social status and prestige; it was an expression of social solidarities and oppositions; it was an essential iconic device in a system of teachings. The Lega carving or sculptural art did not exist in isolation, but contributed only a small part of a vast number of material objects used and interpreted in the initiations. It was complementary to the other objects, but not exclusive of them or a replacement for them. On the contrary, these other objects were easily substituted for artworks. The artworks were charged with mystic meanings for their owners and for all those who did not own them but who aspired to acquire them through initiations. Such art objects achieved their finish only through consecration in the initiations. Through prolonged and regular use, the ivories and many of the wooden sculptures acquired the delicate shades of patination and coloring that are their single most distinctive quality. This was a highly specialized art that had no raison d'être outside bwami.

In the colonial period, bwami was the target of much corrosive action from the outside. Bwami as a form of organization, as a world view, and as a system of ethics continued to exist and to function, but within the changing social framework it steadily lost much of its external pomp and grandeur. In the general disarray, the tradition of creative artistry vanished rapidly; carvings and sculpture were no longer essential. But bwami could continue to function because there was other art available; the older, traditional art was gradually replaced and the carvers and sculptors died out. The initiates took the stoic position: "Poverty is no shame and not a reason to become a thief." To be ashamed and persecuted, however ("chicken is beaten by rain, the feathers are hanging"), is unbearable.

20. Functional and Tourist Art Along the Okavango River

B. H. Sandelowsky

The Okavango, a river without an outlet into the sea, rises in central Angola. For about a third of its course it forms the boundary between South West Africa and Angola before it disperses in the Okavango Swamps in northern Botswana (see map 9). It is a smooth-flowing river, which may be as wide as a mile in some places during the rainy reason but only a hundred years wide in other places during the dry time of the year. Since it can be crossed easily by tree-trunk canoes, members of the same family often live on both sides of the river. The banks are fairly densely populated, whereas villages are more widely scattered as one moves inland into the flat, sandy, thickly bushed plain.

On the northern bank, settlements of whites are limited to police stations, trading stores, and mission stations. Larger centers in northern Angola can be reached only by four-wheel-drive vehicles over very poor roads. On the southern side of the river a scraped gravel road runs parallel to the river all along the border. At some places, two-wheel tracks branch off into the bush for distances of from five to ten miles, beyond which only the single tracks made by ox-pulled sledges lead to villages farther away. The loose sand and dense *mopane* vegetation make it very difficult to drive a car in these regions.

Rundu, the administrative capital of the Okavango Territory, approaches the size of a small town, with a trading store, a post office, a hospital, and depots for the government departments of roads, water affairs, and education. Situated on the bank of the river, Rundu is also the terminus of the gravel road from Grootfontein, about one hundred fifty miles south, its nearest town in northern South West Africa.

The Okavango Territory is a Bantu Homeland, an area administered somewhat similarly to an Indian reservation in the United States. It covers an area of approximately

Beatrice Sandelowsky was awarded her Ph.D. in anthropology from the University of California, Berkeley, for her work on the iron-age archeology of Southern Africa. As a native and resident of South West Africa, she has carried out research on both the archeology and ethnology of the area and is currently staff archeologist of the Namib Desert Project.

16,400 square miles and borders on Ovambo-land, another Bantu Homeland, in the west. In the east, South West Africa borders on Botswana, Rhodesia, and Zambia in the Caprivi Strip. The South African government is developing the Okavango Territory by building roads, opening up water resources, and constructing administrative and social centers. These undertakings employ local people as well as whites from South and South West Africa, who are permitted to stay here temporarily in their official capacity. The only white visitors allowed into the area are friends and relatives of these people and of the missionaries who have a history of about seventy-five years in this region (Streitwolf 1911). During recent years, the police and the army have manned stations in this territory and have a high turnover of personnel.

The People of the Okavango Territory

According to the 1960 population census (Odendaal Report 1964), 27,871 people inhabit this Bantu Homeland. The bulk of the population belongs to one of the five Bantu-speaking Okavango groups, but there are a few wandering bands of Bushmen. For political and economic reasons, small groups of Chokwe, Kalochasi, Wanyemba, and Shimbundu have immigrated into the area from farther north in Angola during the last three or four decades. Some wanted to escape the terrorism that had been raging in Angola for many years; others came to seek employment; and two informants stated explicitly that they came to South West Africa because their wood carvings sold better there.

Geographic and linguistic differences distinguish the Okavango groups from one another. Traveling from west to east, one crosses the areas of the Kwangari, the Mbundza, the Sambyu, the Gciriku (Mohlig 1967), and the Hambukushu (van Tonder 1965), who spread into the Caprivi strip. Stanley (1968) claims that differences between the languages of the Mbundza, the Kwangari, the Sambyu, and the Gciriku are dialectal, whereas the Hambukushu speak an altogether different language. According to informants, the languages of the Kwangari and Mbundza are very similar and mutually intelligible with the Sambyu language. Speakers of these three languages generally claimed ignorance of the Gciriku and the Hambukushu languages.

The immigrant groups from Angola resemble the Okavango groups physically and linguistically. Their villages or homesteads, comprising from five to fifteen huts built of wood and grass, sometimes enclosed by a wooden stockade, are similar and members of all groups plant maize, sorghum, and tobacco, and raise cattle, goats, poultry, and pigs. The farm produce is not sold on a large scale but is mostly for local use. Small quantities are sometimes exchanged between individual families and also with Bushmen families, who offer wild vegetables and berries in return.

Markets and marketing are foreign to the indigenous peoples of this area, as well as to those farther south in central and southern South West Africa. This is in contrast with most other parts of Africa, where markets are widespread and usually associated with people who practice agriculture and live in per-

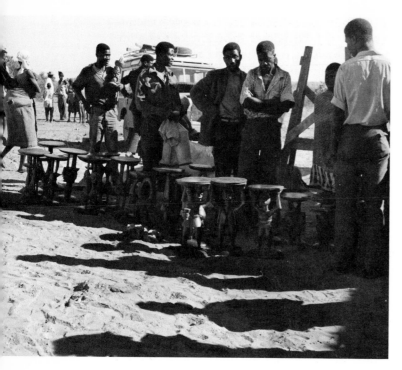

109. The weekly art market at Rundu.

Guthrie (Oliver 1966) has suggested that four major migrations of Bantu-speaking peoples have taken place in the last two thousand years. The Okavango groups probably represent the descendants of the earliest arrivals of the fourth Bantu migration into the area, at about 840 A.D. (Sandelowsky 1971), whereas the Angolan immigrants perhaps represent the final phase of this movement.

When attitudes toward commerce and marketing were explored, a remarkable difference was discovered between the Angolan immigrants and the Okavango groups. Whereas the immigrants seem to be familiar with the principles of marketing and are handling commercial concepts in the process of making and selling wood carvings, the Okavango groups are either unaware or uninterested in this economic sphere. Consequently, the bulk of wood carvings sold commercially along the Okavango are produced by the immigrant groups, many of whom are Chokwe (cf. Crowley 1965).

The Market for Art Objects

All over the world the demand for African arts, and wood carvings in particular, has increased over the last decade or so, and this tendency can be noticed also in South West Africa. Whereas it was hard to find carvings for sale in a shop ten years ago, today there are souvenir shops dealing in nothing but ethnic arts and crafts. Department stores devote whole sections and large display windows exclusively to these souvenirs, particularly during the tourist season. In most homes, white as well as African, carvings are used for

manent villages. Most parts of South West Africa were traditionally inhabited by Khoisan-speaking hunters and gatherers and by pastoralists, including one of the few Bantu-speaking pastoralists, the Herero (Vedder 1928). The Herero occupied areas south of the Okavango region in pre-European times. It is therefore interesting to consider the Okavango Territory as a border area between seasonally migrant, hunter-gatherer, Khoisan-speaking peoples in the south and sedentary, agricultural Bantu-speakers in the north.

both decorative and utilitarian purposes—bowls, stools and chairs, sculptures of animals and people. Some people have started fine collections of which they are proud.

The South African government has realized the potential of the art market and is handling the bulk of the trade in the Okavango Territory. A government agency holds a weekly market at Rundu, where almost every carved article for sale is purchased. Early on Friday mornings people start assembling and line up in front of the office (see figure 109), where an official sits with his assistants who mark and store the purchased goods in the adjacent shed. Many carvers, their wives, or whoever brings the articles to be sold come from Angola and may have traveled one or two days on foot or on bicycle. While they are waiting in a line to file past the official's table, they will still be busy polishing their carvings. In the office, transactions take place rather rapidly. It was difficult to ascertain how prices were fixed, but there seemed to be some kind of norm to which the sellers adjusted. I observed whites buying from the people in the line outside the office. The sellers appeared to be rather inflexible about the prices they asked. Following them into the office, I was surprised to hear them demand twice the price from the government official, but I recognized the strategy when I found that they would then reluctantly agree to half the price in accordance with the official's counter offer. Often the government agent would explain the prices he paid with such comments as "This is smooth and well-finished, therefore I give you a good price" or, rather more subjectively, "I do not like this kind of bowl . . ." The personality of

this official is instrumental in creating the atmosphere at the market and his taste has quite a strong influence on the style and content of carvings. The crafts bought by the government are shipped directly to Pretoria, from where the bulk are sent to overseas markets in Europe and America.

Some people also take carvings to the three or four trading stores along the river that are run by a labor-recruiting organization, which also owns a large gift shop in Grootfontein. Tourists will travel hundreds of miles to Grootfontein in order to buy at this shop, where prices are more than twice as much as at the Okavango but still less than they would be in Windhoek or in other towns farther south.

Along the road from Grootfontein, a few miles before Rundu, there are two large stands where Africans sell carvings to people in passing cars twice weekly. Similarly, for a stretch of about 25 miles west of Rundu, one comes across small stands every two to three miles. They are marked by a mask tied to a pole (figure 110) or by a carving on a small pedestal and are generally run by immigrants who live along the road and sell to those whites who are allowed to enter the territory. Often these travelers are asked to buy carvings for their friends. Gift-shop owners try to get people to bring back whole carloads. Many police and army recruits who come from the Republic of South Africa are also keen to bring home souvenirs from this remote area.

As soon as a car stops at one of these small stands someone will come running from a nearby hut carrying one or two carvings and will try to sell them. The longer one stays and the greater the interest and money shown the

110. A roadside stand marked by a mask tied to a pole.

"We try to find out what people want to buy." Those pieces that sell readily are recarved and those that do not sell are not repeated.

Prices along the roadside are rather erratic and depend on a number of factors. Afrikaans is the lingua franca and those Africans who have gone to school in South West Africa or have worked for whites can usually speak it. But people who have immigrated only recently, or perhaps have come across the river to sell some carvings, may be unable to communicate with white buyers, who can only rarely speak Fanagalo or any Bantu language. If the seller is unfamiliar with money or with the local currency, his problem is compounded. Not only will he be unable to understand how much he is being offered, but also he will not know how to evaluate the sum.

Finally, the selling of carvings to Africans should be mentioned. Local people usually seem to acquire carvings in exchange for farm produce or service. Some probably also buy carvings, but they are not seen as customers at the stands unless they accompany white visitors. My assistants, who were Tswana and Colored, bought articles to take home to Windhoek.

Most carvers have little understanding of the factors influencing the general demand, probably because they are so far removed from the retail market. In the beginning of 1970, prices for carvings along the Okavango dropped to a ridiculously low level (e.g., $1.00 for a carved stool 2-feet high) because the government agency in Rundu, in this case the greatest consumer, suddenly stopped buying; they had run out of storage space. Many people did not realize that this was only a tem-

more people will come with articles for sale. An awareness of marketing principles and a concern to make money were displayed by sellers, who were prepared to discuss the merits of their work in relation to price. The method of marketing was described to me:

porary state of affairs and were anxious to sell for any price they could get.

Experienced Chokwe and Kalochasi carvers in villages I repeatedly visited over two years said that they did very well selling their products by the side of the road, since, they maintain, they do good work. They do not take their carvings to the Rundu market because the prices paid there are too low. They said, however, that in Angola white people pay even less and that is why many people from Angola come to sell at Rundu. The monetary gain from carving is not so great as to make carving the most desirable method of obtaining money. Philipus Lokuna, a young Chokwe carver I met at the Rundu market on my first visit to the area, had taken up a job with the road-building team when I came back a year later. He said he wanted to see whether he could make more money there. He still liked to carve, but he had very little spare time to devote to it.

ARTS OF THE OKAVANGO GROUP

The Okavango groups essentially carve functional objects for their own use or for local African customers. Wooden buckets, mortars, pestles, drums, spoons, bows and arrows, throwing sticks and walking sticks, spears and boats are the objects a young Okavango boy learns to carve. The first attempts often are on a small scale and serve as toys. Although most men can carve, some have the reputation of being better carvers than others; often individuals excel in the carving of one particular object. It seemed a matter of common knowledge who carved the drums and boats, although some might have been carved many years ago. Many of these utilitarian articles are decorated. *Urenga* is the word for decoration in the languages of the Kwangari, Mbundza, and Sambyu. Markus Karopu, a Kwangari drummaker, explained a number of other terms that referred to specific design elements on drums and to parts of the drum. This indicates a certain degree of specialization and a concern with nonutilitarian issues.

In discussing the Western concept of "art" with Alex Kudumo, a Kwangari informant, I could discover no similar single term. *Muhongi* is a word for "expert," someone who distinguishes himself as a dancer, carver, or metalsmith. There also is a word for the concept "providing people with pleasure" by doing something extraordinarily well, such as singing or playing the drums. Individuals to whom these terms are applied are openly admired and considered gifted or talented. According to Alex Kudumo, language and music, poetry, riddles, proverbs, and games involving singing and dancing are genres of art that the Okavango peoples developed and emphasized more than the graphic and plastic arts. Many games require spontaneous rhyming or prose composition, as well as the composition of short tunes or melodies. Such entertainment can stimulate artistic expression that might otherwise be channelled into sculpture or painting.

Several carvers of the Okavango groups were interviewed with the aim of ascertaining their awareness of the tourist market and their interest in carving to make money. These in-

111. An entrepreneur's souvenir stand not far from Andara.

A Hambukushu man, curiously enough living in a remote part of the territory, was very money conscious and determined to exploit every possibility of making a profit. Although he could not carve very well himself, he was selling the carvings of his brother, who was more concerned about carving than about selling. In addition to carvings, this unusual entrepreneur also sold beer and provided entertainment to anyone prepared to pay. His lucrative cafe-cum-souvenir shop is situated right next to the road, not far from Andara. As soon as a car slows down, carvings are brought out of a hut and displayed on a table (see figure 111), which serves as a counter behind which the salesman positions himself in a business-like manner. In contrast to his money-conscious attitude, his wife refused to sell me a ladle with which she was stirring food. Although I offered a good price and her husband urged her to sell it, she could not be persuaded to part with it.

I talked to only one other member of the Okavango groups who was convinced that much money could be made from selling carvings. He was learning to carve stools from a Kalochasi man who was himself a successful carver. Other isolated instances of such apprenticeships were mentioned to me but this could not be said to be a common trend in 1968 and 1969.

A Sambyu man known for making beautifully decorated *dolf*-wood spoons as well as knives with wooden sheaths for local customers was obviously not interested in changing his ways. His homestead is close to the main road and this is where he works. Africans will walk long distances to come and

terviews indicated that many carvers of the Okavango groups do not make use of their carving skills for getting cash money from the tourist market. Only two informants were enthusiastic about the profit that could be made from selling to whites.

ask him to carve something for them. His output is rather small, since he lives by himself and also has to do the gardening and housework. When I visited him, he was working on two spoons for an African teacher from Rundu. The spoons had handles about 10 inches long attached to spherical bowls. A complex geometric design was incised into the handles. He was reluctant to take on orders for making more spoons or knives. It was apparent that he did not consider the possibilities implicit in the fact that people were continuously placing orders with him and that if he did have surplus items he could always sell them to passersby on the road, Africans as well as whites.

A Kwangari man who lived far away from the main road had decided that he would do better economically if he spent his time looking after his cattle and his fields than if he spent his time carving. He was rather bitter about having tried to make money from carving and having found it unfeasible because too little money was paid for the long hours of hard work. If someone came to his homestead and wanted to buy something, as I did, he would consider selling it, but ordinarily he only carved things for his own use, like the elegant pipe he was smoking.

This general attitude was shared by another Kwangari man, also living far from the road. He was making wooden buckets, canoes, spatulas, and spoons for his own use, and had never sold anything to white people, but if they came to his homestead he would be willing to sell them things he had made. He had heard that the Chokwe people were making money selling to white people, but he did

not really know them. Once he had gone down to the river to sell five wooden buckets he had made and he sold them to Africans. He was not contemplating doing something like that again because it took two full days to make one bucket and it was too far to walk. Presumably, too, the prices paid were too low.

One man who was reported to be able to make good drums had been to Johannesburg many years before. Although he must have been exposed there to ideas of marketing and the selling of tourist art, he was not interested in making drums or other articles for sale.

Most carvers from the Okavango groups make no effort to enter the market for tourist art. The immigrant carvers, however, make use of what opportunities there are to sell tourist art, and the Okavango groups are therefore exposed to the possibilities of economic gain through woodcarving. It seems doubtful, however, that the functional art production among the Okavango groups will develop into production for tourist trade unless the economic and prestigious advantages attached to woodcarving become more obvious.

THE ARTS OF THE IMMIGRANT GROUPS

The Angolan immigrant groups also carve functional objects for their own use, and some items, such as combs and mortars, are sold to the Okavango groups or to each other. Madonnas and ornamental items that perform religious functions are also carved for mission

112. Abisai Kasanga, a Chockwe carver.

Carving for sale to whites figures more prominently among these groups than does the carving of functional objects for their own use. Woodcarving is often discussed. Carvers criticize each other and are rated by other members of their group. When I showed two accomplished Chokwe carvers items I had bought elsewhere along the road, they identified the makers and then proceeded to comment "Who has ever seen a person with such eyes?" or "How can a person have such a chin?" Such remarks indicate a concern with the accepted style and with realism.

Most men carve, but reputations vary considerably. Four or five carvers may be seen, sitting together in the shade of a tree or under the roof of an open hut on the ground or on logs of wood, working with a hacksaw to get the base of a stool even or roughing out a mask. Onlookers, often old men, comment and give advice, particularly if someone has a problem. When part of a nose that one man was carving broke off, he was told "you could glue it on or make it smaller and broader." Tools lying near the carvers usually consist of a hand drill, a file, sandpaper, and floor polish (figure 112). The most commonly used tool is a hatchet; it is made by hand and consists of a wooden handle with a thickened head for hafting the blade, which can be inserted either vertically, to be used like a knife, or horizontally, to be used like an axe. Okavangos as well as Angolans carry this hatchet almost anywhere they go, the blade hooked over the shoulder. It is used for felling trees as well as for doing the more delicate work of cutting out the design on a carving; pocket knives are used in the final stages.

churches. Traditionally, carvings also served religious functions in rituals and ceremonies. The ultimate purpose of these carvings, therefore, is still the same, a religious one, but there have been changes at the level of medium and technique.

ART PRODUCTION AND INTERCULTURAL TRANSMISSION

In the Okavango Territory, contact between the dominated small-scale society and the larger civilization is twofold. On one level, there is direct personal contact between the members of the two groups, which is limited here because of the small number of whites permitted into the area. There are most likely many Africans here who have never had individual face-to-face contact with whites. On another level, however, there is an overall awareness of the existence of the dominating culture. How far the knowledge of the outside world goes is hard to ascertain, since many people, particularly women, have never left their homelands. An interest in conditions beyond the borders can be deduced from the fact that I have been asked questions about what people do with the wood carvings they buy when they get home.

Sociopolitical conditions influence both the supply and the demand for wood carvings in the Okavango Territory. Since movements of people, particularly potential buyers of ethnic or tourist art, are restricted, the government can control the bulk of the demand. Presumably, prices will be kept at a sufficiently high level to ensure the continuation of carving, since the government has recognized its commercial value. These prices would be seriously affected if other buyers were to enter the market.

There have been rumors that the Territory might be opened to tourists at some time in the future. Such an eventuality would increase the contact between the carvers and a wider spectrum of their customers. At the moment, the response to the carvings by most of the individual buyers is known to the carvers only through those individuals who visit the territory and buy items for themselves and their friends. The reaction of the official buying for the government must be considered a personal one, since there appeared to be no organized or reliable method of feedback from the wholesalers and, in turn, the retailers. But a system relaying buyers' preferences may develop as a result of pressure from wholesalers; for example, a wholesaler in Johannesburg expressed to me her dissatisfaction over not getting the articles she was requesting from the Okavango Territory—on the other hand, she showed me some beaded tennis balls that had been produced by Ndebele bead workers in answer to her request for some type of Christmas decoration!

It may be the present lack of a more general reaction from a wider cross section of the buying public that has prevented carvers in the Okavango Territory from organizing a factory type of art production. Conveyor-belt type of art production like that found among the Kamba carvers in Kenya (see page 6, above) is not foreseen here. Although many aspects and values in the indigenous culture are changing owing to the influence of the dominant culture, the effects are not as gross here as they would be in an urban situation, such as in Nairobi, where contact between the different groups is both more intensive and more extensive. Constant exposure and competition with the dominant culture tends to downvalue indigenous standards. It has been suggested that this may stifle the expression of a

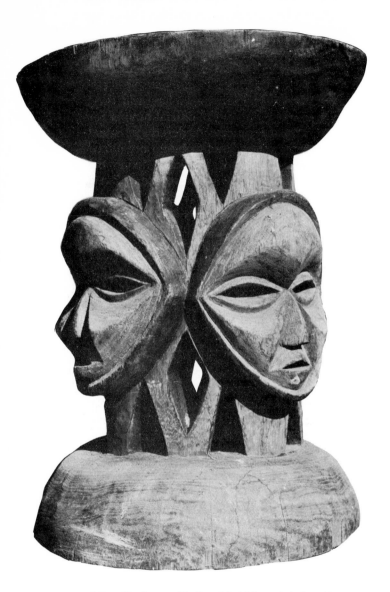

113a. Stool carved in the old, African style (ca. 46 cm. high).

self-image, replacing it with one representing the values of the dominated culture (Graburn 1969b, c).

Many of the whites coming to the Okavango Territory (which is markedly different from the white areas in the rest of the country) have a different attitude toward Africans and their way of life here from the one they have toward Africans with whom they are in closer contact elsewhere in the country. This attitude minimizes overt differences between whites and Africans, since it is characterized by more interest and understanding than "at home" where the standard ethnocentric set of values is not questioned. Although Africans in towns and farms in South West Africa have adopted many outward characteristics of Western culture, such as dress, housing, and occupation, the inhabitants of the Okavango Territory have maintained a traditional lifestyle that gives them a touch of the exotic. The production of artistic carvings could enhance this attitude and become a powerful symbol of ethnic identity and pride.

Changes in content and style of the wood carvings indicate that carvers have enough self-confidence to create and innovate in order to adjust to changing circumstances. Although there is a considerable amount of repetition in the carvings, it cannot be said that only those items that have proved successful sellers are being made.

Round stools with from two to four faces of masks carved into the central supporting stem are the oldest and best known Okavango art article. They were collected by early travelers, and specimens in museums, private collec-

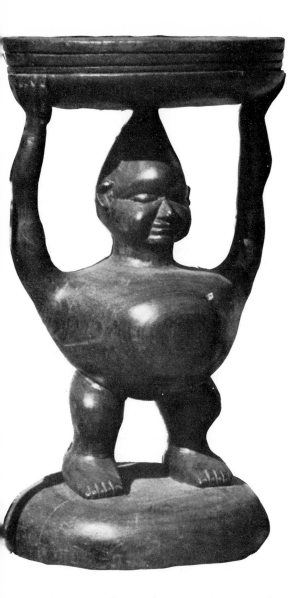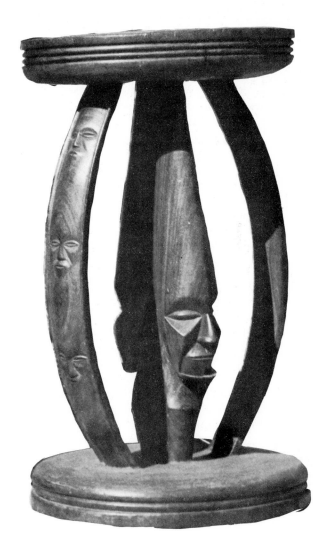

113b. Two stools, carved in the new commercial, polished, style (ca. 46 cm. high).

tions, and at mission stations (figure 113a) date back to the turn of the century and possibly prior to that. The style and size of these stools has changed; stools today are rarely as large as the old ones (figure 113b). One reason for this may be a lack of large trees, which have all been cut down to fill the carvers' demands for wood. The indigenous *dolf* tree supplies the raw material for all the carving. Younger trees are light in color and the older ones have a dark red to brown color. Today, these trees are so scarce that the South African government is planning to plant more and to import wood. Saw mills will be built where the carvers can get precut blocks of wood for their carvings.

Motifs that are no longer carved are those depicting a group of people performing hunting magic, holding a council meeting, or attending to the birth of a child under traditional circumstances. Today, hunting magic is discouraged and the exemplary way of having a child would be in a hospital. It is possible that the activities formerly depicted are no longer being carried on and that the disappearance of these themes in art may be a reflection of that. But is is also conceivable that there is a difference between the image that the people actually have of themselves and the self-image that they choose to portray to the superordinate culture. Since magic and rituals are condemned by the dominant society, these customs may be denied and would not be used as an expression of the cultural self-image in carving. But these practices may still be carried on and may be an important part of the actual self-image of the group.

The maintenance and expression of a self-image by the Okavango peoples may aid the mutual understanding and communication between the two cultures, as is illustrated by the following two examples. When the buying and selling at the weekly market and at the roadside stands is observed, it is obvious that certain types of carvings are more common than others. Unusual articles may attract attention but do not necessarily sell well. The prices of such articles often drop to a fraction of what they were originally and sometimes elaborate carvings, which must have taken a great deal of time and effort to make, sell for very little.

Mr. Hoehn, an official residing at Rundu who collects ethnic arts, recounts the instance when the carving of a large figure in strange array wearing a mask with a tall,pointed hood attracted his attention. The maker had come from far away and could not sell his carving. It was meaningless to all potential customers because it portrayed a traditional dance costume unknown to all but the ethnologically well-versed white. Mr. Hoehn purchased the carving and never came across another one like it. The carver had represented something of value in his own culture but failed to communicate its important meaning to members of the other culture.

Another carver had a similar experience. He tried to capture the spirit of an item from the dominant culture by carving a chalice out of wood (figure 114) that resembled the gold or bronze chalices used for wine during Roman Catholic church services. But it was not recognized as such, possibly on account of its size projection, the raw material, or because it is unusual to see items of this type produced in the medium of tourist art. Here, too, the carver

had great difficulty in selling his work because he failed to communicate its meaning to his buyers, or they were not interested in an atypical version of the familiar item.

In contrast to these two examples, are carvings of soldiers, guns, pistols, airplanes, and madonnas. Some madonnas were made according to the precise instructions of a white lay priest who is a carpenter and prides himself on teaching the local people many things about wood work (e.g., drawing the circumference of a circle with the help of a piece of string fastened in the center). All the items just mentioned sell extremely well. Army recruits were seen to buy soldiers and guns three at a time. By successfully selling these items, the carvers have demonstrated that they have grasped and portrayed values of the dominant culture that its members eagerly acknowledge, thereby succeeding in the process of communication that had failed, and had thus proved unprofitable, in the case of the costumed figure and the chalice.

In view of the extreme racial segregation and sociopolitical attitudes typical in South West Africa, it is interesting to consider the hypothesis that the continuation of art production leads to increased respect for the artists (Graburn 1969c). Although art production in Okavango Territory is not carried on as a sole means of earning a livelihood, the whites are becoming increasingly aware of this art. Individual carvers are gaining reputations even among Afrikaans-speaking South West Africans, who are generally prejudiced against Africans. An old carver living in Angola is well known for making large stools supported by stylistically carved human figures, as well as

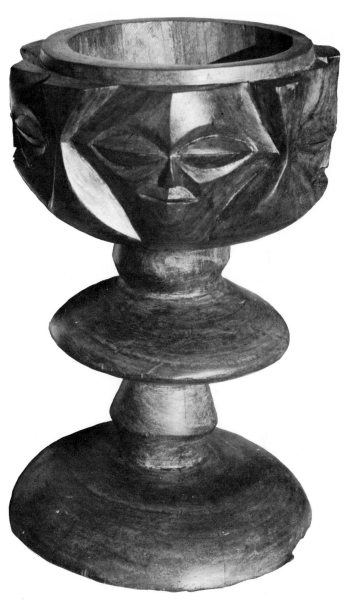

114. Wooden chalice (ca. 30 cm. high).

other exceptional pieces, such as adorned boats with human figures sitting in them. It is impossible to obtain any of his work on the spot because he has a list of customers prepared to wait six months or longer for anything he will carve for them. He is also said to carve only when he feels like it and will sometimes not carve at all for months on end. The only comments I heard from whites about this fact respectfully attributed it to his artistic temperament—illustrating the projection of a Western stereotype onto African society.

Similarly, a man living not far from Rundu makes a certain type of easy chair, which combines European and African stylistic features. It is accepted by whites that he cannot be ordered to complete assignments within a given time, and people continue to place orders with him since his work is very popular.

A positive attitude towards ethnic arts and crafts is also reflected in conversations with whites in the rest of the country. There has been a change from ignorance or arrogance to awareness and acceptance. This attitude has probably also been influenced by the worldwide attention drawn to African art. In South West Africa, this made itself felt through books in bookstores, occasional news items in newspapers or the cinema (South West Africa does not have television), and through visitors from abroad.

CONCLUSIONS

From the data given above, it would appear that to encourage increased understanding and mutual respect between the two groups in this colonial situation, one of the most important steps to be taken, or that is in the process of being taken by the dominant group, is the conscious identification of African woodcarving with the conventionally accepted European concept of art. Since art is essentially a prestigious value in Western culture, a positive basis for mutual understanding could be established if the dominant culture recognizes that it shares such a cherished value with the dominated culture. By representing an area of mutual interest, the wood carvings provide a meeting ground for the members from the different cultures. The nature of the relationship ensuing from this contact and the degree to which it grows closer, as well as the rate at which it develops, depend on a number of factors. But essentially the production of art acts as a mediating or positive influence in the situation of contact between the superordinate white culture and the subordinated African culture in the Okavango Territory.

It seems almost as though conditions along the Okavango River were set up for experiments in social science, with a number of different variables in otherwise similar situations. On the northern riverbank, the effects of industrialization and Western economic enterprise are very slight. Considerable effort is demanded from an individual to come into contact with Western society and its art-buying clientele if his works are going to be sold commercially on a large scale. On the southern bank, the impact of a Western, industrially minded society is much greater, although political conditions impose restraints on the market.

Furthermore, woodcarving is practiced here

by two culturally similar groups of people whose attitudes to commerce and marketing differ remarkably. Possibly the reasons for this difference can be attributed to influences from other population groups over the last centuries. Bantu-speakers moving southward from areas where markets are familiar appear well-equipped with commercial concepts. Bantu-speakers whose ancestors arrived in the Okavango area possibly more than a thousand years ago seem unfamiliar with the principles of marketing. If one assumes that the first arrivals practiced marketing, it is conceivable that it fell into disuse because a local population, which may have been in the majority, did not accept such an innovation.

Sociopolitical developments will play a crucial role in the future of woodcarving along the Okavango River. Further and more intensive study of the issues mentioned here would add to the understanding of processes of acculturation and of the cross-cultural phenomenon of art.

Credits for Specimens Illustrated

38 (a) Courtesy of the Lowie Museum.
 (b) Collection of N. Graburn.
 (c) Collection of Geoffrey Brown.
39 (a) Collection of Geoffrey Brown.
 (b) Collection of N. Graburn.

Chapter 8
47, 49, 50 Collection of the author.

Chapter 9
54, 55 Collection of the author; except 54a, Collection of Sandra McCosker.

Chapter 10
56 Courtesy of the Museo Historico Regional del Cuzco, Peru.
57, 58, 60 Courtesy of the Lowie Museum, #UCLMA 16–11945, #16–11941, and 16–11937.
59 Collection of Francisco Mayer, Huancayo, Peru.

Chapter 11
61, 62, 63, 64, 65 Courtesy of the author.

Chapter 12
67, 68, 71 Collection of N. Graburn.
69, 72, 73 Collection of Setha M. Low.

Chapter 13
74, 75, 75b Collection of the author.

Chapter 14
79 Collection of K. Buxton, Mount Hagen.
80, 81 Collection of the Museum fur Volkenkunde, Basel.
82 Collection of the author.
83 Courtesy of the Port Moresby Museum, Papua-New Guinea.

Chapter 15
 Courtesy of the author

Chapter 16
 Courtesy of the author.

Chapter 17
95 Collection of the Nigerian Museum, Lagos.
96, 98, 110 Collection of the author and Mrs. Bascom.
99 Courtesy of the Lowie Museum, #UCLMA

Chapter 18
102 Property of the artist.
103 Courtesy of the Lowie Museum, #UCLMA 5–3429.

Chapter 19
105, 106, 107, 108 Courtesy of the Musée Royal de l'Afrique Centrale, #55.3.86, #55.3.60 and #55.3.57.

Chapter 20
 Courtesy of the author.

Color plates
1 Lowie Museum of Anthropology, Berkeley, #UCLMA 3–26948
2 Lowie Museum, #UCLMA 2–5710.
3 Collection of Julius Stephen and Melissa Kassovic.
4 Collection of Gobi Stromberg.
5 Lowie Museum, #UCLMA 9–11424
6 Collection of Mari Lyn Salvador.
7b Collection of J. A. Abramson.

Photographers' Credits

Bibliography

ABRAMSON, J. A.
1970 "The Art of the Upper Sepik Undergoes Some Surprising Changes," *Artforum*, November, pp. 54–57.

ABRAMSON, J. A., and R. HOLST
n.d. "Hewa Bark-Painting and Style in New Guinea Art" Manuscript.

ADAIR, JOHN
1944 *Navajo and Pueblo Silversmiths*. Norman: University of Oklahoma Press.

ADAMS, MARIE J.
1973 "Structural Aspects of Village Art," *American Anthropologist* 75:265–279.

African Arts
(since 1967) Los Angeles: University of California, African Studies Center.

AGATHE, JOHANNA, et al.
1975 *Kunst? Handwerk in Afrika im Wandel*. Frankfurt am Main: Museum für Völkerkinde.

ALBRECHT, M. C. et al. (eds.)
1970 *Sociology of Art and Literature*. New York: Praeger.

ALLEN, LEWIS A.
1975 *Time Before Morning*. New York: Thomas Y. Crowell.

ALLEN, WILLIAM L., and JAMES B. RICHARDSON III
1971 "The Reconstruction of Kinship from Archaeological Data: The Concept, the Methods, and the Feasibility," *American Antiquity* 36:1:41–53.

American Indian Art: Form and Tradition
1972 New York: E. P. Dutton (for Walker Art Center, Minneapolis).

AMSDEN, CHARLES A.
1934 *Navajo Weaving*. Santa Ana, California: The Fine Arts Press.
1949 *Navaho Weaving*, second edition. Albuquerque: University of New Mexico Press.

ANDERSON, J. L., and D. HOGG
1969 *New Guinea*. Sydney: Reed.

ANDRADE, R. M. F. de
1952 *As artes plasticas no Brasil*. Rio de Janeiro.

ANONYMOUS
1939 "Corporation des Ebénistes de Buba," *Brousse* 3:39–41.
1968 "Institute of American Indian Arts," U.S. Department of the Interior, Indian Arts and Crafts Board, Washington, D.C.

ATAMIAN, S.
1966 "The Anatukvuk Mask and Cultural Innovation," *Science* 151:1337–1345.

BAHRE, CONRAD J.
1967 "The Reduction of Seri Range and Residence in the State of Sonora, Mexico

(1536–Present)." M.A. thesis, Department of Geography, University of Arizona, Tucson.

BAHTI, TOM

1964 *An Introduction to Southwestern Indian Arts and Crafts.* Flagstaff, Ariz.: K. C. Publications.

1968 *Southwestern Indian Tribes.* Flagstaff, Ariz.: K. C. Publications.

BANK, THEODORE P.

1960 "Contemporary Ainu," *Explorer's Journal* 38:2:12–24.

BARBEAU, CHARLES M.

1953 "Haida Myths Illustrated in Argillite Carvings," *National Museum of Canada Bulletin,* Number 127, Anthropological Series 32.

BARNETT, HOMER G., LEONARD BROMM, et al.

1954 "Acculturation: an Exploratory Formulation" (The Social Science Research Council Summer Seminar on Acculturation), *American Anthropologist* 56:973–1002.

BARRETT, SAM A.

1970 *Pomo Indian Basketry,* originally published in 1908. Glorieta, New Mexico: Rio Grande.

BARROW, TUI T.

1969 *Maori Wood Sculpture of New Zealand.* Wellington: A. H. and A. W. Reed.

1972 *Art and Life in Polynesia.* Rutland, Vt.: Tuttle.

BARTH, FREDRIK

1971 "Tribes and Intertribal Relations in the Fly Headwaters," *Oceania* 41:3:187–188, March.

BASCOM, WILLIAM

1957a "Africa: Equatorial or Esquitorial," *Esquire* 47:2:64–65.

1957b "Modern African Figurines: Satirical or Just Stylistic?," *Lore* 7:4:cover, 118–126.

1967 *African Arts.* Berkeley: Robert H. Lowie Museum of Anthropology.

1969a "Creativity and Style in African Art," in Daniel Biebuyck, ed., *Tradition and Creativity in Tribal Art.* Berkeley and Los Angeles: University of California Press, frontispiece, pp. 98–119, and plates 69–79.

1969b *The Yoruba of Southwestern Nigeria.* Case Studies in Cultural Anthropology (George and Louise Spindler, eds.), New York: Holt, Rinehart and Winston.

1973 *African Art in Cultural Perspective: An Introduction.* New York: W. W. Norton.

BASCOM, WILLIAM, and PAUL GEBAUER

1953 *Handbook of West African Art.* Milwaukee Public Museum, Popular Science Handbook Series, Number 5 (Robert E. Ritzenthaler, ed.). Milwaukee: Bruce Publishing Co.

BATCHELOR, J.

1971 *Ainu Life and Lore: Echoes of a Departing Race.* Landmarks in Anthropology, New York: Johnson Reprint Corp.

BATCHELOR, JOHN

1892 *The Ainu of Japan.* London: The Religious Tract Society.

1901 *The Ainu and Their Folklore.* London: The Religious Tract Society.

BATESON, GREGORY

1936 *Naven.* Cambridge, England: Cambridge University Press (Second edition, 1958, Stanford University Press).

BATTARBEE, R.

1951 *Modern Australian Aboriginal Art.* Sydney: Angus and Robertson.

BATTISS, W. W.

1958 *The Art of Africa.* Pietermaritzburg, South Africa: Shuter and Shouter.

BATTIST, SONDRA

1967 "The Curandera Artist," *Américas* 19:37–40.

BATTY, JOYCE D.
1963 *Namatjira, Wanderer Between Two Worlds.* Melbourne: Hodder and Stoughton.

BAUM, HENRY M.
1903 *Am Kubango: Kunene-Sambesi Expedition.* Berlin: Verlag des Kolonialwirtschaftlichen Komitees.

BEARDSLEY, R. K.
1973 "On the Vitality of Folk Arts in Modern Japan." Paper presented to the Advanced Seminar on Contemporary Developments in Folk Arts, convened by N. Graburn at the School of American Research, Santa Fe, N. Mex.

BEIER, ULLI
1960 *Art in Nigeria.* Cambridge: Cambridge University Press.
1968 *Contemporary Art in Africa.* New York: Praeger.

BEIER, ULLI, and A. M. KIKI
1971 *Hohao: the Uneasy Survival of an Art Form in the Papuan Gulf.* Melbourne: Thomas Nelson.

BEN-AMOS, PAULA
1968 *Bibliography of Benin Art.* Primitive Art Bibliographies, No. 6, New York: The Museum of Primitive Art.

1971 "Social Change in the Organization of Woodcarving in Benin City, Nigeria." Ph.D. dissertation, Department of Anthropology, Indiana University.

1975 "Professionals and Amateurs in Benin Court Carving," in Daniel F. McCall and Edna G. Bay, eds., *African Images: Essays in African Iconology.* New York: Africana Publishing Co.

1977 "Pidgin Languages and Tourist Arts," *Studies in the Anthropology of Visual Communication* 4:128–139.

BERNDT, RONALD M.
1951 *Kunapipi.* New York: International Universities Press.
1952 "A Cargo Movement in the Eastern Central Highlands of New Guinea," *Oceania* 23:51.

BERNDT, R. M. (ed.)
1964 *Australian Aborginal Art.* Sydney: Ure Smith.

BERREMAN, D. G.
1972 "Race, Caste, and Other Invidious Distinctions in Social Stratification," *Race* 13:385–414.

BICKMORE, ALBERT S.
1868 "The Ainos, or Hairy Men of Yesso," *American Journal of Science and Art* 45:135:353–361.

BIEBUYCK, DANIEL P.
1953 "La monnaie musanga des Belega," *Zaïre* 7:7:675–686, July.
1953 "Some Remarks on Segy's 'Warega Ivoires'," *Zaïre* 7:10:1076–1082, December.
1953 "Signification d'une statuette Lega," *Revue Coloniale Belge* 195:866–867.
1954a "De verwording der kunst bij de Balega," *Zaïre* 8:3:273–278, March.
1954b Function of a Lega mask," *Archives internationales d'ethnographie* 47:1:108–120.
1966 "On the Concept of Tribe," *Civilisations* 16:4:500–515.
1967 "Effects on Lega Art of the Outlawing of the Bwami Association," *Journal of the New African Literature and the Arts* 1:3:87–94.
1968 "The Didactic Function of African Art," *African Forum* 3:4:35–43.
1970 "Effects on Lega Art of the Outlawing of the Bwami Association," in Joseph Okpaku, ed., *New African Literature and the Arts*, pp. 340–352. New York: Thomas Y. Crowell Co.

1972a "Bembe Art," *African Arts* 5:3:12–19, 75–84, Spring.

1972b "The Art of the Kindi Aristocrats,, in D. Fraser and H. Cole, eds., *African Art and Leadership*, pp. 7–20. Madison: University of Wisconsin Press.

1973 *Lega Culture: Art, Initiation, and Moral Philosophy Among A Congo People.* Berkeley: University of California Press.

BIEBUYCK, DANIEL P. (ed.)

1969 Introduction to *Tradition and Creativity in Tribal Art*, pp. 1–23. Los Angeles and Berkeley: The University of California Press.

BIRD, JUNIUS B.

1963 "Pre-Ceramic Art from Huaca Prieta, Chicama Valley," *Nawpa Pacha* 1:29–34.

BLACK, R.

1964 *Old and New Australian Aboriginal Art.* Sydney: Angus and Robertson.

BOAS, FRANZ

1927 *Primitive Art.* Cambridge, Mass.: Harvard University Press.

1888 *The Central Eskimo.* Washington, D.C.: Sixth Annual Report of the Bureau of American Ethnology.

BOCHET, G.

1971 "Souvenir-Hunting," *Tam-Tam* 5:1, 3.

BODROGI, TIBOR

1972 *Art of Indonesia.* Budapest: Corvina

BOWEN, T.

(in press) "The Seri," in W. Sturtevant, ed., *Handbook of North American Indians.*

BOYD, E.

1959 *Popular Arts of Colonial New Mexico.* Santa Fe, N. Mex. Museum of International Folk Art.

1964 *Rio Grande Blankets Containing Head-Spun Cotton Yarns.* Santa Fe, N. Mex.: El Palacio.

BOYER, RUTH M.

1970 "Un Azucarero del Colonial Tardío," *Revista del Museo Histórico Regional del Cuzco* Nos. 3, 4, and 5, pp. 27–34.

BRADBURY, R. E.

1957 *The Benin Kingdom and the Edo-speaking Peoples of South Western Nigeria.* London: International African Institute.

1959 "Chronological problems in the Study of Benin History," *Journal of the Historical Society of Nigeria* 1:4:263–287.

1964 "The Historical Uses of Comparative Ethnography with Special Reference to Benin and the Yoruba," in J. Vansina, R. Mauny, and L. V. Thomas, eds., *The Historian and Tropical Africa.* London: Oxford University Press.

1967 "The Kingdom of Benin." In D. Forde and P. M. Kaberry, eds., *West African Kingdoms in the Nineteenth Century.* London: Oxford University Press.

BRAVMANN, R. A.

1974 *Islam and Tribal Art in West Africa.* London: Cambridge University Press.

BRIGGS, C. L.

1974 "Folk Art Between Two Cultures: The Wood-Carvers of Cordova, New Mexico." University of Chicago (ms).

BRODY, J. J.

1970 "The Kiva Murals of Pottery Mound," *Proceedings of XXXVIII International Congress of Americanists*, 1968, Stuttgart, 2:101–110.

1971 *Indian Painters & White Patrons.* Albuquerque: University of New Mexico Press.

BROWN, E. S.

1966 *Africa's Contemporary Art and Artists.* New York: Harmon Foundation.

BUHLER, A.

1962 *The Art of the South Sea Islands, Including Australia and New Zealand* (with T. Barrow and C. P. Mountford) New York: Crown.

BUHLER, C. A.
1971 *Oceanic Art: Myth, Man and Image in the South Seas.* New York: Abrams.

BUNZEL, RUTH
1929 *The Pueblo Potter: A Study of Creative Imagination in Primitive Art.* Columbia University Contributions to Anthropology, 8. New York: Columbia University Press.

BURLAND, C.
1973 *Eskimo Art.* London: Hamlyn.

BURLAND, C., and W. FORMAN
1969 *The Exotic White Man: An Alien in Asian and African Art.* New York: McGraw-Hill.

CALLEY, MALCOLM J.
1968 "Family and Kinship in Aboriginal Australia," *Proceedings: Ethnic Minorities in Australia,* A.C.O.S.S., Fifth National Conference, May. Brisbane, Australia.

CAPELL, ARTHUR, E.
1969 *A Survey of New Guinea Languages.* Sydney: Sydney University Press.

CARLSON, ROY L.
1965 "Eighteenth Century Navajo Fortresses of the Gobernador District," *The Earl Morris Papers,* No. 2. Series in Anthropology, No. 10. Boulder: University of Colorado Press.

CARPENTER, EDMUND C.
1971 "Do You Have the Same Thing in Green? or, Eskimos in New Guinea." Paper delivered at the Shell Program on the Canadian North. Scarborough, Ontario, 28 January. Mimeo.

1972 *Oh What A Blow that Phantom Gave Me!* New York: Holt, Rinehart and Winston.

1973 *Eskimo Realities.* New York: Holt, Rinehart and Winston.

CARPENTER, E., F. VARLEY, and R. FLAHERTY
1959 *Eskimo.* Toronto: University of Toronto Press.

CARROLL, KEVIN
1967 *Yoruba Religious Carving. Pagan & Christian Sculpture in Nigeria & Dahomey.* London—Dublin—Melbourne: Geoffrey Chapman.

CASANOVA ALVAREZ, FRANCISCO
1966 "Las Elites Recotras como Agentes de Cambio Social." Paper presented at the Xi Mesa Redonda de la Sociedad Mexicana de Antropología, Mexico City. Mimeo.

CENSUS OF INDIA
1901 *General Population Tables: Rajputana,* XXV, Part 1. Lucknow: Government of India.

1961 *General Population Tables: Rajasthan,* XIV, Part 11–A. New Delhi: Government of India.

CHAMBERLAIN, BASIL H.
1887 *The Language, Mythology and Geographical Nomenclature of Japan Viewed in the Light of Aino Studied . . . Including a Catalog of Books Relating to Yezo and the Ainos.* Tokyo: Imperial University.

CHAPMAN, KENNETH M.
1936 *The Pottery of Santo Domingo Pueblo.* Memoirs of the Laboratory of Anthropology, vol. I, Santa Fe, N. Mex.

1970 *The Pottery of San Ildefonso Pueblo;* supplementary text by Francis H. Harlow (Monograph Sch. Am. Res. 28) Albuquerque: University of New Mexico Press for the School of American Research.

CHARD, C. S.
1968 *A New Look at the Ainu Problem.* Tokyo: The XVIII International Congress of Anthropological and Ethnological Sciences.

CHARLTON, THOMAS H.
1966 *Archaeological Settlement Patterns: An Interpretation.* Ann Arbor, Michigan: University Microfilms.

1968 "Post Conquest Developments in the Teotihuacán Valley." Grant Proposal submitted to the National Science Foundation. Mimeo.

CHARNAY, DÉSIRÉ
1885 Les Anciennes Villes du Nouveau Monde. Paris: Librairie Hachette et Cie.

CLAERHOUT, G. A.
1965 "The Concept of Primitive Applied to Art," Current Anthropology, vol. 6, pp. 432–438.

COATES, ROSS, and BELLA FELDMAN
1973 "New Cattle Sculpture of Uganda," African Arts, vol. 7, no. 1.

COHEN, ABNER
1969 Custom and Politics in Urban Africa. Berkeley: University of California Press.

COLLINS, JUNE
1950 "Growth of Class Distinctions and Political Authority among the Skagit Indians during the Contract Period," American Anthropologist 52:331–342.

COLLISON, W. H.
1915 In the Wake of the War Canoe. London: Seeley, Service and Company, Ltd.

COLTON, HAROLD S.
1959 Hopi Kachina Dolls: With a Key to Their Identification, revised edition. Albuquerque: University of New Mexico Press.

COLTON, MARY-RUSSELL F.
1938 "The Arts and Crafts of the Hopi Indians," Museum Notes, 11:1. Flagstaff: Museum of Northern Arizona.
1965 "Hopi Dyes," Museum of Northern Arizona Bulletin 41. Flagstaff.

CONNAH, GRAHAM
1967 "New Light on the Benin City Walls," Journal of the Historical Society of Nigeria 3:4:593–609.

CONSULATE GENERAL OF JAPAN
1958 Ainu. Facts, no. A4. New York: Information Office.

COOLIDGE, DAVE, and MARY R. COOLIDGE
1939 The Last of the Seris. New York: E. P. Dutton & Company.

COOMARASWAMY, ANANDA K.
1934 The Transformation of Nature in Art. New York: Dover Publications.

CORDRY, DONALD, and DOROTHY CORDRY
1968 Mexican Indian Costumes. Austin & London: University of Texas Press.

CORDWELL, JUSTINE M.
1952 "Some Aesthetic Aspects of Yoruba and Benin Cultures," Ph.D. dissertation, Department of Anthropology, Northwestern University, Evanston, Ill.

Craft Horizons
1975 Special Issue on the Crafts of Asia. 35:2.

CROSBY, E. U.
1955 Susan's Teeth and Much about Scrimshaw. Nantucket Island, Mass.: Tetankimmo Press.

CROWLEY, DANIEL J.
1965 "Aesthetic Value and Professionalism in African Art: Three Cases from the Katanga Chokwe." Paper presented at the Conference on the Traditional Artist and African Society, Lake Tahoe, 28–30 May.
1970 "The Contemporary-Traditional Art Market in Africa," African Arts 4:1:43–49, 80.

DARK, PHILIP J. C.
1960 Benin Art. London: Hamlyn.
1974 Kilenge Life and Art: A Look at a New Guinea People. London: Academy Editions. New York: St. Martin's Press.

DAVIS, M. L., and G. PACK
1964 Mexican Jewelry. Austin: University of Texas Press.

DAWSON, GEORGE M.
1880 "Report on the Queen Charlotte Islands, 1878," Geological Survey of Canada, Part B.

DAWSON, L. E., VERA-MAE FREDRICKSON, and N. H. H. GRABURN
1974 Traditions in Transition: Culture Contact and

Material Change. Berkeley, California: Lowie Museum of Anthropology.

DEANS, JAMES
1899 "Tales from the Totems of the Hidery," *Archives of the International Folklore Association* 2

DEETZ, JAMES F.
1965 "The Dynamics of Stylistic Change in Arikara Ceramics," *Illinois Studies in Anthropology* 4, Urbana.

DELHAISE, COMMANDER
1909 *Les Warega*. Brussels: Albert de Wit.

DEVOS, GEORGE, and HIROSHI WAGATSUMA
1967 *Japan's Invisible Race*. Berkeley: University of California Press.

DIAZ, MAY N.
1966 *Tonalá: Conservatism, Responsibility, and Authority in a Mexican Town*. Berkeley: University of California Press.

DIEHL, RICHARD A.
1966 "Contemporary Settlement and Social Organization." Paper presented at the XI Mesa Redonda de las Sociedad Mexicana de Antropologia, Mexico City. Mimeo.

DIPESO, CHARLES C., and DANIEL S. MATSON
1965 "The Seri Indians in 1692 as Described by Adamo Gilk, S.J.," *Arizona and the West* 7:1:33–56.

DISSELHOFF, HANS D.
1967 *Daily Life in Ancient Peru*. New York: McGraw-Hill.

DIXON, GEORGE
1789 *A Voyage Round the World*. London: George Goulding.

DOCKSTADER, FREDERICK J.
1954 *The Kachina and the White Man: A Study of the Influences of White Culture on the Hopi Kachina Cult*. Bloomfield Hills, Mich.: Cranbrook Inst. of Art, Bulletin 35.
1959 *Directions in Indian Art*. Report of a Conference Held at the University of Arizona, Tucson. University of Arizona Press.

1967 *Indian Art in South America: Pre-Columbian and Contemporary Arts and Crafts*. Greenwich, Conn.: New York Graphic Society.

DORFLES, GILLO (ed.)
1969 *Kitsch, the World of Bad Taste*. New York: Bell (translated from the 1968 original Italian edition).

DORSEY, GEORGE A.
1898 "A Cruise among Haida and Tlingit Villages about Dixon's Entrance," *Appleton's Popular Science Monthly* 53:160–174.
1903 *Indians of the Southwest*, Atchison, Topeka, and Santa Fe R.R. Passenger Department.

DOUGLAS, FREDERIC H.
1938 "Notes on Hopi Brocading," *Plateau* 11:4. Flagstaff, Ariz.: Museum of Northern Arizona.
1939 "Acoma Pueblo Weaving and Embroidery," *Indian Art Department Leaflet* 89. Denver, Col.: Denver Art Museum.
1940 "Main Types of Pueblo Woolen Textiles," *Indian Art Department Leaflets* 94–95. Denver, Col.: Denver Art Museum.

DOZIER, EDWARD P.
1966 *Hano: A Tewa Indian Community in Arizona*. New York: Holt, Rinehart and Winston.

DRUCKER, PHILIP
1939 "Rank, Wealth and Kinship in Northwest Coast Society," *American Anthropologist* 41:1:55–65.
1965 *Cultures of the North Pacific Coast*. San Francisco: Chandler.

DUFF, WILSON
1956 "Prehistoric Stone Sculpture of the Fraser River and Gulf of Georgia," *Anthropology in British Columbia* 5:15–151.

DUNN, DOROTHY
1968 *American Indian Painting*. Albuquerque: University of New Mexico Press.

DURKHEIM, E.
1893 *The Division of Labor in Society*. New York:

Free Press (1948) (translated from the original French edition).

DUTTON, BERTHA P.
1961 *Navajo Weaving Today*. Santa Fe: Museum of New Mexico Press.

DYE, W., P. TOWNSEND, and W. TOWNSEND
1968 "The Sepik Hill Languages: A Preliminary Report," *Oceania* 39.

EGGAN, FRED
1963 *Social Organization of the Western Pueblos*. Chicago: University of Chicago Press.

EGHAREVBA, CHIEF J. U.
1960 *A Short History of Benin*. Ibadan: Ibadan University Press.

ELKAN, WALTER
1958 "East African Trade in Woodcarvings," *Africa* 28:314–323.

ELKIN, A. P.
1950 *Art in Arnheim Land*. Chicago: University of Chicago Press.

ELLIS, FLORENCE H.
1959 "An Outline of Laguna Pueblo History and Social Organization," *Southwestern Journal of Anthropology* 15:325–347.

EVANS, CLIFFORD, and BETTY J. MEGGERS
1968 "Archeological Investigations on the Rio Napo, Eastern Ecuador," *Smithsonian Contributions to Anthropology* 6. Washington, D.C.: Smithsonian Institution.

EWING, ROBERT A.
1969 "The New Indian Art," *El Palacio* 76:1:33–39, Spring.

FAGG, WILLIAM
1951 *Traditional Sculpture from the Colonies*. London: The Colonial Office.

1955-1956 "The Study of African Art," *Allen Memorial Art Museum Bulletin* 13:2:44–62.

1971 *African Crafts and Craftsmen*. New York: Van Nostrand and Reinhold.

FAGG, WILLIAM, and W. and B. FORMAN
n.d. *Afro-Portuguese Ivories*. London: Batchworth Press Ltd. (1959)

FAGG, WILLIAM, and HERBERT LIST
1963 *Nigerian Images*. London: Lund Humphries.

FAGG, WILLIAM, and MARGARET PLASS
1964 *African Sculpture*. London: Studio Vista Ltd.

FARIS, J. C.
1972 *Nuba Personal Art*. London: Duckworth.

FEDER, NORMAN
1971 *Two Hundred Years of American Indian Art*. New York: Whitney Museum.

FELGER, RICHARD S., and MARY B. MOSER
n.d. "Seri Ethnobotany." Ms. copy on file, University of Arizona, Tucson.

FEWKES, J. WALTER
1919 "Designs of Prehistoric Hopi Pottery." U.S. Bureau of American Ethnology, *Annual Report* no. 33, Washington, D.C.

FIRTH, RAYMOND
1936 *Art and Life in New Guinea*. London: Studio.

1959 *Economics of the New Zealand Maori*, second edition. Wellington: Government Printer.

FISCHER, JOHN L.
1961 "Art Styles as Cultural Cognitive Maps," *American Anthropologist* 63:1:79–93.

FORGE, ANTHONY (ed.)
1973 *Primitive Art and Society*. London: Oxford University Press.

FORMAN, W. and B., and PHILIP DARK
1960 *Benin Art*. London: Paul Hamlyn.

FOSTER, GEORGE M.
1955 "Contemporary Pottery Techniques in Southern and Central Mexico," *Middle American Research Institute*, Publication 22, pp. 1–48. New Orleans.

1965 "The Sociology of Pottery: Questions and Hypotheses Arising from Contemporary Mexican Work," in Frederick R. Matson, ed., *Ceramics and Man*, Viking Fund Publication in Anthropology No. 41.

J. A. Clifton, ed., *Introduction to Cultural Anthropology*. New York: Houghton Mifflin.

GUSINDE, MARTIN
1952 "Bericht über meine Sudafrikanische Forschungsreise," *Anthropos* 47:338–404.

HALLOWELL, ALFRED I.
1926 "Bear ceremonialism in the Northern Hemisphere," *American Anthropologist* 28:1–175.

HAMILTON, AUGUSTUS
1901 *Maori Art: The Artworkmanship of the Maori Race of New Zealand*. Dunedin, N.Z.: Ferguson and Mitchell.

HANIHARA, K.
1966 *Mongoloid Dental Complex with Special Reference to the Dentition of the Ainu*. Sapporo: U.S.-Japan Conference on the Microevolution History of Northern Peoples.

HARDY, LIEUT. R. W. H.
1829 *Travels in the Interior of Mexico*. London: Henry Colburn and Richard Bentley.

HARLOW, FRANCIS, and JOHN YOUNG
1965 *Contemporary Pueblo Indian Pottery*. Santa Fe: Museum of New Mexico Press.

HASTINGS, J. (ed.)
1960 *Encyclopaedia of Religion and Ethics*. Edinburgh: T. & T. Clark.

HAWKES, P. W.
1916 *The Labrador Eskimo*. Canada: Geological Survey, Memoir 91.

HAWTHORN, H. G., C. S. BELSHAW, and S. M. JAMIESON
1958 *The Indians of British Columbia, A Study of Contemporary Social Adjustment*. Berkeley and Los Angeles: University of California Press.

HILGER, SISTER M. I.
1967 "Japan's 'Sky People', the Vanishing Ainu," *National Geographic* 131:268–296, February.
1971 *Together with the Ainu, a Vanishing People*. Norman: University of Oklahoma Press.

HILL, WILLARD W.
1940 "Some Navaho Culture Changes during Two Centuries (with a translation of the early eighteenth century Rabal Manuscript)," *Essays in Historical Anthropology of North America*. Washington, D.C.: Smithsonian Institution Miscellaneous Collections 100.

HIMMELHEBER, HANS
1967a "The Present Status of Sculptural Art among the Tribes of the Ivory Coast," in June Helm, ed., *Essays on the Verbal and Visual Arts*, pp. 192–197. (Proceedings of the 1966 Annual Spring Meeting, American Ethnological Association.)
1967b "Fälschungen und andere Abweichungen von der traditionellen Kunst in Negerafrika," *Tribus* 16:15–34.

HIRSCHMANN, NILOUFER I.
1976 "The World in a Paper Bag," *Kroeber Anthropological Society Papers*, No. 47.

HITCHCOCK, ROMYN
1891 "The Ainos of Yezo, Japan," *Report of the United States National Museum for the Smithsonian Institution*, Washington, D.C., 429–502.

HOLLOMAN, R.
1969a "Developmental Change in San Blas," Ph.D. dissertation, Northwestern University, Evanston, Ill.
1969b "Acculturation and the Cuna," *Field Museum of Natural History Bulletin*, 40:7.

HOLMER, NILS M.
1951 *Cuna Chrestomathy*. Goteborg, Sweden: Etnografiska Museet.
1952 *Ethno-Linguistic Cuna Dictionary*. Goteborg, Sweden: Etnografiska Museet.

HOLMER, NILS M., and HENRY WASSEN
1953 *The Complete Mu-Igala in Picture Writing*. Goteborg, Sweden: Etnografiska Museet.

HOLMES, WILLAM H.
1886 "A Trade in Spurious Mexican Antiquities," *Science* 7:170–172.

1889 "On Some Spurious Mexican Antiquities and their Relation to Ancient Art," in Smithsonian Institution *Annual Report for 1886*, pp. 319–334. Washington, D.C.

HOLT, C.
1967 *Art in Indonesia: Continuities and Change.* Ithaca: Cornell University Press.

HOUSTON, JAMES A.
1951 "Eskimo Sculptors," *The Beaver*, Outfit 282, June.
1952 "In Search of Eskimo Art," *Canadian Art* 9:5, Spring.
1967 *Eskimo Prints.* Barre, Mass.: Barre Publishers.

HOWARTH, DAVID
1966 *Panama.* New York: McGraw-Hill.

ISHIDA, EIICHIRO
1962 "Nature of the Problem of Japanese Cultural Origins," in R. J. Smith and R. K. Beardsley, eds., *Japanese Culture.* Viking Fund Publications, no. 34, New York.

JAMES, GEORGE W.
1920 *Indian Blankets and Their Makers.* Chicago: A. C. McClurg and Co.

JENKINS, JOYCE
1946 "San Gregorio: An Otomi Village of the Highlands of Hidalgo, Mexico," *America Indigena* 6:345–349.

JIMINEZ BORJA, ARTURO
1941 "Mate Peruano," *Huamanga*, Nos. 42 and 43, pp. 21–25.
1948 "Mate Peruano," *Revista del Museo Nacional* 17:34–73, Lima.

JOHNSON, M.
1967 "Floral Beadwork in North America," *Museum News* 28:9–10, (University of South Dakota).

JOHNSTON, BERNICE
1968 "Seri Ironwood Carving," *The Kiva* 33:3:155–168.
1969 "Seri Sculpture," *Pacific Discovery* 22:2: 9–15.

1970 *The Seri Indians of Sonora, Mexico.* Tucson: Arizona State Museum Publications.

JONES, VOLNEY H.
1936 "A Summary of Data on Aboriginal Cotton of the Southwest," *The University of New Mexico Bulletin* 1:5, Albuquerque.

KAHLENBERT, M. H., and A. BERLANT
1972 *The Navajo Blanket.* New York: Praeger (L.A. County Museum).

KAMPUNGU, R.
1965 "Okavango marriage customs investigated in the light of Ecclesiastical Legislation." Ph.D. dissertation. Romae, Basutoland.

KAPLAN, N. I., and V. A. BARADULIN,
1975 "Yakuts Folk Crafts," *Soviet Anthropology and Archeology* 13:74–86 (translated from *Sovetskaia etnografia* 1, 1969).

KASSOVIC, S.
1974 "Tin Can Craftsmen: An Introduction to Folkrecycling." Manuscript copy at University of California, Berkeley.

1975 Whistles and Dragons: Folk Art and Acculturation. Manuscript.

KAUFMANN, CAROLE N.
1969 "Changes in Haida Indian Argillite Carvings." Ph.D. dissertation, University of California, Los Angeles.

KAVOLIS, V.
1967 *Artistic Expression: A Sociological Analysis.* Ithaca, N. Y. Cornell University Press.

KEELER, CLYDE E.
1956 *Land of the Moon Children.* Athens: University of Georgia Press.
1969 *Cuna Indian Art.* Jericho, N.Y.: Exposition Press.

KEESING, FELIX M.
1958 *Cultural Anthropology.* New York: Rinehart and Company.

KELEMEN, PAL
1969 *Art of the Americas, Ancient and Hispanic,*

with a Comparative Chapter on the Philippines. New York: Crowell.

KELLER, BONNIE B.

1967 *Wood Carvers of Zambia.* Special paper of the Livingstone Museum, Lusaka. Zambia.

KENT, KATE P.

1940 "The Braiding of a Hopi Wedding Sash," *Plateau* 12:3. Flagstaff: Museum of Northern Arizona.

1957 "The Cultivation and Weaving of Cotton in the Prehistoric Southwestern United States," *American Philosophical Society Transactions* 47:3. Philadelphia.

1961 *The Story of Navaho Weaving.* Phoenix, Ariz.: Heard Museum of Anthropology and Primitive Art.

1973 "Traditional Textile Arts in Change." Paper presented at the Advanced Seminar in Contemporary Developments in Folk Arts, School of American Research, Sante Fe, N. Mex.

KINDAICHI, KYOSUKE

1941 *Ainu Life and Legends.* Board of Tourist Industry, Japanese Government Railways.

KJERSMEIER, CARL

1935–1938 *Centres de Style de la Sculpture Negre Africaine.* Paris: Editions Albert Morance; Copenhague: Illums Bog-Afdeling.

KLUCKHOHN, C., and D. LEIGHTON

1962 *The Navajo,* Revised edition. Garden City, N. Y.: Doubleday (Anchor Books).

KODAMA, S.

1969 *The Ainu, Ethnological Studies.* Sapporo: University of Hokkaido, Department of Social Education.

1970 *Ainu, Historical and Anthropological Studies.* Sapporo: University of Hokkaido, School of Medicine Series, vol. 3.

KOOIJMAN, SIMON

1972 *Tapa in Polynesia.* Bernice P. Bishop Museum Bulletin 234. Honolulu: Bishop Museum Press.

KRAMER, F.

1970 *Literature Among the Cuna Indians.* Goteborg, Sweden: Etnografiska Museet.

KRAMRISCH, STELLA

1959 "Traditions of the Indian Craftsman," in M. Singer, ed., *Traditional India Structure and Change.* Philadelphia: American Folklore Society, Special Series Volume X:18–24.

KUPKA, KAREL

1965 *Dawn of Art.* New York: Viking Press (translated from the 1962 French original.)

LABOURET, HENRI

1931 "Les Tribus du Rameau Lobi," *Travaux et Mémoires de l'Institut d'Ethnologie* 15, Paris.

LAMEIRAS, BRIXIT et al.

1968 *Alfareria Poblana.* Mexico City: Instituto Mexicano du Cultura, Academia Mexicana de Arte Popular.

LANDOR, A. HENRY

1893 *Alone with the Hairy Ainu.* London: John Murray.

LANNING, EDWARD P.

1967 *Peru before the Incas.* Englewood Cliffs, N.J.: Prentice Hall, Inc.

LATHRAP, DONALD W.

1962 "Yarinacocha: Stratigraphic Excavations in the Peruvian Montana." Ph.D. dissertation, Harvard University.

1969 "The Transmission of Shipibo-Conibo Art Style: Stylistic Similarity and the Structure of Households." Paper read at the 34th Annual Meeting of the Society for American Archaeology, 2 May Milwaukee.

1970 *The Upper Amazon.* London: Thames and Hudson.

1971 "The Tropical Forest and the Cultural Context of Chavin," in Elizabeth P. Ben-

son, ed., *Dumbarton Oaks Conference on Chavin*, pp. 73–100. Washington, D.C.: Dumbarton Oaks Research Library.

LATOURETTE, KENNETH S.
1956 *History of Japan*. New York: MacMillan Company.

LAUER, P. K.
1975 *New Guinea Art in Transition*. St. Lucia, Queensland: Anthropology Museum, Catalogue No. 5.

LAVIOLETTE, FORREST E.
1961 *The Struggle for Survival, Indian Cultures and the Protestant Ethic in British Columbia*. Toronto: University of Toronto Press.

LAYCOCK, D. C.
1965 "The Ndu Language Family" (Sepik District, New Guinea). Canberra, Australia: Linguistic Circle of Canberra Publications, Series C—Books, Number 1.

LEIRIS, MICHEL, and JACQUELINE DELANGE
1968 "African Art," *The Arts of Mankind* (André Malraux and André Parrot, eds.). London: Thames and Hudson.

LEUZINGER, ELSY
1960 *Africa. The Art of the Negro peoples*. Art of the World. London: Methuen.

LEVIN, CLAUDIA L.
1976 "The Effects of Commercialism on the Telegraph Avenue Artisan," *Kroeber Anthropological Society Papers*, No. 48.

LEVIN, M. G.
1963 *The Origin of the Ainu: A Survey of Theories*. Toronto: University of Toronto Press.

LEVIN, M. G., and L. P. POTAPOV (eds.)
1956 *The Peoples of Siberia*. Chicago: University of Chicago Press.

LÉVI-STRAUSS, CLAUDE
1963 *Totemism* (translated by R. Needham), Boston: Beacon.
1966 "The Scope of Anthropology," *Current Anthropology* 7:112–113.

LEWIS, P. H.
1969 *The Social Context of Art in Northern New Ireland*. Chicago: Field Museum.

LEWIS, W. ARTHUR
1955 *The Theory of Economic Growth*. Homewood, Ill.: Richard D. Irwin, Inc.

LINDBLOM, KARL G.
1916 *The Akamba in British East Africa*. Uppsala: Appelbergs Boktryckeri.

LINTON, RALPH, and PAUL S. WINGERT, in collaboration with RENÉ D'HARNONCOURT
1946 *Arts of the South Seas*. New York: The Museum of Modern Art.

LIPS, JULIUS
1937 *The Savage Hits Back*. New Haven: Yale University Press.

LLOYD, PETER C.
1953 "Craft Organization in Yoruba Towns," *Africa* 23:30–44.
1967 *Africa in Social Change*. Baltimore: Penguin Books.

LOFFLER, R. .
1971 "The Representative Mediator and the New Peasant," *American Anthropologist*. 73:5:1077–1091.

LONGACRE, WILLIAM A.
1964 "Sociological Implications of the Ceramic Analysis," Paul S. Martin et al., Chapters in the Prehistory of Eastern Arizona, II. *Fieldiana: Anthropology* 55:155–170. Chicago: Field Museum of Natural History.

LUNDIN, JANE M.
1965 "Ainu Textiles." Master's thesis, University of California, Berkeley.

MacKENZIE, ALEXANDER
1891 "Descriptive Notes on Certain Implements, Weapons, etc. from Graham Island, Queen Charlottes Island, British Columbia," *Transactions of the Royal Society of Canada Proceedings* 9:45–59.

MacKnight, C. C.
1969 "The Macassans." Ph.D. dissertation, The Australian National University, Canberra.

Maduro, R.
1974 "Artistic Creativity and Aging in India," *International Journal of Aging and Human Development* 5:303–330.

1976 *Artistic Creativity in a Brahmin Painter Community*, Research Monograph Series, Berkeley, California: University of California Center for South and Southeast Asian Studies.

Majumdar, Ramesha C.
1922 *Corporate Life in Ancient India*. Calcutta: University of Calcutta.

Manrique, Leonard C.
1969 "The Otomi," in Evan Z. Vogt, ed., Ethnology, vol. 8, pp. 682–722, *Handbook of Middle American Indians*. Austin: University of Texas Press.

Manuel G. and M. Poslums
1974 *The Fourth World: An Indian Reality*. New York: Free Press.

Maquet, J.
1971 *Introduction to Aesthetic Anthropology*. Reading, Mass.: Addison-Wesley.

Marriott, Alice
1948 *Maria: The Potter of San Ildefonso*. Norman: University of Oklahoma Press.

Martijn, Charles A.
1964 "Canadian Eskimo Carving in Historical Perspective," *Anthropos* 59:546–596.

Mataira, Katarina
1968 "Modern Trends in Maori Art Forms," in Erik Schwimmer, ed., *The Maori People in the Nineteen-Sixties*, pp. 205–216.

Mathiassen, Therkel
1928 "The Material Culture of the Igloolik Eskimo," *Fifth Thule Expedition* 6:1, Copenhagen.

Maxwell, Gilbert S.
1963 *Navajo Rugs—Past, Present and Future*. Palm Desert, Calif. Desert-Southwest Publications.

May, R. J.
1974 "Tourism and the Artifact Industry in Papua New Guinea." Paper presented at the Workshop on the Impact on Pacific Island Countries of the Development of Tourism, East-West Center, Hawaii.

Mayne, R. C.
1862 *Four Years in British Columbia and Vancouver Island*. London: John Murray.

McGahan, Jerry
1971 "The condor, Soaring Spirit of the Andes," *National Geographic* 139:684–709.

McGee, W. J.
1898 "The Seri Indians," *Annual report of the Bureau of American Ethnology, 1895–1896* 17:9–298.

McKim, Frank
1947 *San Blas—An Account of the Cuna Indians of Panama*. Goteborg, Sweden: Etnografiska Museet.

McNitt, Frank
1962 *The Indian Traders*. Norman: University of Oklahoma Press.

Mead, Sidney M.
1968 *The Art of Taaniko Weaving*. Wellington: A. H. and A. W. Reed.

1969 *Traditional Maori Clothing*. Wellington: A. H. and A. W. Reed.

1969 "The Costume Styles of the Classical Maori in New Zealand, 1642–1800 A.D.," *Costume* 3:35–53. London: Victoria and Albert Museum.

1973 *Material Culture and Art in the Star Harbour Region, Eastern Solomon Islands*. Toronto: Royal Ontario Museum.

Mead, Sidney M. (ed.)
1978 *Exploring the Art of Oceania*. Honolulu: University of Hawaii Press.

MEGGERS, BETTY J.
 1966 *Ecuador*. London: Thames and Hudson.
MEGGERS, BETTY J., and CLIFFORD EVANS
 1957 "Archeological Investigations at the Mouth of the Amazon," *Bureau of American Ethnology*, Bulletin 167.
MELGAARD, J.
 1960 *Eskimo Sculpture*. London: Methuen.
MERA, HARRY P.
 1939 "Style Trends in Pueblo Pottery in the Rio Grande and Little Colorado Cultural Areas from the Sixteenth to the Nineteenth Centuries." *Memoirs of the Laboratory of Anthropology*, vol. 3. Santa Fe.
 1948 *Navajo Textile Arts*. Santa Fe: Laboratory of Anthropology.
 1949 *The Alfred I. Barton Collection of Southwestern Textiles*. Santa Fe, New Mexico: San Vincente Foundation, Inc.
METGE, JOAN
 1967 *The Maoris of New Zealand*. London: Routledge and Kegan Paul.
METROPOLITAN MUSEUM OF ART
 1975 *From the Land of the Scythians: Ancient Treasures from the Museums of the USSR*. Metropolitan Museum of Art Bulletin, 32:5.
MILLER, WICK R.
 1965 "Acoma Grammar and Texts," *University of California Publications in Linguistics* 40, Berkeley and Los Angeles.
MILLON, RENÉ
 1960 "Variations in Social Responses to the Practice of Irrigation Agriculture," *Anthropological Papers* No. 62, Department of Anthropology, University of Utah, Salt Lake City.
MILLON, RENÉ, CLARA HALL, and MAY DIAZ
 1962 "Conflict in the Teotihuacán Irrigation System," *Comparative Studies in Society and History* 4:494–524.

MILLS, GEORGE
 1959 *Navaho Art and Culture*. Colorado Springs, Colorado: Taylor Museum of the Colorado Springs Fine Arts Center.
MILNE, JOHN
 1882 "Notes on the Koro-pok-guru or Pit Dwellers of Yezo and the Kurile Islands," *Transactions of Asiatic Society of Japan* 10:2:187–198.
MITCHELL, J. CLYDE
 1966 "Theoretical Orientations in African Urban Studies," in M. Banton, ed., *The Social Anthropology in Complex Societies*. London: Tavistock Publishers.
MOHLIG, W. J. G.
 1967 *Die Sprache der Deiriku*. Germany: Köln Universität.
MONTANDON, GEORGE
 1937 *La Civilisation Ainou et les Cultures Archaiques*. Paris: Payot.
MONTHAN, GUY, and DORIS MONTHAN
 1975 *Art and Indian Individualists*. Flagstaff, Ariz.: Northland.
MORRALL, ELAINE
 1971 "Navajo Rugs, A Unique Art Form," *Ford Times* 64:1, Dearborn, Mich.
MOSER, EDWARD
 1963 "Seri Bands," *The Kiva* 28:3:14–27.
 1973 "Seri Basketry," *The Kiva* 38:105–140.
MOSER, EDWARD, and RICHARD S. WHITE, JR.
 1968 "Seri Clay Figurines," *The Kiva* 33:3:133–154.
MUELLER, J. (ed.)
 1973 *Molas: Art of the Cuna Indians*. Washington, D.C.: Textile Museum.
MUNRO, D.
 1967 *English-Edo Wordlist: An Index to Melzians Bini-English Dictionary*. Occasional Publication No. 7, Institute of African Studies, University of Ibadan, Nigeria.

MUNRO, NEIL G.
1963 *Ainu Creed and Cult.* New York: Columbia University Press.

MURDOCK, GEORGE P.
1967 *Ethnographic Atlas.* Pittsburgh: University of Pittsburgh Press.

MURILLO, G. (DR. ATL.)
1922 *Las artes populares en Mexico.* Mexico: Editorial 'Cultura'.

NEQUATEWA, EDMUND
1942 "Nampeyo, Famous Hopi Potter (1859? to 1952)," *Plateau,* 15:2:40–42, Flagstaff, Arizona.

NEWCOMBE, C. F.
1906 "The Haida Indians," *Proceedings of the International Congress of Americanists,* 15:135–160. Quebec.

NEWMAN, THELMA R.
1974 *Contemporary African Arts and Crafts: On-Site Working with Art Forms and Processes.* New York: Crown Publishers, Inc.

NEWTON, D.
1966 "Oral Tradition and Art History in the Sepik District, New Guinea," in J. Helm, ed., *Essays on the Verbal and Visual Arts,* pp. 200–215. (Proceedings of the American Ethnological Society)

NIBLACK, C.
1888 (1890) "The Coast Indians of Southern Alaska and Northern British Columbia." *Report of the United States National Museum, 1880–1890,* pp. 225–386.

NOLASCO ARMAS, MARGARITA
1962 "La Tenencia de la Tierra en el Municipio de San Juan Teotihuacán, Edo. de Mexico," *Acta Anthropológica,* Epoca 2, 2:3.

NORDENSKIOLD, ERLAND
1930 "L'archéologie du bassin de l'Amazone," *Ars Americana* 1. Paris: G. Van Oest.
1938 *Historical and Ethnological Survey of the Cuna Indians.* Goteborg, Sweden: Goteborg Museum, Ethnografiska Audelningen.

NORMAN, JAMES
1966 *Shopper's Guide to Mexico: Where, What and How to Buy.* New York: Doubleday.

ODENDALL REPORT
1964 *Report on the Commission of Enquiry in South West African Affairs.* Pretoria: Government Printer.

OHNUKI-TIERNEY, E.
1974 *The Ainu of the Northwest Coast of Southern Sakhalin.* New York: Holt, Rinehart and Winston.
1975 "On the Present Day Ainu, Discussion and Criticism," *Current Anthropology,* 16:287.

OLIVER, ROLAND
1966 "The Problem of the Bantu Expansion," *Journal of African History* 3.

OMOTO, K. and S. HARADA
1969 "Polymorphism of Red Cell Acid Phosphatase in Several Population Groups in Japan," *Japanese Journal of Human Genetics,* 14:1.

O'NEALE, LILA M.
1932 "Yurok-Karok Basket Weavers," *University of California Publications in American Archeology and Ethnology* 32, 1.

ORTIZ, SILVIA, and GUILLERMO APARICIO
1966 "Mobilidad Ocupacional en San Martín de las Pirámides, Edo. de Mexico." Paper presented at the XI Mesa Redonda de la Sociedad Mexicana de Antropología, Mexico City. Mimeo.

Pacific Arts Newsletter
1975– (P. J. C. Dark, ed.) Southern Illinois U., Carbondale, Ill.

PALMATARY, HELEN C.
1950 "The Pottery of Marajo Island, Brazil," *Transactions of the American Philosophical Society,* n.s. 39:3. Philadelphia.

PARSONS, ELSIE C.
1962 *Isleta Paintings.* Washington, D.C.: Smithsonian Institution.

PARSONS, JEFFREY R.
 1966 "The Aztec Ceramic Sequence in the Teotihuacan Valley, Mexico." Ann Arbor, Mich.: University Microfilms.
PAULME, DENISE
 1962 *African Sculpture*. London: Elek Books.
PEACOCK, J. L.
 1968 *Rites of Modernization: Symbolic and Social Aspects of Indonesian Proletarian Drama.* Chicago: University of Chicago Press
PENDLETON, WADE C.
 1970 "Ethnic Group Identity among urban Africans in Windhoek, South West Africa," *African Urban Notes* 5:1:1–14.
PENG, F. C. C., R. RICKETTS, and N. IMAMURA
 1970 "Continuity and Change in a Modern Community." Unpublished manuscript (Final report GS–2160). Tokyo.
 1972 "Reports on Joint Research on the Saru Ainu," *Journal of the Ethnological Society of Japan*, 16:3–4:1–101.
PITT-RIVERS, GEORGE H. L. F.
 1900 *Antique Works of Art from Benin*. London: Harrison and Sons.
POOLE, FRANCIS
 1872 *Queen Charlotte Islands, A Narrative of Discovery and Adventure in the North Pacific.* London: Hurst and Blacket.
RASMUSSEN, KNUD
 1929 "The Intellectual Culture of the Iglulik Eskimo," *Fifth Thule Expedition* 5:2, Copenhagen.
 1931 "Netsilik Eskimo: Social Life and Spiritual Culture," *Fifth Thule Expedition* 8:1 and 2, Copenhagen.
RATTRAY, ROBERT S.
 1927 *Religion and Art in Ashanti*. Oxford: Clarendon Press.
RAY, DOROTHY J.
 1961 *Artists of Tundra and Sea*. Seattle: University of Washington Press.

READ, CHARLES H., and ORMONDE M. DALTON
 1899 *Antiquities from the City of Benin and from Other Parts of West Africa in the British Museum.* London: British Museum, Longmans and Co.
REAY, MARIE
 1959 *The Kuma*. Melbourne: Melbourne University Press.
REDFIELD, ROBERT, R. LINTON, and M. J. HERSKOVITS
 1936 "A Memorandum on Acculturation," *American Anthropologist* 38:149–152.
REGER, MURIEL
 1970 "Amate Paper," *Artesanos y Proveedores* 5:14–15.
RICKARD, T.
 1932 *Man and Metals: A History of Mining in Relation to the Development of Civilization.* New York: McGraw Hill.
REICHARD, GLADYS A.
 1934 *Spider Woman*. New York: MacMillan Company.
 1936 *Navajo Shepherd and Weaver*. New York: J. J. Austin.
ROBBINS, WARREN M.
 1966 *African Art in American Collections*. New York: Praeger.
ROBERTS, ALFRED E.
 1909 *Visvakarma and His Descendants*. Calcutta: All-India Visvakarma Brahman Mahasabha.
ROBERTSON, D.
 1959 *Mexican Manuscript Painting of the Early Colonial Period: The Metropolitan Schools.* New Haven: Yale University Press.
ROCH, E., P. FURNEAUX, and L. ROSSHANDLER
 1975 *Arts of the Eskimo: Prints*, Barre, Mass.: Barre Publishers.
ROCKEFELLER, M. C.
 1968 *The Asmat of New Guinea: The Journal of Michael Clark Rockefeller*, A. A. Gerbrands, ed. New York: Museum of Primitive Art.

ROSENBERG, BERNARD, and NORRIS FLIEGEL
1965 "Dealers and Museums," in *The Vanguard Artist: Portrait and Self-Portrait*. New York: Quadrangle Books.

ROSENBERG, HAROLD
1965 "The Art Establishment," *Esquire* 63:43, 46, 114, January-June.

ROSSBACH, ED
1973 *Baskets as Textile Art*. New York: Van Nostrand and Reinhold.

ROWE, JOHN H.
1961 "The Chronology of Inca Wooden Cups," in S. Lothrop, ed., *Essays in Pre-Columbian Art and Archeology*, pp. 317–341. Cambridge: Harvard University Press.

ROWLAND, BENJAMIN
1956 *The Art and Architecture of India*, second edition. Baltimore: Penguin.

RYDER, A. F. C.
1969 *Benin and the Europeans 1485–1897*. London: Longmans, Green and Co.

SABOGAL, JOSÉ
1945 *Mates Burilados*. Buenos Aires: Editorial Nova.

SADLER, MICHAEL E. (ed.)
1935 *Arts of West Africa (Excluding Music)*. London: International Institute of African Languages and Cultures.

SAHAGUN, FRAY BERNARDINO DE
1946 *Historia General de las Cosas de Nueva España*. Mexico: Editorial Nueva España.

SALVADOR, M.
1975 "Molas of the Cuna Indians: A Case Study of Artistic Criticism and Ethno-Aesthetics." Ph.D. dissertation, Berkeley: University of California.

SANDELOWSKY, BEATRICE H.
1971 "The Iron Age in South West Africa and Damara Pot Making," *African Studies*, January. University of Witwatersrand Press.

SANDERS, WILLIAM T.
1957 "Tierra y Agua (Soil and Water): A Study of the Ecological Factors in the Development of Mesoamerican Civilizations." Ph.D. dissertation in anthropology, Harvard University.
1963 "Teotihuacán Valley Project, Preliminary Report, 1960–1963 Field Seasons." Mimeo.
1965 *The Cultural Ecology of the Teotihuacán Valley*. University Park, Penn.: Department of Sociology and Anthropology, Pennsylvania State University.

SANNES, G. W.
1970 *African 'Primitives': Function and Form in African Masks and Figures*. London: Faber and Faber.

SAPIR, EDWARD
1924 "Culture, Genuine and Spurious," *American Journal of Sociology* 29, January.

SARICH, VINCENT
1969 "Introduction to Physical Anthropology," *Fybate Lecture Notes*, Berkeley 23:2.

SCHMITZ, C. A.
1971 *Oceanic Art: Man, Myth and Image in the South Seas*. New York: Abrams.

SCHNEEBAUM, TOBIAS
1975 "A Museum for New Guinea," *Craft Horizons*, 35:2, 36:88–89.

SCHNEIDER, B.
1972 "Malangata of Mozambique," *African Arts*, 5:40–45.

SCHUSTER, M.
1970 "The Painters of the May River," *Palette* 33:3.

SCHWAB, GEORGE
1947 "Tribes of the Liberian Hinterland," *Papers of the Peabody Museum of American Archaeology and Ethnology* 31, Harvard University.

SCOULER, JOHN
 1905 "Dr. John Scouler's Journal of a Voyage to Northwest America," *Oregon Historical Quarterly* 6:54–76, 159–205, 276–289.

SEGY, LADISLAS
 1952 *African Sculpture Speaks.* New York: A. A. Wyn, Inc.
 1958 *African Sculpture.* New York: Dover Publications, Inc.

SHARMA, RAM S.
 1958 *Sudras in Ancient India.* Delhi: Motilal Banarsidass.

SHUKLA, D. N.
 1957 "Hindu Canons of Painting," *Bhartiya Vastu-Shastra Series* 4:3. Lucknow: Prem Printing Press.

SIMEON, GEORGE
 1974 "A Hokkaido Village, Fieldwork Report," *Current Anthropology*, 15:78–79.
 1975 "Reply, on Present Day Ainu," *Current Anthropology*, 16:2:287–288.

SMITH, ANNE M.
 1966 "New Mexico Indians: Economic Educations and Social Problems," *Museum of New Mexico Research Records*, No. 1, Santa Fe.

SMITH, B. W.
 1960 *European Vision and the South Pacific.* Oxford: Clarendon Press.

SMITH, SIR HUBERT LLEWELLYN
 1924 *The Economic Laws of Art Production.* London: Oxford University Press.

SMITH, WATSON, and JOHN M. ROBERTS
 1954 "Zuni Law, a Field of Values," *Peabody Museum of American Archeology and Ethnology Papers* 43:1. Harvard University.

SMITH, WILLIAM N.
 1968 "Four-seasonal Coverage of the Ecological Aspects of Survival in a Submarginal Marine-Desert Environment." Tucson: Arizona State Museum. Mimeo.

 1970 "Introduction and Observations," in Ted DeGrazia and William N. Smith, eds., *The Seri Indians*, pp. 3–14. Flagstaff, Arizona: Northland Press.

SOUTER, GAVIN
 1963 *New Guinea: The Last Unknown.* Sydney: Taplinger Press.

SOUTHALL, A.
 1961 *Social Change in Modern Africa.* London: Oxford University Press.

SPICER, EDWARD H.
 1962 *Cycles of Conquest: The Impact of Spain, Mexico and the United States on Indians of the Southwest 1533–1960.* Tucson: University of Arizona Press.

SPIER, LESLIE
 1924 "Zuni Weaving Technique," *American Anthropologist* 26:1:64–85.

SPRATT, P.
 1966 *Hindu Culture and Personality.* Bombay: P. C. Manaktala and Sons, Private Ltd.

SRINIVAS, M. N.
 1952 *Religion and Society among the Coorgs of South India.* Oxford: Clarendon Press.
 1962 *Caste in Modern India.* Bombay: Asia Publishing House.
 1966 *Social Change in Modern India.* Berkeley: University of California Press.

STANLEY, G. E.
 1968 "The Indigenous Languages of South West Africa," *Anthropological Linguistics* 10:5–18.

STEPHEN, ALEXANDER M.
 1936 "Hopi Journal," Elsie C. Parsons, ed., *Columbia University Contributions to Anthropology* 23.

STEVENSON, MATILDA
 1879 Manuscript on Pueblo Indian Clothing in the Indian Department, Denver Art Museum, Denver, Colorado.

STEWARD, JULIAN H., and ALFRED METRAUX
1948 "Tribes of the Peruvian and Ecuadorian Montañ," in Julian H. Steward, ed., The Tropical Forest Tribes, vol. 3, pp. 535–656, Handbook of South American Indians. Bureau of American Ethnology, Bulletin 143. Washington, D.C.

STEWART, G. (ed.)
1972 The Garrick Introduction to Sepik Art. Melbourne: Garrick.

STOUT, D. B.
1947 San Blas Cuna Acculturation: An Introduction. New York: Viking Fund.

STOUT, J. ANTHONY
1966 Modern Makonde Sculpture. Nairobi: Kibo Art Gallery Publications.

STRATHERN, A. and S.
1971 Self Decoration in Mount Hagen. Toronto: University of Toronto Press.

STROMBERG, G.
1976 "The Marketing and Production of Innovation in the Silver Industry of Taxco, Go." Ph.D. dissertation: University of California, Berkeley.

STREITWOLF, H.
1911 Der Caprivizipfel. Berlin: Susserott Verlag.

STURTEVANT, W. C.
1967 "Seminole Men's Clothing," in Essays on the Verbal and Visual Arts. Seattle: University of Washington Press.

SWINTON, GEORGE
1965 Eskimo Sculpture. Toronto: McClelland and Stewart.

1972 Sculpture of the Eskimo. Toronto: McClelland and Stewart.

SZOMBATI-FABIAN, I., and J. FABIAN
1976 "Art, History and Society: Popular Art in Shaba, Zaïre." Studies in the Anthropology of Visual Communication 3:1–21.

TAKAHASHI, M.
1967 Modern Japanese Economy Since the Meiji Restoration. Tokyo: Society for International Cultural Relations.

TAKAKURA, S.
1960 "The Ainu of Northern Japan," Transaction of the American Philosophical Society, 50:4.

TANNER, CLARA LEE
1973 Southwest Indian Painting. Tucson: University of Arizona Press.

1968 Southwest Indian Craft Arts. Tucson: University of Arizona Press.

TAYLOR, W. E., JR., and G. SWINTON
1967 "Prehistoric Dorset Art," Beaver, Outfit 298, pp. 32–47, Autumn.

THOMPSON, RAYMOND H.
1958 "Modern Yucatecan Pottery Making," The Society for American Archaeology, Memoir 15.

THOMPSON, ROBERT FARRIS
1974 African Art in Motion: Icon and Act. Los Angeles, Berkeley: University of California Press.

THOMSON, D. F.
1949 Economic Structure and the Ceremonial Exchange Cycle in Arnhem Land. Melbourne: MacMillan and Co.

TIBOL, R.
1964 Historia general del arte mescicano: Epoca moderna y contemporánea, Volume 3, D. Pedro Rojas, ed. Mexico, D. F.: Editorial Hermes.

TILLEY, MARTHA
1967 Three Textile Traditions, Pueblo, Navaho & Rio Grande. Colorado Springs: The Taylor Museum of the Colorado Springs Fine Arts Center.

TONEYAMA, KOJIN, and CARLOS ESPEJEL
1974 Popular Arts of Mexico. New York: Weatherhill.

TOOR, FRANCES
1947 Mexican Folkways. New York: Crown Publishers, Inc.

TORRES DE TANELLO, R.
1957 *La Mujer Cuna de Panamá*. Mexico, D.F.: Ediciones Especiales del Instituto Indigenista Interamericano.

TOWNSEND, G. W. L.
1968 *District Officer*. Sydney: Tri-Ocean.

TRACEY, A.
1961 "Kamba Carvers," *African Music* 2:55–58.

TROWELL, MARGARET
1954 *Classical African Sculpture*. London: Faber and Faber.

TUCKSON, J. A.
1964 "Aboriginal Art and the Western World," in R. M. Berndt, ed., *Australian Aboriginal Art*, pp. 60–68.

TURNER, PAUL R.
1967 "Seri and Chontal (Tequistlateco)," *International Journal of American Linguistics* 33:3:235–239.

UNDERHILL, RUTH
1953 *Pueblo Crafts*. Bureau of Indian Affairs, U.S. Dept. of Interior, Indian Handicrafts 7.

VALLEE, FRANK G.
1967 *The Eskimo Cooperative at Povungnituk*. Ottawa: Northern Science Research Group.

VAN TONDER, L.
1965 "The Hambukushu." Ph.D. dissertation, University of Stellenbosch, South Africa.

VEDDER, H.
1928 *The Native Tribes of South West Africa*. London: Frank Cass & Co., Ltd.

VIVO, JORGE A.
1958 *Geografía Humana de México: Estudio de la Integración Territorial y Nacional de México*. México D.F.: Editorial Galaxia.

VON HAGEN, VICTOR
1954 *The Aztec and Maya Papermakers*. New York: The American Library.

VON LUSCHAN, F.
1919 *Die Altertümer von Benin*. Berlin: Museum für Völkerkunde.

VOSSEN, RUDIGER
1969 "Archäologische Interpretation und Ethnographischer Befund." Ph.D. dissertation, University of Hamburg.

WAFER, L.
1933 *A New Voyage and Description of the Isthmus of America*. Oxford: Hakluyt Society, Second series, No. 73 (originally 1699).

WAGNER, F.
1959 *Indonesia: The Art of an Island Group*. New York: McGraw-Hill.

WARNER, W. L.
1958 *A Black Civilization*, revised edition. New York: Harper and Brothers.

WATANABE, H.
1966a The Ainu: Present Conditions of Their Life and Urgent Needs for Field Study," *Bulletin of the International Committee on Urgent Anthropological and Ethnological research*, No. 8.

1966b "Ecology of the Jomon people: Stability of Habitation and its Biological and Ethnohistorical Implications," *The Journal of the Anthropological Society of Nippon* 74:749:21–32.

1968 "Subsistence and Ecology of Northern Food Gatherers with Special Reference to the Ainu," in R. Lee and I. Devore, eds., *Man the Hunter*. Chicago: Aldine Publishing Company.

1969 "Famine as a Population Check. Comparative Ecology of Northern Peoples," *Journal of the Faculty of Science* 5:3:4:237–252.

1973 *The Ainu Ecosystem, Environment and Group Structure*. Seattle: University of Washington Press.

WESTPHAL, E. O.
1958 *Kwangari*. University of London: The School of Oriental and African Studies.

WEYER, E. M.
1932 *The Eskimos: Their Environment and Folk-*

ways. New Haven: Yale University Press.

WHITAKER, BEN (ed.)

1972 *The Fourth World.* Eight reports from the Field work of the Minority Rights Group. London: Sedgwick & Jackson.

WHITING, ALFRED F.

1942 "Hopi Crafts." Report prepared for the Arts and Crafts Board. Manuscript on file at the Museum of Northern Arizona, Flagstaff.

WIKE, J.

1957 "More Puzzles on the Northwest Coast," *American Anthropologist* 59:301–317.

WILLETT, FRANK

1967 *Ife in the History of West African Sculpture.* London: Thames and Hudson.

1971 *African Art. An Introduction.* London: Thames and Hudson; New York: Praeger.

WILSON, R. K., and K. MENZIES

1967 "Production and Marketing of Artifacts in the Sepik Districts and the Trobriand Islands," in *New Guinea People in Business and Industry,* New Guinea Research Bulletin 20:50–75, December.

WORMINGTON, H. M., and ARMINTA NEAL

1965 *The Story of Pueblo Pottery.* Denver Museum of Natural History, Museum Pictorial No. 2.

XAVIER, GWINETH H.

1946 "Seri Face Painting," *The Kiva* 11:2:15–20.

YAWATA, ICHIRO

1962 "Prehistoric Evidence for Japanese Cultural Origins," in R. J. Smith and R. K. Beardsley, eds., *Japanese Culture.* New York: Viking.

ZIMMER, HEINRICH

1946 *Myths and Symbols in Indian Art and Civilization.* New York: Harper Torchbooks.

1955 *The Art of Indian Asia,* J. Campbell, ed. New York: Pantheon Books.

Index